D1267243

ELEGY FOR THEORY

# ELEGY FOR THEORY

D. N. Rodowick

HARVARD UNIVERSITY PRESS

Cambridge, Massachusetts
London, England
2014

Library of Congress Cataloging-in-Publication Data

Rodowick, David Norman.
  Elegy for theory / D.N. Rodowick.
      pages cm
  Includes bibliographical references and index.
  ISBN 978-0-674-04669-6
  1. Motion pictures—Philosophy.   I. Title.
  PN1995.R6193 2013
  791.4301—dc23
                                      2013012601

*For Dudley Andrew, who guided my thought at the beginning . . .*

# CONTENTS

Ein philosophisches Problem hat die Form: "Ich kenne mich nicht aus."

—Ludwig Wittgenstein, *Philosophical Investigations*

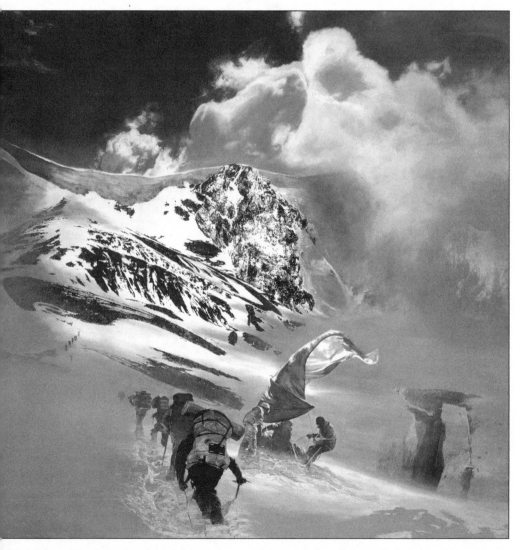

Mark Tansey, *West Face,* 2004 © Mark Tansey. Courtesy Gagosian Gallery. Photography by Robert McKeever.

## In Place of Beginning . . .

A new audiovisual culture, whose broad and indiscernible outlines we are only just beginning to distinguish, calls us to new modes of existence and forms of experience. Like any soul derailed by the vertiginous shock of modernity, we seek a conceptual compass to guide us home. One name for this navigational instrument is theory; another may be philosophy.

*Elegy for Theory* is the second of three books where I discuss the fate of cinema studies as a field of humanistic inquiry in the twenty-first century. The first book, *The Virtual Life of Film,* explored the philosophical consequences of the disappearance of a photographic ontology for the art of film and the future of cinema studies as the creative process of filmmaking becomes overtaken by digital technologies. *Elegy for Theory* surveys critically the place and function of the idea of theory in the humanities as we have lived and still live it today. *The Virtual Life of Film* concludes by reaffirming the importance of theory in that every discipline sustains itself "in theory"—a discipline's coherence derives not from the objects it examines, but rather from the concepts and methods it mobilizes to generate critical thought. *Elegy for Theory* and a third book, *Philosophy's Artful Conversation,* continue this argument through a critical and historical examination of what theory means for the arts and humanities, and why and how it has become a contested concept over the past thirty years. These books also take the fate of theory in cinema studies as exemplary of the more general contestation of theory in the humanities. Indeed, my discovery in researching this project is that theory has always been a difficult, unstable, and undisciplined concept, and this history of unruliness reaches back 2,500 years.

Like every author, I hope this book, and its forthcoming companion volume, *Philosophy's Artful Conversation,* will be read and thought about as a whole composed of many interconnected parts and voicings, where a sympathetic ear attends to the unfolding of themes and variations, harmony and counterpoint, refrains, returns, and improvisations, as different lines of thought

depart from and return to one another in new contexts. Yet having reached the point where I am ready to release my elegy for theory into readers' hands, I discover with some embarrassment that I have and have not written the book I intended to write. This study should be read as a whole, but many readers will justifiably approach it in sections or parts. Originally meant as a single project, my elegy will now be divided into two books. The present volume presents a genealogical perspective on theory's contested life, and its variable and discontinuous senses. The companion study that will follow, *Philosophy's Artful Conversation*, marks a turn in my larger argument where the problematic existence of theory becomes the possibility of philosophy, especially what I call a philosophy of the humanities. My picture of a possible philosophy of the humanities takes inspiration from the later philosophical works of Ludwig Wittgenstein and their influence on figures as diverse as G. H. von Wright, P. M. S. Hacker, Charles Taylor, Richard Rorty, and Stanley Cavell. *Philosophy's Artful Conversation* then concludes with an extensive discussion of Gilles Deleuze and Stanley Cavell as contemporary philosophers with distinctly original conceptions of the specificity of philosophy and of philosophical expression in relation to film and the arts. In reading these two thinkers together, I want to deepen and clarify their original contributions to our understanding of film and of contemporary philosophical problems of ontology and ethics, and interpretation and evaluation.

I have just said that theory is problematic, meaning in a first sense that when we feel puzzled or perplexed, we turn to theory to navigate into and out of the problems blocking our paths to thought. (Theories do not resolve problems. Rather, think of theories and problems as mutually sustaining opposed forces.) This study also views "theory" itself as problematic to the extent that, as a word and concept, it is considered to have *a* sense or to indicate a given practice of thought, or that it even has a single continuous history. In analogy with film's virtual life, theory is a way of thinking that when considered critically and genealogically retreats from us as rapidly as we approach it, like a fata morgana. We moderns in the humanities have lived with theory for what seems like a long time. It has a certain presence to us or for us, which some embrace and others resist. But if theory is considered as something more like a language game, in how many ways could it be played? How variable or consistent would the rules remain across these games, and how many varieties of similarity and difference might become apparent?

Considered in this way, my project now divides into a series of plateaus with different areas and elevations, sometimes separated by impassable crev-

ices and sometimes connected by hidden passages or overlooked bridges. This terrain is rugged and uneven. Some plateaus obscure others from clear sighting until we change our distance or angle, and many are populated with their own distinct ecosystems, some of which are seeded by neighboring land, some not. All of which is to say that I think of this book as something like a topographic map whose aim is to make clear and perspicuous the branching lines of descent, but also the breaks, divisions, or fractures, where theory's meaning takes the form of irregular series.

*Elegy for Theory* is organized around important historical disruptions in our senses of theory. Throughout this book, I argue that the concept of theory has a long pedigree in the history of philosophy, where theory is often in contest or competition with philosophy. At the same time, it is not possible, in either the history of philosophy or in the philosophy of science, to attribute a stable sense to theory that leads inexorably toward a perfectible concept around which a final consensus can be achieved. This is one way that theory, too, has a virtual life with many breaks and variations. It may be that our relation to theory always has been, and perhaps always will be, contingent and historical. For example, in the classical era, a vernacular sense of *theoria* as civic witnessing, watching, observing, or giving official and reliable testimony is displaced around the fourth century BCE by a newer sense of attentive reflection or meditation, something closer to what later became *contemplatio* in Latin translation. Concomitant with this transformation is the invention of a new practice of thought as well as a new mode of life, called *philosophein* or philosophizing, whose reach toward understanding the world also aims at transforming the self. The desire for a philosophical life is driven not only by a thirst for knowledge but also and principally by ethical dissatisfaction and existential dilemmas that encourage the quest for a new way of life or mode of existence.

A second rupture occurs in the later eighteenth century, where variations in concepts of theory make of it a term of mediation between the senses and reason. At this moment, theory is linked to another too-familiar term undergoing new pressures of transformation—aesthetic. Moreover, debates on the senses of theory in relation to art and science, and whether there can be a science of art, are part and parcel with the emergence of philosophy as a university faculty and an academic discipline. While the two moments of rupture are very different and singular in many respects, each discontinuity is also accompanied by a process of retrojection; in other words, the messy and conflictual history of the concept is suppressed in each new instance by projecting historical continuities backward to construct a teleology that leads

inevitably to its present now-favored definition. Every violent conceptual struggle is thus followed by efforts to provide a venerable ancestry for newly won definitions of the concept. New concepts of theory are thus often guided by present interest through forces of retrojection that make the unfamiliar familiar again.

As exemplified in the introduction to Hegel's *Lectures on Aesthetic,* periods of discontinuity and debate also inspire a drive to legislate boundaries between the activities of theory, philosophy, and science, which in turn seek to establish epistemological hierarchies among these practices. But these boundaries, too, are unstable, fluid, and often blurred and indiscernible or exchangeable. The legislative drive often takes the form of debates concerning what a science is, or what philosophy is or may be, with theory as an intermediate term floating uncertainly between the two. To achieve some clarity in evaluating these historical disruptions and debates, I suggest that there are three basic semantic domains where theory is deployed as a language game—what I call the vernacular, the methodical, and the scientific—though in individual uses they can overlap, become interchangeable, or even confused.

By the mid-nineteenth century, the problem with theory, what makes theory problematic in its variable senses, is that it is divided from within by forking genealogical roots—one sunk deeply in the ancient ground of philosophy, the other maturing and flourishing out of the history of positivism and the empirical sciences—that will be unequally nourished in the twentieth century. Even so, the evocation of theory as a practice or special concept of knowledge remains rare up to the mid-twentieth century, especially in the arts and humanities. There are interesting and significant exceptions, however, where the appeal to theory or "theories of," no matter how rare, yield powerful instances, some of which associate an idea of theory with crises of modernity. From this perspective, a work like György Lukács's *The Theory of the Novel* may be read, as Lukács himself suggests in a retrospective preface, in a way where theory signifies the response to this crisis, at once ethical and social, where one no longer feels at home in the world and where the movements of history are experienced not as progress but rather as the headlong rush into catastrophe.

Discontinuity, retrojection, and rarity are important watchwords in my elegy for theory. The second half of the book narrows the historical focus to the twentieth century, where the history of cinema as an art form and the history of thought about cinema emerge alongside a new discourse of the human sciences. I characterize this thought as three historically distinct yet often overlap-

ping discursive modalities: the aesthetic discourse, the discourse of structure or signification, and the discourse of ideology or culture. (*Philosophy's Artful Conversation* will begin by examining the paradoxical question of what comes "after" theory, whether in the form of the post-Theory debates of the 1990s or in the suggestion that theory is displaced by philosophy and history.)

The second half of this book is not so much a history of theory in film or the human sciences as a critical examination of significant moments of rupture, reconsideration, and retrojection where theory takes itself as its own object, examines and reconfigures its genealogy, conceptual structure, and terminology, and posits for itself a new identity and cultural standing. It may seem odd to take the history of thought about cinema as representative of a much larger and more complex debate in the humanities, but there are several advantages of narrowing my analysis in this way. Focusing on the history of a single field of discourse makes my account more manageable. In addition, while film studies is relatively young as a university discipline, thought about cinema has been conceptually and discursively bound up with the main twentieth-century critical debates about both literature and art. In many cases, what comes to be known as literary or art theory is forged in the same historical contexts as writing on film, and all three can be seen as belonging to and interacting in common discursive and conceptual frameworks. Theory is a tangled skein composed from many threads whose filaments must be followed both individually and in the weave of their shifting patterns. Accordingly, my arguments will focus on significant points of passage and displacement in the genealogy of theory: Ricciotto Canudo as exemplar of the aesthetic discourse, Boris Eikhenbaum and Russian Formalism, the filmology movement in France, the rise of structuralism and the early work of Christian Metz, the impact of Julia Kristeva and *Tel Quel*'s *théorie d'ensemble* on what has been called the theory of the subject, and finally, the acknowledged and unacknowledged influence of Louis Althusser on the discourses of political modernism, culturalism, and the politics of identity. These points of passage should be imagined less as fixed and successive periods, or conceptual schemes overturning and replacing one another, than as overlapping and intersecting genres of discourse full of retentions, returns, and unexpected extensions, as well as ellipses and omissions. What I offer here is not a history of contemporary theory, then, but rather something like the elements of a historiography of concepts, enunciative modalities, and discursive formations in which developments in the academic study of film might stand, *pars pro toto,* for the vicissitudes of theory in the humanities more generally.

# 1. A Compass in a Moving World

> All that we reckoned settled shakes and rattles; and literatures, cities, climates,
> religions, leave their foundations and dance before our eyes.
>
> —Ralph Waldo Emerson, "Circles"

In the final pages of *The Virtual Life of Film*, I recounted my puzzlement at being asked if the study of film would remain relevant in an era dominated by electronic and digital images. No doubt cinephiles of a certain generation regard the disappearance of the photographic image with intense nostalgia, perhaps even mourning. Indeed, the millennial form of cinephilia has become historical in a way that swings between mourning and melancholia. A desire in pursuit of a lost object: Has not the experience of film always been such—that is, the longing to recover the past in the present and to overcome lost time? The difference now is that the phenomenological force of photography, fueled by what I called automatic analogical causation, has been almost completely replaced by new series of computational automatisms and experiences. From the perspective of melancholia, film is historical in an archaeological sense: an object lost to history that cannot be recovered; an experience that can be imagined or reconstructed, perhaps, but never felt anew. Consequently, one seeks in digital images an experience that cannot be fully replaced, like widowers who have not yet learned to admire a worthy and seductive lover.

The melancholic cinephile will never let go of his desire for a lost object. (And he may even have forgotten or lost any sense of this experience as perceived or lived.) But mourning can be overcome and new loves reborn. That moving images have a virtual life means that new ways to love them can always be found—they will continue to be meaningful and to give meaning to our present experience. Explaining and evaluating this virtual life require concepts, or rather an ongoing process of conceptualization, of refashioning or inventing ways of understanding commensurate with the image's virtual life. The desire to explain this experience by inventing or developing concepts adequate to thinking with or through it—call this, for the moment, theory—is

inescapably caught up in, indeed engendered by, our confrontations with the ontological perplexities that screened images raise regarding our locatedness in time and in space, in relation both to the world and to each other through the medium of moving images.

But am I not caught in paradox here? In a project devoted to exploring the prospects for studying moving image culture in the twenty-first century, why extol a love that can always be rekindled in the moving image while writing an elegy for theory?

In some respects, theory is present more than ever in our thoughts about moving images. One consequence of the rapid displacement of photography by digital processes has been to fuel a new and welcome fascination with the history of film theory, as if desiring to recover or to reexperience the intense aesthetic pleasure and ontological curiosity of the artists and writers who lived and witnessed the first thirty years of film's virtual life. These philosophical pioneers puzzled over the new qualities of space and time enfolding spectators and defining their modernity, while challenging tenaciously held concepts of aesthetic experience inherited from the nineteenth century. (Writing in 1939, Walter Benjamin expressed this attitude in observing that the question was not whether photography and film could be art, but whether instead they had transformed the entire character of art.[1]) In short, faced with a new medium, they felt compelled to define and explain it, even as its forms shifted before their eyes. Classical film theory has renewed significance for film studies today because the computational arts and communication, which often take on a photographic or cinematographic appearance, confront us with an analogous shock, and compel us to reassess our experience of modernity through moving images. Like Vachel Lindsay, Hugo Münsterberg, or Ricciotto Canudo, not to mention Jean Epstein, Sergei Eisenstein, Siegfried Kracauer, or Walter Benjamin, we strive mentally for concepts to give logical form to the unruly thoughts inspired by images that disorient us in time and that are no longer content to occupy space in ways familiar to us.

An elegy for film fuels the virtual life of theory; the former leads inexorably, and perhaps surprisingly, into the latter, in what turns out to be the single face of a twisting Möbius strip. The displacement of the photographic by the digital inspires new forms and conditions of ontological puzzlement concerning

---

1. "The Work of Art in the Age of Its Technological Reproducibility: Third Version," in *Walter Benjamin: Selected Writings,* ed. Howard Eiland and Michael W. Jennings, vol. 4, *1938–1940* (Cambridge, Mass.: Belknap Press of Harvard University Press, 2003), 258.

our experience of modernity through moving images. And these images now move, and occupy space and time, in ways that are as novel to us as to spectators in the first nickelodeons. Twenty years hence, will readers completely attuned to a computational ontology puzzle over how we could have felt such wonder and anxiety? Classical film theory was a lively period of conceptual innovation and experimentation. Contemporary cinema studies seeks inspiration there perhaps because the shock of modernity is as intense for us now as it was for those thinkers who first confronted the powers of photography and cinema. The desire to explain this experience, indeed the unending task of mastering it through concepts that could settle this moving world and help us find peace within it, was given a name very early in the twentieth century: "theory." Already in 1924, in his wonderful and prescient book *Der sichtbare Mensch*, Béla Balázs called for theory as a conceptual compass in the stormy seas of aesthetic creativity and experience. What film studies has forgotten in the intervening decades is the *strangeness* of this word, as well as the variable range and complexity of the questions and conceptual activities that have surrounded it over time like clouds reflecting light and shadow in ever-changing shapes. The word "theory" has weight, gravity, and solidity in the humanities today. But, as Wittgenstein might have put it, like every overly familiar word, on closer examination it begins to dissolve into "a 'corona' of lightly indicated uses. Just as if each figure in a painting were surrounded by delicate shadowy drawings of scenes, as it were in another dimension, and in them we saw the figures in different contexts."[2]

The idea of theory in art or film has a long and complex history, and this history invariably and recurrently coincides with and departs from the history of philosophy. Indeed, the range of activities covered by concepts of theory comprises a genealogy much longer and more complex than the virtual life of film. As a form of explanation, theory is ever more important to our comprehension of contemporary moving image culture, which is ever more powerfully a digital culture. Yet in film studies, as in the humanities in general, attitudes toward theory remain vexed. The decades since the 1970s have witnessed many critiques of theory, mostly unkind. These attempts to dislodge, displace, overturn, or otherwise ignore it have taken many forms—against theory, post-theory, after theory—as if to contain or reduce the wild fecundity of its conceptual activity or to condemn it to exile. In most cases, these critics have no clearer a view of what theory is than the thinkers who are supposed to practice it. The lack of clarity in our picture of theory haunts the humanities, and this

2. *Philosophical Investigations* II, trans. G. E. M. Anscombe (Oxford: Blackwell, 2001), sec. 6, 155.

is as true for its defenders as for its assailants. However, my goal here is not to give an account of these attacks, or even to respond to or refute them. If you should accompany me to the conclusion of my thoughts in this book, and in its companion, *Philosophy's Artful Conversation*, you will see that I have more modest claims for the practice of theory, and indeed may give a great deal of ground to its rivals. Moreover, to reclaim some territory for theory and to re-assert its powers of explanation and conceptual innovation, we may have to call upon a practice with a yet longer and more venerable history—philosophy. To write an elegy for theory may mean rediscovering a life in philosophy.

The impulse that drives this book goes deeper than debates for and against theory, for there is a hole at the center of this discussion (what once might have been called a structuring absence) that is not so easily filled in or accounted for. My first thoughts on this problem date back to my inaugural lecture at King's College London in 2002, when it occurred to me that the two fundamental prob-lems confronting the revitalization of film studies in the twenty-first century were first, how to assess the displacement of the photographic by the electronic and digital, and second, how to renew the place of theory in this debate.[3] In the days following my lecture, a colleague and good friend, Simon Gaunt, an accom-plished scholar of medieval French and no stranger to contemporary theory, asked a question that, despite its simple and straightforward form, continues to haunt and derail me: "What is film theory?" (He might well have asked, what is literary theory or art theory?) But being a good philosophical friend, Gaunt was provoking me, I continue to think, to confront a deeper and more fundamental problem. Despite thirty years of teaching and writing about the history of theory, I could not give a simple answer to his inquiry, for the question "What is theory?" is as variable and complex as the desire to explain "What is cinema."

Gaunt's question, and my incapacity to respond to it, utterly defamiliarized a mode of existence I had happily occupied for several decades—that of a self-described film theorist. My confidence was shaken, and the word "theory" became unfamiliar to me, melting into its corona of lightly indicated uses. In-deed, to paraphrase Christian Metz at the conclusion of his magisterial essay "The Imaginary Signifier," I discovered that I have loved theory, I no longer love it, I love it still.

---

3. Published as "Dr. Strange Media, or How I Learned to Stop Worrying and Love Film The-ory," in *Inventing Film Studies*, ed. Lee Grieveson and Haidee Wasson (Durham, N.C.: Duke University Press, 2008), 374–397. An expanded version of this essay comprises part 1 of D. N. Rodowick, *The Virtual Life of Film* (Cambridge, Mass.: Harvard University Press, 2007), 1–24.

What is theory that it should arouse such emotion and debate both within the humanities and between the humanities and the sciences? For those of us in the arts and humanities who characterize our work as theoretical, by what conceptual means do we recognize and identify the how, the why, and the what of our doing? What does it mean to belong to a community of thinkers in the arts and humanities who characterize their work as theoretical, and how does this make us different from or similar to a historian, a critic, or a philosopher? Do we have now (have we ever had?) a clear and perspicuous view of theoretical activities, practices, and concepts? Would anyone who knows what "theory" is please raise your hand?

## 2. Many Lines of Descent

> When the past speaks it always speaks as an oracle: only if you are an architect of the future and know the present will you understand it.
>
> —Friedrich Nietzsche, "On the Uses and Disadvantages of History for Life"

In the contemporary context, the concept of theory is like a coin too long in circulation. As the coin has been passed from hand to hand, its surface has become flat and unburnished, its value illegible. If our conceptual picture of theory is clouded, perhaps this is because we have forgotten that it is a *moving* picture. Theory, as we live and challenge it today and as it challenges us, has a history. It is not *a* language-game but many, comprising various overlapping yet often contradictory and contested forms of life. Little wonder that now as in the 1920s it has seemed more a battleground—a test of competing conceptual wills with feints, sallies, and parries—than the rational unfolding of a communal research program. From a scientific point of view, it may seem odd to suggest that theory has a history, or further, to say that our picture of theory is cloudy or unfocused because we have forgotten its history or become blinded to it. However, a genealogical reflection on theory in general, and on the philosophy of art and of film studies in particular, may help restore some conceptual precision to its range of connotations and semantic values. Theory may again become a satisfying word if, as Emerson would recommend, it can be reclaimed from its counterfeit currency.

Genealogy is not history. One must take seriously that Nietzsche's critique of history, of its uses and disadvantages, was one of his untimely meditations. A genealogical approach offers a special kind of historical perspective that

breaks open the linear conception of time as progress or progression, revealing many variable and discontinuous lines of descent. We may set out on straight and well-paved highways, but there will also be culs-de-sac, detours long and short, secret passages, steep turns, and sudden and surprising vistas. Theory has no stable or invariable sense in the present, nor can its meanings for us now be anchored in a unique origin in the near or distant past. If the currency of theory is to be revalued conceptually for the present, we need a history that attends critically to the competing sites and contexts of its provenance in the past and that can evaluate the forces that shape its diverse and often contradictory conditions of emergence and its distributions as genres of discourse. To sketch out a genealogy of theory is to return to it a historical sense of its discontinuities as a concept and as an activity—not retracing a line, completing a circle, or constructing a frame, but rather to follow theory's complex web of derivations and to evaluate the concept in the space of its discursive distributions. Or, as Michel Foucault advises, "to identify the accidents, the minute deviations—or conversely, the complete reversals—the errors, the false appraisals, and the faulty calculations that gave birth to those things that continue to exist and have value for us. . . . The search for descent is not the erecting of foundations: on the contrary, it disturbs what was previously considered immobile; it fragments what was thought unified; it shows the heterogeneity of what was imagined consistent with itself."[4]

Perhaps our picture of theory is not so much a cloud or corona as it is a palimpsest, whose many historical layers compete for our attention in such a way that we are unable to focus on any one of them. The genealogy of theory, its many lines of descent, confronts us as discontinuous series within the history of philosophy that are repeatedly linking to and breaking away from conceptions of ethics on the one hand and aesthetics on the other. In the historical frame of the twentieth century, this pairing of ethics and aesthetics through the conceptual bridge of theory might seem strange, since after Bertrand Russell and Rudolf Carnap, philosophy was reconceived not as a system or theory, but rather as a method of logical or conceptual analysis. In this context, questions of ethics and aesthetics were displaced in philosophy by a renewed emphasis on logic and epistemology. Moreover, the aim of this method, implicitly or explicitly depending on the case, was to make philosophy disappear into science.

---

4. "Nietzsche, Genealogy, History," in *Language, Counter-Memory, Practice: Selected Essays and Interviews,* ed. Donald F. Bouchard (Ithaca, N.Y.: Cornell University Press, 1977), 146–147; trans. mod.

Already in 1914, Russell directly expressed this attitude in writing that "every philosophical problem, when it is subjected to the necessary analysis and purification, is found either to be not really philosophical at all, or else to be, in the sense in which we are using the word, logical."[5] In an essay of the 1920s, Russell states unambiguously that philosophy is "essentially one with science, differing from the special sciences merely by the generality of its problems, and by the fact that it is concerned with the formation of hypotheses where empirical evidence is lacking. It conceives that all knowledge is scientific knowledge, to be ascertained and proved by the methods of science."[6] But this is yet another story, to which I will return later and will discuss more completely in *Philosophy's Artful Conversation*. Still, an oft-repeated desire expressed in the many diverse branches of analytical philosophy in the twentieth century was that philosophy is something modernity needs to be cured of through a renewed grounding in scientific rationality and the elimination of all problems that cannot be subjected to logical analysis. This claim is a far cry from Nietzsche or Emerson, who found in philosophy a means of diagnosis and perhaps homeopathic relief from the disorienting forces of modernity. What line of descent would connect theory to their vision of philosophy?

## 3. *Theoria* as Practical Philosophy

> The best in us has perhaps been inherited from the feelings of former times, feelings which today can hardly be approached on direct paths; the sun has already set, but our life's sky glows and shines with it still, although we no longer see it.
>
> —Friedrich Nietzsche, *Human, All Too Human*

Theory has, in the course of centuries, been a highly variable concept. One finds the noble origins of theory in the Greek sense of *theoria* as viewing, speculation, or the contemplative life. For Plato, it is the highest form of human activity; in Aristotle, the chief activity of the First Unmoved Mover and the only practice loved for its own sake. For Hellenic culture, theory was also an ethos that associated love of wisdom with a style of life or mode of

---

5. *Our Knowledge of the External World as a Field for Scientific Method in Philosophy* [1914] (London: Allen and Unwin, 1961), 42.

6. "Philosophy in the Twentieth Century," in *Sceptical Essays* [1928] (New York: Routledge, 2004), 54.

existence based on practices of self-examination and self-transformation. A profound incommensurability thus separates our contemporary senses of theory from the Hellenic conception of *philosophein* as simultaneously a "theoretic" activity and an ethos, desirable above all others. Indeed, the association and disassociation of theory from ethics and from philosophy will be a recurrent theme in this book and its companion volume, *Philosophy's Artful Conversation*.

Bringing together *thea* (sight) and *theoros* (spectator), theory has often been linked to vision and spectacle. *Theorein* meant to observe attentively, to survey or witness. With its etymological link to witnessing, theater, and spectatorship, no doubt it was inevitable that the young medium of film should call for theory. Nevertheless, the idea of theory as beholding has deep and varied roots.[7] In pre-Socratic thought, the philosopher is the spectator par excellence. When Leon the tyrant of Phlius asked Pythagoras who he was, Pythagoras responded with a word nearly unknown at the time, "A philosopher." In Diogenes Laertius's account, Pythagoras continues by comparing life to the Great Games where some are present to compete in athletic or musical contests and others come to buy and sell at market. The best of all, however, are *theoroi* or spectators—those who neither serve nor seek fame and wealth, but rather observe and pursue wisdom. The

---

7. In his 1954 lecture on "Science and Reflection," Martin Heidegger offers a fascinating etymology of theory: "The word 'theory' stems from the Greek verb *theōrein*. The noun belonging to it is *theōría*. Peculiar to these words is a lofty and mysterious meaning. The verb *theōrein* grew out of the coalescing of two root words, *thea* and *horaō*. *Thea* (cf. theater) is the outward look, the aspect, in which something shows itself, the outward appearance in which it offers itself. Plato names this aspect in which what presences shows what it is, *eídos*. To have seen this aspect, *eidenai*, is to know [*wissen*]. The second root word in *theōrein*, *horaō*, means: to look at something attentively, to look it over, to view it closely. Thus it follows that *theōrein* is *thean horan*, to look attentively on the outward appearance wherein what presences becomes visible and, through such sight-seeing-to linger with it. That particular way of life *(bios)* that receives its determination from *theōrein* and devotes itself to it the Greeks call *bios theōrētikos*, the way of life of the beholder, the one who looks upon the pure shining-forth of that which presences. In contrast to this, *bios praktikos* is the way of life that is dedicated to action and productivity. In adhering to this distinction, however, we must constantly keep one thing in mind: for the Greeks, *bios theōrētikos*, the life of beholding, is, especially in its purest form as thinking, the highest doing. *Theoria* in itself, and not only through the utility attaching to it, is the consummate form of human existence." In Martin Heidegger, *The Question Concerning Technology, and Other Essays*, trans. William Lovitt (New York: Harper and Row, 1977), 163. Of great interest in this lecture is not only Heidegger's fascinating genealogy of the early senses of *theōrein* but also his investigation of how the classical Greek sense of theory is slowly transformed into our more modern scientific sense, where the holistic concept of theory as a *bios* mutates into a concept that compartmentalizes the real in the formation of objects of observation. Heidegger's main point, however, is that these earlier philosophical meanings linger in the concept, like an ancient spring that still nourishes a mighty ocean, waiting patiently to be rediscovered.

ethical dimension of this parable is important. The Pythagorean concept of *theoria* as contemplative spectatorship promoted the active intellectual study of number theory, geometry, music, and astronomy as bringing understanding of the ordered movements of the *kosmos* and the structure of everything it contains, including human thought. But at the same time, these contemplative activities were meant to promote a change in the philosopher's existence, for through *theoria* one attained active assimilation to the divine Intellect or *nous* present in all of us.[8]

This little parable already embodies some fascinating historical paradoxes. The source of this story comes from Cicero's summary of a fragment from Heraclides of Pontus (a member of Plato's Academy). Andrea Wilson Nightingale argues that this is already a fourth-century retrojection of philosophy and theoretic wisdom onto pre-Socratic thought in order to produce a venerable genealogy for a later invention.[9] The emergence of classical philosophy thus already evinces a contestation of *theoria* that dissembles its discontinuities and incommensurabilities with earlier conceptions. Later I will argue that retrojection seems to be a persistent feature of theory formation as all the various and discontinuous senses of theory displace one another in ways that impose forms of continuity that make present history the inevitable culmination of a past trajectory. One important task of a genealogy of theory, then, is to identify, in all their dissension and contradiction, the many lines of descent covered over by the historical force of retrojection.

Diogenes Laertius credits Pythagoras, no doubt apocryphally, with coining the term "philosopher" to characterize Pythagoras's thought and way of life. Before

8. See Diogoenes Laertius's *Lives of the Greek Philosophers,* book VIII (Cambridge, Mass.: Harvard University Press, 200), as well as W. K. C. Guthrie's *A History of Greek Philosophy,* vol. 1, *The Earlier Presocratics and the Pythagoreans* (Cambridge: Cambridge University Press, 1962), 211–212. Also see Pierre Hadot's *What Is Ancient Philosophy?,* trans. Michael Chase (Cambridge, Mass.: Belknap Press of Harvard University Press, 2002), esp. 15–21.

9. See her introduction to *Spectacles of Truth in Classical Greek Philosophy* (Cambridge: Cambridge University Press, 2004), esp. 17–18. This genealogy is yet more complex. My colleague John Hamilton notes that here the historical aspect of Greek lexicography is important. Originally, a *theoros* was the envoy selected to consult an oracle. Only later is the word used to designate anyone who is officially sent to be present at city festivals; hence the noun *theorion,* which denotes a box at the amphitheater. The use of *theoria* as contemplation or consideration in the Pythagorean sense is attested to in Plato's dialogues, especially *Philebus* 38b and *Phaedrus* 84b, where the verb *theaomai* is used with the object *alethes* ("to contemplate the truth"). Even later, with the development of oratorical training, the word *theoria* comes to name the explanatory preface to a speech relating specific concerns *(melete).* See also Hans Blumenberg's *Das Lachen der Thrakerin: Eine Urgeschichte der Theorie* (Frankfurt am Main: Suhrkamp, 1987) and Hannelore Rausch's *Theoria: Von ihrer sakralen zur philosophischen Bedeutung* (Munich: Wilhelm Fink, 1982).

the fourth century, *theoria* most often referred to the civic practice of sending delegates to witness oracles and religious festivals. Moreover, *philosophein* was used only rarely and in a vernacular sense as intellectual cultivation. Thus Plato's setting out of philosophy as a specific kind of practice in *The Republic* shows that by the fourth century BCE *theoria,* in its various conceptual connotations, had become central to a Hellenic characterization of *philosophein* as a specific kind of activity—the ethical choice for a mode of existence devoted to a contemplation of the world that required, in equal measure, an active transformation of the self. This conception is most fully realized in Book X of Aristotle's *Nicomachean Ethics* where *theoria* is singled out as the highest good of humanity and the summit of happiness. Contemplation is perhaps not the best modern equivalent of the word, which in ancient Greek involved not only observation and activities of sight but also the sense of pursuing a theoretic life devoted to pure thought with no ulterior practical motive. For Aristotle, this is the ultimate virtue.

Aristotle encourages a theoretic life as more desirable and more enjoyable than either an apolaustic or a political existence. The life of the intellect, as it contemplates knowledge and seeks out more knowledge, fulfills all the criteria Aristotle thought necessary for happiness: it is the most independent activity, though not an asocial one; compared to practical action, it may be practiced for longer continuous periods; and containing its end within itself enjoys a greater *schole* or leisure. The activity of philosophic thought is thus commensurate with humanity's best part—the intellect or *nous*—that is, "the naturally ruling element which understands things good and divine and is 'either itself divine or the most divine thing in us,' and its activity according to its own particular virtue is perfect happiness."[10] In this respect, "the human *nous* is a faculty or capacity *(dynamis)* activated, like everything else in the world, by the attraction of the First Unmoved Mover who, unlike mankind, is intellect pure, simple and tireless" (*Aristotle* 395). In this way, Greek reason was of a natural order wherein mind and nature were proportionate. To seek wisdom was to understand the *eunomia* of the world, its lawful and just order, by searching for landmarks or guidelines to ways of life in harmony with the divine ordering of nature. In contrast to the "practical sciences" *(episteme praktike),* then, through *theoria* the human mind was capable of deciphering the *logos* of things on its own; call this philosophy as noninstrumental reason. In this manner,

---

10. W. K. C. Guthrie, *A History of Greek Philosophy,* vol. 6, *Aristotle: An Encounter* (Cambridge: Cambridge University Press, 1981), 391. Interior citation from *The Nicomachean Ethics* (1177a12–17).

ethics and epistemology were inseparably linked in classical philosophy with its axiological or value-oriented approach to the investigation of nature. Greek thought was governed by a holistic perception of world and mind emblematized by the interlocking meanings of *physis* as nature (both the physical world and the nature of the world as rationally ordered) and of *physis* as *logos,* an intelligible message written in nature. Reason and value defined a virtuous circle for Hellenic culture where one of the fundamental goals of the theoretic life was to discern a norm for the reasonable order of society in the rational order of nature. And as humanity is one with nature in this holistic perception, rational order could be sought for within oneself, noninstrumentally.

Another incommensurability confronts us here. The Hellenic sense of ethics does not completely correspond to our modern conception of a life guided by implicitly or explicitly stated deontological principles that model moral behavior as duty. Rather, as Pierre Hadot argues, the desire for a philosophical life is driven first by ethical dissatisfaction and existential dilemmas that encourage the quest for a new way of life or mode of existence. Only afterward does philosophy try to justify that choice and that existence through discursive argument. Since at least the time of Socrates, then, the choice of a theoretic mode of existence was not the final outcome or *telos* of philosophical activity. Indeed, the choice of or for philosophy begins in confrontation with other existential attitudes as a critical reaction seeking another vision of the world and another way of life. But this reaction and this choice are not guided by philosophical discourse; philosophical discourse finds its origins in a life choice and an existential option, and not the other way around.

Philosophical expression is not only discursive; it also finds itself crafted as a life, and this process is open-ended and unfinished. *Philosophein* asks of the novitiate a conversion of being driven by the desire to be and to live in a new way, in tune with a changed conception of the world. This decision—the choice of a new mode of existence—also implies the presence or formation of a community as the expression of an ethos. Only afterward, in Hadot's account, will the task of philosophical discourse be "to reveal and rationally justify this existential option as well as this representation of the world. . . . Philosophical discourse must be understood from the perspective of a way of life of which it is both the expression and the means. Consequently, philosophy *is* above all a way of life, but one which is intimately linked to philosophical discourse."[11]

11. *What Is Ancient Philosophy?,* 3–4. See also Michel Foucault's *Care of the Self* (New York: Pantheon, 1986) for related arguments.

Philosophy is lived or presents itself in a life before it is spoken or written. Or rather, it cannot be spoken or written in the absence of a desire for change and the ongoing execution of an existential choice. There is always a separation between philosophy and wisdom, then, for *philosophein* is only a preparatory exercise toward wisdom. At the same time, philosophical expression can and must take place simultaneously on two reciprocal planes: that of discourse and that of a mode of existence that must continuously be examined and challenged or reaffirmed. Call this the perfectionist strain of philosophy, so important to Stanley Cavell's later writings, which—as discourse and existential choice, both in a state of change fueled by dissatisfaction with one's self and the world—reaches for a state of knowledge that can never be fully attained. *Philosophein* is a dynamic state to which one may aspire, and *philosophia* may fuel the desire to attain this state, but one never becomes, ultimately, a philosopher.[12]

For these reasons, the two expressive planes of philosophy—as discourse and existential choice—do not correspond to a distinction between theory and practice. As Hadot insists, philosophic discourse already has a practical dimension—it is meant to transform or to produce a change in the practitioner, but in a noninstrumental way and with no other end than the unending pursuit of wisdom. At the same time, a philosophical life is not theoretical, but rather theoretic; contemplative, certainly, but a form of contemplation whose reach toward understanding the world is also aimed at self-transformation. *Theoria* as practical philosophy.

12. The philosophical character is thus extremely rare and a stranger to society. In his inaugural lecture at the Collège de France, Pierre Hadot notes, "By the time of the Platonic dialogues Socrates was called *atopos*, that is, 'unclassifiable.' What makes him *atopos* is precisely the fact that he is a 'philo-sopher' in the etymological sense of the word; that is, he is in love with wisdom. For wisdom, says Diotima in Plato's *Symposium*, is not a human state, it is a state of perfection of being and knowledge that can only be divine. It is the love of this wisdom, which is foreign to the world, that makes the philosopher a stranger in it." "Forms of Life and Forms of Discourse in Ancient Philosophy," trans. Arnold I. Davidson and Paula Wissing, *Critical Inquiry* 16, no. 3 (Spring 1990): 492.

## 4. The Sage Is Wise Only in Theory

> If philosophical theories seduce you, sit still and turn them over in your mind.
> But never say that you are a philosopher nor allow another to say it.
>
> —Epictetus, *Discourses*, Book III

The modern senses of theory gradually emerge through a series of disconnections, reversals, and remappings of *theoria*, which extend through scholastic philosophy to the early modern period, where the intimate connection between reason and value in Hellenic culture became increasingly strained and eventually broken. Here philosophy becomes, in various and sometimes incommensurable ways, progressively associated with an idea of science, whether conceived as empirical observation and the inductive work of scientific experimentation or with the more deductive mathematical modeling of nature promoted by Descartes, Leibniz, and Spinoza. From one perspective, this is the story of how science gradually disengages and takes for itself from philosophy our modern sense of theory. (In the next section I will examine a parallel dislocation: how philosophy comes into conflict with theory through a transformed sense of aesthetic.) The sense of philosophy as an ethical and existential choice was not completely forgotten, however. As both Pierre Hadot and Michel Foucault have shown, early Christian practices retained and modified the earlier sense of philosophy as preparatory to an ongoing transformation of the self initiated by an existential choice. Moreover, medieval universities kept alive the concepts and traditions of neo-Platonism and Aristotelianism, though in service to theological debate and scholarship. In each case, though, the existential and discursive dimensions of *philosophein* become disconnected from one another, and philosophy was either subsumed under theology or relegated to a hierarchically inferior university faculty, a situation that persists through the early modern period.

In this manner, the story of modern philosophy is often recounted as a gradual process of secularization throughout the Renaissance and into the Age of Reason where philosophy recovers itself from theology to become, after Descartes, a science or in service to science. Here one understands the discursive activity of philosophy as guided by epistemological refinements, rather than existential choices and evaluations that were characterized more and more as scientific or theoretical in both idealist and positivistic contexts. This tendency was associated with the emergence of professional or academic philosophy in the late eighteenth and nineteenth centuries. Especially in a European

context, from the time of Hegel through the appearance of French existential-
ism and even structuralism, the activity of philosophy becomes associated
with speculative theoretical systems or "pure theory," a process Hadot charac-
terizes as a "theoreticizing of philosophy" (*What Is Ancient Philosophy?* 263).

Nevertheless, the ancient conception of philosophy persevered, often in
surprising places. A striking instance appears at the beginning of Descartes's
Third Meditation, not only in the sense of philosophy as an activity of medita-
tion but also as an extended process of self-examination and transformation
where "I will now shut my eyes, stop up my ears, and withdraw all my senses.
I will also blot out from my thoughts all images of corporeal things, or rather,
since the latter is hardly possible, I will regard these images as empty, false,
and worthless. And as I converse with myself alone and look more deeply into
myself, I will attempt to render myself gradually better known and more famil-
iar to myself."[13] Hadot also uncovers other key reference points in Montaigne's
essays, and much later, in the philosophy of Ludwig Wittgenstein both early
and late.

Immanuel Kant is often considered to be the central figure in the emergence
of professional academic philosophy and the exemplar of an idea of philoso-
phy built from speculative theoretical systems, or, more precisely, philosophy
as a *theoretische Wissenschaft* based on synthetic a priori judgments. Yet eth-
ics and moral reasoning are also the linchpins of that system, linking reason
and judgment. In examining Kant's 1784 essay "An Answer to the Question:
What Is Enlightenment?," Michel Foucault notes that the task or activity of
philosophy turns critically from the investigation of metaphysical systems or
the foundations of scientific knowledge to an examination of the present his-
torical moment. The main question of philosophy then becomes how we live
or can live our modernity or contemporaneity. If Descartes asks, "Who am I
that thinks," a unique and individual but also a universal and ahistorical sub-
ject, Kant's question "What are we now, or what are we now becoming?" locates
the thinking subject in a precise and unstable historical movement of power-
ful cultural as well as philosophical change. Universal philosophy does not
disappear at this time; Hegel will be its next great (and perhaps last) exponent.
But Kant's philosophy marks a critical turning point where Foucault argues
that "the task of philosophy as a critical analysis of our world is something
which is more and more important. Maybe the most certain of all philosophi-

---

13. "Meditation Three: Concerning God, That He Exists," in *Philosophical Essays and Corre-
spondence,* ed. Roger Ariew (Indianapolis / Cambridge: Hackett, 2000), 113.

cal problems is the problem of the present time, and of what we are, in this very moment."[14]

What often goes unremarked in Kant is his vision of the impossibility of philosophy, or of becoming a philosopher, that hearkens back to the perfectionist strains in Hellenic thought. This impossibility is also the motive force in the desire and search for a theoretic life. In the *Opus postumum*, Kant portrays philosophy as "the doctrine and exercise of wisdom (not simple science). Theoretically and practically, however, it does not personify itself as the sage *(Scientia ideo non est praedicamentale aliquid; attamen praedicabile). The sage,* according to theory, is a worldly sage and a *philosopher,* that is, a simple *lover* of wisdom in theory (non σόφος, *sed philosophus).*"[15] The sage is wise only in theory. Humanity cannot possess wisdom but only love it and strive toward it, which for Kant is already one of the most praiseworthy occupations: "Philosophy is for man *the struggle for wisdom,* which is always unfinished. Even the doctrine of wisdom is too high for man" (*Opus postumum* 262). Here the perfectionist element of Kant's perspective is unmistakable, for one does not attain wisdom or knowledge in loving it. Rather, we are drawn toward an Idea of philosophy as to an impossible yet imaginable, graspable ideal, where "The 'philosopher' is only an Idea. Perhaps we can throw a glance toward him, or emulate him in some respects, but we will never totally attain this state."[16] In this attitude, Hadot finds in Kant's Idea of philosophy powerful echoes of the more ancient conception of a theoretic life where "the point was always and above all not to communicate . . . some ready-made knowledge but to *form. . . .* In other words, the goal was to learn a type of know-how; to develop a *habitus,* or new capacity to judge and to criticize; and to *transform*—that is, to change people's way of living and of seeing the world" (*What Is Ancient Philosophy?* 274). This Idea of philosophy is, as Foucault might have put it, *actual,* which is to say, ever present as a virtuality or potentiality that one must make actual or present, reactualizing it in contemporary life.

---

14. "The Subject and Power," in Hubert L. Dreyfus and Paul Rabinow, *Michel Foucault: Beyond Structuralism and Hermeneutics* (Chicago: University of Chicago Press, 1983), 216. Foucault's statement echoes in interesting ways Max Horkheimer's idea that "the critical theory of society is, in its totality, the unfolding of a single existential judgment." See "Traditional and Critical Theory" (1937), in *Critical Theory: Selected Essays,* trans. Matthew J. O'Connell (New York: Seabury Press, 1972), 227.

15. *Opus postumum,* trans. François Marty (Paris: PUF, 1986), 245; my English trans.

16. *Philosophische Enzyklopädie* in *Kant's gesammelte Schriften* XXIX (Berlin: Walter de Gruyter, 1980), 8; my trans. The original text reads: "Der Philosoph ist nur eine Idee. Vielleicht werden wir einen Blick auf ihn werfen und ihm in einigen Stücken nachfolgen können, aber nie werden wir ihn ganz erreichen."

Throughout the twentieth century, the impossibility of philosophy took another form whose most radical expression was the will to supplant philosophy with reason; or indeed what one might call in the scientific sense, theory. Late in life, the great Finnish logician Georg Henrik von Wright became increasingly concerned with how modern life and culture were increasingly and tragically marked by a breach between reason and value. This division has a long history, as I have already suggested, but in the twentieth century it was deepened and accelerated by two factors. One was the increasing prestige of a scientific and technological rationality that encouraged an instrumentalization or even technologization of reason; the other was philosophy's paradoxical wish to disappear or to wither away under the assumption that instrumental reason makes irrelevant any other approach to problems of mind, language, or logic. (I will return to and deepen these observations in *Philosophy's Artful Conversation*.) But in von Wright's view, the irony of this story is that the major accomplishments of modern analytic philosophy and the philosophy of science overvalued problems of logic and epistemology in ways that displaced or even exiled moral reasoning and ethical evaluation from the domain of philosophy. Under the towering influence of the twin pillars of Russell and Moore's Cambridge school of analysis and the logical positivism of the Vienna Circle, in its enthusiasm to become a branch of science, philosophy disappeared into theory, fulfilling Brentano's 1866 dictum that *"vera philosophiae methodus nulla alia nisi scientiae naturalis est."*[17] In this state of affairs, von Wright observes, "Value seemed exorcized from the sphere of reason, and rational thought from the sphere of valuations. Excessive scepticism about values has resulted in value-nihilism, and exaggerated faith in the power of reason has encouraged scientific fundamentalism" (*Tree of Knowledge* 246–247).

The deep irony for von Wright, a student of Wittgenstein and deeply influenced by the analytic school, is that science has become a secular fundamentalism that sets aside questions of the value of knowledge, while leaving religion to occupy itself with moral and ethical life but outside the context of reason. In von Wright's assessment, "The erosion of the traditional basis of values in religion and the futility of the efforts to establish a new one in reason, in combination with the overpowering enhancement of the instrumental value of science, has tended to remove altogether from the sphere of rational thought questions relating to moral and other forms of what philosophers call

17. Cited in von Wright's *The Tree of Knowledge and Other Essays* (Leiden: E. J. Brill, 1993), 85.

intrinsic value. A state of value-vacuum or even value-nihilism has come to prevail" (*Tree of Knowledge* 242). This is a rather bleak way of saying that contemporary philosophy has deserted Kant's great critical project to build in philosophy a bridge between epistemology and ethics, or pure and practical reason.

Such an attitude should not surprise us. Already in the first Critique, Kant distinguishes between worldly philosophy and academic or scholarly philosophy. The latter involves "a concept of a system of knowledge which is sought solely in its character as a science, and which has therefore in view only the systematic unity appropriate to science, and consequently no more than the *logical* perfection of knowledge."[18] The only aim of scholastic philosophy is to construct a perfectible system of knowledge. Yet this life is divided from within, and can never reconcile or find itself in the system of thought it seeks. In Kant's sense, it is blind to what interests us all in our worldly and human questioning as a force or *dynamis* that animates all philosophical effort. This approach to thought is not theoretic, but only theoretical.

Alternatively, late in the *Critique of Pure Reason* Kant recalls that ancient philosophy was first a moral philosophy. Organized by a *conceptus cosmicus,* what one might call Kant's cosmopolitan philosophy is worldly in a specific sense. This conception is not exactly a return to the more ancient Hellenic conception where the search for reason in the natural order was the compass of ethical evaluation. Rather, for Kant humanity must find within itself the possibility of bestowing to itself the laws of human reason according to a *Weltbegriff,* a worldly concept "which relates to that in which everyone necessarily has an interest" (*Critique of Pure Reason* 658). Cosmopolitan or worldly philosophy does not seek wisdom in the ground of nature, but rather in principles of reason found only within humanity and in what counts for all humanity. One wants to say that this is a concept that restores philosophy to the humanities, or perhaps makes of the desire to philosophize a human desire. In this respect, the philosopher is an ideal image of or for thought—that Emersonian attainable yet unattained self—for we can never become the sage; we can only learn to emulate her by exercising the talent for reason according to "universal" principles. Call this the capacity for judgment, where Kant will find in the aesthetic the bridge between the understanding and reason, pure and practical philosophy.

18. *Critique of Pure Reason,* trans. Norman Kemp Smith (New York: St. Martin's Press, 1965), 657.

## 5. Variations and Discontinuities: Aesthetic

A theorist of the fine arts—what a grand name!

—Johann Gottfried Herder, *Critical Forests*, "Fourth Grove"

In *Keywords*, Raymond Williams identifies four primary senses of the word "theory" emerging by the seventeenth century: spectacle; a contemplated sight; a scheme of ideas; and an explanatory scheme. Although the persistence of associating thought about art or film with theory might be attributed to the derivations of the term from spectating and spectacle, a contemporary commonsensical notion follows from the last two meanings. Theories seek to explain, usually by proposing concepts, but in this they are often distinguished from doing or practice. In this manner, Williams synthesizes "a scheme of ideas which explains practice," and this is certainly close to the way in which someone like Béla Balázs and other writers on art or film invoked the notion of theory in the 1920s.[19] Call this the standard or vernacular meaning. But theory is also a particular form of *provisional* explanation or account. In an example from 1850, Williams cites, "were a theory open to no objection it would cease to be a theory and would become a law" (*Keywords* 267). Here theory remains close to an idea of speculation. And should this explanation become irrefutable or subject to a broad consensus, its explanatory scheme would pass from the speculative to the factual. (This leaves ambiguous, however, the logical form of explanation and conditions for agreement.) As for practice, Williams identifies two senses of its relation to theory. First, there is practice in the sense of a thing done or effected and observed, which must be related back to an explanatory scheme. Second, there is practice in the sense of a repeated or customary action, perhaps a *habitus* in Pierre Bourdieu's sense of the term. In this way, common sense distinguishes scientific theories, which relate empirically and experimentally to the observation of phenomena occurring in nature from investigations appropriate to cultural and artistic activity with their historically variable norms and customary practices.

Taking Williams as a starting point, it is possible to dig deeper into theory, uncovering the overlapping and sometimes contradictory layers of meaning it accrued throughout the eighteenth and nineteenth centuries. In fact, by the end of the nineteenth century, the concept of theory moved freely across three

---

19. *Keywords: A Vocabulary of Culture and Society* (New York: Oxford University Press, 1976), 267.

semantic domains, which in many usages could be mixed or blended. Most familiar would be ordinary or vernacular deployments of theory, which long remained close to the more ancient, Hellenic senses of viewing, observing, and witnessing. In this semantic domain, to suggest a theory is to offer a speculative framework or viewpoint that is more or less large, and more or less systematic, though incompletely worked through. Here theory presents an ideal yet rational presentation of a state of affairs to which facts or practice may not exactly correspond—it is, in short, a conjectural account often offered as a personal though generalizable view. Theory was often used to project an air of learning or scientific rigor around an argument, especially when deployed in vernacular contexts. Alternatively, a pejorative sense of the vernacular also emerged to imply a too simple or restricted perspective representing facts in so schematic a way that conclusions applicable to reality cannot be obtained.

A second domain was forged out of the varieties of positivism emerging by the middle of the nineteenth century whose best representatives were the works of Auguste Comte and John Stuart Mill. Here the senses of theory push closer to notions of systematic scientific explanation, strictly conceived. What counts as theory in this domain can be characterized by three principal tenets: that all theories are methodologically monistic; that scientific explanations are primarily causal and subsumable to general or covering laws; and finally, that mathematics provides an ideal form for all varieties of logical expression.

Methodological monism insists on the unity of scientific method as a theory-type, regardless of the research domain to which it is applied.[20] In the preface to his *Course on Positive Philosophy* (1830), for example, Comte insists that the various sciences must conform to a unique method and be considered as forming the different parts of a general plan of research. Different classes of positive

---

20. For a fuller account, see Georg Henrik von Wright's *Explanation and Understanding* (Ithaca, N.Y.: Cornell University Press, 1971), 4. Horkheimer's 1937 account is also illuminating in this context: "In the most advanced logic of the present time, as represented by Husserl's *Logische Untersuchungen,* theory is defined 'as an enclosed system of propositions for a science as a whole.' Theory in the fullest sense is 'a systematically linked set of propositions, taking the form of a systematically unified deduction.' Science is 'a certain totality of propositions. . . , emerging in one or other manner from theoretical work, in the systematic order of which propositions a certain totality of objects acquires definition.' The basic requirement which any theoretical system must satisfy is that all the parts should intermesh thoroughly and without friction. Harmony, which includes lack of contradictions, and the absence of superfluous, purely dogmatic elements which have no influence on the observable phenomena, are necessary conditions, according to Weyl" ("Traditional and Critical Theory," 190). The interior citations are from Husserl's *Formale und transzendentale Logik* and Hermann Weyl's "Philosophie der Naturwissenschaft."

theories in the various natural and social sciences, then, are gathered monisti-cally under the dual perspective of the unity of method and the homogeneity of doctrines. The second tenet seeks to subsume all individual cases to general laws of nature, including, one assumes hypothetically, presumed laws of hu-man nature. Theories in this sense take the form of causal explanations, where as Mill put the case in his *System of Logic*, "An individual fact is said to be explained, by pointing out its cause, that is, by stating the law or laws of causa-tion, of which its production is an instance."[21]

The third tenet insists that the exact natural sciences, and in particular math-ematical physics, present a methodological ideal or standard for all theoretical research. A theory, then, is considered as an encompassing synthesis that proposes to explain a great number of facts considered to be hypothetically true. Ideally, such a theory would take the form of a rigorously and systematically organized hypothetical-deductive set of theorems forming a connected system. This idea appears later in a yet stronger form in the logical positivism of the Vienna Circle and the mathematical analyses of the Cambridge School with their common interests in the foundations of mathematics and the philosophy of science. In this respect, von Wright argues that the neopositivism of the Vienna Circle shared "with nineteenth-century positivism an implicit trust in progress through the advancement of science and the cultivation of a rationalist 'social engineering' attitude to human affairs" (*Explanation and Understanding* 10). Through commitments to progressive refinements of logic, often mathematically expressed, the various strains of modern analytic philosophy were most con-cerned with structural aspects of ratiocinative processes of argument, inference, or proof as rules for judging the correctness of the transition from premises to conclusions, not rules for judging the truth of premises and conclusions. This concern for increased clarity was considered not as a purification of philosophy, but rather as the disappearance of philosophy into logic as the expressive founda-tion for scientific theories. Here philosophy was not considered as a system or a theory, but rather as a method, that of the logical analysis of concepts.

The third domain falls between the vernacular senses of theory and more formal subsumptive-theoretic definitions. Applied equally to both the human and natural sciences, here theory refers to that which is the object of a me-thodical conceptualization, systematically organized and consequently depen-dent in its form on certain disciplinary practices or decisions that are distinct from common sense. By the nineteenth century, this sense of theory was often

21. (London: Longmans, Green, Reader, and Dyer, 1868), bk. 3, chap. 12, sec. 1.

associated with "science," though through the broader and more open range of connotations accruing to the German concept of *Wissenschaft*. In his *Introduction to the Human Sciences* (1883), Wilhelm Dilthey offers an admirably clear definition of the purview of *Wissenschaft* in the late nineteenth century:

> By a "science" [*Wissenschaft*] we commonly mean a complex of propositions (1) whose elements are concepts that are completely defined, i.e., permanently and universally valid within the overall logical system, (2) whose connections are well grounded, and (3) in which finally the parts are connected into a whole for the purpose of communication. The latter makes it possible either to conceive a segment of reality in its entirety through this connection of propositions or to regulate a province of human activity by means of it. The term "science" is here used to designate any complex of mental facts which bears the above characteristics and which therefore would normally be accorded the name "science."[22]

In direct confrontation with the positivism of Comte and Mill, Dilthey's objective was to show that the human sciences *(Geisteswissenschaften)* of history, poetics, anthropology, and sociology stand on an equally strong logical and methodological footing as the natural sciences, even though a key epistemological criterion separates them. In a well-known formulation, Dilthey asks us to distinguish between explanation *(Erklären)* and understanding *(Verstehen)*. Open to history and the complexity and variability of human and social interactions, the human sciences seek to understand social phenomena rather than explaining their causes or resolving them to natural laws. (This was the key point on which Dilthey strenuously opposed positivism.) Simply speaking, all that is asked of a scientific theory here is that we acquire a systematic and methodologically unified knowledge of some thing through a coherent program of research. But often this knowledge remains conceptual and independent of practice. It seeks to explain, and perhaps to guide, but knowledge is nonetheless open, incomplete, and continuously revisable.

Dilthey's difficult relation with metaphysics and his desire to ground in theory the scientific basis of the full spectrum of human experience in history were marked by his admiration for the rigor of empirical and experimental investigation but also by his deep skepticism of positivism and its claims to

---

22. Ed. Rudolf A. Makkreel and Frithjof Rodi (Princeton, N.J.: Princeton University Press, 1989), 56–57.

eliminate investigations of society and history that were not grounded in natural scientific methods. In this Dilthey's concept of *Wissenschaft* formalizes the more historically open and fluid evolution of the senses of theory that followed closely the institutional struggle through which, from the beginning of the eighteenth century, philosophy sought to assert its independence and autonomy as a university discipline with respect to the "higher" faculties of theology, law, and medicine. Defenses of philosophy as *Wissenschaft* (science) or *Lehre* (doctrine) were equally defenses or modifications in the domain of metaphysics, taken in its largest sense as that which falls outside of knowledge of the physical world through causal reasoning. Following Aristotle's definition of metaphysics as a first philosophy, Alexander Baumgarten provided the eighteenth century's most concise characterization as the science of the first principles of knowledge. In a sense, Dilthey's later extended attempts to define, preserve, and police the frontiers between the human and natural sciences were also an attempt to defend and clarify the theoretical status of metaphysics in philosophy, even though he himself believed, with and against Kant, that metaphysics was a historically delimited and surpassable epistemological phase. "Kant properly called attention to the fact," Dilthey explains, "that all metaphysics goes beyond experience. It supplements what is given in experience by an objective and universal inner system which arises only when experience is elaborated in light of the conditions of consciousness" (*Introduction to the Human Sciences* 180).[23] Nonetheless, Dilthey's view of philosophy might be thought of as a transformed metaphysics, though one grounded in history as well as self-reflection. Dilthey thus distinguished the properties of human facts from facts of nature by stating, "In nature we observe only signs for unknown properties of a reality independent of us. Human life, by contrast, is given in inner experience as it is in itself. Therefore, only in anthropological reflection is the real there-for-us in its full reality" (*Introduction to the Human Sciences* 435). Later, of course, Wilhelm Windelband formalized this distinction in the contrast between nomothetic and idiographic thought.

In Kant's time, this sense of science was defended as theoretical philosophy, in contrast to the practical philosophies of ethics and politics. While no doubt metaphysical and speculative, a theory in this sense was still subject to rigorous and systematic exposition. Theory is contrasted with practice here as an activity of hypothetical or speculative construction, independent of applica-

23. See also Dilthey's discussion of "The Concept of Metaphysics" in *Introduction to the Human Sciences,* 176–184.

tion, that serves to bridge the formulation of a hypothesis or initiating idea and the working out of its implications in a more formal and systematic argument within a specialized conceptual vocabulary. Note that this is not necessarily restricted to natural scientific arguments. Soon we will see that most philosophies of art from Hegel's *Lectures on Aesthetic* forward into the late nineteenth century aspired to this degree of formal coherence, so much so that I will call them *system aesthetics.*

In all three domains, Williams's implied distinction between two kinds of practice—one that attributes causal reasoning to an observed state of affairs, the other accounted for in reference to custom or cultural norms—still applies. However, the overlapping or even confusion of the senses of theory and practice across this distinction are compounded by two sets of historical discontinuities. One derives from a division within nineteenth-century concepts of theory between a philosophical idealism characteristic of German Romanticism's response to Kant and the emergence of positivism under the influence of August Comte. The invention of aesthetic in the eighteenth century and the struggle to define that concept in relation to concepts of theory and science or *Wissenschaft* form the historical background of this division and contestation. The second discontinuity fuels what I call our contemporary retrojection of "theory" as an umbrella concept covering (and confusing) a wide variety of terms and practices emerging especially in the criticism and philosophy of art in the nineteenth and early twentieth centuries. The aestheticians of the eighteenth and nineteenth centuries believed themselves to be extending and deepening a philosophical path reaching back to Plato and Aristotle, when in fact they were creating a conceptual domain unrecognizable by the ancients, just as our contemporary ideas of film or art theory project an image of continuity onto a history that has more detours, culs-de-sac, and deteriorating bridges than straight and well-marked trails.

These pressures on theory emerged from a number of currents, all of which descend from the profound transformation that another charged concept, aesthetic, was undergoing throughout the eighteenth and nineteenth centuries. Like theory, "aesthetic" is another term too often taken for granted in our time. From the middle of the eighteenth century and throughout most of the nineteenth, the concept was unstable, contested, and historically fluid. The semantic range of the more ancient term *aisthesis* was being completely remapped, though often in ways that went unacknowledged. Most ancient sources from before and after the fourth century BCE used the word to refer to acts of perception but as strictly separate from terms for the making of objects,

such as *poietike, techne,* and *mimesis.* And although perception was considered to be a material event, as distinct from *noesis* as an immaterial and interior product of thought, the problem for ancient Greek philosophy was how to consider the relation between *aisthesis* and *noesis* as one where subject and object were not distinct, but rather part of the same holistic conception of the physical universe. In this way, most ancient accounts of *aisthesis* characterized perception as contact, a physical transmission between bodies and parts, or a continuous flow or flux of materials between outside and inside, and had little to do with the definition or apprehension of the beautiful. This sense of art as a specialized activity, distinct from both daily life and quotidian perception, would seem alien to classical culture. Here the older concept of *aisthesis* was undergoing a set of mutations that, from our contemporary point of view, was irrevocable.

The invention of the aesthetic as a unique domain within philosophy organized around a distinct class of objects was also coincident with the invention of modern philosophy itself, as I will explain in the next section. The project of unifying philosophy as a complete system of thought meant, first, to demonstrate how the perception of beauty was connected to or continuous with a rational faculty. In this way, the senses and the imagination were created, practically for the first time, as objects worthy of philosophical definition and critique, especially those special acts of perception that would soon be qualified as aesthetic. A second, more difficult problem was to respond philosophically to the new accounts of perception, dating from the time of Descartes's optics, in which object and subject were considered as separate and distinct. The invention of the aesthetic not only occurred as a problem for completing a system of philosophy that would incorporate all the human faculties with their different modes of judgment (epistemological, moral, and aesthetic), it also represented the effort to respond to the skeptical break with the world imposed by the new empiricisms—that is, to restore the broken link between the subject's interior relation to knowledge and its exterior relations with nature, the world, and other minds.

The idea of the aesthetic as a project of theoretical philosophy emerged only through a long process of conceptual transformation and remained contested for more than a century. Alexander Baumgarten's influential yet incomplete *Aesthetica* (1750–1758) was the first modern attempt to lay down principles for the criticism of taste considered as a science or systematic philosophy. Baumgarten was widely acknowledged by Kant, Herder, and others as laying the groundwork for a positioning of aesthetic in the system of philosophy, though without completing this system. To do so meant detaching and describing a

special class of objects—in Baumgarten's terminology, "perfect sensate representations" *(perfectio cognitionis sensitivae)* achieved through artistic means—as well as designating for psychological analysis a particular domain of experience.[24] In his presentation of transcendental aesthetic at the beginning of the *Critique of Pure Reason,* Kant praises Baumgarten in 1781 yet objects to this sense of the aesthetic as an aberration of language. In his efforts to construct rational principles for the critique of taste and judgments of the beautiful, Baumgarten wanted to "raise the rules for such judging to the level of a science" *(die Regeln derselben zur Wissenschaft zu erheben).*[25] But Kant calls this endeavor futile; it gives false hope for establishing a priori laws to which judgments of taste must conform. (He later famously modifies this argument in the Third Critique.) A more appropriate stance, Kant suggests, is to let this new name become extinct and to retain the more ancient distinction between the sensible and the intelligible *(aistheta kai noeta)* as the basis for "the doctrine that is true science" *(und sie derjenigen Lehre aufzubehalten, die wahre Wissenschaft ist).* Kant is positioning himself, of course, to reserve for theoretical philosophy only his transcendental aesthetic as the framework for analyzing space and time as the two pure forms of sensible intuition that are the principles for a priori cognition. Alternatively, Baumgarten's modification of the concept of the aesthetic might stand, Kant offers, if resituated clearly as speculative (rather than "theoretical") philosophy, in which case the term would be taken partly in its transcendental sense and partly in Baumgarten's psychological sense.

According to the *Oxford English Dictionary,* Kant's characterization of aesthetic was prevalent in English around 1800, but Baumgarten's conceptualization was finding increasing acceptance by 1830. The 1832 *Penny Cylopedia* explains "aesthetic" as "the designation given by German writers to a branch of philosophical inquiry, the object of which is a philosophical theory of the beautiful." Theory would apply here as a set of rational principles and a systematic method through which judgments of the beautiful are raised to the level of a science. In the same year, however, the *Philology Museum* challenges this use, arguing that it has not been established beyond contest, while defending the Kantian sense as "that branch of metaphysics which contains the laws of perception."

---

24. See, in this respect, David E. Wellbery's *Lessing's* Laocoon: *Semiotics and Aesthetics in the Age of Reason* (Cambridge: Cambridge University Press, 1984), esp. chap. 2.

25. *Kritik der reinen Vernunft. Immanuel Kant theoretische Philosophie,* vol. 1 (Frankfurt am Main: Suhrkamp, 2004), 103. Trans. Werner S. Pluhar as *Critique of Pure Reason* (Indianapolis and Cambridge: Hackett, 1996), 74.

And in his *Lectures on Metaphysics,* Sir William Hamilton offers in 1859, "It is nearly a century since Baumgarten . . . first applied the term Æsthetic to the doctrine which we vaguely and periphrastically denominate the Philosophy of Taste, the theory of the Fine Arts, the Science of the Beautiful, etc.,—and this term is now in general acceptation, not only in Germany, but throughout the other countries of Europe. The term Apolaustic would have been a more appropriate designation." And here it is interesting to observe how philosophy, theory, and science float in a corona of lightly indicated uses around and through the concept of the aesthetic, as Hamilton is ironically aware.

The question remains, however, of how and why "theory" emerged to characterize a certain way of conceptualizing aesthetics or the philosophy of art in particular and the humanities in general. For art to find theory meant that aesthetics was undergoing a transformation related to the transmigration of *theoria* into theory in a sense more familiar to us. Art was becoming an object of knowledge and aesthetics a separate and autonomous domain of philosophical inquiry. This transition was slow in coming, however. For example, in his 1846 study *Modern Painters,* John Ruskin could still deploy a concept of theory that retained its ancient associations with sight and apperception while modernizing it in a post-Kantian frame. "The impressions of beauty," he writes, ". . . are neither sensual nor intellectual, but moral: and for the faculty receiving them, whose difference from mere perception I shall immediately endeavour to explain, no term can be more accurate or convenient than that employed by the Greeks, 'Theoretic,' which I pray permission, therefore, always to use, and to call the operation of the faculty itself, Theoria. . . . Now the mere animal consciousness of the pleasantness I call Æsthesis; but the exulting, reverent, and grateful perception of it I call Theoria."[26] *Theoria* is not yet ready to explain, or to yield itself here to a systematic or scientific study of art. Still primarily a contemplative experience, it is neither active nor conceptual. Rather, Ruskin remains committed to a feeling for art as a subjective vision where the apprehension of beauty is regarded as a moral faculty. Ruskin retains the classical sense of *aisthesis* as ordinary or quotidian perception, the reception of a sensible *eidos* without its matter. But this perception is inchoate and without moral consequence if it does not move the soul by stimulating thought *(noesis)* and claiming its assent through judgment. *Theoria,* alternatively, indicates a perception heightened by a feeling for art, or an intuition of the force of artistic expression, to which we become receptive owing to a heightened moral sense.

26. *Modern Painters,* vol. 2 (London: George Allen, 1906), 13, 17.

What modernity would eventually call the aesthetic is here termed by Ruskin the theoretic.

## 6. How Art Found Theory

> There is nothing more abundant in our age than aestheticians.
>
> —Jean Paul Richter, *Vorschule zur Ästhetik* (1804)

By 1892, the modern sense of aesthetic solidified enough in English to become the subject of Bernard Bosanquet's *A History of Aesthetic*. Bosanquet characterizes his study as a "history of aesthetic consciousness" in which, from antiquity to the present day, the evolution of philosophical expression exists as "the clear and crystallized form of the aesthetic consciousness or sense of beauty."[27] To be able to write a history of aesthetic in the late nineteenth century already implies, first, an assumption of the stability and universality of the experience and value of beauty. At the same time, it is also a forgetting of the instability of the concept in a way that makes possible a retroactive and retrojecting construction wherein the aesthetic appears as the product of a continuous and uniform history of philosophical argument from antiquity to the present. From the very first pages of Bosanquet's history, this project is characterized as "aesthetic theory." And for the history of philosophy, it exemplifies a discursive template set in place by Hegel's *Lectures on Aesthetic* that reappeared with little variation in a long succession of influential accounts. Bosanquet's work is exemplary as one representation of the completion of the invention of the aesthetic in its modern sense—an invention that is at once a forgetting of the emergence of the concept in a 150-year history of contestation and debate and a retrojecting universalization of art and aesthetic experience.

Lost to this discursive template, as Kant already warned, is a sense of the profound discontinuity between the multiple and complex senses of *aisthesis* in classical philosophy and its later reinvention and redeployment in modern philosophies of art. Here the aesthetic gradually emerges as a new domain of inquiry in modern philosophy through the proposal of conceptual systems to account for a particular class of objects as well as a qualitatively unique experience. Moreover, presented as a history of aesthetic and not as a philosophy of art, Bosanquet's argument exhibits a discursive structure in which the

---

27. *A History of Aesthetic* (London: George Allen and Unwin, 1949), xii.

nineteenth-century commitment to historicism is also deeply felt. History in this period is universal history, whose tendency is to suppress differences and to align ideas, concepts, and discourses retroactively in a continuous and progressive evolution whose teleological orientation aspires toward ever-greater levels of complexity and synthesis. Bosanquet's aesthetic theory is also a history but a history of a particular kind, which values the present as the culmination of all past thought. In this respect, history is conceived as a directed and ordered succession of genetically related stages where in thinkers as varied as Hegel, Comte, and Spencer the law of organic development is the law of all progress. Progress is not accidental, but determined by supraindividual and objective processes.

Bosanquet's influential book is thus emblematic of a process whereby, from the turn of the century through the 1920s, aesthetics is set in place in academic philosophy as a scientific discipline. Over a period of nearly 200 years, a series of complex substitutions occurs in which the so-called scientific study of aesthetic experience was mapped in often fluid ways, especially in a German context, yielding several variations on the idea of establishing an aesthetic science, including *Kunstlehren, Philosophien der schönen Künste,* and *Kunstwissenschaften.* These are different but overlapping discursive domains whose translations into English as "theory" suppress significant conceptual and methodological differences in the history of aesthetic. And by the time we arrive at the emergence of *Kunstwissenschaft* as art theory or aesthetic science, concepts of theory will have been remapped from the semantic domain of systematic speculative construction to an empirical and sociological research program conceived in analogy with the explanatory models of the natural sciences.

The invention of the aesthetic was inseparable from the emergence of professional philosophy as an autonomous discipline within the eighteenth-century university. If one worries today that art is not often taken seriously by philosophy, in the 1730s, philosophy as *Weltweisheit* or "worldly wisdom" was itself not taken seriously by the higher university faculties of theology, law, and medicine. Ironically, the position of philosophy in this era was not unlike the place of the humanities in universities today—a domain of self-cultivation preparatory to more serious study. (From this moment forward, the practice of the history of philosophy also tends to suppress the profound discontinuity of theoretic practices.) To be recognized as a higher faculty, philosophy had to become "theoretical"—not just speculative knowing in the classical sense, but rather a rational and systematic account of the foundations of thought, both abstract and sensual.

In a history extending from the expulsion of Christian Wolff from the University of Halle in 1723 to Kant's completion of his three Critiques seventy years later, the practice of philosophy sought to overcome its marginal status as *Weltweisheit* by presenting itself as a unique discipline with its own distinctive method devoted to the systematic investigation of the foundations of knowledge. As Howard Caygill observes, "This lay behind the near obsession of eighteenth-century German philosophers, from Wolff to Kant, with the methodology of philosophy and the necessity of its systematic presentation."[28] Philosophy was becoming more theoretic in its struggle to supplant theology and to clarify the rational foundations of knowledge, and more theoretical in its desire to found philosophy on universal and systematic principles. This universalism translated into curricula that offered encyclopedic surveys of human wisdom: not only logic, metaphysics, and ethics but also lectures in history, psychology, politics, physics, natural history, pure and applied mathematics, geography, and ancient and modern languages. In short, philosophy was responsible for the entirety of the humanities and social sciences as we conceive them today.

Wolff and then Baumgarten's vision of philosophy was also guided by the Enlightenment idea that the progress of knowledge toward ever-greater distinctness of thought and more refined analysis of our representations was to be understood as a progress into language—from perception and imagination to the manipulation of arbitrary signs in logical expression. This idea of progress meant that language should become more "philosophical"—securing definitions, becoming more "grammatical" or logical, and therefore more subject to law. The scientific or *wissenschaftliche* character of what would be called theoretical philosophy was thus founded in an indissociable link between the improvement of knowledge and semantic and syntactic refinements of philosophical language. For a good part of the modern philosophical era, theory would be a code word for epistemology in general—the problem of mind and how the world is apprehended and made knowable by the mind. And because perception (or sometimes intuition) is the vehicle of this apprehending, aesthetics found itself inseparably yoked to theory.

Baumgarten divided the philosophical organon into the areas of theoretical and practical philosophy, commensurate with the eighteenth-century tendency to promote a universal philosophy legislating all fields of knowledge. Theoretical philosophy included the four branches of metaphysics (ontology, cosmology,

28. *Art of Judgement* (Oxford: Basil Blackwell, 1989), 150.

psychology, and theology) plus physics. The field of practical philosophy, following Aristotle's scheme, encompassed ethics and politics. Conceivably, for Baumgarten aesthetic would fall under theoretical philosophy, though its application to particular works as a poetics would be included within practical philosophy. This was commensurate with his characterization of aesthetic as a kind of frontier or contested border between perception and reason.

The story of how art found theory, then, is equally a story of how aesthetics became a "science," or rather, in the more fluid German vocabulary, a *Wissenschaft*. The nearly one hundred years that stretched from Baumgarten's *Reflections on Poetry* to the publication of Hegel's *Lectures on Aesthetic* witnessed the persistent desire to work out a complete system of philosophy, to make of philosophy a universal philosophy, where the concept of the aesthetic was confronted as an essential yet intractable problem. However, the very idea of a systematic aesthetic was paradoxical for a number of reasons. One often leaves the hardest problems for last so that confrontation with the aesthetic often waited until the end of a philosophical career. Many of the most influential works of the eighteenth and nineteenth centuries exist only in the form of incomplete manuscripts, lecture notes, and drafts, which, like Schelling's *Philosophy of Art* or Hegel's *Lectures on Aesthetic,* were reconstituted posthumously by students and disciples. In an era when philosophy longed for a complete system or doctrine of thought, incompleteness was the rule. Many of the important writers of German Romanticism embraced the fragment, of course, or like Herder believed that the desire to erect systems was a weakness of human nature. But in the period when modern philosophy was inventing itself, rebuilding its prestige in the university, and asserting its claim to legislate every activity that fell within or close to the domain of reason, the problem of the aesthetic—as sensation, perception, intuition, and free imaginative creation—was the rough sea that wrecked every ship. The lure of the aesthetic was a kind of sirens' song where the formal unity and completeness of works of art offered philosophy an image of perfectability: an ideal of beauty in an expressive structure where everything is related and everything is connected to everything else, and where the sirens' neighboring reef shimmered close to the shores of reason. This was the place where every universal philosophy came aground and split into fragments.

Within this context, the idea of theory represents the will to find reason in art and to make art reasonable. It is important to understand fully, however, that ideas of theory in this period are as unstable as concepts of the aesthetic. And if the two notions were yoked together in such interesting ways, it was

because theory was so semantically malleable with a genealogy rich enough to accommodate the activities of both the senses and reason.

Howard Caygill observes that in the eighteenth century, the construction of the new conceptual domain of aesthetics became simultaneously both the basis of and marginal to the establishment of theoretical philosophy. The term "aesthetic" first appears in its modern sense at the conclusion of Baumgarten's *Reflections on Poetry* (1735), which in its argument and conceptual architecture completely prefigures his later, unfinished *Aesthetica*. Baumgarten conceived aesthetics as the foundation of a new science of perception. Responding critically to Christian Wolff, Baumgarten argued that rational and aesthetic knowledge differ only in degree, not in kind. Poetry is a form of sensual thought but it is thought nonetheless. From the *Reflections on Poetry* through the *Aesthetica*, Baumgarten attempted to bring philosophy and poetics together, wherein logic as an art of judgment was complemented by aesthetic as an art of invention and imagination. The goal of this project was to reunite thought and sensibility in an expanded system of philosophy that reconciled *aestheta* and *noeta*. Thus, in the first paragraph of the *Aesthetica*, Baumgarten offers the following definition: "Aesthetics (as the theory of the liberal arts, as inferior cognition, as the art of thinking beautifully and as the art of thought as analogous to reason) is the sensuous cognition."[29] A faculty or form of cognition and an art as well, aesthetics was also a theory—that is, a rule-governed form of explanation.

Baumgarten's argument presents rational and poetic discourse as distinct yet continuous forms of thought, in effect building the foundations for a discursive formation that finds theory in art. The project turns on a system of analogies where poetic images are presented as analogous to logical concepts and the logical structure of the syllogism finds its pendant in the aesthetic discourse of the poem. Baumgarten's concept of aesthetic thus unfolds as a general theory of interpretation where the logical rules of syllogistic reasoning are complemented by an art of judgment that guides the interpretation of all forms of signification. The theoretic dimension of Baumgarten's aesthetic already appears in paragraph 115 of the *Reflections on Poetry* where a philosophical poetics is promoted as "the science guiding sensate discourses to perfection. . . . It would now be the task of logic in its broader sense to guide

---

29. "AESTHETICA (theoria liberalium artium, gnoseologia inferior, ars pulcre cogitandi, ars analogi rationis) est scientia cognitionis sensitivae." *Ästhetik*, vol. 1 (Hamburg: Felix Meiner Verlag, 2007), 10.

this faculty in the sensate cognition of things."[30] In a complete system of philosophy, then, poetics guides art toward perfection just as imagination inspires reason to conceptual innovation. While things known form the province of logic, and things perceived the province of aesthetic, logic must extend down to imagination for the source of its inventiveness; yet it must also guide and regulate that indistinct and pleasurable perception of perfection that is aesthetic experience.

Though Baumgarten never completed his *Aesthetica*, it inspired an explosion of writing in the latter half of the eighteenth century producing the background, no doubt, for Kant's complaint that aesthetic was a conceptually unsound, even impure term. In many respects, Kant was right. Rather than continuing the project of producing a universal theoretical philosophy that would include perception and imagination in dialogue with reason, the near mania for the aesthetic yielded numerous theories of art and manuals for the cultivation of taste. In this manner, a certain idea of theory as *Wissenschaft* became disconnected from philosophy, or even worse—as Herder makes clear in his sharp attack on Friedrich Just Riedel and other "theorists" of fine arts and letters in the "Fourth Grove" of his *Critical Forests*—it risked diluting and undermining the epistemological and critical powers of philosophy as advanced by Baumgarten.

After Baumgarten, then, two overlapping yet divergent variants of theory struggled to claim descent from this influential thinker and to assert their claim on the "scientific" study of art. The first phase, heavily influenced by Baumgarten, conceived the systematic study of perfect sensate representations as the attempt to establish a continuum between the higher spiritual and rational faculties and the more fluid material and perceptual or intuitive ones. What one might call theory in this era is close to the rational method of aesthetic investigations so clearly foregrounded in one of Baumgarten's most interesting exponents, Moses Mendelssohn.

It may seem strange that Baumgarten's *Aesthetica*, written in Latin in the form of terse yet crystalline syllogisms, unleashed such a vogue for beautiful thinking. Yet Baumgarten's approach to philosophy came to represent a kind of model for philosophical language in the form of a logical system ideally able to generate all possible noncontradictory concepts and judgments, which, through an algebraic form of calculation, could decide the truth of any state-

---

30. *Reflections on Poetry*, trans. Karl Aschenbrenner and William B. Holther (Berkeley: University of California Press, 1954), 77.

ment. This was a first concept of a scientific aesthetic where the beauty of philosophical language resided in its clarity and distinctness as a transparent instrument of thought identical to reason itself. (Later, a fault line will appear within the idea of *Wissenschaft* where theory could mean either the beauty of clear and distinct thinking or simply belles lettres—that is, tasteful thought and writing. This will be the second variant of theory.) The work of Mendelssohn, whom Herder admired, set the logical parameters for what would become modern aesthetics more so than the master himself. Mendelssohn's writings exemplify the structure of most theories of art as they persisted well into the twentieth century, specifically in their claim to establish a science of aesthetics whose systematic and logical character would rise to the level of a *Wissenschaft*.

Mendelssohn's major statement on aesthetic is "Über die Hauptgrundsätze der schönen Künste und Wissenschaften" (1771) ("On the Main Principles of the Fine Arts and Sciences"). Here Mendelssohn's thought demonstrates how aesthetic was thought to comprise three interrelated logical tasks: define the autonomy of the domain, draw up a taxonomy of expressive types, and describe the quality of subjective experience within this domain as embodied in those types. The idea of aesthetic was thus erected on the premise that all art forms be considered members of a single class of representation—in Baumgarten's terminology, perfect sensate presentations. For aesthetics to constitute a science, art in general must be considered to have an essence, and this essence must branch logically through, and be reflected in, each genre or medium of art. The classification and ranking of the individual arts, then, a key feature of all general aesthetics, had to demonstrate the aesthetic quality of the individual arts (that they belonged to the entire class) as well as the exclusivity of their expressive means. Call this a transmission of essence, where the autonomy and identity of art had to be reflected in the expressive purity and mutual exclusiveness of each medium of art. In any case, comparative descriptions became a universal feature of aesthetic theories as a way to discern the presumed inner affinities and mutual exclusions that obtained among the arts and to delimit their proper domains.

Just as art in general had to be considered as a specific and exclusive class of representations, the autonomy and self-sameness of individual forms of art were defended, first, by establishing qualifying predicates indicative of medium specificity. For example, in Mendelssohn's scheme, painting evokes perfect sensate presentations through the use of two-dimensional natural signs. Then the classification was developed by establishing a set of rules intrinsic to each art form to legislate the range of contents they can or should transmit.

These aesthetic rules were often prescriptive, taking the form of restrictions on content selection derived from the presumed overriding aesthetic purpose of the representation as well as from the nature of the sign vehicle the representation deployed. The goal of these rules was to establish the conditions for the maximum efficacy of individual art forms, both in the selection of appropriate content and in their promotion of the aesthetic effect, through examining and establishing the distinctive semiotic features of each medium, especially in the quality and degree in which they affect the process of aesthetic reception.

These classificatory schemes were the bridge between ontological definitions on the one hand and characterizations of subjective effects on the other. To classify and compare the arts was a means for identifying how this special class of representations could evoke aesthetic intuition in the receiver. The subjective experience induced by art in aesthetic sensation was considered, first, to take the form of a kind of internal perception—the activation of an intense emotional response deriving from the mental reactualization of the aesthetic presentation as an experience of illusionary internal presence. Analogously, the experience of aesthetic pleasure was conceived both as an external perception of the intrinsic formal qualities of the presented object and as the stimulation of the subject's internal representational and emotional capacities, though in the form of intuitions, not concepts. It was the function of theory to hone these intuitions into concepts through a philosophy of the aesthetic. The theoretical structure of aesthetics was a game of mirrors, however. Just as the essence, self-identity, and autonomy of art were reflected in each expressive medium of art, so too was aesthetic intuition reflected and reproduced within the subject as a kind of autoaffection—a self-given or self-produced activity. Aesthetics thus defended the experience of art as a profound practical and acculturating activity. While falling short of a rational activity, aesthetic intuition was thought to have significant powers of socialization and acculturation, developing and exercising faculties that bound the human community together sympathetically, while forging the basis of its universal identity through the harmonious play of the representational faculties. Through beauty in art, one found beauty in one's self and humanity in an axiological system that was at once tautological and universalizing.

Mendelssohn's arguments were emblematic of the theoretical structure of the main strand of Enlightenment aesthetics. The chief aim of theory so conceived was to develop a set of rules proper to each art and to develop a grammar governing combinations of different art forms. These were both rules of art in general (pertaining to aesthetic presentations) and rules following the

essence or purpose of each individual art (maximizing medium efficacy). The form of argumentation was deductive and the style of writing philosophically neutral, reflecting the impersonality and objectivity of a rule-governed system. As David Wellbery observes, in contrast to the cult of genius that would soon overtake aesthetics in the period of German Romanticism, the idea of a science of aesthetics expressed the attitude that "the arts do not at all reflect the creative force of an individual or cultural identity, but rather the entirely impersonal rules that govern the deployment of aesthetic representations. What the theory aims for is a calculus of aesthetic efficacy" (*Lessing's* Laocoon 93). Nonetheless, as I have already suggested, the structure had an axiological component that promoted and legitimated specific aesthetic and cultural norms. Most classifications and taxonomies also led to aesthetic hierarchies, ranking the arts according to their semiotic potential for provoking beautiful thought, valuing some and devaluing others.

Mendelssohn's works do not characterize themselves so much as "theoretical," but rather as "scientific," as reflected in the title of his essay, *Über die Hauptgrundsätze der schönen Künste und Wissenschaften*. In the latter half of the eighteenth century, however, *Theorie* comes to the foreground and takes on a different sense. This is the second variant after Baumgarten, one that echoes a conception of the education of taste, already prominent in the 1730s. In this context, theory meant something closer to our sense of poetics, and this usage probably informs later associations of *Theorie* with *Lehre* in the sense of a doctrine or method. This approach often took the form of encyclopedic collections and synopses meant to guide the cultivation of taste. A typical work was Riedel's 1767 *Theorie der schönen Künste und Wissenschaften,* a work blasted by Herder in the aforementioned "Fourth Grove"; this title was reprised by J. A. Eberhard in 1786. But the key formulation, no doubt, appears in J. G. Sulzer's influential *Allgemeine Theorie der schönen Kunste* (*General Theory of Fine Arts* [1771–1774]), which claimed to elevate aesthetic to a science by proposing a general theory and deducing the rules of fine art from the nature of taste.[31]

From the 1760s, then, aesthetic theory took up again the program of promoting "worldly wisdom" and became increasingly concerned with the education of taste defined as the cultivation of a graceful and exemplary life. As Kant,

---

31. Sulzer's entry on "aesthetic" begins with the assertion that "Die Philosophie der schönen Künste, oder die Wissenschaft, welche sowohl die allgemeine Theorie, als die Regeln der schönen Künste aus der Natur des Geschmacks herleitet" (Leipzig: Weindermannschen Buchhandlung, 1792), 47.

Herder, and Hegel were painfully aware in their very different ways, though these works took the form of academic treatises, they fell far short of Baumgarten's or Mendelssohn's intellectual precision. Taste was a fuzzy concept describing an instinctive or intuitive judgment operating independently of reason yet strangely in harmony with it. It was also a guiding or directive concept that was supposed to teach individuals to "esteem that which . . . reason would infallibly have approved if it had had the time to examine it sufficiently" and by virtue of which it is thus the "leader and steward of the other noble powers of the human soul."[32] Though taste no doubt had local variants, it was nonetheless considered to be a universal faculty and therefore a standard, no matter how inchoate, for assessing the value of works of art and for producing rules both for the making of art and for expressing aesthetic judgments. As Gregory Moore explains, "Good taste in art was, naturally enough, reasonable, balanced, measured; and bad or corrupt taste pedantic, emotional, immoderate. These virtues were best embodied by the art of the ancients and the polite literature of the day" ("Introduction" 20). In any case, this is what passed for "theory" in the time bracketed between Baumgarten's *Aesthetica* and Kant's *Critique of Judgment.* And just as Kant respectfully considered the *Aesthetica* to be an abortive attempt to produce a science of taste, Herder disparaged the reduction of Baumgarten's revolution in philosophy to a psychology of taste. This was the basis of his critique of Riedel, Georg Friedrich Meier, and other "theorists" of taste. Despite its title, in Meier's *Anfangsgründe aller schönen Wissenschaften* the object of aesthetic is not the scientific understanding of sensibility, Herder complains in the "Fourth Grove," but rather the promotion of beautiful thinking and the cultivation of taste. Each from his own perspective, Kant and Herder wanted to restore theoretic powers to the aesthetic by promoting theoretical philosophy against the "science" of taste, though unlike Kant, Herder believed that the development of such a science was possible and desirable. Despite some reservations, Herder admired Baumgarten's aesthetics as a metapoetics or a synthesis of poetry and philosophy that pointed the way toward a genuinely scientific approach, meaning properly philosophical in its promotion of reflexive knowledge—a true theory.

32. Ulrich König, *Untersuchung von dem guten Geschmack in der Dicht- und Rede-Kunst. Anhang zu: Des Freyherrn v. Canitz' Gedichte* (Leipzig, 1727), 261. Cited in translation in Gregory Moore's "Introduction" to Johann Gottfried Herder's *Selected Writings on Aesthetics* (Princeton, N.J.: Princeton University Press, 2006), 20.

## 7. Philosophy before the Arts

Thought and reflection have spread their wings above fine art.

—G. W. F. Hegel, *Lectures on Aesthetic*

By the 1820s, aesthetics had discovered metaphysical ambitions that went beyond questions of perception or the beautiful in general. In the same era, however, theory fell out of fashion, or rather was folded into a larger conception of the philosophy of art, sometimes referred to as a *Kunstlehre,* the title given to A. W. Schlegel's Jena and Berlin lectures of 1797–1798 and 1801–1804. In his 1829 *Lectures on Aesthetic,* K. W. F. Solger characterizes his position as "a philosophical doctrine of the beautiful, or better, a philosophical doctrine of art" *(eine philosophische Lehre vom Schönen, oder besser eine philosophische Kunstlehre).*[33] What unites the most influential figures of the period, such as the Schlegel brothers, Schelling, Solger, Schleiermacher, and Hegel, is the project to define the essence or identity of art in general as a metaphysical and ontological concept. This sense of the philosophy of fine art was erected on an interest in the beauty of "free art" as a metaphysical question, where philosophy finds in art its true expressive capacity as a transcendental practice. In many of the figures of German Romanticism, reason was considered a limit that must be transcended and renewed through art's creation of new forms of reflection. Indeed, the notion that philosophy could provide technical rules for the practice, use, or moral aims of art—and this was consistent with an earlier sense of "theory"—was anathema to the Romantic emphasis on the freely creative imagination, leading Hegel to rail against "art doctors" whose prescriptions for curing art were even less reliable than those of ordinary doctors for restoring health.[34] Likewise, the philosophy of art became increasingly less committed to Kant's view, which characterized the aesthetic as a capacity or potentiality of cognition (a position criticized by A. W. Schlegel in his *Kunstlehre*). Rather, it envisioned in art the manifestation of the absolute and the representation of truth. Art or the beautiful in art was thus for Schelling the "ideal of science [*Vorbild der Wissenschaft*], and where art is, science has yet to attain to"; it was

---

33. *Vorlesungen über Aesthetik* (Leipzig: Brockhaus, 1829), 1; my trans.

34. *Hegel's Aesthetics: Lectures on Fine Art,* vol. 1, trans. T. M. Knox (Oxford: Oxford University Press, 1975), 15. Additional citations in the original German will be indicated in italics, referring to the Suhrkamp edition of Hegel's collected works, *Vorlesungen über die Ästhetik,* vol. 1 (Frankfurt am Main: Suhrkamp, 1970).

also "the only true and eternal organ and document of philosophy" *(das einzige wahre und ewige Organon zugleich und Dokument der Philosophie).*[35]

At the beginning of the nineteenth century, then, a variation appears in debates on aesthetic signaling the promotion of a relatively new domain: the philosophy of art. The other key conceptual component to this debate involved defending the superiority of philosophy to theory with respect to claims for its scientific or *wissenschaftlich* character. Another decisive shift was taking place in this respect. Though Kant could complain in the *Critique of Pure Reason* that "aesthetic" was a misuse of language and a conceptual aberration, forty years later few would question the place of aesthetic in a system of philosophy. Rather, in the context of German Idealism, the place of theory was now contested in the creation of new philosophies of art.

In this context, Hegel's "Introduction" to his *Lectures on Aesthetic* still stands as one of the most influential statements of the nineteenth century. Delivered in Berlin in the years 1823, 1826, and 1828–1829, Hegel's lectures had an impact on the philosophy of art that would last for the next hundred years. In Germany, no less than in France, England, and the United States, philosophical considerations of the aesthetic could not avoid confronting these arguments, first published posthumously in 1835 as three volumes in his collected works. Bosanquet's commitment to the work, for example, is evidenced by his translation and publication in English of the "Introduction" in 1886; the closing section was also reprinted as an appendix to his *History of Aesthetic* in 1892. Despite its uncertain provenance—the manuscript was never completed in Hegel's hand—Hegel's philosophy of art exerted a profound if controversial influence throughout the nineteenth century and into the twentieth. This influence was not without its historical paradoxes, however.

Of central interest in the "Introduction" is how Hegel maps conceptually the contested terrain that lies between aesthetics on the one hand and theory on the other. Indeed, Hegel opposes his speculative philosophy to theory with two interesting consequences. First, one sees the malleability of the concept of *Wissenschaft* in its full and contradictory semantic range. Second, despite his far-ranging influence, Hegel's elevation of the philosophy of art over all other approaches to aesthetics would be, historically, largely a failed project. (The domain of *Kunstwissenschaft* ultimately takes another form.) Yet one finds

---

35. *System of Transcendental Idealism,* trans. Peter Heath (Charlottesville: University of Virginia Press, 1978), 227, 231. The corresponding German is found in Schelling's, *Sämtliche Werke,* vol. 3 (Stuttgart and Augsburg: J. G. Cotta, 1858), 623, 627.

here the various and contested discursive paths and thickets through which the history and theory of art would gradually emerge by the end of the nineteenth century. Looking ahead to the 1960s, this desire to adjudicate the claims of philosophy with respect to science and theory will be reprised in Louis Althusser's epistemology, so important to the structure of contemporary film theory. And in a similar way, Hegel's dialectic of self-consciousness, in art or philosophy, will be found to haunt the deep structure of contemporary theory.

Hegel prefaces the lectures by expressing dissatisfaction with the prominence of aesthetics in the vocabulary of his age. If one takes Wolff and Baumgarten at their word, aesthetics should have been the name of a new science of sensation and feeling, but for Hegel the philosophical sense of the concept has become too disordered, though too widespread to be ignored or displaced. (And here is a refrain, already present in Kant, that would repeat and develop across the next century: no one is happy with the term "aesthetic," yet everyone insists on deploying it after their fashion. In our time, the same will be said of "theory.") Let the term stand, then, Hegel relents, "but the proper expression for our science is *'Philosophy of Art'* and, more definitely, *'Philosophy of Fine Art'*" (*Der eigentliche Ausdruck jedoch für unsere Wissenschaft ist* "Philosophie der Kunst" *und bestimmter* "Philosophie der schönen Kunst") (1, *13*).

Hegel is well aware that what he calls the reawakening of philosophy as universal thought and thought's highest vocation is intimately linked to an analogous rediscovery of the science of art. The rediscovery of philosophy in the early eighteenth century was signposted by problems of aesthetic. The association of philosophy with *Wissenschaft* in the opening statement of the lectures, then, signals Hegel's desire to complete through aesthetics Baumgarten's project of elevating philosophy as the undisputed domain of universal reason. One of the first objections that Hegel confronts is not simply whether art is a suitable subject for philosophical treatment, but indeed whether the philosophy of art can treat these questions in a "scientific" manner. Hegel cleverly remaps the concept of science by revisiting a series of arguments already debated by Wolff, Baumgarten, and Kant, where the aesthetic turn is imagined as a way to complete the system of philosophy by reconciling thought and perception, or reason and the senses. Science is pursued through the domain of pure thought, while art offers itself to sense, feeling, intuition, and imagination. Science deals in rules, regularities, and conformity to law, while art is produced and enjoyed in the realms of freedom and play that elude the "dark inwardness of thought" (*Aesthetic* 5). And where science is concerned with nature and its regularities, art is more free than nature, for "Art has at its

command not only the whole wealth of natural formations in their manifold and variegated appearance; but in addition the creative imagination has power to launch out beyond them *inexhaustibly* in productions of its own" (5). For these and other reasons detailed in the "Introduction," fine art would seem to elude scientific discussion by resisting thought's regulative activity.

Yet within fine art, reason might also renew itself in significant ways through the powers of a free and unlimited creative will. Here Hegel revisits, though in a completely original way, the problem that so concerned Baumgarten and his successors: how to heal the breach between thought and feeling or sensation, and in so doing create a new ground for the practice of philosophy. To demonstrate that fine art may be treated scientifically means showing where reason lies within it—that it is a medium of thought and of the expression of ideas. Art, in this respect, is of the same order as religion or philosophy, sharing their vocation in a special way. In art, spirit expresses itself externally and seeks the infinite in a finite form—that is, as created from material nature and set before the subject in perception. Ordinary or quotidian reality is thus transformed; it is made both sign and Idea *(Vorstellung)*,

> namely by displaying even the highest [reality] sensuously, bringing it thereby nearer to the senses, to feeling, and to nature's mode of appearance. What is thus displayed is the depth of a supra-sensuous world which thought pierces and sets up at first as a *beyond* in contrast with immediate consciousness and present feeling; it is the freedom of intellectual reflection which rescues itself from the *here* and now, called sensuous reality and finitude. But this breach, to which the spirit proceeds, it is also able to heal. It generates out of itself works of fine art as the first reconciling middle term between pure thought and what is merely external, sensuous, and transient, between nature and finite reality and the infinite freedom of conceptual thinking. . . .
>
> Art liberates the true content of phenomena from the pure appearance and deception of this bad, transitory world, and gives them a higher actuality, born of the spirit. Thus, far from being mere pure appearance, a higher reality and truer existence is to be ascribed to the phenomena of art in comparison with [those of] ordinary reality. (*Aesthetic* 7–8, 9)

Here is the domain where art and Idea come together. (We do not yet know whether or not theory has a place in this domain.) The sphere of thinking (or, better, pure spirit) is the highest reality for Hegel, above all because it is

conceptual, infinite, and immaterial. Hegel calls this the "Idea as such" or the Absolute—truth in itself in its not-yet-objectified reality. Art, however, expresses or gives form to its own Ideas. Our perception of beauty is essentially an individuated configuration of reality that embodies and presents the Idea, and therefore, for Hegel, the beauty of art is something more than reality and mere sensuous appearance—it signposts a path wherein the subject will, in the course of time, refind itself thoughtfully reflected in the actual forms of art. "Accordingly," Hegel continues, "there is here expressed the demand that the Idea and its configuration as a concrete reality shall be made completely adequate to one another. Taken thus, the Idea as reality, shaped in accordance with the Concept of the Idea, is the *Ideal*" (*Aesthetic* 73–74). Eventually, each historical stage in humanity's progress toward reason and self-reflection will pass through its own Ideal of art.[36]

The brute materiality of nature and the contingency of quotidian existence immersed in the complexities of present historical life resist the spirit and its access to the Idea, whereas fine art makes nature and history yield to the expression of the Idea. For these reasons, as Hegel puts it, fine art cannot be less true or more deceptive than either "historiography" *(Geschichtsschreibung)* or immediate perception and, in fact, it is closer to the higher truths of religion and philosophy. Art is also something less than philosophy, however. Whatever truths might be unveiled there and whatever space art might give to thinking are both enabled and constrained by the material immediacy of the senses and their relations to the external world and the contingencies of history.

---

36. Bosanquet provides a beautifully concise account of Hegel's thinking here: "[In] *the first place* the whole world of imagined beauty or concrete fancy, which is called the 'ideal,' is conceived as passing through phases determined by the progression of intelligence and also by the cumulative result of the sequence itself. And in *the second place,* the human mind being at all times a many-sided whole, the same needs of expression which thus separate themselves each into its own successive phase in time, also appear, as a co-existing group of modes of fancy, relative to different media of expression, within each of the great historical forms or stages of the 'ideal' or art-consciousness. The former set of successive phases are what Hegel calls the three forms of art, symbolic, classical, and romantic, and taken together make up the main outline of the historical evolution of the ideal. The latter group of co-existing modes of expression, a group which repeats itself within each of the historical art-forms, is the system of the several arts, primarily differentiated from each other by the sensuous vehicles which they respectively employ. . . . And the same needs of expression being at the root of both differentiations of the ideal, the successive and the simultaneous, it follows that though all the arts recur in each epoch, yet in each recurrence one or more of them have a prerogative rank, depending on the coincidence of their special tendency with the spirit of the age within which they then are" (*History of Aesthetic,* 345–346).

The mention of historiography here should not go unexamined. Within the domain of the scientific study of art, the history of art is granted a special though subordinate status within Hegel's philosophy of fine art. (In Hegel's own philosophical history of the deduction of the true Concept of art, Johann Joachim Winckelmann occupies pride of place in a pantheon that includes Kant, Schelling, Schiller, and Goethe.) In this respect, Hegel anticipates the reuniting of philosophy and history into something like a systematic *Kunst-wissenschaft*. In any case, Hegel's interest in history is strongly present in the lectures in that the evolution of artistic forms expresses the essence of the human as the search for the self-given Idea, and thus the history of humanity's expressiveness is also the story of continuous dialectical progress toward that Idea.

The structure of Hegel's philosophy of art is already completely given in the "Introduction" as a kind of grand operatic overture in three movements. The first stage in a systematic consideration of the fine arts, as we have just seen, must include a universal part developing the Concept, as "both the universal Idea of artistic beauty as the Ideal, and also the nearer relation of the Ideal to nature on the one had and to subjective artistic production on the other" (*Aesthetic* 73). In the second stage, a complete philosophy of fine art must account for the historical development of the media of art in their essential differences. And finally, this examination of the essential difference of the individual arts must yield a concept of the essence of art itself as it unveils itself in a synthetic account of the total system of the arts, "since art advances to the sensuous realization of its creations and rounds itself off in a system of single arts and their genera and species" (73). This idea marks Hegel's account of the successive historical forms of art (symbolic, classical, and romantic) as well as his evaluative system for asserting and ranking the different means of artistic expression, including architecture, sculpture, painting, music, and poetry. The historical development of the essence of art through the evolution of its means of expression is thus presented as a progressive though asymptotic harmonization in which the spiritual idea seeks out forms closest to its (immaterial) essence, and where matter is overcome and shaped by the spirit that seeks to transform it meaningfully. Implicitly or explicitly, this structure will replicate itself as a kind of master template for all future attempts to erect a total system of the fine arts. (In sections 10 and 11, we will also find this template reprised in what I call the aesthetic discourse of classical film theory.)

The philosophy of fine art is first and foremost philosophy, and whatever science one might find in art must first be realized in philosophy—the history

of art is only in service to that larger scientific project. In this respect, there are two sides or dimensions to the dialectical movements of history in the "Introduction." First, there is the force of universal history driving the spiritual development of humanity. Hegel characterizes this force as a "sequence of definite conceptions of the world [*bestimmter Weltanschauungen*], as the definite but comprehensive consciousness of nature, man, and God, gives itself artistic shape" (*Aesthetic* 72, *103*). These world-concepts provide the spiritual content of art as the development of successive stages of a world-spirit in its symbolic, classical, and romantic forms.

Universal history is then complemented by a history of the forms of art in their immediate existence and sensuous being. Here another dialectic is at work. Art proceeds from the Absolute Idea, and its end is the sensuous presentation of the Absolute itself. Art strives for a particular reality—that is, a reality adequate to its historical Concept—yet the Idea must also struggle with the external shapes of nature in order to represent itself there in the external world. Therefore, in Hegel's reasoning, what is best in artistic presentations, what will characterize the essence and historical perfectibility of the medium of art, "will depend on the degree of inwardness and unity in which Idea and shape appear fused into one" (*Aesthetic* 72). Hegel is not simply looking for the fusion of content and form here, for the successive history of artistic forms is also the history of the philosophical subject passing through the dialectical stages of its progress toward self-discovery and self-unveiling. This consideration of art as a medium for thought—what stands between pure thought and brute substance—is the core of Hegel's conception of art. In it are found the essence of art and the source of all of Hegel's axiological distinctions and hierarchies defining the nature of different forms of art. The one and universal essence of art is to mediate between thought given perceptible form and nature transformed as idea, and in this manner the identification of forms of art emerges in an asymptotic progression toward pure thought and away from brute substance and immediate perception.

For Hegel, these arguments also characterize the modernity or contemporaneity of his age as the culmination of a line of development in the dialectical relation between art and philosophy evolving since the dawn of history and humanity, one of whose outcomes is the progressive refinement of the Ideal in the particular forms of the beauty of art. Hegel refers to this as his doctrine of the *forms of art (Lehre von den Kunstformen)* (*Aesthetic* 75, *107*). The dialectical progress and development of the different forms of art each express ways

of grasping the Idea as content and giving shape to it in the sphere of art. At the dawn of humanity, primitive art first gives rise to symbolic forms. The earliest symbolic forms occur in unworked or lightly worked natural materials that stand only as mere tokens or totems for the Idea. Later, however, a religious spirit is embodied and shaped in the development of the art of architecture. Here the forms of inorganic nature are fashioned in relation to what Hegel calls an abstract Understanding—leveling a place for the god, forming his external environment, and building for him a temple "for the inner composure of the spirit and its direction on its absolute objects" (84).

In symbolic forms, the Idea is presented to consciousness only in an abstract and indeterminate way. The relation of the Idea to the objective world is largely a negative one, and the correspondence between meaning and shape is inadequate, leading to the next stage in this evolution—the classical forms of Greek and Roman art. Here a new ontology emerges where beauty is made sensuously present in the human form through sculpture. The form of spirit concentrates and gives shape to something corporeal—god or the Idea permeating inert mass and giving it human form—as the free and adequate embodiment of the Idea in a shape appropriate to its essential nature. "Therefore," Hegel explains, "here the spirit is at once determined as particular and human, not as purely absolute and eternal, since in this latter sense it can proclaim and express itself only as spirituality" (*Aesthetic* 79). What classical art accomplishes is a unification of spiritual and sensuous existence as a form of correspondence between the two. "But in this blending of the two," Hegel continues, "spirit is not in fact represented in its *true nature*. For spirit is the infinite subjectivity of the Idea, which as absolute inwardness cannot freely and truly shape itself outwardly on condition of remaining moulded into a bodily existence as the one appropriate to it. . . . In other words, thought is 'inwardness' in the sense that thoughts are not outside one another in the way that the parts of a body are. This is why the spirit cannot find an adequate embodiment in things but only in thoughts, or at least only in the inner life" (79).

Through symbolic and classical forms, reason finds its way through art as a vehicle for knowledge of the Absolute, and the forms of art establish points of equilibrium or correspondence between sense and thought. However, in the romantic age, Hegel's age, works of art no longer serve the same kind of spiritual need: "The impression they make is of a more reflective kind, and what they arouse in us needs a higher touchstone and a different test. Thought and reflection have spread their wings above fine art" (*Aesthetic* 10). Thus the romantic ontology expresses an immaterial idea to which no physical form is

adequate; the romantic arts have become less spatial and more temporal, sig-
naling a withdrawal from space into the time of self-reflection and judgment.
Both architecture and sculpture transcend their symbolic and classical di-
mensions in romantic art, but they are not as fully adequate to the expression
of inwardness as are painting, music, and poetry, each of which Hegel consid-
ers as successive stages toward self-reflection and spiritual expression. Painting,
for example, frees art from the sensuous spatiality of material things in reduc-
ing space to a plane surface—perception retreats from a volumetric space and
produces visibility in pure acts of contemplative seeing. In turn, music cancels
the indifferent self-externality of space such that "sound releases the Ideal . . .
from its entanglement in matter" (88). In this way, Hegel characterizes sight
and hearing as "theoretical senses" not only because, in his view, they exclude
enjoyment as the satisfaction of desire but also because, at a distance from
touch and from nature, through them the sensuous appearance of art is spiri-
tualized in a negation or overcoming of matter and space as a withdrawal into
an immaterial perception set at a nontactile distance. The temporal ideality of
sound thus negates space, marking a transition from the abstract and external
spatial sensuousness of painting to the abstract inner spirituality of poetry.
Understood in its specific difference as a medium of art, romantic poetry thus
completes the system of the arts and unveils the one essence that flows
through them all as the power "to call forth from all the depths of conscious-
ness a sound and an echo in the spirit" (39). This emphasis on sonority shows
the phonocentric bias that drives Hegel's account of what is highest and most
spiritual in art. In poetry, sound is no longer the feeling of sonority, but rather
an internal sign of the idea, which has become concrete in itself: "Sound in
this way becomes a *word* as a voice inherently articulated, the meaning of
which is to indicate ideas and thoughts" (88). In this way, romantic subjectiv-
ity is created out of the articulate sounds of poetry as "the self-conscious indi-
vidual who out of his own resources unites the infinite *space* of his ideas with
the *time* of sound" (89). "Therefore," Hegel continues,

> the proper element of poetical representation is the poetical *imagination*
> and the illustration of spirit itself, and since this element is common to
> all the art-forms, poetry runs through them all and develops itself inde-
> pendently in each of them. Poetry is the universal art of the spirit which
> has become free in itself and which is not tied down for its realization to
> external sensuous material; instead, it launches out exclusively in the in-
> ner space and the inner time of ideas and feelings. Yet, precisely, at this

highest stage, art now transcends itself, in that it forsakes the element of a reconciled embodiment of the spirit in sensuous form and passes over from the poetry of the imagination to the prose of thought. (89)

Let us not mistake Hegel's meaning here. Through poetry, art transcends itself and approaches philosophy, the prose of thought. Through romantic or Christian art, the unity of divine and human nature is elevated from an *immediate* unity to a *known* one, from an actual and material presentation (aesthetic, sensuous) to a theoretic or noetic one: "the *true* element for the realization of this content is no longer the sensuous immediate existence of the spiritual in the bodily form of man, but instead the *inwardness of self-consciousness. . . .* Thus the unity of divine and human nature is a known unity, one to be realized only by *spiritual* knowing and *in spirit. . . .* In this way romantic art is the self-transcendence of art but within its own sphere and in the form of art itself" (80). The content of romantic art is free concrete spirituality manifested as spirituality to the spiritually inward. This is a negation and overcoming of immediate, sensuous presentations wherein perception and consciousness withdraw from externality and turn inward to (self-) reflection. There is no content to romantic art other than subjectivity itself. One might say that in Hegel's view it is the "theoretic" form par excellence.

Here the English translation finesses one of the boldest moves of Hegel's "Introduction": that philosophy is more than science, or rather embraces an enlarged conception of science as universal reason. In a clever rhetorical maneuver, Hegel sets out to deflect suspicions about philosophy by dispelling doubts concerning the scientific treatment of art, thereby demonstrating, through the possibility of a philosophy of art, the superiority of philosophy itself. Considered in itself, fine art might indeed elude full scientific treatment, for it can never be identical with reason. Indeed, Hegel admits, in a nod to Baumgarten and his followers, that as a free and contingent creation of the imagination, art appears in forms that resist thought, and consequently, thought is compelled to dissolve these forms in order to pursue its characteristic activity. Even the philosophical consideration of art may be confined to "the essential inner progress of its content and means of expression" (*Aesthetic* 12); in other words, aesthetic expression is limited of necessity to concrete sensuous forms and their histories. Art either resists the Idea or must completely yield to it, in which case it is no longer art but philosophy.

For Hegel, then, fine art in the romantic age is already philosophy, or rather a form of protoconceptual thought that calls for philosophy. Art is more than

nature because it seeks its Idea through forms wrested from nature and so imbues them with thought. Art makes of these forms sensuous objects for self-reflection. Thinking cannot find its purest activity here; this practice is reserved for philosophy. But the practice of fine art does have a special function for thought. It shifts the inwardness of the Concept from its own ground toward the concrete externality of sense. And in this respect, thought not only is able to grasp itself in its proper form as thinking but also is able to know itself again in a new and unfamiliar way by passing through its opposite: externality, sense perception, and objects and forms distinct in space. "Thus the work of art too," Hegel concludes, "in which thought expresses itself, belongs to the sphere of conceptual thinking, and the spirit, by subjecting it to philosophic treatment [*wissenschaftlichen Betrachtung*], is thereby merely satisfying the need of the spirit's inmost nature.... [Art], far removed ... from being the highest form of spirit, acquires its real ratification only in philosophy" *(erhält in der Wissenschaft erst ihre echte Bewährung) (Aesthetic* 13, 28).

Hegel continues this line of argument by demonstrating the superiority of the philosophy of fine art to other ways of treating beauty and art scientifically. At stake here are the variable meanings of *Wissenschaft*—a tug of war occurring since the time of Christian Wolff—whose aim is to demonstrate the primacy of philosophy to history on the one hand and to theory on the other, each of which have a claim to science. Philosophy, too, must overcome its prior history, which unfolded out of the concept of aesthetic and so-called philosophies of taste. With undisguised sarcasm, Hegel calls the philosophy of taste (read "theory" in Riedel's sense) an abstract philosophy of the beautiful where science abandons itself to a thought that is unable to address works of art in their particularity. The history of art fares somewhat better. Hegel refers to history as the indispensable starting point for a consideration of fine art since every work of art belongs to its own time, environment, and people. The scholar must be acquainted with the vast corpus of artworks, both ancient and modern, amassing detailed material facts to account for the spiritual and formal conditioning of their existence. This knowledge is empirical, Hegel emphasizes, since the work of art is something individual and particular, not abstract.

For Hegel, however, works of art also express something both immaterial and absolute, which is their Idea. But we cannot fully achieve this Idea through theories of art *(die Theorien der Künste) (Aesthetic* 15, *31)*, which only offer abstract general characteristics to formulate prescriptions and rules for the making of art. Hegel's disdain for theory is reacting, no doubt, to how late-eighteenth-century philosophies of taste not only failed Baumgarten's project

but in so doing failed the project of philosophy. These works mostly addressed the external appearance of works of art, and as such are as one-sided as other nonphilosophical sciences. They may justly recognize the beautiful in the aptness or perfection of sensuous form, but they cannot comprehend the Ideal in the concept of beauty as such. Theory must be overcome by philosophy in order for the Concept to find itself in self-reflection. Moreover, for Hegel, theory has already been cast aside in Germany owing to the emergence of Romantic art and "genuinely living poetry," which not only creates freely without formulae or prescriptions but also recognizes in philosophical Idealism its thoughtful counterpart: "the Concept, aware of itself as the thinking spirit, has now recognized itself on its side, more deeply, in philosophy, and this has thereby immediately provided an inducement for taking up the essence of art too in a profounder way" (20–21). For Hegel, the empirical history of art retains its scientific value as the background to philosophical reflection. But philosophy—or "purely theoretical reflection" *(die ganz theoretische Reflexion)* must account for that process of self-reflection that gives rise to the Concept of the beautiful (21, 39).

Here Hegel turns from degraded forms of theory to a properly scientific consideration of fine art whose true name is the philosophy of fine art. The value of theory derives from the degree of its scientific character, and in this respect Hegel uses *Theorie* and *Wissenschaft* almost interchangeably in a variety of contexts. But Hegel reserves for philosophy itself the activity of pure theoretical reflection and complete scientific knowledge, so much so that throughout the "Introduction," *Philosophie* and *Wissenschaft* also become interchangeable.

But almost with the same breath, Hegel must confront an intractable problem. Only through philosophy can we arrive at the Concept of the beautiful and examine it scientifically. But being of a spiritual nature, art is shot through with subjective, imaginative, and unreasonable elements. In order to know the Concept of the beautiful in itself, one needs a reasoned context for sorting out the relation of the subjective to the objective, to understand how the external necessity of an object is in conformity or not with our inner impressions and responses. This would require, Hegel admits, a universal philosophy of which the philosophy of art is only a part; it presupposes the "encyclopedic development of the whole of philosophy. . . . For us the Concept of the beautiful and art is a presupposition given by the system of philosophy. But since we cannot here expound this system and the connection of art with it, we have not yet got the Concept of the beautiful before us scientifically. What *is* before us is

only elements and aspects of it as they occur already in the different ideas of the beautiful and art held by ordinary people, or have formerly been accepted by them" (*Aesthetic* 25). In other words, even in the "Introduction," all we may have before us are theories of art that suggest or indicate the coming philosophy. In this context, the Concept of art can only be considered lemmatically as a self-given concept, universally held. Only when philosophy finds itself through the completed dialectic of Idealism can the essence of art be completely understood. And here the system of philosophy may not yet be complete (or perhaps cannot yet come to completion) because humanity still has need of art to guide its way out of the dark inwardness of thought toward self-reflection. Philosophy turns to the beauty of art, then, as "one of the means which dissolve and reduce to unity the above-mentioned opposition and contradiction between the abstractly self-concentrated spirit and nature—both the nature of external phenomena and that of inner subjective feeling and emotion" (56). But the system still being incomplete, reason seeks another mediating term or activity, one that falls between art and philosophy yet may have the power to bridge them conceptually. Without a complete system of philosophy, strangely enough, theory must be our guide.

How, then, can theory guide us toward the concept of the beautiful? Or conversely, how do we acquire this concept from or through our intuitions of beauty? What Hegel derides as "rule-providing theories" or "prescriptions calculated for practical application" (*Aesthetic* 26) will be of little use here. A philosophy of fine art understands, first, that if there were rules for the creation of art, then anyone could be an artist. But for Hegel fine art is not the production of general human activity, but rather the creation of a special and unique kind of subjectivity. This is the Romantic conception of genius, which knows only free creation as "an entirely *specially gifted* spirit which now, however, is supposed to give free play simply and *only* to its own particular gift, as if to a specific natural force; it is to cut itself altogether loose from attention to universally valid laws and from a conscious reflection interfering with its own instinctive-like productive activity" (26). Hegel's logic is striking here. This subject is not philosophical, since it functions instinctively like a natural force, yet it is subject to scientific examination, since it operates only according to its own inner necessity.

A second consequence follows from this argument leading to Hegel's controversial account of the end (and ends) of art. The sensuous value of fine art is tied ineluctably to the measure of the spiritual within it and to the degree of

free play allowed to spiritual expression. Both matter and technique resist this expression, leading to the distinction, common in this period, between the free and mechanical arts. The more fine art is dependent on external workmanship and the struggle with matter, the less free rein can be given to the inventive spirit, wherein the Idea seeks to find itself in something close to its proper temporal and immaterial domain. The less art relies on handwork, the closer it stands to the Idea, thus leading toward Hegel's axiological system in the lectures, where the fine arts progress in history through the forms of architecture and sculpture, evolving toward the higher forms of painting and music before achieving their telos in lyric poetry. The history of art, then, is marked by a continuous transformation of matter and nature directed by humanity's spiritual search for the Idea, which circles back finally to find itself within itself. External existence is not what makes a work a product of fine art, Hegel insists, but rather

a work of art is such only because, originating from the spirit, it now belongs to the territory of the spirit; it has received the baptism of the spiritual and sets forth only what has been formed in harmony with the spirit. Human interest, the spiritual value possessed by an event. . . , is grasped in the work of art and blazoned more purely and more transparently than is possible on the ground of other non-artistic things. Therefore the work of art stands higher than any natural product which has not made this journey through the spirit. . . . For everything spiritual is better than any product of nature. Besides, no natural being is able, as art is, to present the divine Ideal. (*Aesthetic* 29)[37]

Things of nature are variable, transient, impermanent, and resolutely nonsubjective. But art as free subjective creation makes spiritual inspiration conspicuous—it is embodied and given external existence by humanly working the materials of nature, which then may embody the Ideal because they must first pass through and be transformed by what is human and subjective.

From the other side, this freely creative subjectivity is also informed by a universal, absolute, and noncontingent *need* to produce art. Things in nature

37. John Hamilton reminds me of the pervasive influence, here and elsewhere, of Schiller's Aesthetic Letters on Hegel's arguments. Time and space are lacking here to account for this influence, above all as it relates to an idea of art as belonging to a domain of freedom from nature, and to the decisive role that Schiller plays as the historical bridge between Kant and Hegel.

are singular and intractable, but the thinking subject, as the spiritual motor of the dialectic in philosophy or art, is double or doubling. As a thinking consciousness, the human subject reflects on itself by actively projecting outward representations of itself; the subject recognizes what it is—what it has or can become—only by duplicating itself in representation, both theoretically and practically. This consciousness of self is achieved theoretically, in Hegel's terms, as a kind of inward sight or inner self-representation—an image of self achieved through a thought that can be externalized and recognized by others. In practical activity, this image of self-consciousness in thought is then produced by "altering external things whereon [the subject] impresses the seal of his inner being and in which he now finds again his own characteristics. Man does this in order, as a free subject, to strip the external world of its inflexible foreignness and to enjoy in the shape of things only an external realization of himself. . . . The universal need for art . . . is man's rational need to lift the inner and outer world into his spiritual consciousness as an object in which he recognizes again his own self" (31).

In the *Lectures on Aesthetic,* Hegel represents man as an amphibious animal caught between two worlds that contradict one another. Consciousness wanders between the two sides of this contradiction, finding neither satisfaction nor a home in one side or the other: on one side, there is an enslavement to need, passion, and matter, "the common world of reality and earthly temporality" (*Aesthetic* 54); on the other, the ideal and spiritual territory of eternal ideas, of thought and freedom, which the subject gives to itself through the free exercise of will—a transcendence of nature and passion through the self-providing of universal laws and prescriptions. Philosophy is the highest calling of this self-given gift in showing the way to truth as the dissolving of contradiction and the reconciling of humanity's divided consciousness. Art, too, paves the way toward philosophy, or perhaps philosophy completes the path set out by art, since "art's vocation is to unveil the *truth* in the form of sensuous artistic configuration, to set forth the reconciled opposition just mentioned, and so to have its end and aim in itself, in this very setting forth and unveiling" (55).

Here, then, are the two sides of art's special dialectic: the theoretical activity of making what is within the subject explicit to itself in thought, and the practical activity of fashioning this image of self as an outward reality (an exteriorized duplication of self by bringing it into sight / hearing and knowledge for itself and others). Later, the axiological dimension of this argument becomes more apparent and linked intimately to Hegel's thoroughly conservative view of the aims of art. Like the Concept of the State, the Concept of art

needs both a common end for all art making and what Hegel calls a higher substantial end, which is as much moral as philosophical or scientific. And just as the State assures societal order, the aim of art derives from "the capacity and vocation to mitigate the ferocity of desires" (*Aesthetic* 48). "The mitigation of the power of passions," Hegel continues, "therefore has its universal ground in the fact that man is released from his immediate imprisonment in a feeling and becomes conscious of it as something external to him, to which he must now relate himself in an ideal way. Art by means of its representations, while remaining within the sensuous sphere, liberates man at the same time from the power of sensuousness. . . . [Art] lifts him with gentle hands out of and above imprisonment in nature" (49). In this way, Hegel characterizes our preoccupation with artistic objects as "purely contemplative," or rather *"rein theoretisch"* (49, 75).

Just as natural forms cannot give us a concept of beauty, the poorest mode of apprehension is simple sensuous apprehension, hence the need for a purely contemplative relation to art. Alternatively, the artwork inspires another kind of relation through sensuous appearance, which leaves the object free to exist on its own account, and to which the subject relates without desire, "as to an object which is for the theoretical side of the spirit alone" *(nur für die theoretische Seite des Geistes) (Aesthetic* 36–37, 58). And here we come ever closer to the subject of theory as called forth by the apprehension of fine art. If there is a *philosophy* of art, it must be something higher, better, and closer to the spirit than either immediate sense perception or the practical desire to possess, transform, or consume external things. Hegel calls this "the theoretical study of things" or "the purely theoretical relation to *intelligence*," which finds satisfaction in the work of science (37). The theoretical relation wants to know things "in their *universality,* finding their inner essence and law, and conceiving them in accordance with their Concept" (37). Theory retreats from things as sensuous external forms: "intelligence goes straight for the universal, the law, the thought and concept of the object; on this account not only does it turn its back on the object in its immediate individuality, but transforms it within; out of something sensuously concrete it makes an abstraction, something thought, and so something essentially other than what the same object was in its sensuous appearance" (37). Theoretical activity transforms the (art) object in thought, releasing its concept, just as the freely creative genius releases the Idea in matter, and so produces the beauty of art.

What is the relation of theory to art, then? Art cannot produce scientific satisfaction, nor should it, yet it also inspires something that transcends the purely practical desire to hold, transform, or possess. Art inspires in us, Hegel

reasons, something less than philosophy but something more than immediate perception. This is a perceptive and thoughtful relation, though one that is not entirely scientific and reasonable. Throughout the "Introduction," the word Hegel uses is *Betrachtung,* which can mean consideration but also view, contemplation, inspection, and study, all of which relate back to ideas of theory as regarding or spectating. This philosophical view differs from the purely theoretical activity of scientific intelligence, "since it cherishes an interest in the object in its individual existence and does not struggle to change it into its universal thought and concept" (*Aesthetic* 38). It lets art be, then, and be open to theoretical consideration.

What philosophy seeks in art is a special kind of theoretical relation, one where thought finds or refinds itself but in a particular form. Here thought or spirit gravitate to a sensuous presence that must remain sensuous, available to perception, but that at the same time is liberated from the shackles of purely material nature. As opposed to things of nature, the work of art is pure appearance and, as such, takes its distance both from nature (material transformed by the externalization of thought) and from thought itself (pure spirit as inward reflection). As an object of theoretical consideration, "the work of art stands in the *middle* between immediate sensuousness and ideal thought. It is *not yet* pure thought, but, despite its sensuousness, is *no longer* a purely material existent either. . . ; on the contrary, the sensuous in the work of art is itself something ideal, but which, not being ideal as thought is ideal, is still at the same time externally there as a thing" (*Aesthetic* 38).

Romantic art calls for theory or philosophy as the end(s) of art, and this perspective sheds new light on Hegel's notorious claim that "art, considered in its highest vocation, is and remains for us a thing of the past" (*Aesthetic* 11). In an era in which reason predominates, the universal and the rational are no longer contained by the imagination and brought into harmony with material, sensuous appearance. And in this respect, philosophy is something more than religion, or perhaps has become the new religion of the Enlightenment. Art no longer brings the Absolute concretely before us as the embodiment of the gods or beauty and an opening onto an intuition of the suprasensible, nor does it inspire immediate enjoyment. Rather, romantic art drives us inward and calls us to judgment and (self-)reflection, modes of engagement and inquiry that lead us toward questions that only philosophy can answer. And here philosophy aspires to a special and universal practice identical with knowledge itself: "The *philosophy* of art [*Wissenschaft der Kunst*] is therefore a greater need in our day than it was in days when art by itself yielded full satisfaction. Art invites

us to intellectual consideration, and that not for the purpose of creating art again, but for knowing philosophically what art is" *(was die Kunst sei, wissenschaftlich zu erkennen)* (11, 25–26). The end of art is the crowning of philosophy, through theory.

## 8. The Rarity of Theory

> "Philosophy is really homesickness," says Novalis: "it is the urge to be at home everywhere." That is why philosophy, as a form of life . . . , is always a symptom of the rift between "inside" and "outside," a sign of the essential difference between the self and the world, the incongruence of soul and deed.
>
> —György Lukács, *The Theory of the Novel*

In Hegel, philosophy is not the mirror of nature, but rather the mirror of consciousness endlessly reflected in art. Now we can only look back ironically at Hegel's claim that art has come to an end. Even Hegel realized that the system of philosophy may not yet be complete, for humanity still has need of art even if only to inspire the prose of thought. Moreover, the admission that art can inspire only a theoretical relation, not a philosophical one, is a tacit confession that the Romantic era had not fulfilled its historical promise in either poetry or philosophy. Unable to lay claim fully to the accomplishment of a universal reason, philosophy turns to theory as something like an intermediate or transitional activity. At the same time, and even in their unfinished form, Hegel's *Lectures on Aesthetic* complete a logical and discursive template for aesthetic theory whose core problems and concepts were already set in place by Baumgarten, Mendelssohn, Lessing, and others. Well into the 1940s (recall Clement Greenberg's call for a newer *Laocoön*), the basic elements of aesthetic inquiry and valuation reprised, refined, or offered variations on the same tripartite schema. First, the concept of art was presented as a special form of apprehending by defining deductively its specific expressive modes or media. To define a medium of art meant in turn to establish criteria for asserting its relative autonomy and substantial self-similarity as a species of art, where all the major modes are distinct from one another yet all related through the same aesthetic principle. And finally, media specification included axiological criteria for ranking expressive modes according to their closeness to, or distance from, the guiding aesthetic principle. One of Hegel's major contributions to this schema was his strong sense of the teleological force of history as human-

ity's progressive discovery of a free and reasonable subject within itself, a discovery that could take place only through its successive externalizations in sensuous form. The long march toward the Absolute—a historical movement into philosophy and its forms of self-reflection—also followed the paths of progress of art in general as well as the evolution of the expressive means of art.

Through all the elegant and sinuous twisting and turning of their dialectical reasoning, and in the very form of their incompleteness, Hegel's arguments show how the variability and instability of concepts of theory in the context of the aesthetic are intimately linked to often repeated, and just as often failed, attempts to create a system of the arts as the anticipatory reflection of a complete system of philosophy. Many of the great figures of late-eighteenth- and nineteenth-century philosophy found something troubling about the aesthetic; hence the appeal to theory or science as a way to contain that trouble or to cure philosophy of it. In a sense, the aim of a book like Bernard Bosanquet's 1892 *History of Aesthetic,* at its heart a profoundly Hegelian work, was to make aesthetics a respectable subject for academic philosophy by showing that it *had* a history concomitant with the entire span of Western thought from the pre-Socratics to the present day. After Hegel, Bosanquet also develops a more or less specific definition of theory in relation to philosophy. For Bosanquet, aesthetic theory is a branch of philosophy whose interest is understanding the place and value of beauty in the system of human life. As such, the project of theory is both speculative and conceptual as "the succession of systematic theories by which philosophers have attempted to explain or connect together the facts that relate to beauty" (*History of Aesthetic* 1). The perception or intuition of beauty is something like a constant of human history for Bosanquet, though obviously it is valued differently by different cultures in different times. In this respect, what Bosanquet calls aesthetic consciousness comprises the "content" of aesthetic, its "data" being archaeological and other historical facts relating to art making as well as to the observations of art criticism. Aesthetic consciousness finds expression in works of art but also in the perception of art, whether intuitive or active; it is therefore available to conceptual analysis. In defining these concepts, we make theories. And here, what is most striking in Bosanquet's rather long and pedantic book is his degree of self-consciousness that ideas or concepts of the aesthetic have a history as variable and inconsistent yet systematic responses to the philosophical conundrum brought into focus by Alexander Baumgarten: "'How can the sensuous and the ideal world be reconciled?'" or "'how can a pleasurable feeling partake of the character of reason?'" (*History of Aesthetic* 173).

No doubt this is a retrojection of the modern idea of aesthetic onto earlier concepts. At the same time, Bosanquet's notion of theory is an interesting transitional concept. On one hand, it is quite close to what Ruskin meant by "Theoria." On the other, it strongly implies that theory is historical, and that the historical variability of theory is an important component of a broader philosophical account. In Bosanquet's own summary, "the History of Fine Art is the history of the actual aesthetic consciousness, as a concrete phenomenon; aesthetic theory is the philosophic analysis of this consciousness, for which the knowledge of its history is an essential condition. The history of aesthetic theory, again, is a narrative which traces the aesthetic consciousness in its intellectual form of aesthetic theory, but never forgets that the central matter to be elucidated is the value of beauty for human life, no less as implied in practice than as explicitly recognized in reflection" (*History of Aesthetic* 2). Conceptual analysis, art criticism and the history of art, and finally the history of aesthetic theory are the three components of what Bosanquet calls "aesthetic science," an explicit rendering in English of the German term fashionable at the time, *Kunstwissenschaft*.

Almost all of the synthetic accounts of aesthetic in the late nineteenth and early twentieth centuries are also histories of the idea and, concomitantly, of theories of the aesthetic but in a way that imposes a logic of continuity, origins, and ends. This historicizing gesture is already strongly present in Hegel's concept of *Weltanschauungen* and subsequently its influence on Bosanquet, Benedetto Croce, the young György Lukács, and others. Nonetheless, it largely remains a retrojection whose continuities are more apparent than real, as Kant was well aware in his own time. When one considers deeply the genealogy of theory with its many lines of descent, the one strong commonality that emerges, ironically, is the retrojecting force of contemporary accounts, which always forge present continuities from past discontinuous series. This remaking of history *après-coup* in a retrojecting gesture guided by present interest structures the vicissitudes of theory in the nineteenth century, and will reappear again in the middle of the twentieth.

There is one last point to make here, relating to the grammatical difference between "theory" and "theory of." In the almost 200-year history of aesthetic that stretches from Baumgarten's *Reflections on Poetry* into the early twentieth century, one did not offer theories; rather, one constructed philosophical systems or doctrines, hence the reversibility of *Philosophie* and *Wissenschaft* in Hegel's "Introduction." In the standard sense, and sometimes more, theory was not an uncommon word. Still, it is important to hold onto a genealogical

perspective attentive to its discontinuous and often contradictory meanings. The senses to which we (post)moderns have become accustomed are incommensurate with these earlier days, and in this respect, "theory" as the designation for a specific kind of activity, whether philosophical or scientific, was *rare*—it was almost entirely absent from the titles of major works in the arts and humanities. Any account of the invention of the aesthetic, then, should retain the senses of conflict and disorder, often projected into the evolving concept of the aesthetic itself, wherein the theoretical philosophy of Kant's time tried to hold on to a more classical and Hellenic concept of theory (what I have termed the theoretic), or where Hegel tries to create a new concept of theory as a special intermediate form of apprehension that is something more than art but less than philosophy, philosophy becoming in turn "pure theory" or science. In the late eighteenth century, Riedel's and Eberhard's published "theories of" the fine arts are exceptional instances, even aberrations, where a special and limited sense of theory as artful or beautiful thought, considered as a kind of *Wissenschaft*, so scandalized Herder or Hegel. And this is why it seemed important at the end of the nineteenth century to defend, as Bosanquet does, a concept of aesthetic science as the philosophy of fine art. One must wonder then (and I will return to this point) whether the title of György Lukács's 1920 *The Theory of the Novel* was not received as something rather experimental and shocking, or what epistemological sense Boris Eikhenbaum was trying to convey in his retrospective account in 1926 of "The Theory of the 'Formal Method.'" Commonplace now, these were daring titles eighty years ago, signaling a new sense and a new status for theory, making it visible and active in potentially new ways. In any case, this use of theory to designate a singular explanatory or evaluative account would remain rare in the arts and humanities until the 1940s and 1950s.

A consequence of the rarity of theory was that the major conflicts of the nineteenth and early twentieth centuries did not take place around ideas of theory so much as the senses of science or *Wissenschaft* in relation to philosophy and to art. In the "Introduction," Hegel readily turns the philosophy of art into a science, or rather believes that there is no science of art that will not also automatically be philosophy. This was, it must be said, the philosophical *bestimmte Weltanschauung* in which he thought and wrote. Insofar as German Idealist philosophy understood itself as an established and veritable philosophical science, Idealist philosophies of art regularly characterized themselves as scientific. In his influential *Philosophy of Art* (1802–1803), Schelling considered philosophy as offering "a strong scientific perspective on art" *(eine*

*streng wissenschaftliche Ansicht der Kunst)* because only philosophy goes beyond the contingent nature of empiricism to construct a scientific whole from "absolute principles."[38] In this way, Schelling anticipates Hegel's contention that there is no science of art that is not, at one and the same time, a philosophy of art in which empirical and historical research must serve the broader and deeper metaphysical investigation of the Concept in art and in reason.

The theoretical relation that art offers by inspiring self-reflection is on the way to a science or to a philosophy that remains as yet (and perhaps forever) unfinished. In this respect, yet another set of transformations of the aesthetic took place after Hegel wherein *die Wissenschaft der Kunst* became a *Kunstwissenschaft*—from the philosophy of art to "aesthetic science." In the second half of the nineteenth century, and in the immediate wake of Hegel's lectures, one did not offer theories or even philosophies of art, but rather *Wissenschaften des Schönen*. An entirely representative title is F. Th. Vischer's three volumes, *Ästhetik oder Wissenschaft des Schönen,* published between 1846 and 1857. Still, the debate over the senses and methods of science in relation to theoretical knowing were not over. Until the early twentieth century, aesthetics remained a somewhat problematic enterprise within the university and academic philosophy. Moreover, when *Kunstwissenschaft* and eventually art history were established as university disciplines, they would ultimately find their way through other compass points. The first congress of *Kunstwissenschaft* took place in Vienna in 1873, but it was not a meeting of philosophers, or at least philosophy was not its main concern. The first academic journal of aesthetics was only created in 1904—the seminal *Zeitschrift für Ästhetik und allgemeine Kunstwissenschaft,* edited by Max Dessoir, and in France, the first Chair of Aesthetics at the Sorbonne was not created until 1921, when it was offered to Victor Basch.

Nearly 200 years after Baumgarten's initial defense of Wolff and his effort to promote the aesthetic as a reasonable discipline, art finally began to find a home in the university. This achievement came at a price, however. From the second half of the nineteenth century, documentary approaches to visual art—informed by classical philology, archaeology, connoisseurship, and documentary history—came more and more to present themselves as "art sciences," reflecting the emergence of the history of art as an empirical and positivistic discipline. The attachment of *Wissenschaft* to what we now call art history

---

38. *Philosophie der Kunst* in Schelling's *Sämmtliche Werke,* vol. 5 (Stuttgart and Augsburg: J. G. Cotta, 1859), 359; my trans.

arises no doubt from the same set of discursive formations that produced the idea of the aesthetic and the philosophy of art. Nonetheless, tectonic shifts were reshuffling the discursive landscape on which the senses of the term were nourished. At the end of the nineteenth century, the history of art was informed more and more by a larger discussion in the disciplines of history as to whether historical laws operate in analogy to natural laws. Here a fault line develops between the history of philosophical idealism and a more positivist and empirically informed art history that strove not only to enumerate facts and events but also to seek explanations and interpretations for the development of style. This change of emphasis reflected a general reorientation of the emerging discipline around the problem of form as the expression of an artistic will. The earlier archaeological and philological approaches to art history then became subdomains, though important ones, of a larger research program that referred to itself more and more frequently as *allgemeine Kunstwissenschaft*, or "general art science," a term that after the turn of the century became strongly associated with the work of Max Dessoir.[39]

The enterprise of *allgemeine Kunstwissenschaft* was conceived methodologically as a comparative study of the arts, including literature and music, though nonetheless from a philosophical point of view. Dessoir believed that neither speculative and conceptual analysis nor empirical and psychological research was sufficient unto itself; both must be accommodated in a general science of aesthetic. However, Dessoir opposed idealist philosophy with its exclusive concern for the beautiful, and instead emphasized understanding the general function of art in mental and social life. In this conception, a general science of art was comparative and critical, testing the conditions, methods, and aims of different theoretical approaches (poetics, music theory, psychology) in order to bring them together into a systematic perspective on art able to adjudicate among a number of competing approaches, both speculative and empirical.

The study of art as *Kunstwissenschaft* became respectable, then, by casting doubt on the philosophy of art. Hegel had won the battle but was losing the war. In the late nineteenth century, under pressure from the broad and deep influence of positivism in a variety of domains, the senses of theory in relation to *Wissenschaft* began to turn away from philosophy and toward the social

39. Dessoir's major statement is *Ästhetik und allgemeine Kunstwissenschaft* (Stuttgart: Ferdinand Enke, 1906; rev. 1923). Trans. Stephen A. Emery as *Aesthetics and Theory of Art* (Detroit, Mich.: Wayne State University Press, 1970). Dessoir edited the first academic revue devoted to aesthetics, the aforementioned *Zeitschrift für Ästhetik und allgemeine Kunstwissenschaft*, from 1906 until 1937. The journal continued publication until 1943.

sciences, and here the semantic range of the concept began to shift. Where before *Wissenschaft* could sustain a philosophical or even metaphysical sense, it now felt more strongly the pressures of a positivistic and empirical approach. Even Bosanquet is trying to adapt to this climate while preserving pride of place for speculative philosophy with respect to what he calls the "exact aesthetic" of figures like Herbart, Fechner, Zimmerman, and Stumpf. This reversal is exemplified by the work of Gustav Theodor Fechner, an important pioneer of experimental psychology. As reported by Benedetto Croce, in his *Introduction to Aesthetic* (1876) Fechner "claims to 'abandon the attempt at conceptual determination of the objective essence of beauty,' since he desires to compose not a metaphysical Aesthetic from above *(von oben)*, but an inductive Aesthetic from below *(von unten)* and to achieve clearness, not sublimity; metaphysical Aesthetic should bear the same relation to inductive, as the Philosophy of Nature to Physics."[40]

Yet more vivid is Croce's account of Ernst Grosse's *The Origins of Art* (*Die Anfänge der Kunst* [Leipzig, 1894]). "Contemner of all philosophical research into art," Croce explains, "which he dismisses under the title of 'Speculative Aesthetic,' Grosse invokes a Science of art *(Kunstwissenschaft)* whose mission is to dig out all the laws lying hidden in the mass of historical facts collected to date" (Croce 397). Croce refers rather testily to the work of Spencer, Helmholtz, Taine, Fechner, Grosse, and others as "the superstitious cult of natural sciences" (391). Nevertheless, this body of work formed the discursive environment of what theory was becoming within the historical context of a "general art science." Through the establishment of an *allgemeine Kunstwissenschaft,* the philosophical idealism of Hegel and his time was being eroded and displaced by another version of theory, influenced by positivism, which took inspiration from the epistemological models of the natural sciences.

As we come closer to the twentieth century and the invention and commercial development of the projected motion picture, as well as the initial debates on the significance, if any, of film as a new medium of art, it is interesting to reemphasize the rarity of works self-described as theory. Certainly, there are as many theories as before, but "theory" does not exist as a genre of discourse, nor does one find many "theories of" the arts. Philosophies of art continue to be written; in 1926 Rudolf Harms even publishes a *Philosophie des Films* in

---

40. Benedetto Croce, *Aesthetic: As the Science of Expression and General Linguistic* [1909], trans. Douglas Ainslie (New York: the Noonday Press, 1953), 394. The interior citation is from Fechner's *Vorschule der Ästhetik* (Leipzig, 1897–98), n.p.

Germany. However, within the domain of the aesthetic, the most significant debates occur within conceptual definitions of *Kunstwissenschaft* and between *Kunstwissenschaft* and the philosophy of art. Within this context there is one strong exception worth noting, György Lukács's *The Theory of the Novel*.

Here we confront one last twist in the story (or at least one of the stories) of how art found theory, one that brings us closer to theory in a sense or senses more familiar to us. György Lukács's second major work, *The Theory of the Novel*, was composed in 1914–1915 in the time of the European march toward total war. It was first published in Dessoir's *Zeitschrift für Ästhetik und allgemeine Kunstwissenschaft* in 1915 and printed in book form in 1920, just after the conclusion of the war. Folded into the work, then, is a sense of a break in history and the suffering of a discontinuity where reason is disjoined from the world and society. And there is another turn, presented in Lukács's retrospective account of his youthful work in the 1962 preface to the republication of *The Theory of the Novel*. There is very little retrojection here as the elder Lukács takes pains to criticize his younger incarnation (always referred to in the third person as a kind of prehistorical self), for offering "a fusion of 'left' ethics and 'right' epistemology" in the years before discovering his own scientific perspective in Marxist philosophy, whose outcome was the controversial and still-compelling *History and Class Consciousness* (1923).[41] The preface is thus a history of erring paths and epistemological breaks.

My interest here is not to review Lukács's arguments concerning the history of the novel as a social and philosophical form, but rather to make present and perspicuous what language game he was playing in offering a "theory of" the novel in 1914–1915, especially in his pre-Marxist period. This task is made more difficult in that neither in the book nor in the retrospective preface does Lukács offer an explicit account of the logic and value of theory as distinct from aesthetics, the philosophy of art, or *Kunstwissenschaft,* all of which would be more common characterizations for the period. In an era when theory is still rare, how can one account for its presence here, as if it were a pelorus sighting a distant land where few had so far traveled?

One of the most striking aspects of Lukács's book, considering its time and place of composition and publication, is its Hegelianism. Lukács's reference to his fusion of left ethics with right epistemology provides an important signpost for the stakes of theory at this historical moment. Lukács relates that the

41. Preface, *The Theory of the Novel,* trans. Anna Bostock (Cambridge, Mass.: MIT Press, 1971), 21.

book was written under the influence of the *"geisteswissenschaftlichen Methoden"* of Wilhelm Dilthey, Georg Simmel, and Max Weber and that the influence of Dilthey's 1905 study of *Poetry and Experience* was in particular deeply felt. Lukács describes Dilthey's influence as the appeal of an intellectual world of large-scale syntheses in both theory and history. In turning to Hegel, Lukács was rejecting the neo-Kantian formalist and positivist aesthetics dominant at the time, which for the younger Lukács contaminated even Dilthey and the "human sciences" school. And in turn, aesthetics seemed implicitly not the right way to characterize this approach, but rather theory. In the 1962 preface, Lukács gives an admirably concise definition of the apparent aims of theory as a "method of abstract synthesis" where it "became the fashion to form general synthetic concepts on the basis of only a few characteristics—in most cases only intuitively grasped—of a school, a period, etc., then to proceed by deduction from these generalisations to the analysis of individual phenomena, and in that way to arrive at what we claimed to be a comprehensive overall view" (*Theory of the Novel* 13). In his approach to the novel, Lukács Hegelianized Dilthey as a way to present "a general dialectic of literary *genres* that was based upon the essential nature of aesthetic categories and literary forms, and aspiring to a more intimate connection between category and history than he [the younger Lukács] found in Hegel himself; he strove towards an intellectual comprehension of permanence within change and of inner change within the enduring validity of the essence" (16). These were the conceptual components of theory as Lukács understood them at the time.

Lukács notes that there was renewed interest in Hegel's writings on logic and epistemology in the years before the outset of the Great War but that *The Theory of the Novel* was the first work to apply Hegel's philosophy concretely to problems of aesthetics as conceived by the "human sciences" school. The elder Lukács does not shy away from the originality of his youthful turn to Hegel. Yet one must read between the lines of the preface to grasp that Lukács's sense of history and its relation to theory, in 1915 and in 1962, departs strikingly from Hegel's teleological point of view. Lukács is responding sympathetically, no doubt, to the critical reaction of Dilthey and other philosophers to positivism and historicism, a reaction that was strongly present in other ways in the turn-of-the-century reception of Nietzsche. At the same time, Lukács implies that his youthful fascination with Hegel is analogous to that of the young Marx as a prescientific though necessary preliminary step toward a correct (theoretical) understanding of history and its relationship to art or literature.

Theory has another special role to play here as the critical response to a felt crisis in history, a crisis where other practical and conceptual possibilities seemed blocked or as yet unthought or unthinkable. Lukács relates that *The Theory of the Novel* was conceived in a period of deep existential as well as historical crisis, "written in a mood of permanent despair over the state of the world," and where "nothing, even at the level of the most abstract intellection, helped to mediate between my subjective attitude and objective reality" (12). What I want to suggest here is that theory signifies the response to this crisis, at once ethical and social, wherein one no longer feels at home in the world and where the movements of history are experienced not as progress, but rather as the headlong rush into catastrophe or cataclysm.

This is where the turn to Hegel's aesthetic seems strange, and where philosophy seems no longer to console or to provide a searchlight guiding humanity toward reason. In assessing the influence of Hegel's aesthetic on his book, Lukács notes that a guiding concept is that art both follows and foreshadows the historical and philosophical abolition or overcoming of previously dominant forms and Ideals. In other words, art is always responding positively and conceptually to the evolution of the historical Idea by giving it sensuous form, a form that both anticipates and brings to completion the Idea, offering it to thought. In Romanticism, sculpture and architecture thus recede to the background as poetry ascends to give voice to thought that is as rational in art as it is in politics. In Lukács's account, "the 'world of prose,' as [Hegel] aesthetically defines this condition, is one in which the spirit has attained itself both in thought and in social and state praxis" (*Theory of the Novel* 17).

Alternatively, for Lukács the art of his modernity is the novel. And this is also where he marks his difference from Hegel, not only because the modern form of the novel was practically unknown to him but also because it suggests another relation to history. As Lukács relates, for Hegel history is continuous—a steady progressive march toward reason—and in moments of historical change or transformation, only art becomes problematic as the signifier for one form and Idea replacing another. Art becomes problematic, or rather confronts philosophy with problems calling for conceptual clarification, because reality itself has become nonproblematic. Philosophy is the solution to art's ontological puzzles as humanity continually refinds and refines itself in reason. For Lukács, however, the novel is expressive of a lived crisis in history, one where the world and history have gone out of joint and where art is unsure of its place. This is why the prose of life—poetry or philosophy—is "here only a

symptom, among many others, of the fact that reality no longer constitutes a favourable soil for art; that is why the central problem of the novel is the fact that art has to write off the closed and total forms which stem from a rounded totality of being—that art has nothing more to do with any world of forms that is immanently complete in itself" (*Theory of the Novel* 17). The novel, it would seem, is less Stendhal's mirror held to life than an irregular or broken crystal that presents the world in fragments.

The historical realism of the novel is the historical crisis of modernity. Here the desire for totality, as represented in the perfectibility of aesthetic form, or as a relation of identity between the subject and world or the subject and reason, all come to grief, and not for artistic, but rather for historical and philosophical reasons: "'there is no longer any spontaneous totality of being,' the author of *The Theory of the Novel* says of present-day reality. A few years later Gottfried Benn put the same thought in another way: '. . . there was no reality, only, at most, its distorted image" (18). In concluding the 1962 preface, Lukács makes explicit that the desire to create a theory of the novel was not intellectual, but rather ethical: "that the author was not looking for a new literary form but, quite explicitly, for a 'new world'" (20). In or through theory, Lukács understands that the progress of art is unfinished and falls into fragments in humanity's confrontation with the emergence of modernity and the global scale of violence of World War I. Lukács's appeal to theory is a reversal of Hegel in this respect. Where philosophy or metaphysics has failed in history, there is little left but to turn to theory. As in Marx and Kierkegaard's writing after Hegel, the aim of theory was not to affirm existing reality as the culmination of history but to criticize existing reality as spiritually and historically incomplete and insufficient. Finding no solace in art as the image of either a perfectible world or a world guided by reason, one turns to theory.

Expressing in its forms a crisis both ontological and historical, the novel presents history in a state of traumatic change; for the young Lukács, this transformation was potentially destructive and chaotic. History would present him with new compass points, however—the Russian revolution of 1917 and the short-lived Hungarian Soviet Republic of 1919. As a mode of art, the novel is not the completion of a stage in history, but rather the anticipation of a new historical shift forged in violence. The young Lukács experienced this historical violence as a barrier—he had to find his way in theory. Retrospectively, the elder Lukács sees the problem posed by the novel as one of an anticipated revolution, which called for a response not from philosophy or metaphysics, but from theory as the complement to revolutionary practice. In turn, the his-

tory of the novel is something like the prelude to this theory; or, as Fredric Jameson notes, Lukács's later adoption of the concept of reflection *(Wieder-spiegelung)* from Lenin's *Materialism and Empiriocriticism* was "not so much a theory in its own right as the sign of a theory to be elaborated."[42] Theory turns to, or turns into, praxis in the extent to which it is capable of thinking change. In this respect, knowledge will no longer be theoretic—the static and contemplative standpoint of abstract thought and pure reason—but rather turns through theory to what is concrete, actual, and capable of transformation. Just as art was for Hegel the not-yet anticipating the completion of the system of philosophy, theory after Lukács was the always-to-come of world revolution as anticipated in the "problematical" structure of the novel itself. At the same moment, another group of writers were working through the problematic experience of modernity in relation to another form, whose relation to art not only was uncertain but also threw up a challenge to the reigning concepts of aesthetics—cinema.

Hegel announced the end of art (and perhaps the beginning of modern philosophy), but the concept of free art also signaled the completion of a vast social change indicative of a new, modern relation to art. A more sociological and historical view would explore how Romantic ideas concerning free art were informed by the erosion of religious and aristocratic contexts of reception and patronage, the rise of state-sponsored museums, and the emergence of the autonomous art object as a commodity form circulating in art markets. By the early nineteenth century, artworks were definitely becoming objects with a special kind of value. And from Winckelmann through Hegel, the scientific study of art recognized ever more strongly and complexly the historical nature of this value. But it would take another hundred years before the twentieth-century avant-gardes would undermine and disturb, before philosophy and aesthetic science themselves, the concept of beauty as the axiological foundation for concepts of art. Indeed, the emergence of art theory, as

---

42. *Marxism and Form* (Princeton, N.J.: Princeton University Press, 1971), 188. Edward Said is an equally attentive and original reader of Lukács, especially with respect to how Lukács's earlier concerns with subject-object relations in aesthetic experience prefigure his later commitments to revolutionary Marxism. "Theory for him," Said observes, "was what consciousness produced, not as an avoidance of reality but as a revolutionary will completely committed to worldliness and change." See Said's "Traveling Theory" in *The World, the Text, and the Critic* (Cambridge, Mass.: Harvard University Press, 1983), 234. Said takes up this argument again in an illuminating way in "Traveling Theory Reconsidered" in *Rethinking Fanon: The Continuing Dialogue*, ed. Nigel C. Gibson (New York: Humanity Books, 1999), esp. 197–202.

distinct from the philosophy of art or *Kunstwissenschaft*, is inseparable from a certain politicization of art in critical theory—whose great critical exponents included Lukács, Bloch, Benjamin, Brecht, and Adorno—that still recognized aesthetic experience as a unique perceptual domain or activity but that placed questions of significance and value in relation to and recognition of art's penetration by the commodity form. Film and aesthetic writing on film have a special place in this account as the emergence of not only a new and perplexing expressive mode—for many writers the very expression of modernity—but also one that was in historical tension with the transformation of aesthetic by the commodity form and capitalistic exploitation of culture and aesthetic experience.

## 9. On the History of Film Theory

> What is found at the historical beginning of things is not the inviolable identity of their origin; it is the dissension of other things. It is disparity.
>
> —Michel Foucault, "Nietzsche, Genealogy, History"

Theory is a vista composed of many layers, and our view of it is oriented by many competing frames. Obtaining a clearer picture of theory means neither choosing a different frame nor drawing a more refined sketch or taking a different perspective, but rather remaining open to the complexity of its past and present movements.

In *The Virtual Life of Film,* I argued that one powerful consequence of the rapid emergence of electronic and digital media is that we can no longer take for granted what "film" is—its ontological anchors have come ungrounded—and thus we are compelled to revisit continually the question, What is cinema? This ungroundedness is echoed in the conceptual history of contemporary film studies by what I call the metatheoretical attitude recapitulated in cinema studies' current interest both in excavating its own history and in reflexively examining what film theory is or has been. The reflexive attitude toward theory began, perhaps, with my own *Crisis of Political Modernism* (1988; rpt. 1994) and throughout the 1980s and 1990s manifested itself in a variety of conflicting approaches: Noël Carroll's *Philosophical Problems of Classical Film Theory* and *Mystifying Movies* (both 1988), David Bordwell's *Making Meaning* (1989), Judith Mayne's *Cinema and Spectatorship* (1993), Richard Allen's *Projecting Illusions* (1995), Bordwell and Carroll's *Post-Theory: Reconstructing Film Studies* (1996), Richard Allen and Murray Smith's *Film Theory*

*and Philosophy* (1997), Francesco Casetti's *Theories of Cinema, 1945–1995* (1993; trans. 1999), Richard Allen and Malcolm Turvey's *Wittgenstein, Theory and the Arts* (2001), and so on.

One characteristic of all these works is the isolation and detachment of "theory" as an object available for historical and theoretical examination, but in doing so, these books take three different approaches. Natural scientific models inspire one approach, both philosophical and analytic, which posits that the epistemological value of a well-constructed theory derives from a precise and generalizable conceptual framework defined in a limited range of postulates. This approach assumes there is an ideal model from which all theories derive their epistemological value. In turn, the value of film theory is measured by its historical progress toward commensurability with this ideal model. Alternatively, Francesco Casetti's approach is both historical and sociological. Agnostic with respect to debates on epistemological value, it groups together statements made by self-described practitioners of theory, describing both the internal features of those statements and their external contexts as a form of social knowledge. In *The Crisis of Political Modernism,* my own approach, inspired by Michel Foucault's *Archaeology of Knowledge,* assumes that the conditioning of knowledge itself is historically variable. Discourse *produces* knowledge. Every theory is subtended by enunciative modalities that regulate the order and dispersion of statements by engendering or making visible groups of objects, inventing concepts, defining positions of address, and organizing rhetorical strategies. This approach analyzes how knowledge is produced in delimited and variable discursive contexts that are investigated as discontinuous, if sometimes overlapping, genres, practices, or modes of discourse.

In a first move, it might seem strange to associate theory with history. Introducing a series of lectures at the Institute for Historical Research at the University of Vienna in 1998, I astonished a group of students by asserting that film theory *has* a history, indeed multiple histories with various yet intertwining genealogical lines of descent. Here the analytic approach to theory on one hand and the sociological and archaeological approaches on the other part ways. The fact of having a history already distinguishes film theory, indeed all aesthetic theories, from natural scientific inquiry, for natural and cultural phenomena do not have the same temporality. Examination of the natural world may presume a progression in which new data are accumulated and new hypotheses refined in modeling processes for which, unlike human culture, we have no prior knowledge. Aesthetic inquiry, however, must be sensitive to the variability and volatility of human culture and innovation; their epistemologies

derive from (uneven) consensus and self-examination of what we already know and do in the execution of daily life, or in adhering to and departing from the cultural protocols of our institutional contexts. And there is yet a third perspective offered by Hegel or the young Lukács, where theory stands somewhere between art and philosophy as the expression and refinement of concepts offered to us in aesthetic experience, but in a preconceptual or protoconceptual modality. For Hegel, art is the perfection of a place where philosophy will arrive and find itself in reason through theory; for Lukács, theory is a lifeline thrown to us in the storms of modernity, where art expresses the disjunction of reason from reality as well as the utopian possibility of their reconciliation.

Here our picture of theory becomes unfocused again. This image now lacks clarity for other reasons, however. Many different conceptual images are superimposed one on top of the other, and each image resembles the others in ways significant enough that they all appear to share the same design. But these images are chimerical and lead us astray if we are unable to recognize that even the short history of writing on film reveals distinct and disjunct strata. Here the discontinuities between different approaches to investigating and evaluating the arts are as important as continuities.

A historical perspective on film theory is wanted here, but what kind of history? One irony in asking this question suggests that our contemporary picture of film theory is ineluctably tied to a certain image of history. To my knowledge, the first synoptic account of aesthetic writing on film, gathering together and organizing conceptually what became the canonic version of classical film theory, was Guido Aristarco's *Storia delle teoriche del film,* published in 1951.[43] Owing to the overlapping senses of the Italian word *storia,* the title of Aristarco's pioneering book could be translated as either the "story" or "history" of film theory. But the appearance of "theory" in the title is equally significant. Our contemporary sense of what theory means may not derive precisely from Aristarco's work, but his particular usage was certainly representative of a broad shift taking place in the immediate postwar period that involved a new set of criteria for identifying theory as a concept allied to a distinct set of institutional practices.

The notion that there is a "story of film theory," a coherent and perhaps teleological historical narrative that could be retroactively superimposed on the

---

43. (Turin: Einaudi, 1951; rev. 1960). I thank Francesco Casetti for leading me back to this important book. See also Aristarco's *L'arte del Film: Antologia storico-critica* (Milan: Bompiani, 1950).

unruly critical writing on film emerging in cinema's first fifty years, is coincident with similar shifts in the study of art and literature, especially the emergence in comparative literature of a new domain of inquiry—the survey of critical theory in a synoptic perspective whose inaugural gesture is René Wellek and Austin Warren's *Theory of Literature* (1949) and whose exemplar is René Wellek's magisterial eight-volume *History of Modern Criticism* (1955–1992). To this general historical perspective we owe the practice of conceptualizing courses in film, art, or literary theory as occupying a single term of study, or perhaps two successive semesters. In a course on aesthetics, which might begin with Plato and conclude with Derrida, this kind of decontextualized and often chronological approach implicitly assumes that there is a continuous, linear, and more or less unified narrative that can be told about aesthetic expression and judgments of value or, similarly, that the concept of the aesthetic itself has a philosophical continuity reaching back to Periclean Athens or before. Hegel's philosophy of history is not too far in the background, even if its outlines are fading, and Bosanquet's notion of aesthetic theory as a continuingly evolving consciousness of the aesthetic lingers nearby. That Aristarco was deeply influenced by Lukács and encouraged him to return to writing about film and that Lukács and Balázs were close friends throughout the 1910s establish an oblique yet distinct network of filiations and family resemblances.

Retrospectively, it is equally curious that early in the twentieth century, film would become associated with theory. This association is not simple, natural, or self-evident. One of the earliest occurrences of the term appears in the aforementioned *Der sichtbare Mensch* (1924), where Béla Balázs argues, "Theory is, if not the helm, then at least the compass of artistic development. And only when a concept sends you in the right direction can you speak of erring. This concept—film theory—you must make for yourself."[44]

The idea of theory presented here is wonderfully contemporary yet also expressive of a very specific moment in the philosophy of art. On one hand, Balázs is suggesting that in order to develop or unfold its expressive possibilities, the new art of film needs critical reflection. Criticism guides film (away from literature or theater perhaps) toward something like a heightened self-understanding, not only of its internal formal possibilities but also of its external cultural presentation of "visible humanity." In many ways, Balázs's book

---

44. (Frankfurt am Main: Suhrkamp, 2001), 12; my trans. See also the new and welcome translations of *Visible Man* and *The Spirit of the Film* in Erica Carter, ed., *Béla Balázs: Early Film Theory*, trans. Rodney Livingstone (New York: Berghahn Books, 2010).

can be read as a founding text of visual cultural studies, one that gives pride of place to film not simply as the art most characteristic of modernity but also as a new scriptural form through which humanity comprehends itself in a post-alphabetic culture and where literacy now means close attention to the physiognomy of things as well as people, social as well as natural space. At the same time, "die Theorie des Films" is not something discovered "from" or "in" cinema as if there were facts there to be uncovered or brought to light. Rather, it is a practice of the construction of concepts that is already curiously close to Gilles Deleuze's observation sixty years later in the conclusion to *Cinema 2: The Time-Image* that theory is made or crafted no less than artistic expression itself.

On the other hand, Balázs's text may appear contemporary to us only as the retrojection of a picture that is far too familiar, and this image may not align precisely with the one Balázs intends. Theory seems always to have accompanied film study on its long march toward academic acceptance, which still seems hardly or only newly achieved in the twenty-first century. It is a word, concept, and practice that we have taken for granted since at least the 1950s. Just as the notion of the auteur appeared as one strategy for legitimating the study of film by trying, and only with some difficulty, to locate filmic expression in a singular creative voice or signature thus defining it as art, perhaps theory also emerged as a way to apply a scientific patina to the discussion of an art form that was barely considered as such in 1924.

But step back further from this picture or try to see it in a different light. What is called theory now might not be legible as such to someone of Balázs's historical place and culture. In 1924, a writer with Balázs's education and experience might well have defended film in the context and vocabulary of the philosophy of art or aesthetics. Here a frame or context is needed where theory seems alien or strange as a usage that is not obvious or self-evident. Indeed, Balázs's particular appeal to theory in 1924 was probably exceptional and the word itself surprising in this context. This was certainly not the way writing on film or art was usually characterized in the 1910s (Lukács's *Theory of the Novel* being an exception, as I have already mentioned). For example, in 1912 Lukács published a short text titled "Gedanken zu einer Äisthetik des 'Kino'"—that is, thoughts toward a cinema aesthetics. Reviewing Balázs's book in 1926, Andor Kraszna-Krausz describes it as a contribution to "aesthetic philosophy," and the title of his review characterizes the book as "eine Filmdramaturgie."[45]

45. "Béla Balázs: *Der sichtbare Mensch*. Eine Filmdramaturgie, *Film Technik* 21 (16 October 1926); reprinted in *Der sichtbare Mensch* 168. This rapprochement of theory to dramaturgy also

This terminology resonates in compelling ways with other fundamental texts of the period such as Sergei Eisenstein's 1929 statement, "A Dramaturgy of Film Form." In his first preface to *Der sichtbare Mensch,* Balázs portrays his arguments as a "philosophy of the art of film" that explores questions of meaning by way of a critical account of the medium's distinctive aesthetic features. Finally, Balázs's most well-known book in English, *The Theory of Film,* a collection and synthesis of texts spanning his entire career as a writer, seems never to have borne that title except in English translation. Published first in Russian in 1945 as *Iskusstvo Kino (The Art of Film),* in 1948 the book appeared in German as *Der Film: Werden und Wesen einer neuen Kunst (Film: Growth and Character of a New Art).* Yet more significantly, the Hungarian title given this work was *Filmkultúra: A film müvészetfilozófiájá (Film Culture: A Film Philosophy of Art).* To complicate this picture, or alternatively, to show that a new usage of a concept of theory was setting in by 1950, it is interesting to note that the first chapter of the German version of Balázs's book argues in its title for "Eine Filmästhetik ("A Film Aesthetic"), while the Hungarian version begins "Az elmélet dicsérete" or "In Praise of Theory."

My point here is that what we call theory today was characterized much differently throughout the long and complex history of writing on film before the end of World War II—as dramaturgy, aesthetic philosophy, and the philosophy of art, if the writers bothered to characterize their work at all. Indeed, the adoption of the English title *Theory of Film* in 1952 is already indicative of a reflex to superimpose retroactively a picture of theory on a complex range of conceptual activities that may not have characterized themselves as such. This picture clouds our image of what those activities meant and were supposed to accomplish both conceptually and historically.

No doubt, many of the best-known writers on film in the 1910s and 1920s did not think of themselves as theorists at all. Like Balázs or Lukács, students of the great nineteenth-century German tradition of aesthetics, they placed themselves, and were trying to place film, in a conceptual domain occupied by the philosophy of art. The appearance of the word "theory" in 1924, then, must evoke a special case, and one that is already in tension with philosophy or the philosophy of art, as we have already seen in the early Lukács.

---

suggests a slippage with one of the German senses of *Lehre.* Often translated as "theory" (Goëthe's *Farbelehre* as color theory or Schlegel's *Kunstlehre* as theory of art), in an aesthetic context the term is closer to doctrine, or better, a systematic poetic guiding or clarifying expression. This particular conception of dramaturgy and poetics will also inform Russian Formalist approaches to "theory."

We still do not know what "theory" means in 1924 or why it should be evoked as a special case. In calling for theory as the compass guiding the aesthetic direction of a new art form, what language-game was Balázs playing? To grapple with the genealogy of this concept does not mean erasing differences and restoring continuities, but rather making the word "theory" alien again, to make it unfamiliar by peeling back the palimpsestic layers of meaning covering it over.

## 10. Genres of Theory

> The modern is never simple; it is always, so to speak, on the top of something else; always charged with a contradiction, with reminiscence, in one word, with a history.
>
> —Bernard Bosanquet, *A History of Aesthetic*

To make these layers distinct again, it may be useful to picture the emergence of film aesthetics in the twentieth century from the perspective of three more or less discontinuous and open genres. It is tempting to think of the history of film aesthetics as a sequence of thirty-year periods—1915 to 1947 for classical, 1947 to 1968 for modern, and 1968 to 1996 for contemporary film theory. But this approach disregards the important overlaps, retentions and returns, irregular continuities, all the dotted lines, straight and curving, that thread through these three discursive series. For reasons that should soon be apparent, I will recast this formulation as the emergence and persistence of aesthetic, structural, and ideological or cultural modes of aesthetic writing on film. These are less chronological periods than distinct though sometimes interpenetrating enunciative modalities whose internal regularities are defined by commonalities of concept formation, institutional contexts, and rhetorical strategies. Blossoming from the soil of Baumgarten's and Hegel's organic and typological categories, the aesthetic discourse is concerned with questions of artistic value and the delimitation of aesthetic a prioris through which film's singularity as an art form could be identified and assessed as well as compared with the other arts of space and of time. The structural or semiological discourse is dominated by problems of meaning or signification in relation to the image. Beginning with the filmology movement in postwar France, it is marked by the introduction of film studies to the university in the contexts of the human sciences and is dominated by the influence of formalism and structuralism in

the 1960s. Finally, the cultural discourse is defined by the psychoanalytic challenge to structuralism, the predominance of theories of the subject, and the problem of ideology.

Periodizing the aesthetic investigation of film as classical, modern, and contemporary is doubtless familiar to most students of cinema and, at first glance, may seem commonsensical. However, it is precisely the sources of this common sense that interest me here, for there are good reasons to challenge them or at least to hold them in suspension if not outright under suspicion. To maintain productively our disorientation with respect to theory, the discontinuities of these genres of discourse must be understood from the standpoint of their institutional contexts and rhetorical strategies but also, and more specifically, as distinct conceptual shifts in which the practice and activities of explanation and evaluation—ways of asking questions and anticipating answers, adapting and transforming terminology, rewriting precedent debates or repressing them—subtly but decisively shift meaning.

Among the earliest emblematic works of the aesthetic discourse are Vachel Lindsay's *The Art of the Moving Picture* (1915) and Hugo Münsterberg's *The Photoplay: A Psychological Study* (1916). Undoubtedly the richest and most complex period of writing on film, this discursive territory ranges from North America across France, Germany, and the former Soviet Union before returning to the United States in the last works, written in English, of Siegfried Kracauer. It includes all the dominant figures of the first fifty years of thought about film: not only Lindsay and Münsterberg but also Ricciotto Canudo, Louis Delluc, Jean Epstein, Germaine Dulac, the French Impressionist and Surrealist writings on film, the Soviet montage schools with Lev Kuleshov, V. I. Pudovkin, Dziga Vertov, the *Poetika Kino* and all of Sergei Eisenstein's writings through his magnificent *Non-Indifferent Nature,* Béla Balázs, Rudolf Arnheim, Erwin Panofsky, Hans Richter, Siegfried Kracauer, and Walter Benjamin, among other important figures. Chronologically, the genre is brought to a close by the postwar writings of André Bazin (still, probably, the most influential texts in the history of film aesthetics) and Kracauer's *Theory of Film*. It is tempting to date the end of the aesthetic discourse with Bazin's death in 1958 and the publication of Kracauer's *Theory of Film* in 1960. (Curiously, Kracauer mentions Bazin nowhere in this book despite its enormous bibliography, which nonetheless includes other important sources in French from the era of filmology.) However, this argument ignores the place of the 1971 publication of Stanley Cavell's *The World Viewed,* still one of the most misunderstood books, both

conceptually and historically, in writing on the cinema. But, as I already suggested in *The Virtual Life of Film,* Kracauer's *Theory of Film* and Cavell's *The World Viewed* stand together in their very different ways as the grand closing gestures of a certain way of thinking about film. And part of their richness, and why they remain compelling works today, is that they represent both the closure of a certain kind of thought and the opening up of new philosophical vistas to which we still have not properly adjusted our vision. They remain, in many ways, untimely works.

What criteria would justify bringing so many diverse figures and so many conceptually rich texts together on a single territory of such geographical, linguistic, and historical diversity—a territory spanning nearly fifty years and two continents?

First, this territory and the set of criteria populating it must be considered as open and variable. The different discursive modalities of aesthetic writing on film, individually and together, are best considered as open sets, indeed something like a genre in Stanley Cavell's logical characterization of that concept.[46] A genre, of course, must contain a definable and delimitable set of criteria according to which membership in the set can be discussed, accounted for, and debated. Membership in the set does not require that each text exhibit or conform to all the criteria, however. Rather, it suffices that all members share at least some significant number of elements in common. The salient features of a genre, and candidacy for membership of individual texts, are therefore open ended: new conceptual features, definitions, and questions are not limitable in advance of critical evaluation. Characterizing a genre, then, does not mean identifying a set that has been closed off in the past, or establishing a rigid typology. It requires attentiveness to both repetition and change as well as contradiction, for genres are future oriented, seeking change and mutation.

The trick, then, is to assess and evaluate commonalities and family resemblances that persist across that repetition, which produces new members of the set until the salient elements change and recombine in such a way that a new genre emerges. The recognition of a new genre—in my example, a new discursive modality of film theorizing—equally requires contests or tests of negation. These contests are not historically linear; the time of repetition and contesta-

---

46. See in particular Cavell's discussion of genre in *Pursuits of Happiness: The Hollywood Comedy of Remarriage* (Cambridge, Mass.: Harvard University Press, 1981), 26–34; *Contesting Tears: The Hollywood Melodrama of the Unknown Woman* (Chicago: University of Chicago Press, 1996), 3–14; and "The Fact of Television," in *Cavell on Film,* ed. William Rothman (Albany: State University of New York Press, 2005), 59–85.

tion can be lateral, moving backward or forward across related groups of texts or arguments. A new genre thus emerges through a process of derivation where there is no a priori standing or necessary set of features that an instance must exhibit to qualify as a member of the set. Indeed, members will emphasize or exhibit different or additional features of the discursive set, and some feature or features will inevitably sit uncomfortably within the set formed by the other members.

One last component, especially characteristic of discourses of theory and the generic transformations of aesthetic writing on film, bears mentioning here. The emergence of a new discursive modality often suppresses its discontinuities with earlier genres by retrojecting its logic, vocabulary, and conceptual structure onto earlier genres and discourses. This would be another way to characterize generic contestation or tests of negation. For example, in his essay on "The Evolution of the Language of Cinema," Bazin resituates the history of film style not as a break between the silent and sound periods, but rather as a contest between "faith in the image" or "faith in reality." Rather than defining the technological history of cinema as divided between the silent and sound periods, one finds the ebb and flow of a constant evolution toward deep focus cinematography. Expressionism and montage are in contest here with composition in depth as a persistent stylistic option. In a founding work of the structural discourse, "Cinema: Language or Language System," Christian Metz remaps the conceptual history of the aesthetic mode with respect to the problem of language, thus transforming the unruly precedent debates on film art as a continuous debate on the question of signification or meaning. When the cultural discourse emerges after 1968, Eisenstein and Benjamin are reread in the context of a materialist and ideological discourse that wants to recover or reconstruct a continuous history of left aesthetics in film, thus rendering the history of film theory as a Marxist theory and history. Very often, these retrojections involve conceptual remappings and replacements of the idea of theory itself. For these reasons, every historical moment of theoretical awakening is, as it were, to some degree metacritical or metatheoretical. In key moments of discursive ramification or reformulation, an idea of theory suddenly becomes conscious of itself and its apparent history. The sections that follow, then, are not a history of film theory so much as a critical examination of moments of rupture, reconsideration, and retrojection in which theory takes itself as its own object; examines and reconfigures its genealogy, conceptual structure, and terminology; and posits for itself a new identity and cultural standing. Theory is a tangled skein composed of many threads, as we have already seen.

We will need to follow them both individually and in the weave of their ever-shifting patterns. My arguments thus focus on significant points of passage and displacement in the genealogy of theory: Ricciotto Canudo as exemplar of the aesthetic discourse, Boris Eikhenbaum and Russian Formalism, the filmology movement in France, the rise of structuralism and the early work of Christian Metz, and finally, the influence of Louis Althusser on the discourses of political modernism and culturalism. (The claims of historical poetics and post-Theory, as well as the potential distinctiveness of philosophy with respect to theory, will be addressed in a companion volume, *Philosophy's Artful Conversation*).

In this context, attention to discursive discontinuities is as important as to continuities. This point is crucial for understanding so-called classical film theory. Before 1950, with some few very notable exceptions, it is rare to find writing on cinema that characterizes itself as theory or theoretical, as I have already pointed out. In the great variety of texts produced in this period, what might be recognized today as film history, criticism, or dramaturgy blends with the conceptual innovation or invention that is more characteristic of the activities and rhetorical strategies of film theory or aesthetics. This observation still leaves unresolved, of course, the question of how to characterize logically a theory of art or of an art form like film. Indeed, the idea of theory and what constitutes a theory in the aesthetic, structural, and cultural modes is something of a moving target. (Nor have we yet arrived at the point where a film philosophy might be distinguished from film theorizing. This will be the aim of *Philosophy's Artful Conversation*.)

Nevertheless, as I suggested earlier, the aesthetic discourse confronts film as a problem, above all because the new medium is perceived to sit only uncomfortably within the then current philosophical discourse of Art or the aesthetic. Indeed, in the first forty years of its existence, film is testing, even negating, the "genre" of Art; its very existence and evolution undermine and throw open the questions of how to settle the identity of a medium or art form, and how to value or not the subjective aesthetic experiences it inspires. The insistence of the questions—what is film? and what is cinema?—thus demonstrates the difficulty of making film visible and intelligible as an object of explanation and evaluation and therefore the object of a theory. At the same time, the persistence of these ontological questions undermines confidence, as did modernism in general, in the concepts that previously assured the identity of art forms and categories of aesthetic judgment. In this manner, theory, in film or in art, first emerges as a form of explanation in confrontation with a problem, and this problem arises because of the variability or ephemerality of the ob-

jects writers are trying to frame or picture. What can be learned from the variety and contentiousness of writing on film, especially in the silent and early sound periods, is that here theory is less a form of unifying and systematizing a body of knowledge about an object than a mode of activity or of conceptual engagement, a manner of interrogating one's self and debating with others about the nature of what counts as a (new) medium and how to describe its subjective effects and cultural significance. There is also the question of responding to larger historical pressures being brought to bear on the concept of art in general, as Walter Benjamin was so well aware.

Consequently, it is especially characteristic of the aesthetic discourse that attempts to construct general and systematic accounts of film are rare.[47] The activity of theorizing, if we can call it that, is rather highly speculative, open ended, and written with poetic and confrontational enthusiasms. Much of this is explainable historically by the open and free-form contexts for debate, writing, and publication. With the exceptions of Münsterberg, Arnheim, and Panofsky, writing before the end of World War II usually occurred outside the university as an institutional context. While many of the participants come from highly cultured backgrounds, they also have eclectic professional commitments: many are filmmakers like Jean Epstein, Germaine Dulac, Sergei Eisenstein, Dziga Vertov, and Hans Richter, working equally within, outside, or on the margins of their national systems of production; others are critics and journalists like Vachel Lindsay, Ricciotto Canudo, Louis Delluc, Siegfried Kracauer, Walter Benjamin, or André Bazin. Film aesthetics is very much an amateur affair here, with all the positive connotations of the term. The professional activities of many of the writers are highly varied, as in the example of Balázs, who was a writer, dramatist, critic, aesthetician, scenario writer, and film producer as well as an educator and a lecturer. The dominant literary form of the period is the belle lettristic essay, blossoming in the flourishing culture of ciné-clubs, galleries, feuilletons, manifestos, and small literary reviews. While collections of essays were fairly common (Jean Epstein's *Bonjour Cinéma* [1921] is a pertinent example), apart from Münsterberg, before Kracauer's *Theory of*

---

47. Interesting counterexamples to this observation would include works like Georg Otto Stindt's *Das Lichtspiel als Kunstform* (1924) and Rudolf Harms's *Philosophie des Films* (1926). Academic treatises written in the context of German "art science" and normative aesthetics, these works are rather exceptions that prove the rule. Moreover, their variance with respect to the aesthetic discourse is documented in unfavourable reviews by both Kracauer and Arnheim. See Sabine Hake's *The Cinema's Third Machine: Writing on Film in Germany, 1907–1933* (Lincoln: University of Nebraska Press, 1993), 130–157.

*Film,* Eisenstein might be the only significant figure who tries, for the most part unsuccessfully, to complete a systematic and synthetic approach to film in the form of a book or books.[48]

None of these contextual remarks, however, provide criteria for characterizing the aesthetic mode as a discursive genre. More important here are the conceptual commonalities that underlie the kinds of questions raised in the period, and the forms of their rhetorical strategies and positions of address as well as alternative responses to these questions. Despite the apparent variety and inconsistency of positions, which often lack an explicit methodological framework, what both enables and constrains the aesthetic mode is a series of complex and contradictory debates that were also characteristic of artistic modernism in general. These debates arose from a confrontation where film, and arguments about film, played a key role, and where concepts of the aesthetic and aesthetic judgment, and the constitutive self-identity of works of art, were consistently challenged, remaining contradictory and fluid. In this way, the perplexing virtual life of film runs parallel to, and is inseparable from, the history of modernism in art.

However, as Noël Carroll has usefully explained in *Philosophical Problems of Classical Film Theory,* the unruly diversity of the genre is nonetheless framed by three fundamental questions.[49] First, what is the determinant or crucial feature of film that establishes its identity and specificity as an art form? In most accounts, this question structures attempts to ground the medium of film according to criteria of autonomy and self-identity. Second, what is the value or role of cinema, both artistically and socially? Does cinema have a place among the seven major arts, or, as Benjamin insisted, does it challenge our very concept of art? Here Carroll notes that the determining features identified by a given writer will generally be considered as "instrumental in realizing or actualizing the value or role the theorist names for cinema" (*Classical Film Theory* 13). Good examples include Balázs's promotion of the close-up as restoring visual acuity and sensitivity to the physiognomies of people and things, an idea echoed in Jean Epstein's linking of the close-up to the concept of *photogénie*—a poetic animation of nature through photography's possibilities

48. Eisenstein's life and work are strewn with projected and incomplete efforts to systematize his thought. See in particular Jacques Aumont's still-indispensable *Montage Eisenstein,* trans. Lee Hildreth, Constance Penley, and Andrew Ross (Bloomington: Indiana University Press, 1987), esp. 1–25.

49. (Princeton, N.J.: Princeton University Press, 1988), esp. 4–15.

of framing and magnification that intensifies visual expression and trans-
forms photography through cinema's qualities of time and movement.

Third, in working through the first two questions, most writers ask, what
processes of articulation are specific to film? Carroll notes, rightly, that before
Bazin the fundamental ground for these three questions was the assumption
"that the most aesthetically significant feature of the film medium is its capac-
ity to manipulate reality, that is, to rearrange and thereby reconstitute the pro-
filmic event (the event that transpires in front of the camera)" (*Classical Film
Theory* 7). The key example here is Rudolf Arnheim's defense of the medium
in *Film as Art* (1932) against the charge that it only mechanically records physi-
cal reality. Arnheim counters with the idea that the expressive possibilities of
film all derive from its potential for creative artistic manipulation according
to its specific means for projecting solids onto plane surfaces, signifying space
pictured in depth, and for fragmenting and reordering space and time. Indeed,
logically the aesthetic mode continually links the three questions by specifying
articulatory features of the medium and then characterizing them according
to a concept or idea that serves simultaneously to define and ground their aes-
thetic value. Eliciting criteria of expression, then, functions as both the *telos*
and *arche* of the aesthetic discourse, connecting and reconnecting concepts of
identity, value, and articulation in often circular ways.

In my account, this observation does not turn the aesthetic discourse toward
theory or away from it. These writings are not pre-theoretical, another kind of
theory, or an alternative to theory. Could the early experience of film have been
accounted for otherwise? In treating these writers as "theorists," criticizable
according to analytic philosophy's standards of argument, Carroll is indifferent
to the complicated and variegate phenomenological dimension of early writ-
ing on film—that is, the fact that almost all writings of the period are struggling
to assess the specificity of the spectatorial experience of projected film as well as
its place as the expression of a culture or an age. My concern, rather, is to indicate
at least in outline how the ontological force of the new medium confronts writers
struggling to comprehend the experience of modernity through their experience
of film. The wild inventiveness of the aesthetic discourse was a continuing and
contradictory response to the perceptual and conceptual vertigo elicited not only
by the novelty of the medium but also by the velocity with which it was continu-
ally reinventing itself and responding to larger historical and cultural forces.

Like most strictly analytical accounts, Carroll also ignores the deeper and
more complex genealogical network of concepts that thread through these
writings philosophically, linking them in sometimes direct and indirect lines,

if not errant displacements, to wider debates in the philosophy of art. It is impor-
tant, first, to recognize in the aesthetic mode the conceptual and rhetorical form
of the systematic aesthetics of the nineteenth century, especially in German phi-
losophy, that would have formed the philosophical background of most of the
writers. Here definitions of the medium or genre of art are motivated by criteria
that delimit and typify major artistic forms such as poetry, music, dance, paint-
ing, sculpture, and architecture, often in ways that reproduce, explicitly or im-
plicitly, the idealist system of Hegel's *Lectures on Aesthetic* and its promulgation
in the late nineteenth century in the works of Bosanquet and others. In most
characteristic accounts, the aesthetic, or what counts as an instance or medium
of Art, is thus framed by enunciative a prioris that define the horizon of all that
can be said or thought within this discursive register. These are the conceptual
grounds of the discourse, which include the criterion of self-identity (that the
existence of a medium of art must be typified as a pure genre); the criterion of
substantial self-similarity (that each genre of art is produced from a medium,
here defined as a single substance or a closed set of qualities); and finally, the defi-
nition of unique aesthetic a prioris for each medium—that is, sets of formal or
stylistic options that are uniquely characteristic of the genre and its medium.[50]

## 11. Excursus: Ricciotto Canudo and the Aesthetic Discourse

> We are living between two twilights; the eve of one world, and the dawn of
> another. Twilight is vague, all outlines are confused; only eyes sharpened by a
> will to discover the primal and invisible signs of things and beings can find a
> bearing through the misty vision of the *anima mundi*. However, the sixth art
> imposes itself on the unquiet and scrutinous spirit.
>
> —Ricciotto Canudo, "The Birth of a Sixth Art"

Ricciotto Canudo's writings on film exemplify the aesthetic discourse in many
ways as well as the philosophical background of idealist aesthetics before Wal-
ter Benjamin's work of the 1930s. At the same time, Canudo's voluminous

---

50. See, for example, my *Reading the Figural* (Durham, N.C.: Duke University Press, 2001),
30–44, and *The Virtual Life of Film*, 31–41. Carroll adds what I have characterized as an "injunc-
tive argument," where the definition of media require an exclusiveness—deriving from their
substantial self-similarity and aesthetic a prioris—that discourages or prohibits uses contrary to
those criteria. In my account, the injunctive criterion was not as widespread or consistent as
Carroll seems to believe, and it is contrary to my characterization of both discursive and artistic
genres as open and variable.

critical writings on cinema are exemplary of the openness of the discursive genre of classical film theory. Canudo was an Italian expatriate who settled in Paris in 1901 at the age of twenty-five. A scholar, writer, and literary entrepreneur, friend of Apollinaire and D'Annunzio, Canudo founded a movement called "Cérébrisme" and from 1913 to 1914 edited an important art journal called *Montjoie!* that advocated "French imperialism" in the domain of the arts. Like Balázs, throughout his lifetime Canudo composed novels, poems, tragedies, and ballets while churning out articles, lectures, and criticism for a great variety of newspapers and little magazines.

Although a posthumous edition of his writings on cinema was published shortly after his death in 1926 as *L'Usine aux images (The Image Factory)*, Canudo never published a book or a systematic account of cinema. Nonetheless, he considered himself an "aesthetician." From 1908 to 1914, he lectured on aesthetics and the philosophy of art at the École des Hautes Études and published two significant works: *Psychologie musicale des Civilisations: Le livre de l'evolution: L'homme* (Paris: Edward Sansot et Cie., 1908) and *Hélène, Faust et nous: Précis d'esthétique cérébriste* (Paris: E. Sansot / R. Chiberre, 1920).[51] During this period and until the time of his death in 1923, Canudo was a tireless advocate for the cinema. Giovanni Dotoli and Jean-Paul Morel's edition of *L'Usine* collects together 102 articles on cinema published between 1908 and 1923, which appeared in a variety of newspapers and little magazines. Characteristic of the institutional context of the aesthetic discourse, many of these articles began as lectures at ciné-clubs and salons. Canudo himself hosted a cinema salon at the Café Napolitain in Paris, and in April 1921 he founded the Club des Amis du Septième Art (often referred to as "C. A. S. A."), which, eighteen months later, began publishing a review, *La Gazette du cinéma*. Although established after Louis Delluc's own pioneering ciné-club, C. A. S. A. was arguably more influential in terms of the personalities enlisted to support it and the variety of activities it promoted. In the same year, Canudo began organizing film events at the still-prestigious Salon d'Automne, established in 1903 by Frantz Jourdain as an alternative to the Salon des Beaux Arts. A critic of the commercialism of the major producers and distributors and a champion of the cinema as Art, Canudo understood that the

51. For a more complete overview of Canudo's life and work, see Giovanni Dotoli and Jean-Paul Morel's introduction to *L'Usine aux images* (Paris: Nouvelles Éditions Séguier et Arte Éditions, 1995), 7–19, as well as Dotoli's *Ricciotto Canudo: Ou le cinéma comme art* (Paris: Didier Érudition, 1999) and Giovanni Dotoli, ed., *Bibliografia critica di Ricciotto Canudo* (Fasano: Schena, 1983).

ciné-clubs and salons were crucial for establishing an institutional context where an aesthetic discourse on and of film could be expressed and defended.

Canudo's writings on the cinema do not constitute a film theory nor were they meant to. As in the writings of his exact contemporary, Vachel Lindsay, the word "theory" appears infrequently and mostly in what I have called its vernacular use. Nonetheless, Canudo consistently deploys a discourse where art, philosophy, and science occupy important roles representative of the logic and rhetoric of the aesthetic debates of the time. The key term for Canudo was "aesthetic," and his idea of the aesthetic was closely tied to a vision of modernity as the wholly new. In the first decade of the twentieth century, Canudo envisioned the potential for a modernist liberation of art as the possibility for achieving a grand idealist synthesis of all the arts. "Cérébrisme" thus names the project for producing a synthetic view uniting all the various avant-gardes (cubist, synchronist, simultaneist, futurist, dadaist, surrealist) while providing a philosophical argument crowning artistic modernism as the Hegelian expression of the new historical spirit of modernity. The rise of an industrial and urban culture dominated by science and technology and the decline of religious sentiment meant for Canudo that humanity must search for emotional and ethical content in new means of expression—in short, the aesthetic would be the new secular religion of modernity. "Only the aesthetic can achieve this indefinite enlargement of the ideal," Canudo wrote in 1911, "where all sensation becomes feeling and thought—religious idea. It alone appears to us as capable of channeling all the errant 'religiosity' of our age toward a true 'religious faith' that is acceptable to our modern spirit. It alone can give us this 'faith,' which is none other than the imposition of an *a priori* organizing principle [*ordonnateur*], an original, multiple, and unanimously accepted direction of mental life and collective feeling—the only one finally that could bring a *style* to the total life of an age."[52] In his 1906 book *Psychologie musicale des Civilisations,* Canudo finds this principle in the expressive possibilities of the Cinematograph, which he hails as "the advent of the supreme synthesis of all the Arts and of all Philosophy in the Metaphysical Theater" that represents for the "Homo Novus, whom we will not see . . . the perfect union of Science and Dream" (*L'Usine* 11; my trans.).

Canudo's aesthetic displays a pastiche of conceptual resources that were not uncommon for his time and place. Reflecting the impact of the French publication of *Thus Spake Zarathustra* in turn-of-the-century Paris, his writing is

52. Cited in the introduction to *L'Usine*, 10; my trans.

heavily influenced by the aphoristic style of Nietzsche and the rhetorical gestures of Emerson. (Oddly in this context, his basic philosophical position is Hegelian.) A persistent theme of his writings throughout the aughts and teens is that the *Homo novus* or modern man is, like Nietzsche's Overman, yet to come—this form of subjectivity is still being forged in a nascent modernist culture. Even at the time of his last writings in 1923, for Canudo the cinema was not yet a mature modern art, even though it still expressed completely the Hegelian spirit of the age. Here aesthetics had a specific role to play in identifying, clarifying, and defending art's anticipatory forms and affects. In a 1921 essay, "L'Esthétique du septième art (1)," Canudo clearly lays out the tasks of aesthetics as attending to historical facts as they occur, close examination and discussion of individual works, and the precise description of stylistic trends. This was all the more important in the case of the Cinematograph as it was at once both the highest summit of aesthetic expression and still an immature art. Canudo continues,

> And since we are considering an Art that is new in all its aspects, we wish *already* to draw out the general laws, spiritual orientations, and the common rhythm of similar expressions [*manifestations*]. In a word: Aesthetic.
>
> Every Aesthetic, applied to whatever art, is its explication and its philosophy. It is more than "criticism" and has nothing in common with "reporting." It seeks out the rules that dominate this human representation of interior life which is the whole of artistic vision. And since I must define it in an introductory way, I will say that the Aesthetic is to the work of art what Philosophy is to the work of reason. In sum, a "system," a unitary conception of the aspirations and achievements that make every artistic work appear as a phenomenon which is never isolated, but is always part of a larger whole linked to the global spirit of an age. (*L'Usine* 59; my trans.)

All the generic characteristics of the aesthetic discourse are already apparent in one of Canudo's earliest essays on film, "The Birth of a Sixth Art," published in October 1911 in Paul Vuilliaud's esoteric literary review *Les Entretiens idéalistes*.[53] Canudo opens his argument by asserting that the five extant arts—music, poetry, architecture, sculpture, and painting—have all evolved from a universal aesthetic response to the natural environment. Eleven years later,

---

53. Trans. Ben Gibson et al. in *French Film Theory and Criticism (1907–1929)*, ed. Richard Abel, vol. 1 (Princeton, N.J.: Princeton University Press, 1988), 58–66.

Canudo presents this argument as his "theory of the seven arts" (dance has now been added) in his "Manifeste des sept arts."[54] This is not a *film* theory, but rather a general aesthetic accounting for the system of the arts and their evolution, following, in schematized form, the logic of Hegel's *Lectures on Aesthetic*. It is also representative of a displacement throughout the 1910s and 1920s whereby system aesthetics becomes gradually identified as a "theory." Still, one might imagine that for Canudo, who understands cinema to be in its infancy and not yet having even achieved its adolescence, film would not yet merit a theory, since it had not yet discovered or developed within itself a system of aesthetic a prioris or unique articulatory mechanisms.

What are the components of this "theory"? Already in *Psychologie musicale des Civilisations,* as well as "Birth of a Sixth Art," Canudo asserts that aesthetic expression is a fundamental and universal human response to the ravages of time and to survival in the natural environment. The two principal or founding arts, existing since the "dawn of humanity," are architecture (responding to the need for shelter) with its complementary spatial expressions of sculpture and painting; and dance, with its complementary art, poetry, arising from a basic human emotional drive toward temporal and rhythmic expression. The fundamental aesthetic motive for all aesthetic expression is to struggle against death by fixing all that is transient in life: "elevating above ephemeral realities and affirming the eternity of things that stir the emotions of man" ("Manifeste" 162). In Canudo's view, the function of architecture and music for primitive humanity was to arrest, fix, and give form to the plastic and rhythmic powers of its emotional existence. Subsequently, as humanity evolves culturally, the arts branch out and evolve toward increasing spiritual complexity: from music come the temporal arts, rhythmic movement (dance) combined with speech (lyric poetry); from architecture, the material and spatial arts of painting and sculpture. All of these arts produce dreams of "perpetuity in space and in time" (162).

In "Birth of a Sixth Art," Canudo argues that after thousands of years, the Cinematograph now presents in outline the emergence of a fundamentally new art that combines the rhythms of space (the plastic arts) and the rhythms of time (music and poetry). The novelty of cinema for Canudo takes the form of its absolute modernity—not only the apogee of a continuous artistic and spiri-

---

54. From a lecture presented at the first Congrès de la Fédération internationale des Arts, des Lettres et des Sciences (Brussels, 18–20 April 1922) and first published in the Belgian review *7 arts* 4 (23 November 1922): 1–2. Reprinted in *L'Usine,* 161–164.

tual evolution but also a definitive break with thousands of years of human history ("the eve of one world and the dawn of another"). In contrast to the more ancient form of theater, then, cinema presents a new synthesis of forms previously held separate: *"Plastic Art in Motion"* or *"a Painting and a Sculpture developing in Time,* as in music and poetry" ("Birth of a Sixth Art" 59). Moreover, combining the spatial and temporal branches of artistic evolution, this grand synthesis of the arts reaches toward the expression of a universal aesthetic will, creating "the total art towards which all the others have striven" ("Manifeste" 161). From a very early period, Canudo considered the Cinematograph as representative of all that was new and modern in art and culture.

Throughout his essays on film, Canudo considers himself as something like an aesthetic midwife for the new art, capturing and articulating its fundamental elements of expression as they appear. In 1911, Canudo defines the fundamental elements of the Cinematograph as the symbolic and the real. The symbolic refers to the new formal capacity of film to create forms through velocity or excess of movement—speed given expression or made expressive in being heightened to a poetic level as "a series of visions and aspects woven in a pulsating beam of light, seen as a living organism" ("Birth of a Sixth Art" 59, *33;* my trans.). Here Canudo echoes futurism and anticipates the machine aesthetic of the European avant-gardes of the 1920s. As projected by the Cinematograph, characters move with speeds impossible in real life and all movements are produced and regulated with a mathematical and mechanical precision. This symbolic velocity, a poetics of speed, is also considered as something like a perceptual rapid transit system, analogous to the railroad or the automobile. Undoubtedly referring to the emergence of the capacities of editing, Canudo calls this "the symbolic destruction of distance" ("Birth of a Sixth Art" 60), or the ability both to combine images in space and to erase boundaries between nations, classes, and cultures. (Might he have seen *Tour du monde d'un policier* [Pathé, 1906]?)

What Canudo calls the "real" refers to the cinema's powers of affect and for expressing and remaking subjectivity. This is not so much the reproduction of the world as the making of a new world—in fact, a new ontology, where humanity actively seeks a meaningful presentation of the transformations it undergoes with respect to the cultural and technological forces of modernity. Previous forms of art stylized and typified life by immobilizing it, rendering it as still life. But the cinema does not capture life from one side or in one aspect; "it represents all of life in action, and in an action which, even when slowly unfolding the chain of its typical aspects, is there developed as rapidly as possible" ("Birth of a Sixth Art" 61, *35*). In his own somewhat orientalist analogy, Canudo presents

the Cinematograph as intensifying the basic psychic condition of Western life expressed in action, movement, speed, and the elimination of distance, just as Eastern life manifests itself in contemplation. The real connects to the symbolic here in that the expression of velocity and the collapse of space together characterize the spectacular forces of industrialization and urbanization; what audiences seek out in the rapid proliferation of cinemas is the desire to reexperience in a poetic or aesthetic form the transformations of body, time, and space undergone in the modern metropolis as "a lucid and vast expression of . . . internal life."[55]

For Canudo the proliferation of cinemas is representative of the new promise of an ancient desire—what Canudo calls "Festival" or *la Fête,* which in French can also mean holiday, fair, or carnival—where especially film comedy overturns hierarchies and unleashes liberatory energies. Canudo envisions this cinematic Festival as a utopian collectivity. What is both moving and comic here is how the cinema eliminates all human obstacles created by the slowness or awkwardness of the body's movements in space, thus creating a new comedic type expressive of the utopian aspirations of cinema audiences. The carnival-like atmosphere of the cinemas is fueled as well by the moving image's elimination of a distance that is as much social as geographical:

> The comic can suppress hierarchies, it can join together the most different beings, give an extraordinary impression of the mixture of the most separate universes, which in real life are inflexibly separated. Since the comic is essentially irreverent, it gives a deep sense of relief to individuals oppressed in every moment of their real lives by social discriminations, so emphatically present. . . . ("Birth of a Sixth Art" 63–64, *38*)
>
> But more than spectacle, what is striking, characteristic, and meaningful, is the will of the spectators, who come from every social class, from the most plebeian to the most intellectual. This is the will for a new Festival, for a new joyful *unanimity,* realized in a spectacle and in a place where together, all people can forget, in greater or lesser measure, their isolated individuality. This forgetting—the soul of every religion and source of all aesthetic feeling—will one day be absolutely triumphant. And the [cinema] Theater holds this undoubtedly still vague promise

---

55. "Reflections on the Seventh Art," trans. Claudia Gorbman in Abel, 293. This section of the essay was originally published as "Les domains propres au cinema" in *L'Amour de l'art* 3, no. 5 (May 1922): 158–159; reprinted in *L'Usine,* 122–123.

never before dreamed of in any age: *the creation of a sixth art, of a plastic art in movement,* already created in a rudimentary way in modern Pantomime. Modern life participates in this triumph. (65, *39*)

In portraying the Cinematograph's significant elements as the symbolic and the real, however, Canudo is not searching to define the uniqueness of the medium, for in 1911 it has not yet become an art (nor will it have become one by 1923). What is representative is rather a set of possibilities or potentialities expressive of a new ontology: "Unexpectedly, summing up immediately all the values of a still eminently scientific age, abandoned to Mathematics rather than Dreaming, the Cinematograph asserts itself through a remarkable expansion, like a new theater, a kind of scientific theater made of precise calculations and mechanical expression. Our unquiet humanity welcomes it with joy" ("Birth of a Sixth Art" 60, *34*). Yet the birth of the new art is incomplete. The technological precision of the Cinematograph is born of a mechanical and rationalized society, but the dreams it inspires are still scientific not poetic ones. The cinema awaits the heightening of its symbolic capacity, pregnant with possibility but not yet attaining the birth of a new aesthetic responsive to the most ancient, as well as most modern, concerns of humanity.

In the conclusion to the essay, unpublished in translation, Canudo expresses directly the Hegelian inspiration for his ideas. The sixth art is uniquely capable of manifesting the historical spirit of modernity, and in a way unimaginable by Hegel, who famously announced the end of Art. But for Canudo, the cinema has not yet become art, for it has not found a directive idea:

Presenting a succession of gestures, attitudes, and figures, just like life, spreading out the picture of space, immobile and enduring, in a time where it shows and transforms itself, the Cinematograph forces us to dream of what it could become if an authentically higher directive idea held it to an ideal and profoundly meaningful line—the essential aesthetic idea of pictures that move [*des tableau qu'il déroule*]. We can dream of the creation of a sixth plastic Art in movement. Who could have dreamed this before our time? No one, for man's spiritual evolution had not yet attained the flowering of a violent desire to reconcile Science and Art in the complex representation of life in its totality. Every day the Cinematograph renews, and every day a bit more powerfully, the promise of this great reconciliation, not only of Science and Art, but also of Rhythms of Time and Rhythms of Space. (40; my trans.)

In sum, for Canudo the cinema is potentially the apogee of aesthetic evolution, and the art most expressive of the universal spirit of modernity, but it is not yet an Art, for it has not completely discovered or developed fully its expressive potentials: "Cinematographic language ... is feverishly seeking its speech, articulating its syllables, striving toward an optical pronunciation. So far it generally lacks elegance, or pleasing spontaneity."[56] Citing the philologist Max Muller, Canudo equates the acquisition of speech to the expansion of thought: "The more words one knows in a language, the more thoughts one can produce with grace and flexibility" (295). At the same time, Canudo is presenting an argument similar to Lindsay, and which will be taken up by Balázs and later Eisenstein—that the silent cinema "is a universal language and not just by virtue of its visual and immediate expression of all human emotion" (295, *125*). (The idea here is not to establish firsts in film theory but to portray a discursive atmosphere as concepts and arguments emerging from shared series of aesthetic arguments and ideas in the philosophy of art so characteristic of the aesthetic discourse.) In this, cinema is becoming a kind of modern writing, but one that, paradoxically, draws its emotional energy and universal expressiveness from the most primitive origins of human communication. Reprising themes from his earlier writings, Canudo attributes the invention of graphic scripts to a human desire to transcend finitude and the ephemeral by fixing life and making it communicable. Unconsciously evoking the arguments of Vachel Lindsay, and anticipating Eisenstein, Canudo appeals to the examples of ideographic and hieroglyphic scripts to assert the origins of language in images. "In its groping infancy, the cinema seeks its voices and words. It is bringing us with all our acquired psychological complexity back to the great, true, primordial, synthetic language, visual language. . . . The Screen, this single-paged book as unique and infinite as life itself, permits a model of the world—both internal and external—to be printed on its surface" (296, *126*). In drawing out and upon the multiple possibilities of expression in images, in cinema there emerges the possibility of a universal language that brings the representation of life "back to the sources of all emotion, seeking *life in itself* via movement" (296). As the only form of plastic expression organized by time, in fact, by the mechanical manipulation of time, cinema captures and arrests the ephemeral, not in stillness, but in its integral movements which, further, may be speeded up or slowed down—in short, visually decomposed

56. "Reflections on the Seventh Art," 295. Originally published as "Du langage ciné-matographique" in *L'Amour de l'art* 3, no. 7 (July 1922): 221–222; reprinted in *L'Usine*, 124–126.

and analyzed. And these forms of analysis will enrich the poetic and painterly imagination in becoming the new elements of aesthetic expression in film.

## 12. On the Way to Language

> If there is an art that does not admit—or not yet—theory,
> it is certainly the art of Cinema.
>
> —Ricciotto Canudo, "The Seventh Art and Its Aesthetic" (1921)

Arguing in 1922 that the cinema is an art that must not resemble any other, for it is unlike any other, Canudo fully deploys conceptual criteria that define the horizon wherein the aesthetic discourse curves back upon itself. Contrariwise, the openness of the genre is assured because the historical persistence of this discourse is challenged and undermined by the very objects it is trying to define, limit, or construct. From Canudo through Benjamin, the more one tries to defend film as Art through the conceptual vocabulary of system aesthetics, the more film, as Benjamin so eloquently put the case, redefines the question of what is Art. What continues to fascinate about prewar writing on film is that it poses problems without solutions—a discourse that raises more questions than answers. The wild proliferation of aesthetic a prioris throughout the 1920s and into the 1930s—*photogénie, cinégraphie,* rhythm, close-up, montage, pure or absolute film, and so on—is best characterized as something like the generation of concepts in open-ended series of explanations or accounts that vary positively in their *failure* to come to terms with defining art, or film, in the implied framework of a systematic aesthetics. In fact, the success or failure of a "theory" is irrelevant here; what is at stake, and what the authors strive for, are conceptual invention and innovation commensurate with the newness, modernity, or contemporaneity of film as a means of expression and a form of experience. A new genre of discourse thus emerges through the gradual erosion and contestation of historically precedent concepts. Indeed, one might say that what characterizes the historic period of modernism is that "theory" emerges in the confrontation with and transformation of "aesthetics." It becomes the sign, as it were, of an opening on the discursive horizon toward a new territory.

This new territory is the discursive genre of modern film theory, or what I call the discourse of structure or signification. In contrast to earlier writings, the structural or semiological discourse emerges from a more or less tightly

focused set of institutional and historical contexts. This is also the moment when theory in the sense most familiar to us emerges as a covering concept for the conceptual analysis of literary and artistic works. As a discursive genre, film theory, and indeed theory in general, is produced in a broad epistemic shift that takes place in the years following the end of World War II. The distinctiveness of this transformation should not be underplayed. In aesthetic writings on film in the first half of the century, the term "theory" is deployed primarily in a vernacular sense; at times it is synonymous or exchangeable with aesthetics or linked in the formation "aesthetic theory." In terms of rhetorical strategies, positions of address, and conceptual invention and deployment, however, the discourse is aesthetic and fully congruous with the forms and debates of late-nineteenth-century discourses on the philosophy of art. Moreover, across the three genres (aesthetic, structural, and cultural), the rupture between the aesthetic discourse and the discourse of signification is the most significant, forceful, and apparent, though this break was subsequently erased through habits of use. It is a real epistemic change that shifts across multiple registers, and one in which we still live and think. Here theory first emerges as a genre, a discursive practice, and an institutional position of address. With the important exceptions of Münsterberg, Arnheim, and Panofsky or more marginal works like Rudolf Harm's *Philosophie des Films,* the aesthetic discourse was out of sync with the larger debates in the first half of the twentieth century concerning the methods and concepts of *Kunstwissenschaft*—the regulative term for "aesthetic theory." Indeed, that Arnheim's 1932 book should be called *Film as Art* was indicative of the difficulty of accepting film within the purview of the scientific study of art. (The tension between theory—formal, sociological, and positivistic—and philosophy would persist in the modern university well into the period of structuralism. Indeed, the rise of structuralism in Europe in the 1950s and 1960s can be understood as the will to challenge philosophy with a certain view of theory, where the "human sciences" of linguistics, anthropology, history, and political economy erect the epistemological pillars for the study of art, literature, and culture. In the 1960s, theory is structuralist in tone and logic. The phenomenon of "poststructuralism" might be understood then as philosophy's struggle to refind its place. Our contemporary sense of "theory" still feels this cleavage, and this confusion.)

All of this is to insist once again that theory, in the senses most familiar to us now, is a postwar phenomenon. While I am focusing here on the invention of film theory, it is important to keep in mind that this could take place only

within a much larger discursive formation marked by the appearance of structuralism and the rise of a new conception of the human sciences that was affecting the academic study of anthropology, sociology, psychology, literature, and the history of art no less than film. Here theory as a special genre of discourse is invented in relation to contemporary formations in the humanities in ways that would be unfamiliar to, and in tension with, earlier critical discourses.

In the context of postwar film studies, the "when" of this turn is more ambiguous than the "how" of the discursive formation that rapidly settled in. Two fundamental historical markers bracket this shift, opening a rift of thirteen years' distance where the discourse of signification gradually settles and gels. I have already mentioned how in 1951 Aristarco's *History of Film Theory* traces a conceptual map that, through an inaugural retrojecting gesture, links and unifies the first forty years of writing about film. In 1964, Christian Metz's first major methodological essay, "Le cinéma: Langue ou langage" (awkwardly translated as "Cinema: Language or Language-System"), opens with a long account of the problem of language in film theory, no doubt desiring to place the construction of a semiology of film as the latest stage in that genealogy. The idea that theory is a discursive register or genre and that it has been present for the entire history of writing about film will soon become fully accepted and as common as air. Nonetheless, this historical bracket is full of paradoxes, ellipses, and equivocations. One of the most striking is the absence of theory as a regulative concept in the 1950s even as the discursive and institutional contexts that frame its conditions of possibility rapidly emerges and settles into place. (One will have to wait until the 1960s, when the full historical influence of Russian Formalism and Prague School structuralism is felt within the larger discursive regime of French structuralism.) Within the thirteen-year period opened by this parenthesis, the deployment of "theory" to characterize a discursive genre is still relatively uncommon with a few interesting exceptions—for example, Kracauer's *Theory of Film*, which is productively read as a curious transitional text between classical and modern film theory. Nonetheless, the rapid launch and flame-out of filmology in France in the years 1946 to 1960, with its sort of protostructuralism, sets fully in place a discourse of structure that is discontinuous with the earlier aesthetic discourse, and this discourse is produced within a fundamentally new conceptual, rhetorical, and institutional context. However, as the era of filmology contracts and the age of structuralism and semiology expands, "film theory" is suddenly fully present

as a discursive genre in the 1960s, like a familiar friend always present with us. Nonetheless, both Aristarco and Metz, each in his own way, produce their discourses through a logic of retrojection—in Aristarco's case, a discourse of aesthetics and realism with a political twist, fueled by Lukács and Gramsci, which threads together and gives form to the historical outline of film theory; in Metz, the discourse of language and signification that will soon concern us.

In retrospect, the discursive shift that occurs in Europe in the immediate postwar period is extraordinary and exceptional, although it did not happen all at once. The filmology movement, for example, which sets the institutional conditions for the attachment of theory to film, neither wished to propose a synthetic theory nor characterized its diverse multidisciplinary work as "film theory," as did Aristarco. In contrast, a seminal figure, Jean Mitry, carried forward a number of important questions, concepts, and approaches from the aesthetic discourse, maintaining its enunciative a prioris in the new context while debating the image's capacity for conveying meaning as sign, language, symbol, or analogon. In his two great works of the postwar period—the *Aesthetics and Psychology of Cinema* (1963 and 1965) and the *History of Cinema* (1967)—Mitry projected and retrojected forms of continuity that believed in the possibility of a total and synthetic knowledge of all cinema. Mitry's was perhaps the first and the last great effort to produce a system of comprehensive thought about film. Yet he did not call this system a theory, but rather an aesthetics, perhaps to preserve the contrast with Metz and structuralism. Curiously, though, to the extent that his aesthetic presents an account of meaning and symbol in relation to the film image, and despite his hesitancies and antagonism toward semiology, his work remains conceptually congruent with the discourse of signification. (I will address these arguments later in greater depth.)

Before expanding and deepening the senses of theory as a concept and a genre of discourse—with its peregrinations, pilgrimages, and periods of exile and return, triumph and decline—a better understanding of the changed institutional context that made possible the idea and concept of film theory is wanted. One fundamental strand of this narrative involves the local interest of Russian Formalism in film, along with Sergei Eisenstein's fascination with the philosophy of art, dialectical materialism, and Soviet anthropology and psychology, all of which anticipate a discourse that would be formalized in the postwar period within the rise of structuralism. The Russian Formalist use of "theory" in the 1920s and after is especially important in the way that it prepares the ground for the flowering of formalism and structuralism after the war. Nonetheless, the structural period opens suddenly in 1946 and 1947

in France and in Italy through a closely packed sequence of events, associated primarily with the rapid promotion of filmology and its concomitant research program in France. Despite its seeming abruptness, this shift was prepared by another specific institutional context—the formation of national film schools in which the teaching of film aesthetics and history held important and formative roles for international film culture. The model for these institutions was the VGIK, or All-Union State Institute of Cinematography, founded in Moscow in 1919, where Sergei Eisenstein led the direction faculty from 1935. As David Bordwell relates, from the early 1930s Eisenstein mounted an ambitious curriculum "that situated cinema within an enormously broad cultural framework. The program included physical training. . . ; the study of biographies of 'outstanding creative personalities' (Lenin, Gogol, Henry Ford); the examination of the laws of expression revealed in the writings of some twenty thinkers, from Plato to Pavlov; and the study of images in language, theatre, and the visual arts."[57] The structure and curriculum of Italy's Centro Sperimentale di Cinematographia, created in 1935, closely followed the Soviet model. Many institutional exchanges took place in the years preceding the Centro Sperimentale's founding and immediately after. Umberto Barbaro in particular was keenly interested in Eisenstein, Timoshenko, and especially Pudovkin, translating and disseminating their writings and including them in the nascent curriculum of the Centro Sperimentale. In addition to his translations of Pudovkin, Barbaro assembled with Luigi Chiarini collections of film texts to be used for cinematic education at the Centro Sperimentale, including "I problemi

57. *The Cinema of Eisenstein* (Cambridge, Mass.: Harvard University Press, 1993), 140; interior citation is from Vladimir Nizhny's *Lessons with Eisenstein,* trans. and ed. Ivor Montagu (New York: Hill and Wang, 1958), 143–164. It is interesting to note that in the period between *The General Line* and *Alexander Nevsky,* when Eisenstein is primarily engaged in teaching and research after his return from North America and Mexico, he begins explicitly to refer to this work as "theoretical." For example, in his speeches to the All-Union Creative Conference of Soviet Filmworkers held in Moscow in 1935, Eisenstein states: "I think that I must make a picture, and I will make pictures, *but I feel that this must be worked on in parallel with equally intensive theoretical work and theoretical research.*" As these speeches are as much political as intellectual, Eisenstein is trying to situate this work no doubt in the framework of theory and practice as expressed in political and philosophical Marxism. At the same time, until the 1939 *Non-Indifferent Nature,* these speeches are among the most systematic exposition of his research and thinking in aesthetics, and therefore, Eisenstein may self-consciously be placing himself in a genealogy of theory wending its way from Potebnja through the Formalists and current ideas of *Kunstwissenschaft.* See *S. M. Eisenstein: Selected Works,* ed. Richard Taylor, trans. William Powell, vol. 3, *Writings, 1934–1947* (London: BFI, 1996), 16–46. The quote above is on p. 44. I will examine the Formalist conception of theory in the next section.

del film," "L'attore," and "L'arte dell'attore," which consisted in large part of selections from Pudovkin, Eisenstein, Timoshenko, Balázs, Arnheim, Spottiswoode, and Rotha.[58] Equally important was the founding of L'Institut des hautes études cinématographiques (IDHEC) in 1944 in Paris under the leadership of Marcel l'Herbier. Jean Mitry was appointed a professor of cinema there in 1946, where apparently he taught the first course on film aesthetics in France. In all three situations, a special kind of institutional context was created where ideally the systematic study of film aesthetics and history was integrated with practice.

The creation of film schools was also a sign of the increasing acceptance of the cultural presence and importance of cinematographic art, especially as recognized by state governments, whose policies and support were encouraged by notable intellectuals. André Malraux's *Equisse d'une psychologie du cinéma,* published in the periodical *Verve* in 1939 and reprinted in a limited hardback edition in 1946, gave one important imprimatur to film art in France; Benedetto Croce's 1948 letter to *Bianco e nero,* in which he fully accepted cinema as belonging to the system of the arts, was another, equally important intervention in Italy. European film schools were also important sites for the formation of a serious film culture, and were often linked through close networks of institutional filiation to the creation and publication of film journals, *Bianco e nero*'s attachment to the Centro Sperimentale being the most significant example. In this respect, the institutional conditions for thinking and writing about film changed significantly. Before the war, writing about cinema was an amateur affair, open to anyone and without claim to any specific methodology or system of thought. By the 1950s, writing about film was becoming a more specialized, pedagogical, and scholarly pursuit. Previously a phenomenon of ciné-clubs, galleries, and little magazines, film writing was starting to become a specialized activity, conditioned by research groups in film schools and universities and published in academic journals. Moreover, it now had more settled institutional and academic contexts, one of the most important

58. For a more replete account of this story, see Maria Salazkina's "Soviet Film Theory in 1930s Italy: Towards a New Genealogy of Neorealism" in *Global Neorealism: The Transnational History of a Film Style,* ed. Robert Sklar and Saverio Giovacchini (Jackson: University of Mississippi Press, 2011). In her essay "Moscow-Rome-Havana: A Film-Theory Road Map (*October* 139 [Winter 2012]: 97-116), Salazkina also maps out the dissemination of this institutional discourse in the Hispanic Americas in the formation of Fernando Birri's Sante Fe School in Argentina, and the Cuban Institute of Film Art and Industry. Another welcome contribution to the institutional formation of discourses on cinema is Malte Hagener's *Moving Forward, Looking Back: The European Avant-Garde and the Invention of Film Culture, 1919–1939* (Amsterdam: Amsterdam University Press, 2007).

models being the establishment of the Institut de Filmologie at the Sorbonne in 1947 and its support of one of the first academic journals of film research, *La Revue de filmologie.*

Rhetorical strategies also changed significantly. No longer written in the belle lettristic and literary style of the aesthetic discourse, the discourse of signification emerged as a professional and academic jargon of specialists; in short, it became "theoretical," with a special conceptual vocabulary forged from the human and social sciences with which it was institutionally associated, especially linguistics and anthropology. This trend would deepen and complexify with the debates on film semiology that proliferated throughout the 1960s in the works of Christian Metz, Umberto Eco, Pier Paolo Pasolini, and others, which generated a whole new conceptual vocabulary of signifiers, signifieds, codes, semes, syntagms, paradigms, denotation, connotation, representamen, indexes, symbols, and im-signs. As a genre of discourse, theory became distinct from criticism. In the aesthetic discourse, the boundaries between film reviewing and interpretation, and more abstract and general accounts of the nature of film, were often fluid and indistinct. In the postwar period, serious film criticism still appears in little magazines and journals of opinion, and specialized magazines devoted to film criticism begin to appear, such as *La Revue du cinéma, Positif,* and *Cahiers du cinéma.* But this is also the moment of the appearance of specialized journals of film research, such as *Bianco e nero, Cinema Nuovo,* and the *Revue de filmologie.* At first, progress is slow. For example, Metz's key texts would appear mostly in academic venues of general research in the human sciences and semiology like *Communications,* the journal of the École Pratique en Hautes Études, where Metz worked from 1963 until his retirement in 1991, though he also published in magazines like *Cahiers du cinéma.* Specialized journals of film theory would really start to appear only in the post-1968 period when *Cahiers du cinéma* takes a "theoretical turn." This is also the era of the founding of *Cinéthique, Screen, Camera Obscura, Ça Cinéma, Framework, iris, Hors Cadre, Jump Cut, Cine-Tracts,* and other important journals of film theory. With the interesting and difficult exceptions of Jean Mitry and Noël Burch, the figure of the filmmaker-theorist would also become more and more rare, as positions of address reorganize around accredited academic researchers working in universities and professional schools.

All of these conditions foreground key differences between the two discursive genres. The aesthetic discourse is characterized by its heterogeneity and by the syncretism of its concepts, positions of address, and rhetorical stances. The discourse of structure or signification, however, is marked by a new tendency: the

desire for formalization, methodological unity, and conceptual coherence. The tendency toward formalization and methodological unification in postwar film theory was initially and primarily fueled by the rapid emergence of filmology in France, with its network of affiliations and links, both direct and oblique, radiating from the Sorbonne to IDHEC and throughout French film culture, and with its creation of an international research network, binding in particular academic communities in France and Italy. These are the first shoots and branches of the discourse of structure in film study. The roots of this discourse, however, are nourished in foreign soils.

## 13. The Travels of Formalism

> The point of theory is . . . to travel, always to move beyond its confinements, to emigrate, to remain in a sense in exile.
>
> —Edward Said, "Traveling Theory Reconsidered"

Rereading the first preface to Wellek and Warren's 1949 *Theory of Literature*, one cannot ignore their doubts and hesitations and at the same time their elation over the possible senses of theory. The book begins with a naming crisis. The authors are unsure of how to characterize the object of their enterprise, no less than the range of activities and concepts that might be covered by a "theory of." The senses of theory seem open and difficult to denominate. "Even a proper 'short title,' 'Theory of Literature and Methodology of Literary Study,' would be too cumbersome," they admit. "Before the nineteenth century one might have managed, for then a full, analytic title could have covered the title-page while the spine bore the inscription 'Literature.'"[59]

At the same time, Wellek and Warren recognize the novelty of their enterprise, that they have written a book without "any close parallel" (*Theory of Literature* 7), and this surprising assertion is coming from figures who were well aware of Lukács's *Theory of the Novel* no less than Eikhenbaum's "Theory of the 'Formal Method.'" Theory therefore carries a sense of the new. It seems to be a critical and historical activity that borders on many others; it springs from deep genealogical roots, yet it flowers in ways yet unseen. Theory borders on poetics and rhetoric, yet it is unlike them in many ways—it is not literary appreciation, criticism, or history, though it may be helpful to all those enter-

---

59. René Wellek and Austin Warren, *Theory of Literature* [1949], 3rd ed. (New York: Harcourt, Brace and World, 1970), 7.

prises. The authors are also deeply aware of their proximity both to a German tradition of Julius Petersen's *Die Wissenschaft von der Dichtung* and to a Russian Formalism so far unknown in Western academic culture. Theory, however, presents not the concepts of literature or literariness as such, but rather what Boris Eikhenbaum might call "method." Wellek and Warren characterize this approach as the attempt "to formulate the assumptions on which literary study is conducted" (7); or later, "to provide an *organon* of method" (8). The senses of theory become present, then, only once one is attentive to the conceptual infrastructure, or the criteria, categories, and schemes that support, make possible, and limit our analytical and interpretive responses to aesthetic works. Perhaps a theory of art or literature begins with a critical attentiveness to the possibilities and limits of thought about art or literature.

Still, some questions remain (and perhaps must remain) incompletely answered: How and by what discursive channels and forces was the word "theory" transformed into a concept as the semantic descriptor for a given practice? What genealogical roots was Aristarco drawing on, no less than Wellek and Warren, in evoking with such confidence and facility the term "theory" to characterize ways to approach literature, art, or film?

Commenting on the new maturity and variety of modern cinematographic practices in 1946, the venerable Russian Formalist Boris Eikhenbaum wrote, "We must organize the creative study of artistic problems in modern cinema. The study of cinema must become an object of systematic research, as the principal domain of artistic criticism. It is necessary that the greatest number of critics apply themselves to this task, for the study of modern cinema cannot do without theoretical experience."[60] Eikhenbaum's short essay was titled "We Need a Theory of Cinematographic Art," a call to theory in film that would be answered in the postwar period in different though related ways by Italian film criticism on one hand and by the filmology movement in France on the other.

Eikhenbaum, of course, was no stranger to theory, having in the year 1927 published a programmatic defense of Russian Formalism, "The Theory of the 'Formal Method,'" and edited one of the most important collections of Soviet aesthetic writing on film, the *Poetika Kino*. This crossroad between literature and film places Eikhenbaum at the intersection of two related but nonetheless incongruent discursive series. The *Poetika Kino* offers contributions to a poetics

---

60. "Il faut une théorie de l'art cinématographique," trans. in *Les Formalistes russes et le cinéma: Poétique du film,* ed. François Albèra (Paris: Nathan, 1996), 227; my English trans. from the French. Originally published in *Kadr* 7 (1946).

of cinema, but nowhere do its various essays and authors make claims for an overarching theory or method in the study of film, concepts largely absent from the essays including Eikhenbaum's own fundamental contribution on "Problems of Cine-Stylistics." As befits the aesthetic discourse, the approach here is largely syncretic, a reflection from a variety of perspectives, as Kirill Shutko asserts in the preface, "on the essence of cinema, its laws, its style, etc."[61] At the same time, Eikhenbaum's authoritative account of the "formal method" is one of the most important instances of "theories of" in the 1920s; indeed, it is as influential as or more influential than Lukács's *Theory of the Novel* for a possible conceptual cartography of the senses and stakes of theory, especially as they take form in the 1950s and 1960s in the discourse of structure and signification.

A more detailed historical account than I can offer here might show that the most direct genealogical line of descent for theory—with all its various and contradictory senses and values, with its forces of attraction and repulsion, its doubts and certainties—passes through the Russians, coming sharply into focus as a site of contestation just before and during the early years of the Soviet revolution, and then dispersing throughout the 1930s and 1940s in a diaspora that passes through the former Czechoslovakia, Italy, and North America before finally regrouping in France in the decade of structuralism's greatest influence. (Another version of this story might follow Roman Jakobson's peregrinations from Moscow to St. Petersburg, Prague, New York, and other cities, mapping his participation in the Moscow Linguistic Circle and OPOYAZ, meeting Shklovsky, Troubetzkoy, and Levi-Strauss, gathering up and synthesizing all the conceptual components defining the structuralist sense of theory and its reconfiguration of the human sciences through the twinned enterprises of linguistics and anthropology.) In other words, it is almost certainly the case that the Russians invented "theory" in the modern sense for the humanities. Russian Formalism cleared the path for the discursive crossroads leading toward, on one hand, structuralism, semiology, and the emergence of theory as a genre of critical discourse, and on the other, to

---

61. *The Poetics of Cinema*, ed. Richard Taylor, *Russian Poetics in Translation* 9 (1982): 1. Even the very act of formulating film's concepts is considered syncretically as represented in Shutko's question, "Do we in Soviet Russia, where film production is only just taking its first steps, need to waste our efforts *now* on theorising, on *philosophising* about films?" (1). Theory and philosophy are interchangeable here and deployed only in vernacular senses. Moreover, the border between poetics and theory seems indistinct, though influenced no doubt by Formalism's own ambivalences with respect to theory.

film theory considered not only as a subset of semiology but also, in a retro-jecting gesture, as a genre of writing about film stretching back continuously to Ricciotto Canudo. In any case, the discursive seeds were planted in Russian soil, even if historical currents quickly transported them to other climes: from Moscow and St. Petersburg to Prague, New York, Rome, Paris, and even Iowa City as an essential conceptual influence on Wellek and Warren's *Theory of Literature.*

In its polemical refusal of aesthetics and metaphysics, completely in tune with Russian Futurism's modernist rejection of all the dusty ideas of the past, Formalism turned to theory as a way to clear a new epistemological space for literature and, eventually, film. Throughout the 1920s, theory became some-thing of a catchword, drawing its semantic force not only from the influence of positivism on the study of art and literature but also from the conflation of the physical and historical sciences often wrought in claiming a scientific sta-tus for the different variants of dialectical and historical materialism. And here is the key interest of Eikhenbaum's "The Theory of the 'Formal Method.'"[62] This essay demonstrates the basic features of a discursive regime organizing around theory that would travel to Prague and then to Rome, where, in the context of the Centro Sperimentale di Cinematografia, film theory in the modern sense would take root as a historical concept and as a covering term for a certain genre of discourse. Theory was not created ex nihilo by the young Turks of Moscow and Saint Petersburg, however. Despite Victor Shklovsky's particular anathema to academic forerunners such as Aleksandr Potebnja (1835–1891), both the basic approaches of the Formalists and their way of characterizing theory had a Russian pedigree stretching back to the late nine-teenth century. Victor Erlich demonstrates how Potebnja, deeply influenced by the works of Wilhelm von Humboldt, prefigures not only the Formalist insistence on studying poetry and prose as linguistic phenomena but also how this approach was deployed in and as theory. For example, one of Potebnja's major collections from 1894 was titled *Iz lekcij po teorii slovesnosti (Lectures on Literary Theory)*; after his death, his students popularized his ideas in a collective volume titled *Problems of the Theory and Psychology of Art* (8 vols., Petrograd-Xar'kov, 1907–1923). Similar attitudes can be found in the

---

62. "Teoriya 'formalnovo metoda.'" First published in Ukrainian in 1926, and then in Rus-sian in the important Formalist collection, *Literature: Theory, Criticism, Polemics,* published in Leningrad in 1927. English trans. Lee T. Lemon and Marion J. Reis, *Russian Formalist Criticism: Four Essays* (Lincoln: University of Nebraska Press, 1965), 99–139.

inductive poetics and antipsychological orientation of Aleksandr Veselovskij (1838–1906).[63]

Eikhenbaum was a key member of the OPAYAZ group, an acronym for the Society for the Study of Poetic Language, founded in Saint Petersburg in 1914. His analysis of Gogol's *The Overcoat* was an important contribution to the first Formalist collection, *Poetics: Studies in the Theory of Poetic Language,* published in Saint Petersburg in 1919. Eikhenbaum was one of the principal polemicists of Formalism, and his essay is important not only for how it maps the relation of theory to the "formal method" but also for how an idea of theory became associated with poetics in contrast to aesthetics or philosophy. In addition, Eikhenbaum's text is important not only for its defense of "theory" and description of its conceptual and methodological framework but also for his account of Formalism's scientific claims to theory in response to Marxism. In 1926, Eikhenbaum is responding implicitly to criticisms launched first by Leon Trotsky in *Literature and the Revolution* in 1923 and then in a symposium published in 1924 in *The Press and the Revolution,* an influential literary magazine. Eikhenbaum's essay thus follows other attempts to reconcile the Formalist conception of theory with Soviet concepts of historical materialism, or at least to demonstrate their "scientific" compatibility.[64]

In contrast to Lukács's *Theory of the Novel,* here the claims to theory—to have or possess a "theory of"—are a central component of Eikhenbaum's argument, although as Lemon and Reis note in making the claim for a Formalist method compatible with scientific method, Eikhenbaum tends to exaggerate both the conceptual coherence and the unity of Formalist analyses of literature, as well as the orderly and systematic progress of their research. Nonetheless, the text is a key conceptual reflection on what theory is or might mean as a genre of discourse and a working method; its force continued to be felt many years later. The essay is therefore a lens that magnifies and focuses the senses of theory that would later be deployed in both film studies and the human sci-

63. See Ehrlich's *Russian Formalism: History, Doctrine* (New Haven, Conn.: Yale University Press, 1955), esp. chap. 1, 19–32.

64. See Lemon and Reis, 99–101. On the complex relation of Formalism to Marxism, also see Ehrlich's account, 99–117, and Jean Narboni's "Introduction à 'Poetika Kino,'" *Cahiers du Cinéma* 220–221 (May–June 1970): 52–57. In Ehrlich's gloss, Eikhenbaum's response to Trotsky's criticisms was that "Formalism and Marxism are not so much polar as incommensurate concepts: the former is a school within an individual humanistic discipline, namely literary scholarship; the latter, a philosophy of history. To put it in operational terms, [in] Marxism sociology inquires into the mechanism of social change, while [the] Formalist study of literature deals specifically with the evolution of literary forms and traditions" (*Russian Formalism,* 108).

ences, especially in structuralism and semiology. Still, Eikhenbaum is curiously ambivalent about theory throughout the text, and this is strongly felt in his opening gambit. The formal method, Eikhenbaum suggests, is neither a theory nor a method as much as an approach guided by two principles: first, to define what the object of literary study actually is, and second, to work inductively and empirically through "the examination of specific material in its specific context" ("Theory" 102). The criterion of immanence is crucial here. Seeing themselves as the founders of a new positive science—the science of literature—the Formalists felt it necessary to be guided solely by the concrete data under study. As Eikhenbaum himself put it, "Neither 'Formalism' as an aesthetic theory nor 'methodology' as a finished scientific system characterizes us; we are characterized only by the attempt to create an independent science of literature which studies specifically literary material" ("Theory" 103). Further, in a key passage of the essay, Eikhenbaum insists on what might be called the intermediate or transitory qualities of theory:

> In our studies we value a theory only as a working hypothesis to help us discover and interpret facts; that is, we determine the validity of the facts and use them as the material of our research. We are not concerned with definitions, for which the latecomers thirst; nor do we build general theories, which so delight eclectics. We posit specific principles and adhere to them insofar as the material justifies them. If the material demands their refinement or change, we change or refine them. In this sense, we are quite free from our own theories—as science must be free to the extent that theory and conviction are distinct. There is no ready-made science; science lives not by settling on truth, but by overcoming error. (102–103)[65]

A theory, then, should be open, revisable, and falsifiable, and in this respect, a science is built by progressively freeing itself from theory. In other words, theory is only a stepping-stone toward science, such that Eikhenbaum characterizes his project as showing "how the formal method, by gradually evolving and broadening its field of research, spread beyond the usual 'methodological'

---

65. This attitude is already apparent in a text of 1922, where Eikhenbaum states that "in scientific work, I consider the ability to see facts far more important than the construction of a system. Theories are necessary to clarify facts; in reality, theories are made of facts. Theories perish and change, but the facts they help discover and support remain." In *Melodika russkovo liricheskovo stikha* (Petrograd, 1922); cited in *Russian Formalist Criticism*, 125.

limits and became a special science of literature, a specific ordering of facts" ("Theory" 103). Eikhenbaum is careful to note that this amounts neither to an "aesthetic theory" nor to a "finished scientific system," but only asks "for recognition of the theoretical and historical facts of literary art as such" (103).

Why a special science and not a science as such, or a theory but not an aesthetic theory? Committed to inductive and nomothetic reasoning, Eikhenbaum is keeping his distance from what he calls " 'aesthetics from above' " and "self-styled general theories" ("Theory" 103–104), which are not so thinly veiled references to what I have called the system aesthetics of the nineteenth century. A progenitor of post-Theory, Eikhenbaum is retreating here from philosophy's claims to a universal knowledge of aesthetics or any other domain. Rather than focusing on general and conceptual problems, such as the nature of beauty or the essence of art, Formalism sought a middle-level framing and analysis of specific questions of artistic form and evolution. Following a now-familiar debate, Eikhenbaum places Formalism specifically in an alternative genealogy that passes through both a scientific *Kunstwissenschaft* and Heinrich Wölfflin's "art history without names." In fact, Eikhenbaum notes admiringly how the development of an "art science" in Germany displaced and reformed, as it were, the philosophical study of the visual arts; in Soviet Russia, he hopes, Formalism will do the same for the study of literature.[66]

In this context, Formalism and Futurism were bound together by history as both a symptom and a cause of a crisis in philosophical aesthetics: a symptom in that Futurism heralded a poetic modernism, grounded in the material of language and of art, which confronted the conceptual coherence of the reigning norms of aesthetics; a cause in that this modern art called for a new critical approach, for which Formalism was the response, where aesthetics is displaced by poetics and the formal method. Both were intent on derailing the conceptual claims of philosophical aesthetics. Eikhenbaum portrays this conflict as a historical battle between generations. And in fact, this is a struggle in

---

66. In a diary entry from January 1919, concerning Heinrich Rickert's *Kulturwissenschaft und Naturwissenschaft*, Eikhenbaum asserts in undisguised form that "Proceeding from Rickert, one realizes that the methods of the natural sciences must be applied to the history of the arts (1) when we speak of the social aspect of art (the poet's social situation), the orientation of his art toward a particular existing [social] stratum, etc.; or (2) when we deal with the 'nature' of the material from which the work is made. In both cases it is conceivable to construct laws and definitions." Cited in Peter Steiner's "The Roots of Structuralist Esthetics," in *The Prague School, Selected Writings, 1929–1946*, ed. Peter Steiner (Austin: University of Texas Press, 1982), 207.

and over the senses of theory where the theoretical heritage of Potebnja and Veselovsky, so valued by the Symbolists, is depicted as dead capital that must be transformed into new currency. In Eikhenbaum's polemical account, Formalism's academic forebears offered little more than a mélange of faded aesthetic, psychological, and historical concepts. Thus, the Formalists waged war against the Symbolists and their philosophical exegetes,

> in order to wrest poetics from their hands—to free it from its ties with their subjective philosophical and aesthetic theories and to direct it toward the scientific investigation of facts.... Hence our Formalist movement was characterized by a new passion for scientific positivism—a rejection of philosophical assumptions, of psychological and aesthetic interpretations, etc. Art, considered apart from philosophical aesthetics and ideological theories, dictated its own position on things. We had to turn to facts and, abandoning general systems and problems, to begin "in the middle," with the facts which art forced upon us. Art demanded that we approach it closely; science, that we deal with the specific. ("Theory" 106)

This passage discloses an interesting slippage between poetics and theory in the Formalist method. One way to look at this ambiguity is to suggest that the theory of the formal method is not a theory of art or literature—what might usually be called literary theory is referred to by the Formalists as poetics. What theory refers to, then, *is* the method—the epistemological parameters of investigation, the conceptual bases of research, and the guiding assumptions of historical and analytical work—or what Wellek and Warren call "an *organon* of method." The middle way of Formalism was therefore something less than philosophy and something more than an aesthetic theory based on subjective judgment. After Kant and Hegel, and following the framework of positivism, Formalism sought to lower the sights of science or *Wissenschaft*, and to make theory a meaningful term as an alternative to philosophy. What was objectionable in the Symbolist generation was not their methods per se, Eikhenbaum offers, but rather the irresponsible mixing of disciplines, methods, and problems. To create a science of literature required applying instead a principle of specificity while avoiding speculative aesthetics, finding a conceptual foundation to anchor this science and to give it unity and consistency. To create a specific and factual aesthetic science meant constructing an object of scientific investigation—something that would ground the investigation

epistemologically, define strict parameters for its methodological activities, and preserve its conceptual homogeneity.

Increased conceptual clarification is needed here, for in Eikhenbaum's account, the object of a science of literature is not individual works of poetry or fiction, but rather "literariness"—that quality or function wherein expression divagates from instrumental or prosaic uses and thus becomes aesthetic or literary, achieving in this respect an independent value. Here Eikhenbaum cites with admiration Jakobson's 1921 study, *Modern Russian Poetry*. And in making the claim for grounding the discipline of literary research in literariness rather than given works of literature or literature as a genre of art, Jakobson is not only stressing the importance of function but also attempting to purify and specify the theoretical or conceptual foundation of a "literary science."[67] In order to avoid speculative aesthetics and inconsistent hybrid methods, Formalism sought a principle of specificity to serve as the foundation from which the quality of literariness or aesthetic function could be derived and characterized.

The principle of specificity grounding the formal method derived from one of Formalism's most important and original conceptual formations—the distinction between poetic and practical language, which was developed in a series of key texts by Leo Jakubinsky, Victor Shklovsky, and Roman Jakobson, among others. The emphasis on *language* is crucial here, for in order to avoid a methodological hodgepodge drawn from history, culture, sociology, and aesthetics, the Formalists sought to ground their method in a single material, language, and associate it with a single discipline, linguistics. In this way, linguistics offered not only a specific material and a method, Eikhenbaum notes, but also

a science bordering on poetics and sharing material with it, but approaching it from a different perspective and with different problems. Linguistics, for its part, was also interested in the formal method in that what was discovered by comparing poetic and practical language could be studied as a purely linguistic problem, as part of the general phenomena of language. The relationship between linguistics and the formal method

67. In the passage quoted by Eikhenbaum, the aesthetic school of Potebnja and his followers are likened by Jakobson to policemen who indiscriminately seize any and all who cross their paths. "The literary historians used everything—anthropology, psychology, politics, philosophy. Instead of a science of literature, they created a conglomeration of homespun disciplines. They seemed to have forgotten that their essays strayed into related disciplines—the history of philosophy, the history of culture, of psychology, etc.—and that these could rightly use literary masterpieces only as defective, secondary documents" (107).

was somewhat analogous to that relation of mutual use and delimitation that exists—for example, between physics and chemistry. Against this background, the problems posed earlier by Potebnja and taken for granted by his followers were reviewed and reinterpreted. ("Theory" 108)

Linguistics is appealed to here as a site alternative to philosophy and aesthetics, and one proximate to science, or at least close enough to enjoy its light and warmth. The methodological principles and concepts guiding poetics are something akin to theory, then, as that which falls between philosophy and science.

Anchoring the method in a specific discipline, linguistics, and a concrete material, language, the distinction between practical and poetic language also served as a filter. Through the poetic function, linguistic patterns acquired independent value; in other words, they become more purely and structurally language, and attuned to the rhythm and materiality of language. In short, they achieved form. Form was thus considered a structure—or rather as arising from a structuring principle, open to observation and whose laws could be defined and discovered in theory. In a variety of texts, Shklovsky in particular emphasized a principle of the active perception of form, that form becomes discernible, perceptible, or brought forward in independent outline when amplified by the poetic function through techniques such as defamiliarization and "roughened form." "*Perception* here is clearly not to be understood as a simple psychological concept (the perception peculiar to this or that person)," Eikhenbaum insisted, "but, since art does not exist outside of perception, as an element in art itself. The notion of 'form' here acquires new meaning; it is no longer an envelope, but a complete thing, something concrete, dynamic, self-contained, and without a correlative of any kind" ("Theory" 112).

In Eikhenbaum's conception, the active perception of form does not convey the meaning of either an object or some content that lies within the object, for the independent function of art is to disrupt communication and meaning so as to increase the difficulty and span of perception. Aesthetic perception is an end in itself; it is attentive only to form and the dynamic unfolding of form. In Shklovsky's own summary, offered as an explicit critique of Potebnja, the active perception of form thus becomes a gateway to building theory: "Poetic language is distinguished from practical language by the perception of its structure. The acoustical, articulatory, or semantic aspects of poetic language may be felt. Sometimes one feels the verbal structure, the arrangement of the words, rather than their texture. . . . The creation of a scientific poetics must

begin inductively with a hypothesis built on an accumulation of evidence. That hypothesis is that poetic and prosaic languages exist, that the laws which distinguish them exist, and, finally, that these differences are to be analyzed."[68] Here Eikhenbaum clearly states the stakes of theory for Formalism: that one must begin with the establishment of a series of theoretical principles leading to clearly defined concepts, which in turn provide working hypotheses for the further investigation of data; that these data are defined and derived inductively; and finally, that theory grows out of contest and negation, here a defeat of theories of image and symbol derived from Potebnja's followers in favor of an account of form. For Eikhenbaum, in a first phase this is largely a question of conceptual clarification, of sorting out the "differing uses of poetic and practical language," and that, as Shklovsky suggests, to show that these differences are defined and sustained by laws (115). Theory is thus more concrete and factual than philosophy; like science, the method aspired to derive and test hypotheses for laws of empirical uniformity. In this respect, for Peter Steiner the formal method hovers between the nomological and historical-hermeneutic sciences. And even if Formalism stopped short of declaring the method a true science, in choosing the natural sciences as a model for all scholarship, Steiner suggests that it "betrayed an essentially positivist bent" ("Roots of Structuralist Esthetics" 207). This was equally the case not only for later variants of Formalism, such as Prague School structuralism, but also for structuralism in general. (Later, this tendency will again be displayed in the claims of historical poetics and post-Theory in contemporary film study. I will examine this connection more deeply in *Philosophy's Artful Conversation*.)

Yet, despite the attraction to positivism, Formalism retained an important historical dimension, and its specific sense of the force and logic of history informs the method's claims to theory in important ways. Eikhenbaum's text offers an interesting concept of history and how it relates to theory in ways often commensurate with what will later be called historical poetics in film study. Eikhenbaum notes how questions of literary evolution are raised naturally alongside theoretical problems. Eikhenbaum divides the theory of the formal method into two interrelated lines: studies of literary evolution as such and theoretical study of problems of form. The two are interrelated through the concept of form. If form is at once dynamic and historical, if it changes continuously against the background of other devices and styles, then it needs to be approached "without abstract, ready-made, unalterable, classical schemes;

68. Shklovsky, "Potebnja," *Poetika* (1919); cited in Eikhenbaum, "Theory," 114.

and we had to consider specifically its historical sense and significance. . . . The theory itself demanded that we turn to history" ("Theory" 132). The way form drives the history of style and how stylistic change modifies history are key elements in Eikhenbaum's conception of method. Formalism is not looking for the causal factors of formal or stylistic change, but rather seeks to define something like a moving picture of structure, and how one device or set of devices yields to others over time; hence, the importance of knowing how to identify and evaluate functional significance in different historical contexts.

While causal relations seem to be of little significance to the Formalist conception of history, their image of change is a key component of their characterization of history. Above all in their theoretical struggle with the literary heritage of Symbolism, Eikhenbaum portrays change, whether literary or critical, as a violent contest and an upheaval. One wonders to what degree this view is a real conceptual element of the theory, or whether Eikhenbaum speaks in a coded language of revolutionary struggle, setting up a tone of sympathy or fellow traveling with dialectical materialism. In any case, the tenor of Eikhenbaum's argument is unmistakable. The deposing of one theoretical paradigm by another takes place "without the idea of progress and peaceful succession" ("Theory" 133). Later, Eikhenbaum continues with yet greater emphasis: "Thus the basic passion for our historical-literary work had to be a passion for destruction and negation, and such was the original tone of our theoretical attacks; our work later assumed a calmer note when we went on to solutions of particular problems" (134). After the revolution, the slow work of building a science begins.[69]

Literary evolution was thus characterized by the notion of struggle or of "periodic uprisings" analogous to or in sympathy with the forces of revolution themselves. These uprisings, however, are not led or promoted by heroic figures or visionary leaders, but rather by collective and impersonal forces, which led Osip Brik to quip that if Pushkin had never existed, *Eugene Onegin* would have

69. In "The So-called 'Formal Method,'" Osip Brik suggests that in its focus on studying the laws of poetic production, OPOYAZ does contribute directly to the revolutionary problems of culture. In answering the question, "What does 'Opoyaz' contribute to the proletarian construction of culture?," Brik offers the following responses. The Formalist method contributes "1. A scientific system instead of a chaotic accumulation of facts and personal opinions; 2. A social evaluation of creative people instead of an idolatrous interpretation of 'the language of the gods'; 3. A knowledge of the laws of production instead of a 'mystical' penetration into the 'secrets' of creation" (324). In sum, OPOYAZ is the best education of proletarian writers because, Brik implicitly suggests, it is the closest relative in art theory to a scientific materialism. "The So-called 'Formal Method,'" *LEF* 1 (1923): 213–225. Trans. *Art in Theory (1900–1990)*, ed. Charles Harrison and Paul Wood (Cambridge: Blackwell, 1992), 323–324.

written itself. What frees history and theory from the subjectivist errors of the Symbolists and what gives them their epistemological standing is the lack or erasure of the subject. In analogy with Wöfflin's art history without names, the Formalists conceived of aesthetic history without a subject, or at least, without authorial personality as a cause; Eikhenbaum calls this "the study of literature as a *self-formed social phenomenon*" ("Theory" 136). Literature is seen here as a collective process, at least to the extent that it forms an inter-connected discursive environment in which popular genres have a place no less significant than more elevated forms, and in which the two are continu-ally interacting. In any case, the dynamism of change is not fueled by indi-vidual creative agents, but rather by more impersonal and collective forces of shifting functions and techniques vying for novelty.

This perspective on history is also reflected in Eikhenbaum's theoretical portrait of the formal method to the extent that the collective force and epis-temological claims of the method rely less on the aggregated contributions of individual authors than on a dynamic process of collective and impersonal col-laboration. The subject of theory, always greater than the sum of its parts, is not Eikhenbaum, Shklovsky, Brik, or Jakobson, but rather Formalism itself as a theo-retical stance, binding them all in a common method and conceptual frame-work. That the historical nature of theory is not a "personal affair" is how Eikhenbaum characterizes Formalism's "chief connection with the times. Sci-ence itself is still evolving, and we are evolving with it" ("Theory" 138). In this sense, as a dynamic and impersonal force, history, or rather attention to the forces of history, is what saves the method either from falling into an abstract (or worse, subjectivist) philosophical system or from congealing into an in-flexible theory. "We have no theory," Eikhenbaum insists, "that can be laid out as a fixed, ready-made system. For us theory and history merge not only in words, but in fact. We are too well trained by history itself to think that it can be avoided. When we feel that we have a theory that explains everything, a ready-made theory explaining all past and future events and therefore need-ing neither evolution nor anything like it—then we must recognize that the formal method has come to an end, that the spirit of scientific investigation has departed from it. As yet, that has not happened" (139).

But perhaps theories do have ends, or rather follow historical arcs that wax and wane, where periods of great conceptual novelty and innovation alternate with staleness or obsolescence. Galin Tihanov puts the matter forcefully in asking, "Why Did Modern Literary Theory Originate in Central and Eastern

Europe? (And Why Is It Now Dead?)."[70] In ways coincident with my own, Ti-hanov has argued that the idea or concept of a theory of literature is histori-cally delimited, emerging and declining in the context of specific cultural and discursive situations. In his account, the era of theory stretches from the ini-tial work of the Russian Formalists in the 1910s, declines with Wolfgang Iser's turn from reception studies and a phenomenology of reading to "literary an-thropology" in the 1980s, and comes to a close with the death of Yuri Lotman in 1993. In their inaugural moment, the claims to theory in Russian Formal-ism were motivated by two factors. First was the desire to construct literature as a specific object and as an autonomous domain for analysis, separate from the other arts as well as other historical, social, and psychological factors. Fo-cusing on the quality of literariness and the formal logic of the literary device, Formalism sought support in the still-young and rather marginal domain of linguistics to study the immanent form and logic of poetic and narrative texts. This is the wellspring that would finally nourish the discourse of signification in the 1960s.

Second, the flowering and fading of theory are equally marked by a turn from and return to philosophy. The linguistic turn in the 1910s was the sign of a desire to retreat from philosophy and system aesthetics, seeking an alterna-tive in "theories of." The appeal of linguistics was not only its novelty or con-temporaneity (Saussure's *Course in General Linguistics* was first edited and published by his students in 1916) but also its proposal of an immanent form of analysis with a rigorous, even scientific, methodology. For the Formalists and fellow travelers, linguistics was a young, marginal, and forward-looking method alternative to the dusty debates of philosophy and philology. From the 1970s, however, the discourse of signification and of a textual semiotic still guided by linguistics began itself to age and fray into what Francesco Casetti characterizes in *Theories of Cinema* as "field theories," multiplying both the ob-jects and subjects of investigation while turning from textual specificity to cul-tural analysis—theory was becoming Theory, and the discourse of form and signification was remapping itself through concepts of ideology and culture. In particular, deconstruction began to cast epistemological doubt on the stabil-ity of the concepts of sign, structure, and subject that grounded the discourse of signification as a "scientific" enterprise. Derrida's tour de force critiques of Saussure, Rousseau, and Levi-Strauss in *Of Grammatology* thus inaugurate

70. *Common Knowledge* 10, no. 1 (2004): 61–81.

the discourse of poststructuralism, and the coming senses of Theory. In addition, for Derrida's readers in literature his work signposted a departure from the grand structuralist project back into a philosophy of literature, even if in a North American context this return retained the form of textual criticism. "Thinking and writing about literature," Tihanov comments, "thus lost the edge of specificity and uniqueness, and the boundary between literary and nonliterary texts, solemnly guarded since the Formalists' time, was rendered porous and eventually insignificant. Similarly, feminism, postcolonialism, and New Historicism were all ways of reading more than just literary texts; they were strategies of cultural theory" ("Modern Literary Theory" 62).

The appeal of theory in the 1920s, then, as both a concept and a sort of rallying point, was the definition of a methodological and an epistemological space alternative to and in contestation with the Hegelian and to a certain extent neo-Kantian approaches to aesthetics dominant at the turn of the century. This tendency is already clear in Lukács's own complex and difficult struggle with Hegel in *The Theory of the Novel*. Tihanov states the case clearly: "The emergence of literary theory was conditional upon the process of disintegration and modification of monolithic philosophical approaches that occurred around the time of World War I" ("Modern Literary Theory" 65). In a very concrete sense, all of the conceptual resources for theory that flowed together into the discourse of structuralism are located in a retreat from aesthetics toward immanent analysis in a nomothetic framework: the modern linguistics of Ferdinand de Saussure; Russian Formalism; the innovations of the Prague Linguistic Circle, especially the advances in phonology carried out by Nikolai Trubetskoy and Roman Jakobson in the 1930s; the debt of narratology to Vladimir Propp's studies of the folktale; and so on. In fact, the two principal conceptual springs of theory may well be, first, the slow transformation of philology into linguistics, already signaled by the interest of the Formalists in the work of Aleksandr Potebnja and their critical reaction to it, and second, Lukács's application of Marxism to the study of literature in the 1930s.

The idea that there might be currents of exchange flowing between Formalism and Lukácsian realism in the 1930s is not as strange as might seem at first glance. As Tihanov explains, "Lukács's writing on realism and the novel, done mostly during his time in Moscow, placed him in an internationally constituted field of literary theory to which he had not before fully belonged. This field was shaped by the Prague Circle's deliberations on realism, most notably Jakobson's article of 1921, 'On Realism in Art.' But the field was also shaped by the lingering presence in the 1930s of a fatigued Russian Formalism (above

all, by Shklovsky, who polemicized openly and covertly against Lukács) and by Mikhail Bakhtin's powerful responses to Lukács's theory, which were unpublished (if not unheard) at the time" ("Modern Literary Theory" 73). Following his unorthodox engagement with Marxism as a philosophical metadiscourse in the 1923 *History and Class Consciousness,* and responding to a desire to concretize the concepts of Marxist analysis through an account of literature and culture, Lukács's studies of realism and the novel gave a new imprimatur, and a methodological context, to the study of culture along the main lines of Marxist "theory." In this respect, the appeal to immanent analysis and concreteness in both streams can be understood as an ongoing project in response to Hegel and Hegelian theories of totality, to neo-Kantian accounts of essence and appearance, and to *Lebenphilosophie*'s attempts to reconcile form and life. Philosophy made concrete in cultural expression equaled "theory."

Significantly, these two streams—of linguistics and Marxism—would flow together into the soft Marxism of the Formalists and their interests in the literary and aesthetic avant-gardes, though it would sink underground or be diverted to other countries with the rise of Stalinism. Paradoxically, Formalism and Lukácsian realism, strange bedfellows in any context, would then arrive together in Italy in the 1930s and 1940s, finding a home in film study at the Centro Sperimentale di Cinematografia in Rome. Here indeed is where an idea of film theory is first given conceptual clarity, especially as a materialist alternative to the idealism of Benedetto Croce and Giovanni Gentile. For Umberto Barbaro and Guido Aristarco, it may well be that Formalism and Marxism come together in an Italian context to define "theory" as a particular kind of materialist account of art, forged both in a social dialectic and in deep attention to the facticity of physical and social reality—this would be a founding idea of neorealism as the model of modern cinema, indeed the very modern cinema Eikhenbaum might be referring to in 1946. Ironically, the deep divide between formalism and realism, so present in post-1968 film theory, was unknown in this context. Nonetheless, before the discourse of structure and signification fully congeals and sets in place in the early 1960s in France, one more branch on the genealogical tree of theory must be accounted for.

### 14. An Uncertain and Irrational Art

> All this is undoubtedly not a science . . . ; but without it there is no science.
>
> —Théodule Ribot, cited in Gilbert Cohen-Séat's *Essai*
> *sur les principes d'une philosophie du cinéma*

Two fundamental lines converge in the 1960s to produce "theory" as a discursive formation or genre: first, the directive idea of filmology that positivism guides every discipline applied to the "scientific" study of art, and second, a transformation of the conceptual framework of the human sciences effected by the increasing dominance of structuralism. The latter especially would be deeply influenced by a concept of theory forged by the travels of Formalism in the 1930s and 1940s. In both cases, the disciplines of linguistics, anthropology, and sociology took precedence in the study of art and literature with the problem of language or signification as their underlying foundation, though with very different conceptions of discourse and the logic of signs. Nonetheless, both lines developed a concept of structure as the "scientific" foundation for the study of culture and the life of signs in society, though here semiology ultimately displaced the positivism of filmology in a manner analogous to Dilthey's vision of *Wissenschaft* taking ground from positivism in the late nineteenth century.

The influence of filmology on the invention of film theory has been undervalued and underexamined in this story. With the exception of Edward Lowry's superb and still-unsurpassed study, filmology remains for the most part unknown in North America today and is practically forgotten in France.[71] Yet for ten years in the late 1940s through the late 1950s, it flourished as an international network of university scholars, though ironically in a way that runs parallel to the extraordinarily vibrant film cultures of the 1950s without really interacting with them. Filmology sought a science of film, but filmologists were for the most part not lovers of cinema.[72] Nonetheless, filmological research

71. *The Filmology Movement and Film Study in France* (Ann Arbor, Mich.: UMI Research Press, 1985). This state of affairs has changed with the publication of a superb double issue on the movement, "La filmologie de nouveau," *CiNéMAS* 19, no. 2/3 (2009), ed. Martin Lefebvre and François Albéra.

72. See, for example, in 1955 Amédée Ayfre's withering criticism of filmology, "Cinéphile et filmologue," *Cahiers du cinéma* 48 (June 1955): 57–60. Writing in *Cahiers du cinéma* 5 (1951) under the pseudonym Florent Kirch, André Bazin produced an equally skeptical view in his "Introduction à une filmologie de la filmologie." See Dudley Andrew's account in "The Core and Flow of Film Studies," *Critical Inquiry* 35 (Summer 2009): 891–894.

turned up in translation and citation in important journals like *Bianco e nero,* was an important framework for Christian Metz's semiological essays throughout the 1960s and early 1970s, and was even significantly represented in the bibliography of Siegfried Kracauer's *Theory of Film.*

Guido Aristarco's 1951 *Storia* marks the first appearance of a historical conception of theory in the modern sense for film study, but the opening volley of the structural discourse in France was the publication of Gilbert Cohen-Séat's *Essai sur les principes d'une philosophie du cinéma* in 1946. Although no doubt a man of letters, Cohen-Séat was not an academic, but rather a journalist, film producer, and sometimes director with close ties to the French government, to the film industry, and to the Parisian intellectual community. Divided into two parts, "The Cinema in Contemporary Civilization" and "Fundamental Themes and Vocabulary of Filmology," Cohen-Séat's *Essai* was projected as the first of four volumes that would also include studies of "Aesthetics and Individual Psychology," "Cinematographic Values and Collective Mentality," and finally, "Methodology." These last three studies never appeared in print, though many of the problems they proposed in outline were taken up and developed by other researchers in the filmological circle. In 1946 Cohen-Séat is not presenting or arguing for a theory of film, but rather trying to lay the foundations for a philosophy of cinema. However, philosophy has a specific sense in this context that will set the conditions for what theory meant and could mean in the postwar period. Indeed, for a brief period of time, "filmology" largely meant what would later be called "film theory" in the 1960s.

Although several concepts from the *Essai* would have a lasting impact on film study in France, especially the methodological distinction between filmic and cinematic facts, Cohen-Séat's larger talents were in networking, lobbying, and institution building. As Edward Lowry observes, Cohen-Séat's book set off a widespread "organized attempt by the French intellectual community to arrive at a comprehensive, methodical approach to film within the context of the university and its established fields of study" (*Filmology Movement* 4). Not so much a theory as a manifesto or white paper, the *Essai* proposed a twofold project. First, sounding an alarm on the power and crisis of cinema in postwar society throughout the world, Cohen-Séat sought to promote the scientific study of cinema within the established academic disciplines of anthropology, sociology, psychology, and comparative aesthetics. Second, the *Essai* had ambitions to lay the methodological and conceptual foundations for a comprehensive and unified research program in film that could take place across a variety of disciplines in the social sciences and humanities. Here, fundamental

philosophical principles appropriate to the study of cinema were to supply the method for a possible filmology whose subdisciplines would suggest a variety of theories. In fact, Cohen-Séat offered the distinction between filmic and cinematic facts as a way to divide up territories of research between aesthetics or the human sciences on one hand and the social sciences on the other, while setting up the methodological terms of exchange and communication between them. In this sense, Cohen-Séat's characterization of method was entirely commensurate with positivism's commitment to the idea that there is or should be a single scientific framework valid for all research. In Cohen-Séat's conception, filmic facts were to account for film as an aesthetic or signifying object, and as a social force. In his often-debated definition, "*the filmic fact* consists in expressing life, the life of the world or of the mind, of the imagination or of beings and things, by a determined system of image combinations. (Visual images: natural or conventional, and auditory: acoustic or verbal.)"[73] Or further, filmic facts include "all the elements of film susceptible to being taken for its signification as a sort of absolute, from the point of view of intelligibility or from the point of view of aesthetics" (*Essai* 108). In contrast, cinematic facts were established through the study of the context of larger social, cultural, and economic institutions. Commenting on this distinction in 1971, Christian Metz noted that "film is only a small part of the cinema" and that the cinematic fact comprises a vast range of phenomena, some of which occur before the film (economic and technical infrastructure, censorship), others after the film (audience response and political or cultural impact), and others during the film but aside from and outside of it (theater architecture, rituals of film-going, etc.).[74]

Though much discussed, criticized, debated, and refashioned, the distinction between filmic and cinematic facts—or aesthetic and institutional analysis—remains powerfully present in contemporary film study in a variety of forms. Moreover, in spite of all the frictions that divided aesthetics from the social sciences in the era of filmology, the camps ultimately converged on the same problem, which would become the central concern of contemporary film theory: spectatorship. Or, as Cohen-Séat put it, "Otherwise said, our perspective does not begin with the making of films, but rather with the consumption of the spectacle. It is in effect within and during the 'performance' [*représenta-*

---

73. *Essai sur les principes d'une philosophie du cinéma,* 2nd ed., rev. and exp. (Paris: Presses Universitaires de France, 1958), 54; my trans. unless otherwise indicated.

74. *Language and Cinema,* trans. Donna Umiker-Sebeok (The Hague: Mouton, 1974), 12.

tion] that the object and the new activity instituted by the cinema are found" (*Essai* 54). The crisis of cinema was thus conceived as a historical and cultural crisis but also a psychological one compounded by a lack of data, or knowledge of any kind, of film's physiological, cognitive, and emotional effects on spectators. This would account later for the predominance of psychological and anthropological studies in filmology at the expense of more aesthetic and qualitative analyses. In this manner, throughout the 1950s, the varieties, conditions, effects, and activities of film spectatorship became the founding objects of filmology as a positive science. Spectatorship would retreat somewhat as the discourse of signification came to the foreground in the 1960s only to reemerge, however, with the second semiology and the concept of "signifying practice" in the 1970s.

The impact of Cohen-Séat's book and the effects of his lobbying were rapid and significant. An Association pour la Recherche Filmologique was created in January 1947 with Cohen-Séat as its secretary-general, and by July of the same year it began editing and publishing an academic journal, *La Revue internationale de filmologie*. The association brought together some of the most important scholars and intellectuals of the postwar period: Étienne Souriau, appointed to a chair in Aesthetics and the Science of Art at the Sorbonne in 1945; Henri Wallon, professor of the Collège de France and a leading child psychologist; Raymond Bayer, also a professor at the Sorbonne and cofounder with Souriau and Charles Lalo of the *Revue d'esthétique* in 1948; Edgar Morin, who was rapidly becoming one of the most important sociologists and public intellectuals in France; Léon Moussinac, devotee of Soviet film and a leading figure of French film culture since the 1920s, director of the École Nationale des Art Décoratifs and soon to be the director of L'Institut des hautes études cinématographiques (IDHEC); and other professors of the Université de Paris and schools throughout Europe. The first International Congress of Filmology was held at the Sorbonne in September 1947, and one year later an Institut de Filmologie began research activities at the Sorbonne, though it was only officially created in October 1950. Among other activities, the Institut de Filmologie offered a two-year course of study leading to a university degree, and while the Institut was attached in principle to the *faculté des lettres* at the Sorbonne, in fact it operated as an autonomous institution, which would cause problems later on.[75]

75. For a deeper and more complex version of this story, see Lefebvre and Albéra's "Présentation: Filmologie, le retour" and especially Lefebvre's "L'aventure filmologique: Documents et

The appeal of filmology to French academics was less aesthetic than it was sociological. It was, further, a discourse framed in terms of urgency and crisis. Where the aesthetic discourse forged its variants in confrontation with film as the emblem of modernity, an emblem that swept away previous concepts of art and that embraced the medium's perceived transformation of nature and its vertiginous unlocatability in time and space, the new institutional discourse both admired and feared film, not as an artistic medium but as a mass medium of unprecedented power and influence. And where the aesthetic discourse often romantically embraced a certain irrationality in the experience of film, surrealism being the best example, the structural discourse created itself out of the anxiety that the power and reach of cinema exceeds the capacity of any rational discourse to frame it or to guide its evolution. In the late 1920s and into the 1930s, photography and film could serve for Kracauer and Benjamin as emblems for a crisis of experience in modernity, of history "going-for-broke" (to cite Kracauer's famous phrase from the 1927 essay on photography) toward society's complete collapse under capitalism or its rebirth as a socialist utopia. But in the wake of European fascism and its modernization of propaganda, the mass destruction of World War II, and the trauma of the German occupation, Cohen-Séat's liberal humanism proposes a very different project—a reconstruction, as it were, that reasserted the project of scientific rationalism in the study of cinema, which in turn stood for a potentially global, humanist culture.

Cohen-Séat's rhetoric of crisis was fueled by his vision of cinema as an intrusive and omnipresent force whose effects are uncertain and badly understood in both their negative and positive dimensions. Reaching an audience of unprecedented size and scope, Cohen-Séat portrays the history of film as the rapid development and dissemination of an aesthetic superreality—an autonomous world whose logic is largely unconscious and preconceptual, and whose psychological effects are unknown or badly understood. In this lie both the powers and the dangers of the medium, which Cohen-Séat judges according to the "quantity of humanity" it affects and the "quality of humanity" it may inhibit or promote. The first concept refers to the cinema's international and transcultural scale as a mass medium and its potential for becoming the first global art form, for the cinema reaches an audience of unprecedented size and

jalons d'une histoire institutionelle" in *CiNéMAS* 19, no. 2/3 (2009): 13–56, 59–100, respectively. In particular, Lefebvre provides a rather astounding account of the rise and fall of the Institut de Filmologie at the Sorbonne.

responds on a world scale to "the demand for a homogenous unity and a di-
rect universal efficiency" (*Essai* 18). To the extent that it is an art, and poten-
tially a language, the cinema has thus created something like a new universe
of signs or a new "collective consciousness," in Émile Durkheim's sense of the
concept, as the collective and institutional expression of ideas, symbols, and
values that define a society and legitimate its institutions.

In spite of its collective nature and global influence, for Cohen-Séat film may
have become a popular art, but it had not yet become a humanist art, or rather
realized its potential to affect the quality of humanity as "an instrument of
reconciliation for humanist and collective values" (*Essai* 30). The difficulty of
assessing film's powers in this respect opens up a problem that will define the
structural discourse for another thirty years: to what extent is film a language?
Or to the extent that it conveys meaning or value, what kind of language is it?
Cohen-Séat is an important transitional figure in this respect. Taking up one
of the key themes of the aesthetic discourse, Cohen-Séat portrays cinema as
the first universal art form: "For the first time such a *sign,* so intimately linked
to the secrets of history and the will of humanity, affects all at once the surface
of the earth. . . . *For the first time in the history of mankind, the masses play the
same game at the same time across the surface of the earth.* The same game: not
with different traditions, as in music and dance, nor with different approaches,
as with dolls or hoops, nor with a greater or lesser degree of perfection, nor
with different ways of adapting more or less to reality, but the very same to the
last degree" (19–20). World cinema has thus created a kind of ideational
"superreality" *(surréalité),* "anterior to concept and indifferent to language"
(24). The cinema has become a new global mentality or form of collective
thought, but a fraught one composed from "unconscious judgments, novel in-
ductions, eccentric and secret syllogisms, commentaries, and interpolations; or,
alternatively, critical suppressions of sensations interpolated into the real by
who-knows-what kind of imperfection or prejudice of our faculties, a whole
world of generic perceptions or basic impressions that unleash a mysterious as-
sault on our usages, our 'normality,' our experience, and even our feelings" (25).

Herein lies the curious polarity that drives Cohen-Séat's manifesto. Cre-
ated, exploited, and disseminated in a context of unbridled capitalism and
governmental neglect, and expressing a technological reason unguided by any
ethical motive, cinema has evolved in a lawless and uncontrolled manner;
hence its susceptibility to irrationality, emotion, and propaganda. In a 1948
essay published in the *Revue,* Cohen-Séat put the matter more directly:

It is understood that the cinematographic spectacle plays a role in the concrete conditions of existence that determine our states of activity and behavior. The direct or indirect action of these "representations" transform the conditions of psychological life more than any other previous human invention. One realizes that this action can affect the intimate dispositions that condition attitudes as well as the active intentions [*intentions réalisatrices*] on which daily activity depends. It is not impossible that this action comes to transform man himself, by a violent perceptual *information* and representation of life through which his relations with nature, with his peers, and with himself, must be corrected. Considering this global force, generative of interminable human consequences, and the infirmity of means, of knowledge and interpretation, one has with respect to its effects . . . , one agrees to see in the cinema one of the most worrisome developments of scientific progress and technology, and to say that this phenomenon must be studied."[76]

The ultimate conclusion of this perspective, as Lefebvre accurately remarks, was, "If the cinema is really a conditioning agent, then it is not a simple and inconsequential entertainment, and it represents even a potential menace for the security of the State and for public order" ("L'aventure filmologique" 75; my trans.).

Alternatively, in the ideal world of Cohen-Séat's liberal humanism, the popularity and global reach of cinema give evidence of a nascent and underdeveloped impulse toward a collective thought, and a collective language or game, that transcends barriers between individuals and nations, potentially creating a form of universal creative communication. This argument echoes one of the main themes of the aesthetic discourse—the rebirth or reinvocation of the utopia of film as an international language of reconciliation.

But here another difficulty, and another potentiality, arises. Cinema is something like a cultural lingua franca, but an underdeveloped or undernourished one. In terms of social function, cinema is comparable to language, yet in Cohen-Séat's view it is not strictly speaking a *langue,* or rationally ordered speech. Significantly, there is no capacity for intercommunication—the spectator receives or views; she or he does not create or interact. Still, aesthetically the cinema aspires to something like a system of universal signs. And here, finally, is the task of a philosophy of cinema wherein theory will play its

76. "Filmologie et cinéma," *Revue internationale de filmologie* 3–4 (1948): 237; my trans.

part. This philosophy is not so much aesthetic as ethical; its objective is not to guide film form and to elevate it artistically, but rather, to the extent that film is a language, to make that language more rational, humane, and cosmopolitan.[77] "The question," Cohen-Séat concludes, "is thus to know whether the cinematic message can develop or create in its current condition the elements of spiritual life—principles of fellow-feeling, of universal values, where spiritual life is threaded—that can release from each 'spectator' a *person* [*qui puissent échapper dans chaque 'spectateur' au personnage*], who before being of man, of his feelings and gesticulations, also belongs to the substance of the human being, so to speak, to the very essence of humanity that each person carries within himself" (*Essai* 37). Briefly put, the goal of a philosophy of art or cinema is to create a rational context wherein the individual becomes more human, more universally human, as if one needs to discover, through a universal art, an unrecognized capacity for becoming human.

In *Philosophy's Artful Conversation,* I will discuss more thoroughly the ethical dimension of philosophy's encounter with film. Nonetheless, in hindsight it is clear that Cohen-Séat's discourse is marked by a rather unreflective and underconceptualized humanism as well as a cultural ethnocentrism. Written just after the end of World War II, the *Essai* is permeated by a fear of irrationality, conflict, and cultural disorder. Being a product of unchecked capitalism with unpredictable psychological effects, cinema was an emblem of this disorder, and filmology was conceived as a way to bring cinema under control through a systematic and rational discourse, guiding this new art toward democratic ends under principles of humanism and through a methodologically coherent sociology. In its attempt to lay the conceptual foundations for a filmology, the *Essai* is searching, then, for a scientific framework—in short, a theory or group of theories—that could serve as compass points for the rational

---

77. In his 1947 essay "Le cinéma et les études humaines," Raymond Bayer expands on Cohen-Séat's vision of film's ethical vocation: "A successful film is a collective thought enlarged and conveyed by time. . . . The question is neither to know in fact what films are, nor the manner in which they deceive us, but rather to carry out instruction and inquiry into their possibly unknown powers. The cinema must also be a reformer, a creator of values, a founder of schools of art; a discriminator in any case, confessor, or dispenser of justice. From one point of view, it is an instrument of confession and of psychoanalysis: for the modern spectator it replaces both one and the other. . . . Film's vocation is deontological. . . . Just as art is an affair of conscience, taking into account a spirit that is both consciousness and science, the film also has an educational and collective role to play. I gladly imagine the moralist attitude of a Schiller, adding a Letter on the Cinema to his Letters on Aesthetic Education." *Revue internationale de filmologie* 1 (July–August 1947): 33; my trans.

evolution of cinema as an art form and as a social institution, one that is driven by positivism's faith in the rational and progressive development of a culture where "man is capable of creating the conditions of a superior life" (*Essai* 30). Filmology was thus conceived as an elite and scientific enterprise with a specific political and ethical objective—the creation of an institution where the mass of democratic individuals could be guided aesthetically toward human improvement.[78]

With these aims, the goal of Cohen-Séat's *Essai* was nothing less than to locate film as the object of a positive science in the tradition of Auguste Comte and the scientific sociology of Émile Durkheim, who are both significant influences on the book. (Durkheim and Marcel Mauss will play similar roles for structuralism.) Every line of Cohen-Séat's discourse is underscored by positivism's confidence in the ability of scientific inquiry to organize research in every social discipline, and to manage society rationally so as to direct the course of human history. Taking as his watchword "To understand is first to systematize; one understands as soon as one systematizes" (*Essai* 43), Cohen-Séat turns to positivism not to produce a general and synthetic theory of film, but rather as a structure of methodological belief that could guide research in a variety of social sciences and enable communication between them in the systematic formulation of concepts and methodologies.

In developing its own discursive logic, the goal of filmological research was to guide the evolution of a prerational discourse and psychological experience within a coherent scientific framework. In this one can already foresee the friction that would arise between academic filmology and the more cinephilic culture of serious film criticism in France. As a positive science, filmology imposes order and rationality from the outside on a phenomenon considered to be infantile, anarchic, and unreasonable. Guided by a love of reason rather than of art, filmology examined empirically almost every aspect of cinematic experience while ignoring both the formal power of individual films and their

78. One of Lefebvre's more astonishing discoveries in his archival research on filmology was that through Cohen-Séat's connections the Institut's activities were secretly supported and funded by the French government on the assumption that the cinema was not only psychologically dangerous but also a potential weapon of mass destruction, as it were. After the election of de Gaulle in 1959 with Michel Debré as prime minister, the new government asked Cohen-Séat to relinquish control of the Institut and to move his operations under the umbrella of the Centre National des Recherches Scientifiques, which he refused to do. In summer of 1959, the government withdrew funding for Cohen-Séat's projects, including the Institut. The apparently sudden disappearance of filmology at the end of the 1950s was thus as much political as it was intellectual. See Lefebvre's "L'aventure filmologique," esp. 76–90.

value as art forms. Criticism and aesthetic valuation have no place in the filmological project. Only the scientific method promoted by positivism, Cohen-Séat all but insisted, can impose order on the diverse range of disciplines and research projects that can be brought to bear on the full spectrum of filmic and cinematic facts. Along these lines, Cohen-Séat concludes the *Essai* not with a call to theory, but rather with a call for order in filmological research, carried out from the tripled perspectives of philosophy, practice, and science, each of which has a specific role to play. Through cinema, philosophy may acquire new means through which we discover, or challenge, "the knowledge we believe to have of ourselves" (*Essai* 188); this framework is implicitly ethical. Practice is more problematic, however, since for its first fifty years cinema has been abandoned by any systematic approach, even if technicians and artisans bring important knowledge of the forms and techniques of cinema to the table. The final arbiter in this sequence is not philosophy, then, but rather science, which must be brought to the study of cinema to raise knowledge to a new objective and transindividual level. Asking, finally, "What is science?," Cohen-Séat responds with what was perhaps the most oft-cited definition in twentieth-century France, but one that certainly responds to his demand for system and method: "A 'body of knowledge and research having a sufficient degree of unity and generality, and liable to lead individuals subscribing to these conditions to agreed conclusions, which result neither from arbitrary conventions, nor from the taste and individual interests common to them, but rather from objective relations that one discovers gradually, and which one confirms by defined methods of verification."[79] This definition echoes in most respects Dilthey's definition of *Wissenschaft*, and through it filmology sees the path to theory.

The *Essai* thus promotes the study of cinema through what Cohen-Séat calls the "methodical disciplines," the disciplines ruled by method—primarily psychology, sociology, anthropology, and a comparative aesthetics close to and influenced by Max Dessoir's earlier conception of aesthetic science or *Kunstwissenschaft*—that together define a common ground or meeting place for a research program owing to their presumed unity of method and aims. This approach was reflected in the First International Congress of Filmology, which took place at the Sorbonne on 15–21 September 1947, and which established five basic research groups: psychological and experimental research, devoted mostly to cinematic perception and the study of the cinema

---

79. André Lalande, *Vocabulaire technique et critique de la philosophie* (Paris: PUF, 1926), 954; cited in the *Essai*, 189, in my trans.

audience; psychological and sociological studies of "non-normative" subjects, such as children, the mentally disabled, and other "pathological" variants; the aesthetic, sociological, and philosophical analysis of the filmic universe and filmic reality; the comparative and philosophical examination of film as a language, in itself and in relation to other art forms; and finally, a working group on the development of "cinematic empiricism," set up to provide methods and mechanisms for the international exchange of filmological research (*Filmology Movement* 50–52). The immediate effects of this congress were wide-ranging. It attracted academic researchers from throughout Europe, including Italy, England, Belgium, and Switzerland, and cooperative arrangements were quickly established between the Institut de Filmologie at the Sorbonne and analogous institutions in other cities, including Oxford, Madrid, and eventually Milan.

The two-year curriculum of the Institut de Filmologie at the Sorbonne followed similar lines. A section on Psychological Studies, directed by Henri Wallon, offered lectures on film and child psychology, youth and education, and empirical studies of filmic perception. The section on Technical Studies, headed by Cohen-Séat, was devoted mainly to the history of cinema. A third section on General Filmology and Philosophy, directed by Raymond Bayer, included subsections studying "General Morphology," or aesthetic / linguistic approaches to film, as well as the "General Aesthetics of Effects"; a fourth section of Comparative Studies was concerned with film in relation to the other arts. In addition, Lowry identifies sections devoted to "Filmic Anthropology" and "Ethics and Ideology," which included Maurice Merleau-Ponty's noted lecture on "The Signification of the Cinema" (*Filmology Movement* 54). Despite the obvious intention here to balance the social and human sciences, by the end of the 1950s the institute became more and more focused on experimental research and sociological studies of mass communication; by 1954, the *Revue* was publishing only empirical and experimental research.

In this context, the constructed research object of filmology was less film per se than those aspects of cinema that could be defined and studied as "social facts" in Durkheim's sense. Despite the diverse disciplines sheltered under the tent of filmology, and the real difficulty of precisely formulating a common methodological framework, filmological research approached cinema only from angles coincident with its positivistic perspective. Favoring cinematic over filmic facts, as a positive science filmological research was guided by the fundamental principles of Durkhiem's sociology: that social facts have definable empirical properties and form real transindividual systems; that they are subject to principles of determinism in a manner consistent with those of the

physical world; and that social facts are structured by invariant relations or laws that express the network of relations that bind social phenomena into larger systems through discernible relations of causation and interdependence. For all these reasons, the scientific method is the most appropriate framework for investigating the patterns of development and causal laws of social phenomena.[80] Filmology was mostly concerned with generalizable and transindividual forces that act as constraints on individual choices and actions and that operate as a kind of second nature according to recognizable laws—hence Cohen-Séat's vision of cinema as an ideational superreality permeating contemporary society.

Filmology privileged the social and psychological study of the cinematic fact since it believed that only within the realm of the social fact can laws of cause and effect be isolated, determined, and studied. Similarly, filmology quickly found itself studying spectators rather than films. In a 1949 questionnaire published in English and French in issue number 5 of the *Revue,* the object of filmology was defined as "the reactions of the audience during the film and also, naturally, the conditions which produce those reactions. By 'audience' we do not mean only a collection of individuals sitting in front of a screen, but also the groups on which the film can have an effect, either directly or indirectly, through the 'atmosphere' it creates. Those effects or those conditions can be physiological, perceptual, intellectual, aesthetic, ethical or social" (13). In fact, filmology's resolute focus on the psychological and physiological effects of film watching was motivated by the assumption that not only was film a powerful medium for influencing the thought, conduct, and emotions of spectators, it also acted powerfully and directly on the body itself. One of the goals of filmology was to master these dangers, to control them, and to shield spectators from them, especially children and adolescents. As Lowry observes, the empirical audience research carried out by filmology was thus divided into two broad categories. The first category of research tested "the viewer's psycho-physiological responses to filmic stimuli, with an emphasis on the monitoring of brain waves by means of the electroencephalograph (EEG)," and the second category of research employed "methods of psychological testing to provide descriptive data for the evaluation of the film / viewer relationship in terms of the viewer's response, comprehension and memory" (*Filmology Movement* 137). Filmology thus followed a line already traced out in Raymond Bayer's 1947 essay "Cinema and the Human Sciences," where the question of

---

80. See Durkheim's *Les règles de la méthode sociologique* (Paris: Presses Universitaires de France, 1973), esp. chap. 1, "Qu'est-ce qu'un fait social?," 3–14.

the value of cinema was tied explicitly to its sociological force. Here, "sociology becomes axiology," Bayer wrote, and to such a degree that contemporary aesthetics should be a "socio-aesthetics" that gives priority to the social sciences (34). This displacement or resituating of aesthetics was so rapid and complete that, as Lowry notes, when Étienne Souriau's important collection *L'Univers filmique* appeared in 1953, it brought together a group of scholars concerned with aesthetic and stylistical approaches to cinema, including Henri Agel and Jean-Jacques Riniéri, who would never again be published in the *Revue* (*Filmology Movement* 64).

Still, the filmic fact did not entirely disappear from the discourse of filmology. Owing to the stature and influence of Étienne Souriau, the aesthetic study of film within filmology pushed forward and formalized the structural discourse while setting the conditions for a new strain of film theory to emerge: the discourse of signification. In his lifelong effort to formulate a scientific approach to aesthetics, Souriau can be understood as a protostructualist and precursor to film semiology. In a 1980 necrology of Souriau, Christian Metz outlines with great generosity how Souriau opened the French university to the serious study of film and laid the foundations for what would become a structural and semiological approach to film.[81] Yet Souriau's conception of "science" within the human sciences would not be quite the same as structuralism's, though implicitly the two discourses were connected by the undercurrent of positivism already flowing through Formalism.

Despite the increasing marginalization of aesthetic, morphological, and comparative studies in institutional filmology, Souriau was an important figure whose methodological commitments were commensurate with the positivistic bent of the movement, while keeping the study of aesthetics and the filmic fact alive within it. Souriau's structural and comparative approach was strongly influenced by the predominance of *Kunstwissenschaft*'s definition of aesthetics as a positive academic discipline, though he ultimately pushed the "science of aesthetics" in another quite original philosophical direction. In contrast to the semiology that would come to the foreground in the 1960s, Souriau's interest was not in meaning or signification, but rather in the existential analysis of art, or how art comes into being or creates an autonomous

---

81. "Sur un profil d'Étienne Souriau," "L'Art instaurateur" (Special issue on Étienne Souriau), *Revue d'esthétique* 3/4 (1980): 143–160. An English translation was published as "A Profile of Étienne Souriau" in *On Film* 12 (Spring 1984): 5–8; however, all translations here are my own. Also see *The Filmology Movement*, 73–97.

universe through a series of processes that Souriau called "instauration." The comparative method formed the basis of Souriau's approach to a scientific aesthetics, above all in the effort to define and characterize the core features of the "universe" of art and of individual media of art through ascertaining their structural correspondences. Therefore, "If one wishes to penetrate to the heart of each art," Souriau claims in *La Correspondance des arts,* "to seize the primary correspondences, the considerations whose principles are the same regardless of the most varied techniques, to discover laws of proportion or structural schemas as valid for poetry as for architecture, or for painting or dance, a whole new discipline must be founded, new concepts forged, a common vocabulary organized, perhaps inventing truly paradoxical means of investigation.... One therefore evokes here a whole and truly scientific discipline."[82] Seeking the structure of art underlying all of the arts through a positive and comparative methodology, Souriau was completely in sync with the logical framework of filmology.

Souriau's philosophy of art was guided then, no less than Cohen-Séat's, by the directive idea of positivism, and so much so that in an essay on "Filmology and Comparative Aesthetics," Souriau states unambiguously, "The Science of Art is a positive discipline," whose principal task is "to discern clearly the different and essential forms of each art according to their specific materials and constitutive forms."[83] In a 1950 lecture delivered at the institute and subsequently published in the *Revue,* Souriau also explains that "filmology is, must be, wants to be a science. And if a science is not uniquely, according to the celebrated formula of Condillac, 'a well-made language,' it at least requires and supposes such a language. To refuse the effort necessary to establish this language, to adopt it, to take it and to use it in a correct and normal manner, is to be condemned in advance to a scheme of badly posed questions, vague researches without solid and positive results, poorly drafted observations, and provisional and confusingly heuristic studies."[84] Here, the commitment to method is as strong as or stronger than in Cohen-Séat. From his earliest works, such as *L'Avenir de l'esthétique* published in 1929, Souriau sought to establish a systematic, rational, and scientific research program for the study of the aesthetic fact, especially

82. (Paris: Flammarion, 1947), 10–11; my trans.

83. "Filmologie et esthétique comparée," *Revue internationale de filmologie* 10 (April–June 1952): 113; my trans.

84. "La structure de l'univers filmique et le vocabulaire de la filmologie," *Revue internationale de filmologie* 2, no. 7/8 (1951): 231; my trans. Also see Souriau's contribution to *L'Univers filmique,* ed. Étienne Souriau (Paris: Flammarion, 1953), 5–31.

through a comparative approach, a project carried forward in *La Correspondence des arts*. This approach was the foundation for filmology's comparative method, wherein the various arts may be categorized and their common components defined, analyzed, and studied, with a view toward identifying and analyzing a process of coming into being unique to art, and present in every instance or genre of art.

This approach is presented with great clarity in a methodological statement titled "Nature and Limit of the Positive Contributions of Aesthetics to Filmology," published in the first issue of the *Revue internationale de filmologie*.[85] To begin, Souriau asks, what role does aesthetics play in the creation of cinema and, more importantly, what is its "proper and indispensable contribution to a complete and scientific filmology?" (47). Aesthetics groups together several disciplines—psychology, sociology, technological studies—and sets them to work toward a common objective, each one bringing its observations, its laws, and its knowledge of causes producing certain effects. Starting from the point of view of the work of art, the place of aesthetics, then, is to reunite the variety of disconnected facts about art scattered in these domains in order to assemble them systematically so as to reconstitute the unity and specificity of the "fact of art" in itself and in each of its genres. Aesthetics is therefore a normative activity to the extent that it draws from this activity "a theory susceptible to practical applications" (48). "The fact of art is the positive domain of aesthetics," Souriau concludes, "that which is absolutely proper to it, whose only quality is to say *what can give the characteristic of art* to an activity as much as a work" (48). Although very different from the Formalists, Souriau shared with them a certain functionalism, though pushed in a yet more radical direction. Aesthetics, in Souriau's view, was concerned neither with the artist's intentions nor with judgments of artistic quality. "The problem," Souriau writes, "is not to know up until what point an *artistic intention,* more or less superficial or real, and an apparent artistic *quality,* more or less vaguely evaluated or judged by those more or less competent and according to their personal preferences, succeeds in producing commercially interesting results. Rather, it is knowing at what point these results derive from the quantity of *real art* effectively put to work; from this art, I would say, *quantitatively* evaluated

85. Souriau, "Nature et limite des contributions positives de l'Esthétique à la Filmologie," *Revue internationale de filmologie* 1 (July–August 1947): 47–64; my trans.

(even measured) according to methods that are rigorous, objective, and controlled" (49).

This certainty about how to identify the presence of art, and even to measure the quantity of art present in a given work, clearly demonstrates the degree and extent of Souriau's commitment to a science of aesthetics, even if he himself only rarely used empirical methods. Throughout his essay on the "Nature and Limit of the Positive Contributions of Aesthetic to Filmology," and indeed in his entire philosophical oeuvre, Souriau's discursive position is that of an aesthetician "or if you wish," he mentions parenthetically, "a theoretician" ("Nature et limite" 49). At the risk of reading too much or too deeply, Souriau's wry acknowledgment of another term, and perhaps another position of address, signals a profound discursive rupture that will soon take place in the study of film and in the discourse of the human sciences. Souriau uses the term "theory" fairly infrequently. What we might call theory in hindsight is fully accounted for semantically by what Souriau would call, as would most philosophers before the 1960s, aesthetics or aesthetic science. In any case, when he evokes the term, for Souriau aesthetics and theory are interchangeable, with the proviso that aesthetics becomes theory when it aspires to the logical conditions and methods of a positive science.

And it is here that the rupture of the discourse of signification will become most apparent, and where aesthetics will become diminished and displaced by theory in the rhetorical strategies and concept formations of the human sciences in the great decade of structuralism. Aesthetics is concerned with the existence and value of art, both of which are measurable qualities for Souriau. Therefore, in his view, the positive contributions of aesthetics to filmology are threefold: "on one hand, the choice and indication . . . of facts that concern and directly condition the artistic value of film; on the other, study of the systematic assembly of these facts, as they come together in a truly artistic film; finally, indication of the conditions that model and specify aesthetic knowledge in general, in its particular applications to the art of film" ("Nature et limite" 50).

This last activity is what Souriau would call theory, perhaps. Nonetheless, filmology's dreams of a unified and unifying method creating a positive science of film ultimately proved elusive. The Second International Congress of Filmology took place at the Sorbonne in 1955, almost eight years after the first. Despite the fact that it brought together 350 delegates from twenty-nine countries, in retrospect it was the swan song of the short-lived movement. Lowry notes that the movement, rather than moving forward toward a global and

synthetic account of cinematic experience, fractured along disciplinary lines, fraying into "a hierarchy of hermetic discourses attached to various university disciplines which acknowledged one another largely on the level of rhetoric" (*Filmology Movement* 157). As the positive science of filmology gravitated more and more to strictly empirical methods, the study of film through aesthetics, phenomenology, history, or psychoanalysis, all previously included under the tent of filmology, became more and more marginal. Moreover, in the decade to come, the problem of aesthetic value would disappear almost entirely from the structural discourse to be displaced by the discourse of signification on the one hand and the critique of ideology on the other. Filmology would be rapidly replaced by another claimant to method in the human sciences, often contested and marginal but rapidly gaining ground throughout the 1950s: structuralism and the discourse of semiology.

Filmology thus occupies a curious place in the temporal parentheses opened between Aristarco and Metz. "Theory" as a concept, or as a characterization of a certain genre of discourse, is almost entirely absent from filmology, despite the imprimatur given it by Aristarco's 1951 collection. To the extent that theory has a place or function in the protostructuralism of filmology, it veered in two directions. On one hand, the conclusion of Cohen-Séat's *Essai sur les principes d'une philosophie du cinéma* suggests that theory may be only an intermediate stage of formulating concepts and methods that will yield a complete positive science of film—not a film theory but a filmology. Filmology did not produce an overarching theory of film or cinema. Yet it offered many intermediate theories of aspects of cinema, such as the perception of motion, depth, and rhythm, and made real conceptual contributions to the psychological study of moving images. In each of these cases, following the directive idea of positivism, the social sciences modeled their research on the natural sciences, formulating hypotheses, collecting data, and progressing piecemeal toward a larger picture of the phenomena under investigation. Alternatively, Souriau suggests that the comparative method already involves a positive science—aesthetics—and so much so that a properly conceived positive aesthetics is already synonymous with theory. The positive contribution of aesthetics to filmology is, for all intents and purposes, only to show how film may be included in a general science of comparative aesthetics, which for Souriau was already fairly well elaborated.

However, here one last absence is worth commentary. Filmology was remarkably, if not willfully, ignorant of the more general discourse of serious

film criticism, research, and analysis. Further, it demonstrated almost no knowl-
edge or awareness of the fifty-year history of writing on film that was being exca-
vated and canonized by Aristarco and others in the postwar period. What I
have called the aesthetic discourse was largely invisible to filmology. Filmol-
ogy was thus entirely concerned with defining and investigating filmic and
cinematic phenomena inductively and within the methodological framework
of a positive science. Theories could be produced only within that conceptual
framework, and therefore, implicitly other kinds of discourse were scientifi-
cally invalid and institutionally unrecognized. There was no history of film
theory for filmology because, in its own perspective, the possibility of a theory
in which filmic and cinematic facts would be established and play a part only
begins with filmology. For someone like Aristarco to collect, value, and iden-
tify these writings as a canon of "film theory" might very well have repre-
sented the attempt to give this work an institutional standing it had as yet in
no way achieved.

The evocation of Aristarco is important here because of the influence of
filmology in Italy and its afterlife there. In the late 1940s and early 1950s, for
example, *Bianco e nero* had an active interest in French filmological research
and translated several essays. As Lowry observes, in the years following the
second Congress, filmological research regrouped in Italy under the aegis of
Luigi Chiarini and Umberto Barbaro. The *Revue internationale de filmologie,*
renamed *Ikon* and still published today, moved to Milan in 1962. Still, Aristar-
co's usage remained unusual for an indefinite period. Reviewing the journal
up to and just after the first publication of Aristarco's collection turns up only
infrequent evocations of theory, with the exception of Aristarco's contribu-
tions, which include studies of "the theory of Canudo," or of Rotha or Eisen-
stein, for example. (An interesting exception is a multipart essay by Giuseppe
Massi, "Per una teoria dinamica dell'espressione cinematografica.") Yearly
indexes through 1951 categorize articles under the headings General and
Various; Aesthetics; Criticism and History; Filmology; Cinema and Music;
Documentary; Didactic Cinema; Intellectuals and Cinema; Economy and Pro-
duction; Technology; Small Formats; and book and film reviews. The presence
of "filmology" and the absence of "theory" are significant. While "theory" is
emerging in the titles of some articles, in indices they are usually character-
ized generically under the headings Aesthetics and Filmology. More often
than not, "Filmology" referred to empirical studies by specialized academics
in psychology and other empirical disciplines. Aristarco is writing a number

of essays, however, like "The Theory of Eisenstein," that indicate discursively the appearance of a gradual substitution, and a new use, in which theory comes to substitute for aesthetics. For a short time at least, the term "filmology" covered sociological or psychological theories within the study of cinema, while "aesthetics" indicated general and philosophical approaches to film. By 1951, Filmology is dropped as a heading, while an interest in aesthetics remains widespread, though with its own ebbs and flows.

Souriau was a curious transitional figure in this context, a crossroad or cloverleaf where various possible paths of theory intersected, bridged, and bypassed one another. Though respected and appreciated by Roland Barthes, Raymond Bellour, and Christian Metz, he was in no way part of the semiological generation or its institutional context. Still, the undercurrent of positivism in Formalism and linguistics, as they traveled from Saint Petersburg and Moscow to Prague, New York, and Paris, enabled cine-structuralism to recognize in Souriau a fatherly precursor. This "scientific" orientation of filmology was not completely antithetical to new attitudes toward the human sciences, nor was it alien to the emergent, parallel discourse of structuralism. Still following Cohen-Séat's maxim that "to understand is first to systematize" or that film is a "logic awaiting its laws," and exhibiting above all in Souriau's comparative aesthetics a concern with defining structures that underlay the logic of human expression, structuralism and filmology had many points of contact. At the same time, neither linguistics nor semiology was recognized as an accepted method of filmology, whether in comparative aesthetics or anthropology, nor did they have any institutional currency in French universities of the 1950s. While at least in film study Souriau's influence and generosity set an enabling context for the discourse of signification, and filmology itself made the study of cinema possible in an academic context, the discourse of semiology was still suspiciously foreign to French academics in both the figurative and literal sense. Its flowering in the 1960s would mark a real scientific revolution.

## 15. A Small History of Structuralism

> And now, let those who are weak on vocabulary, let those with little compre-
> hension of theory call all this—if its appeal is stronger than its meaning for
> them—structuralism.
>
> —Michel Foucault, "The Discourse on Language"

In his necrology for Étienne Souriau written in 1980, Christian Metz asserts that
*l'Univers filmique,* published in 1951, remains one of the most indispensable
works on cinema ever written. Although filmology was at that time almost for-
gotten in France and hardly known in anglophone countries, with characteristic
generosity Metz foregrounds links between filmology, structuralism, and film
semiology that are often forgotten in accounts of the postwar film period. Among
the most important connections was Souriau's role with Cohen-Séat in opening
the French academy to the study of cinema. (Metz's own role in the 1960s and
1970s will be no less important.) And despite the fact that Souriau published
comparatively little on film, Metz outlines convincingly Souriau's contribu-
tions to the (unfinished and incomplete) progress toward theory, including a
version of theory that will later include both semiology and psychoanalysis.

Metz's inclusive gesture, however, is less straightforward than appears at
first glance and offers insight into a new conception of theory that begins to
form in the 1960s through the full emergence of the discourse of signification
against the background of structuralism's conceptual transformations of lin-
guistics, anthropology, and psychoanalysis, and where Metz himself will play a
fundamental institutional and conceptual role. In his retrospective, and perhaps
retrojecting, survey of Souriau's contributions to film study, Metz describes an
erratic and incomplete trajectory that models in miniature the invention and
transformation of a discursive landscape where theory and film are mapped
and located as neighboring domains. In a way that echoes Souriau's remark
on "theory" in "Nature et limite des contributions positives de l'Esthétique à
la Filmologie," Metz notes that in Souriau's writings, "One does not find a
(complete) theory of cinema. He cared little for it" *(on ne trouvera pas chez lui
une théorie (complète) du cinéma. Il n'en avait cure)* ("Sur un profil" 148), and
that one finds in Souriau "a constant rigor without ever any 'scientific' claims"
(148). Certainly, it is true to say that Souriau did not attempt or wish to present
a complete theory of cinema. In any case, as will soon be seen, according to
Metz's conception of theory this would not have been conceptually possible. But
to say that Souriau cared little for theory or was cured of it opens an interesting

breach in this retrospective account, one that can be accounted for only in a broader discursive context. Already, Souriau's (and indeed all of filmology's) view of theory as marked by the protocols and methods of a positive science are not Metz's conceptions and characterizations of theory. For Souriau, aesthetics was everything, and the aesthetician, working in the context of positivism and *Kunstwissenschaft,* was already a theoretician working "scientifically," and with such confidence that it could go unmentioned. For Souriau, filmology was probably a long though important footnote to aesthetics as a total conceptual system accounting for all the arts and for the fact of art itself. For Metz, this perspective is in some respects reversed. Souriau here makes interventions, stages or stepping-stones toward a film theory yet to be accomplished. Moreover, later in the same paragraph, Metz mentions, in homage to Souriau's epistemological modesty, that the human sciences are not sciences in the strict sense, even if they differ from literature or philosophy, and in this case, they are not theory or theoretical in Souriau's sense.

These comments from 1980 show a modesty that is at odds with structuralism's claims in the 1960s to have founded a new conception of the human sciences, indeed to have placed the critical study of culture on a scientific footing. In his first major academic essay, "Le cinéma: Langue ou langage?," Metz already challenges, often in surprising ways, the scientific claims of hard structuralism. This essay was published in 1964 in the special and somewhat legendary issue number 4 of *Communications* devoted to "Semiological Research" under the direction of Roland Barthes. The number also contained Barthes's seminal work "Elements of Semiology," and was widely considered to be the opening volley in structuralism's attempt to promote a Saussurian-inflected semiology as the method for the critical study of culture, a project whose first important programmatic statement was Barthes's essay "Myth Today," which appeared as the second half of *Mythologies.*[86] The issue included not only Metz's "Le cinéma: Langue ou langage?" but also an important text by Claude

---

86. (Paris: Éditions du Seuil, 1957); trans. Annette Lavers (New York: Hill and Wang, 1972). The book collected a series of essays on contemporary France that Barthes published in *Les letters nouvelles, Ésprit,* and *France-Observateur* between 1954 and 1956. His 1970 preface brings into sharp focus the critical nature of the semiological project of the time: "on the one hand, an ideological critique bearing on the language of so-called mass-culture; on the other, a first attempt to analyse semiologically the mechanics of this language. I had just read Saussure and as a result acquired the conviction that by treating 'collective representations' as sign-systems, one might hope to go further than the pious show of unmasking them and account in detail for the mystification which transforms petit-bourgeois culture into a universal nature" (9).

Brémond on Vladimir Propp, "Le message narratif," and Tzvetan Todorov's first published essay in French, "La description de la signification en littéra-ture." Metz's essay, to which I will return, not only has a central role in the es-tablishment of a general semiology as a model for the human sciences, it can also be read retrospectively as a foundational text on the possibilities and pros-pects of and for theory in the senses most familiar to us in any domain of the arts and humanities.

The sudden disappearance of filmology around 1960 as a discourse, as an institutional setting for research on cinema, and as an approach to what Cohen-Séat would later call "visual information" is less striking when one considers the web of institutional filiations linking it no longer to the Sorbonne, but rather to a rival institution: the École Pratique des Hautes Études (EPHE). Indeed, on a closer look, one sees less a definitive break between filmology and structural-ism than a series of displacements and generational shifts. Roland Barthes taught with Souriau at the Institut de Filmologie, published two essays in its *Revue,* and accompanied Cohen-Séat to an important conference in Milan in 1960.[87] Claude Brémond, another founding figure for the structural analysis of narrative, worked with Cohen-Séat as a research assistant. Indeed, all of the members of the editorial committee of *Communications*—Georges Friedman, Barthes, Bremond, Edgar and Violette Morin—worked with the Institut in capacities great and small throughout the 1950s. In this manner, the Centre d'études des communications de masse (CECMAS), created in 1960 and di-rected by Georges Friedmann at the EPHE, as well as the editorial home of *Com-munications,* can be understood as an institutional successor to the recently

87. See Barthes's review of the "Première Conférence internationale sur l'Information visuelle," *Communications* 1 (1961): 223–225; my trans. In this short but provocative report, Barthes also draws clear lines of demarcation between the filmological and semiological projects. Among his main objections are to how "visual information" is constructed as an object of knowledge and how as a model for mass media cinema is only considered as information analyzable in its effects. "To a sociology or a physiology of visual information," Barthes writes, "one needs to add a semantic of images" (224). Moreover, in response to filmology's conception of the dangerous and irrational nature of images, Barthes adds that "one knows that mass communication considered in its actu-ality, according to the most recent research, rarely modifies information: above all it confirms beliefs, dispositions, sentiments, and ideologies that are already given in the social, economic, or cultural state of the public analyzed" (224). That mass communications only transmit or sustain given attitudes both deprives censorship of its rationale and filmology of one of its fundamental assumptions—that the cinema is a dangerous and active psychological force capable of modeling the behavior of a receptive public. Here a discursive transformation is already taking place along institutional, conceptual, and rhetorical lines. Also see François Albéra and Martin Lefebvre's "Présentation: Filmologie, le retour?," *CiNéMAS* 19, no. 2–3 (Spring 2009): 29–33.

closed Institut, though emphasizing sociology and anthropology over experimental psychology. In stronger terms, the research produced and published through CECMAS gives evidence of a rapid transformation around 1960—an institutional, conceptual, and rhetorical reorganization where the emergent discourse of signification changes almost entirely the stakes of "theory," not only in relation to film but also for the critical study of culture in general. As the institutional home for structuralism's epistemological and critical revolution, the EPHE was also the primary site promoting and putting into practice Saussure's vision for expanding linguistics into a general semiology accounting for all aspects and objects of culture in their capacity for signification.

To account fully for what film theory becomes within the horizons of the discourse of signification means tracing out how that discourse is framed historically by structuralism, and what theory means to structuralism, or not. On one hand, there are clear continuities between filmology and structuralism, most of which also pass through and nourish the main conceptual components of the discourse of signification through its genealogical roots in Russian Formalism, Prague School structuralism, and even some variants of Marxist critical theory. The influence of Durkheim and a common commitment to sociology are always historically present here in a broad network of capillaries leading back to the beating heart of positivism, and to the idea that the human sciences are nonetheless sciences in a fairly well-defined sense. On the other hand, once we turn to look more closely at the founding debates for a *film* semiology in the 1960s, the ruptures or discontinuities through which the aesthetic discourse passes into the discourse on signification will be more clearly seen.

Barthes's deeply influential account of the "Elements of Semiology" was the capstone of *Communications* 4, which both retrospectively and at the time of its publication was understood as a collective manifesto presenting structural linguistics as a model for literary and cultural analysis. Drawn from his seminar taught in the sixth section of the EPHE, the work is a product of a moment when Barthes was overtaken with a "methodological intoxication" or passion whose dream was twofold: first, to make of semiology a truly scientific enterprise based on the methods and conceptual vocabulary of Louis Hjelmslev's structural linguistics, and second, to fulfill Saussure's vision of a general semiology accounting for the life of signs in society.[88]

88. This self-characterization is from a 1970 television interview with Barthes. See François Dosse's *Histoire du structuralisme I. Le champ du signe (1945–1966)* (Paris: Éditions de la Découverte, 1992), 243. I am indebted throughout this section to Dosse's detailed conceptual and in-

In the conclusion to this long essay, Barthes foregrounds how the objectives of semiological research are marked by a certain functionalism, strongly reminiscent of Formalism and Prague School structuralism, that aspires "to reconstitute the functioning of systems of signification other than speech [*langue*] in accordance with the project of all structuralist activity, which is to build a *simulacrum* of the observed objects."[89] The epistemological status and clarity of this enterprise rely on borrowing from linguistics the idea that analysis is guided by clear principles of pertinence. The concept is already familiar to us from Eikhenbaum's "Theory of the 'Formal Method'." Through a process of framing or limitation, "one decides to describe the assembled facts only from *a single point of view,* and consequently, only to retain from the heterogeneous mass of these facts the traits that interest this point of view to the exclusion of all others" (*Elements of Semiology* 95, *132*). Thus, phonology, in Barthes's example, concerns itself only with the sound of language as a physical and articulatory system. In a similar way, semiology is concerned primarily with how objects attain meaning within implicit or explicit systems of signification considered apart from other determinations, whether psychological, sociological, economic, or physical. In this manner, Barthes continues, "The principle of pertinence surely constrains the analyst to a situation of *immanence*—one observes a *given* system from the *interior.* However, as the examined system is not understood in advance of its limits (since this involves precisely reconstituting the system), at the beginning *immanence* can only apply to a heteroclite set of facts, which it must 'treat' in order to know the structure" (96, *133*).

Thus a material is assembled or framed in advance of analysis according to choices that may be unavoidably and inevitably arbitrary—Barthes calls this "the corpus." On one hand, the corpus must be large enough that one can have a reasonable expectation of defining a fairly complete system of resemblances and differences. On the other, the corpus must be as homogenous as possible, meaning in the first case, having substantial consistency. In Barthes's examples, the phonologist works only on the substance of spoken language; or in film, one must examine the multiple expressive substances of image, speech, and music in their formal interrelationships and exchanges. One may allow a

---

stitutional account of the history of structuralism in France. Trans. Deborah Glassman as *History of Structuralism,* vol. 1, *The Rising Sign (1945–1966)* (Minneapolis: University of Minnesota Press, 1997), 205; trans. mod. Italicized page numbers refer to the original publication.

89. *The Elements of Semiology,* trans. Annette Lavers and Colin Smith (New York: Noonday Press, 1988), 95, *132;* trans. mod. Italicized page numbers refer to the original publication in *Communications* 4.

heterogeneous corpus, then, on two conditions: the systematic articulations of included substances must be carefully studied, and the same "structural interpretation" must be applied to their heterogeneity (*Elements of Semiology* 98). The structural interpretation thus follows conditions outlined in Saussure's *Cours,* especially with respect to the necessity of synchronic analysis. A temporal homogeneity must overlay the substantive heterogeneity, and the corpus must maximally eliminate diachronic elements: "it must coincide with a state of the system, a 'slice' of history" (98, *134*). Along these lines, Barthes insists that one should not prejudge the rhythm of systemic change because "the perhaps essential objective of semiological research ( . . . ) is precisely to discover the proper time of systems, the history of forms" (98, *134*). Or as Barthes will put it in an equally famous essay, the structuralist activity takes from Saussure the necessity of a certain "immobilization of time . . . in so far as diachrony tends to represent the historical process as a pure succession of forms."[90]

These among others are determined elements that unite semiology and an earlier Formalism into a common discourse of signification. Barthes's methodological essay also implicitly exhibits another link between formalism, filmology, and semiology—that is, their common attitude that research progresses by gradually assembling or incorporating elements (facts, concepts, methods, even disciplines) into ever-larger and more unified systems. All three discourses are equally marked by an implicit teleological attitude where the idea of eventually constructing a complete explanatory account of the objects considered by the discourse drives each domain.

There are also significant differences, however. In striving to be scientific, formalism aspired to be value neutral; in the passage from filmology to semiology, the axiological component of filmology (film is not "rational" discourse) disappears or is displaced by the critical commentary of structuralism. As conceived in Barthes's earlier work, *Mythologies,* semiology was here understood as a contestatory and countercultural enterprise—a method for both the social analysis of mass cultural signification and the critical deconstruction of myth and ideology as structures of naturalized meaning. Barthes's structuralist activity is thus guided by a certain *directed* functionalism, which studies not the meaning or signified of objects, but rather their conditions of

90. Originally published in *Lettres nouvelles* as "L'activité structuraliste" in February 1963, the essay was soon reprinted in Barthes's *Essais Critiques* (Paris: Éditions du Seuil, 1964), 213. Trans. by Richard Howard as "The Structuralist Activity" in *Critical Essays* (Evanston, Ill.: Northwestern University Press, 1972), 214. French page numbers are given italics when the translation is modified.

intelligibility, or what makes meaning or signification possible. Barthes felt strongly that while meaning is a fact of culture, culture tends to naturalize the process of signification by making the signifier slip behind the signified. Semiological analysis, then, was meant to reverse this process in an interested model or simulacrum, and thus to contribute to a decryption of the cultural code, a denaturalization of the process of signification, and a critique of ideology. Clearly, the structuralist activity is marked by a certain *ethos,* a stance or perspective on culture that is both epistemological and evaluative—it is nothing less than the imagination of a new conceptual and enunciative position in theory. Thus one striking aspect of the essay, as Metz recognizes later, is Barthes's definition of structuralism not as a school or movement, but rather as a conceptual approach to the world defining a practice, an activity, even a way of life, where it is necessary to place both analysts and creators "under the common sign of what we might call *structural man,* defined not by his ideas or his languages, but by his imagination, or better yet, his *imaginary,* that is to say, the way in which he mentally lives structure. . . . [Structuralism] is essentially an *activity,* which is to say, the controlled succession of a number of mental operations" ("Structuralist Activity" 214, *214*). These operations are guided by a very particular will to knowledge. If the heart of the structuralist activity is to decompose the real in order to reproduce its systematic functioning in a simulacrum, between these two gestures or processes one also produces the *new;* one does not simply reproduce the object in another form as much as give it intelligibility or a newly apparent conceptual clarity: "The simulacrum," writes Barthes, "is intellect added to the object, and this addition has anthropological value in that it is man himself, his history, his situation, his freedom, and even the resistance that nature opposes to his mind" (215, *215*). Later, Barthes names this new ethical perspective: "Homo significans: such would be the new man of structural research" (217, *218*).

The promise of structuralism in Barthes's first conception was that of a method tending toward a science, indeed providing a new context and definition for the human sciences but also a new critical consciousness. This approach was coincident with Claude Levi-Strauss's conviction that semiology should be conceived as a *critical* sociology, not only a scientific practice but also a demystifying one that investigated the unconscious and unapparent logics of signification through which culture is produced. This attitude was representative of Levi-Strauss's commitments to the importance of both Freud and Marx for structuralism, and reinforced by his habit of rereading Marx's *18th Brumaire of Louis Napoleon* each time he undertook a new project. At the

same time, semiology and structural linguistics were still considered marginal disciplines by the Sorbonne, the citadel of academic prestige in France. During the 1950s, they were nonetheless growing in stature owing to the steadily increasingly influence of Levi-Strauss, especially after the critical and commercial success of *Triste Tropiques* in 1955; in turn, *Structural Anthropology,* Levi-Strauss's collection of essays from 1958, was considered for many years to be the founding methodological text of structuralism. Further, because of Levi-Strauss's association with the EPHE, structuralism and semiology found a winter garden where they could flourish and blossom throughout the 1950s and into the 1960s.

The main concepts of structural anthropology were forged at the New School for Social Research in New York, where Levi-Strauss sat out the war and completed his 1948 thesis, *The Elementary Structures of Kinship,* a work that would soon be viewed as igniting an epistemological revolution in the human sciences. Here Formalism and the Prague School rejoin the story of theory. In 1942, Levi-Strauss encountered Roman Jakobson at the New School, where he followed Jakobson's course on phonology and where Jakobson attended Levi-Strauss's course on kinship relations; the two thinkers would have a profound effect on one another, their lines of thought meeting on the common ground of "structure" and their common interest in Ferdinand de Saussure. Jakobson had discovered Saussure's *Course on General Linguistics* in Prague in the 1920s, through his work on phonology with Nikolai Trubetzkoy and his involvement with the Prague Linguistic Circle. A concept descending more from Durkheim's *Rules of Sociological Method* than from Saussure, structuralism built upon a number of Formalism's fundamental principles, including an emphasis on the immanence of poetic language defined by principles of pertinence distinct from those of practical language, the formulation of a concept of poetic structure as a dynamic whole having an internal coherence greater than the sum of its parts, and finally, the desire to use linguistics to make of poetics a nomothetic science.

Levi-Strauss's often-stated ambition was to make structural anthropology the foundation of a new, unified conception of the human sciences. Indeed, the concept of structure in Levi-Strauss should be understood as a remapping of the concept of "science" in the human sciences, and in turn, as nourishing a certain conception of "theory." Levi-Strauss brought an idea of science to the study of societies that joined structuralism to the main lines of Comtean positivism, though Levi-Strauss certainly did not share positivism's optimism for the progress of human evolution. Still, the influence of positivism is felt in

his conviction that knowledge should be organized in every domain on the model of the scientific method and should aspire to the same rigors as the natural sciences.

This attraction to an idea of science can also be understood historically as a withdrawal from and a challenge to philosophy, as we have already seen in Tihanov's account of the invention and decline of literary theory. Structuralism thus emerged in the context of a postwar disappointment with philosophy, whether phenomenological or Marxist, in its failures to formulate a secure epistemology and to assert itself as a substantial critical force. In Dosse's view, the scientific claims of linguistics as a sort of hard theory, rigorous in its concepts and open to mathematical modeling, were an instrument of "de-ideologization" for a number of militant intellectuals influenced by Levi-Strauss and disappointed by the political disillusions of the postwar period. In the search for an escape from existential disarray, hard structuralism had "a tendency to ontologize structure that, in the name of Science and Theory, became an alternative to traditional Western metaphysics" (*History of Structuralism I* xx).

Levi-Strauss claimed a pivotal role for anthropology in this program because, in his view, it lay at the intersection of the natural and human sciences, and thus anthropology "does not despair of waking among the natural sciences at the hour of last judgment."[91] The influence of Jakobson's conception of linguistics and poetics is keenly felt here. Both formalism and the Prague Circle tended toward the idea that a science is founded on clearly defined principles of pertinence—that is, a poetic science can develop independently of metaphysics or philosophy only if it concentrates on restricted and therefore definable aspects of reality. Semiology's methodological focus on locating the elementary and distinctive unities of language as fundamental and coded articulations defined through the binary distinctions of signifier / signified, denotation / connotation, expression / content, paradigm / syntagm, and synchrony / diachrony brought new concepts and principles of pertinence to this enterprise. Moreover, through the model and methods of linguistics, especially phonology, structuralism sought to bring the human sciences closer to the model of the exact sciences, or at least to efface or reduce the frontier between them. The principles of phonology, especially Jakobson's Saussurian-influenced version, inspired a number of structuralism's fundamental ideas and kindled Levi-Strauss's conviction that structural analysis would find "its

91. "Le Champ de l'anthropologie" (Leçon inaugurale au Collège de France, 5 January 1960), in *Anthropologie structurale deux* (Paris: Plon, 1973), 29; my trans.

model is already in the body," because phonology lay at the intersection of the corporal, the psychological, and the cultural.[92] Phonology was also understood as addressing phenomena that do not operate on a conscious level; language was thus conceived as a transindividual or asubjective structure operating outside of the purview of consciousness or individual agents' subjective judgments. Levi-Strauss also asserted, "Like phonemes, the terms of kinship are elements of signification; like them, they acquire signification only on the condition of integrating themselves into systems."[93] Here one sees the influence not only of Saussure but also of Durkheim or Marcel Mauss. Meaning or signification arises only as a system of differential relations, and the goal of the human sciences will be to construct general and nonsubjective laws from the study of systems of signification.

In its search for systematic invariants in the multitude of iterative instances, and its emphasis on the unconscious components of structure by withdrawing from any recourse to a self-conscious subject of speech, structuralism also sought an epistemological security alternative to the models of postwar French philosophy, especially the existential phenomenology of Jean-Paul Sartre. The very definition of structure in Levi-Strauss or Jakobson was that of a signification without a subject, and this perhaps also promoted a certain scientific conception of knowledge as free of subjective conditioning. In a way that would deeply influence Jacques Lacan, Levi-Strauss remodeled Saussure's concept of the sign by giving a dominant role to the signifier: "Like language, the social is an autonomous reality (the same one, by the way); symbols are more real than what they symbolize; the signifier precedes and determines the signified."[94] The code is independent of the message and the subject is always submitted to the law of the signifier. In all of these ways, structural linguistics was considered as modeling and guiding the methodological and epistemological claims of the social sciences in general. And as structuralism's influence began to spread in France throughout the 1950s and into the 1960s, the domains of linguistics, anthropology, and psychoanalysis all tended to conceive of structure as an immanent or virtual force, something outside the reach of consciousness and manifest meaning, that underlay all the systems of culture.

92. See *L'homme nu* (Paris: Plon, 1971), 619; my trans. On the importance of phonology for the conceptual foundation of structuralism, also see Dosse, 38–41.

93. "L'Analyse structurale en linguistique et en anthropologie," in *Anthropologie structurale deux* (Paris: Plon, 1958), 40–41; my trans.

94. "Introduction à l'oeuvre de Marcel Mauss," in *M. Mauss, Sociologie et anthropologie* [1950] (Paris: PUF, 1968), xxxii; my trans.

One can see a direct link between filmology and structuralism, then, through the influence of Durkheim and positivism, especially in their similar commitments to the concept of the social fact, and in their concept of culture as an autonomous and independent structure. At the same time, these two discursive formations are divided by structuralism's deep commitment to linguistics and the problem of signification. A sidebar for filmology, the problem of discourse becomes the central feature of structuralism. Indeed, despite the presence and increasing influence of André Martinet, who came to the Sorbonne in 1955, linguistics was seen as a minor and technical discipline by the French academy, still dominated by commitments to philology and historical grammar. Alternatively, to a whole generation of French thinkers coming of age in the immediate postwar period, structuralism and semiology were embraced as particularly modern or cutting-edge methods, attractive in their disciplinary confrontations with the university establishment. One better understands in this context the institutional friction between the Sorbonne and the EPHE, and later, with the Althusser faction at the École Normale Supérieure, exemplified in an anecdote reported by Dosse. When Tzvetan Todorov came to Paris from Bulgaria in 1963 to study what he called the "theory of literature" at the Sorbonne, he was astounded at his total rejection by the dean: "He looked at me as if I came from another planet, and very coldly told me that literary theory was not practiced at this university, and it is out of the question that it will be" (*History of Structuralism I* 194, *230*). For the structuralist generation, the Sorbonne was an emblem of an enclosed and static institution, resistant to change and new thought. Adventurous young thinkers like Todorov or Metz would find a more welcoming home at the EPHE.[95]

Though odd to think of now, virtually all of the leading figures of structuralism were based in institutions that, while often prestigious, were still subordinate to the main institutions of academic power like the Sorbonne, or else like Jacques Lacan they followed career arcs at the margins or completely outside the traditional university system. This observation provides insight

---

95. The academically marginal status of the key authors of structuralism and poststructuralism is also represented in Pierre Bourdieu's recounting of "the astonishment of a certain young American visitor, at the beginning of the seventies, to whom I had to explain that all his intellectual heroes, like Althusser, Barthes, Deleuze, Derrida, and Foucault, not to mention the minor prophets of the moment, held marginal positions in the university system which often disqualified them from officially directing research (in several cases, they had not themselves written a thesis, at least not in canonical form, and were therefore not allowed to direct one)." See his "Preface to the English Edition" of *Homo Academicus,* trans. Peter Collier (Stanford, Calif.: Stanford University Press, 1988), xviii.

into the unique institutional position of the sixth section of the EPHE for the history of structuralism and the emergence of the discourse of signification. Created in 1868, the EPHE had an interesting status with respect to other French institutions of higher learning in that instructors, called *directeurs d'études,* could be recruited from outside the university system and were not required to have higher degrees. Students could also follow courses without having passed the French *baccalauréat.* Roland Barthes, for example, had no degree higher than a *licence* in classical literature, and his project for a *doctorat d'État,* eventually published in 1967 as *The Fashion System,* was refused by both André Martinet and Claude Levi-Strauss. (Remember that Canudo also lectured on aesthetics at the EPHE in the 1910s in his capacity as a practicing critic.) In 1947, the sixth section of the EPHE, previously devoted only to economics, was restructured under the leadership of Marc Bloch and Lucien Febvre into a section called "Social and Economic Sciences," eventually evolving to become an independent institution in 1975, the École des Hautes Études en Sciences Sociales (EHESS).

Levi-Strauss returned to France under the sponsorship of Georges Dumézil, where in 1949 he became a *directeur d'études* on "Peoples without Writing" in the fifth section of the EPHE (Sciences of Religion). Elected to the Collège de France ten years later, Levi-Strauss continued to exert profound influence on the EPHE. The two other key figures in this context were Roland Barthes and Algirdas-Julien Greimas, who were close friends since the time they both taught at the University of Alexandria in the early 1950s. In fact, Barthes discovered Saussure and Hjelmslev through Greimas, and Greimas's commitment to a version of structural linguistics, proximate to the hard sciences and committed to the rigors of mathematical modeling, fueled Barthes's methodological passion for semiology.

Roland Barthes joined the EPHE in 1962 and two years later was appointed a *directeur d'études* in the sociology and semiology of signs and symbols, where his seminars exerted considerable influence, especially the famous course on the elements of semiology. Greimas, however, was considered by many to be the intellectual leader of the semiological program. Influenced deeply by Levi-Strauss's structural anthropology and by Merleau-Ponty's program for remapping philosophy in the context of a new vision for the human sciences dominated by Saussure and Levi-Strauss, in 1956 Greimas published one of the fundamental manifestos of structuralism, "The Actuality of Saussurianism," in which semiology was promoted as the foundation for a unifying method for the social sciences in its vision of culture as a structured and

signifying system.[96] With the support of Levi-Strauss, Barthes helped to elect Greimas to the sixth section of the EPHE in 1965, where he organized a research group devoted to linguistics and semiology within the laboratory of social anthropology of the EPHE and the Collège de France under Levi-Strauss, whose activities would support the early careers of Oswald Ducrot, Gérard Gennette, Tzvetan Todorov, Christian Metz, and later, Julia Kristeva. (Metz served as secretary-general for the laboratory from 1966 to 1969.) It is also worth noting that through the interventions of Fernand Braudel and Louis Althusser, in 1964, after the creation of the École française de psychanalyse, Jacques Lacan's seminars were given a home at the École normale supérieure through the sixth section of the EPHE, a relationship that would continue for five years. The EPHE was thus the intellectual heart as well as the institutional base for the structuralist program, and throughout the 1960s, Levi-Strauss, Greimas, and Lacan were considered something like a troika of a "hard" structuralism that promoted a conception of the human sciences aspiring to the methodological unity and rigor of the natural sciences.

The place of "science" in this new conception of the human sciences functioned in curious ways that illuminate both structuralism's frictions with postwar French philosophy and the place of theory in the discursive formation of structuralism. If structuralism is now associated with Theory in a contemporary context, this is owing to a retroactive, and retrojecting, construction through the emergence of the discourse of ideology after the late 1960s. Just as the discourse of filmology needed no special concept of theory ("filmology" already signified a scientific theory for its adherents), analogously, "semiology" also already signified a critical and scientific approach. By the same token, if one could found a semiology of film, there would be no need for a theory of film, which in any case would be only a subset of a general semiology.[97] No special concept of theory was needed beyond that which was

96. "L'Actualité du saussurisme," *Le Français moderne* 24 (1956): 191–203. This essay was written to celebrate the fortieth anniversary of the publication of Saussure's *Cours de linguistique générale*. Greimas's later work *Semantique structurale* (Paris: Larousse, 1966) became a key text of a structural linguistics gravitating toward mathematical modeling and the hard sciences.

97. What will make Metz's texts yet more striking in this context, then, is the absence of a special concept of theory in other key works of the 1960s, including Mitry's *Aesthetics and Psychology of Cinema* and Noël Burch's *Praxis du cinéma*. This absence is coincident with the perspective of structuralism wherein "semiology" was largely substituted for "theory." Even Peter Wollen's *Signs and Meaning in the Cinema,* arguably the first English language book of modern film theory, initially cast itself in the context of aesthetics and the history of aesthetic thought. The 1972 conclusion to the revised edition, with its early account of poststructuralism, thus marked out a

already signified by semiology as a covering term. (Indeed, a fundamental characteristic of the discourse of ideology and political modernism was to make of Theory a discursive genre or practice in which semiology was less a pilot science than a method in service to the broader goal of the critique of ideology.)

In a similar way, to speak or write from within the discourse of the human sciences was to claim an epistemological perspective that divagated from the position of philosophy and claimed precedence over it. In the English-language preface to *Homo Academicus,* Pierre Bourdieu observes that one important consequence of structuralism's intellectual domination of the human sciences was that in France in the 1950s and 1960s there was something like a wholesale abandonment of philosophy for the social sciences.[98] Similarly, François Dosse notes that even though most of the influential figures of structuralism had backgrounds in philosophy—including Levi-Strauss, Bourdieu, Lacan, Althusser, and Foucault—the attraction to the human sciences as a new discipline fueled a retreat from and even a challenge to postwar French philosophy, often in the form of a kind of academic revolt where young thinkers sought a different vision of intellectual life in anthropology, linguistics or semiology, psychoanalysis, sociology, and even history (*History of Structuralism I* 382–385). In short, philosophy suffered a diminishment of prestige in epistemology and ethics. *Homo significans* had replaced *Homo philosophicus.*

If structuralism conceived itself as a scientific alternative to philosophy, what did philosophy mean in this context? The two main projects of postwar French philosophy, Sartrian existentialism and phenomenology, were both philosophies of consciousness and of the subject. In fact, the relation of structuralism to phenomenology in its broadest conception was complex. Sometimes the two approaches clashed in public conflict, the most notorious being Levi-Strauss's attack on Sartre in the introduction to *The Savage Mind* (1962). More often, however, the two discourses, structural and phenomenological, were held in an unsteady, complex, and often paradoxical system of attraction and repulsion. This is attributable to the fact that phenomenology itself encompassed a variety of distinct yet overlapping philosophical approaches. On one hand,

---

key turning point in the discourse of signification toward that of political modernism. See my *Crisis of Political Modernism* (Berkeley: University of California Press, 1994), 42–66.

98. *Homo Academicus,* xxvi. In this retrospective text, Bourdieu presents a slightly cynical yet concise and informative account of conflicts and tensions arising in the conflicts between the Sorbonne and the EPHE, on the one hand, and philosophy and social or human sciences on the other.

there was the undeniable influence of Husserl's phenomenology and its concern with how the world is given through experience and investigated through eidetic reduction, the intentionality of consciousness in regard of things, and the desire to make of philosophy a kind of science, a perspective rich enough to have been a major influence on the very different figures of Sartre and Jakobson. Another major influence of the 1950s was Jean Hyppolite's resurrection and remapping of Hegel's phenomenology and his influential approach to the history of philosophy, to which both Michel Foucault and Gilles Deleuze were indebted. And finally, there was the almost inescapable undertow of Heidegger, whose influence was felt implicitly everywhere, especially in Derrida and Foucault, although rarely acknowledged outright. In fact, the twinned influence of Nietzsche and Heidegger will eventually return to define the fault lines where poststructuralism emerges through a deconstruction of structuralism's central concepts of sign, system, and language.

No doubt, the dominant figure in the postwar context is Sartre; if there was a resistance to philosophy in postwar France fueling the influence of structuralism, it was in most respects defined through a reaction formation to Sartre's enormous political and philosophical prestige. Indeed, one way to look at the discursive formation of structuralism is through its recurrent confrontations with Sartre's concept of agency as a kind of humanism where man is freely active as the self-conscious motor of his own history, and where the ego was considered as a limpid and transparent consciousness, present to itself as substance and as the site of truth. Foucault referred to this as a theology of man as the Cartesian *cogito,* and in turn characterized the whole prestructural epoch of humanism as the middle or dark ages of modernity. If philosophy was to remain a critical force within the human sciences, its major task, according to Foucault, was to join structuralism in uncovering fractures in a certain historical conception of the *cogito* as substance and as a self-identical consciousness, and therefore to undermine its epistemological confidence and prestige. In a 1966 interview in *La Quinzaine Littéraire* after the publication of *The Order of Things,* Foucault puts the matter bluntly: "The point of rupture occurred the day when Levi-Strauss showed us, with respect to societies, and Lacan to the unconscious, that *meaning* is probably only a sort of surface effect, a shimmering, a froth, and that what passed through us so deeply, what was before us and sustained us in time and space, was the system."[99]

---

99. Entretien avec Madeleine Chapsal, *La Quinzaine Littéraire* 5 (15 May 1966), n.p.; my trans. Also see Dosse, 330–342.

Structuralism's antihumanism and its attack on the *cogito* were motivated by its scientific aspiration—the idea that structuralism is or could be a science (or perhaps a set of theories tending toward a science), unifying all the human sciences in the common project of a critical examination of culture through its logic or systems of signification. Moreover, the founding gesture of structuralism was to overturn the centrality of the subject in philosophy with the concept of structure as a transsubjective and asubjective force.

Herein lies the strange yet powerful and pivotal role of Maurice Merleau-Ponty, who in giving primacy to the logic of sense as viewed from a phenomenological perspective sought to find a communicating passage between philosophy and the human sciences. (Althusser will later play a similar conceptual and institutional role for the discourse of ideology or power.) Throughout the 1950s, in fact, Merleau-Ponty assembles into something like a whole the major conceptual components of structuralism—through linguistics, anthropology, and psychoanalysis—which come together in his 1960 work *Signs*. (He is also an important link between the Institut de Filmologie and the broader emerging discourse of structure.) For example, in a lecture presented in 1951 on the phenomenology of language reprinted in *Signs*, Merleau-Ponty is among the first in France to stress the importance of Saussure's work for a theory of meaning. "What we have learned from Saussure," wrote Merleau-Ponty, "is that, taken singly, signs do not signify anything, and that each one of them does not so much express a meaning as mark a divergence of meaning between itself and other signs."[100] A sign is only capable of transmitting sense through its variable placements in a differential system of relations. Merleau-Ponty's philosophical and political falling out with Sartre and his rapprochement with Levi-Strauss added the anthropological component to this domain. In the fourth chapter of *Signs*, "From Marcel Mauss to Claude Levi-Strauss," Merleau-Ponty ardently defended the anthropological turn: "Social facts are neither things nor ideas; they are structures. . . . Structure does not deprive society of any of its weight or thickness. Society itself is a structure of structures: how could there be absolutely no relationship between the linguistic system, the economic system, and the kinship system it employs?" (*Signs* 116–117, 118).

---

100. "Indirect Language and the Voices of Silence" in *Signs*, trans. Richard C. McCleary (Evanston, Ill.: Northwestern University Press, 1964), 39. For a broader account of Merleau-Ponty's relationship with structuralism, see Dosse, 37–42. It is thought anecdotally that Lacan discovered or was encouraged to read Saussure through the influence of Merleau-Ponty.

As one of the principal institutional figures of postwar French philosophy, Merleau-Ponty thus designed a curious place for the role of philosophy with respect to the human sciences. No longer the great arbiter and final ground of reason (how could it be, if meaning was transmitted no longer by the subject, but rather through a locale or position in a virtual system of differences?), Merleau-Ponty sought to make of philosophy the methodological *consigliere* to structuralism. Somewhat ironically in this respect, Merleau-Ponty's phenomenology imagined itself as having a place and function in modern Continental philosophy analogous to that of logical positivism and analytic philosophy in an Anglophone context. Philosophy would provide a sort of metalanguage for structuralism, bringing out the sets of conceptual intersections wherein it could become a unified epistemological model for the human sciences. And herein lies the uncertain place of philosophy with respect to structuralism. Throughout the 1950s, Merleau-Ponty is searching for a way to ascertain the claims of reason in a discursive field where the subject is displaced and decentered with respect to the new concepts of sign and system; for philosophy, then, the "task is to broaden our reasoning to make it capable of grasping what, in ourselves and in others, precedes and exceeds reason" ("From Mauss to Claude Levi-Strauss," *Signs* 122). In this respect, his project is imminently philosophical. At the same time, through Merleau-Ponty, philosophy annexes itself to the larger territory of structuralism and assumes a more modest position with respect to linguistics, anthropology, or psychoanalysis. No longer the guardian of logic and epistemology, philosophy functions rather like a crossing-guard or traffic cop, signaling the paths that cross and connect the various analytical approaches to structure and signification on the larger map of the human sciences. François Dosse explains well the profound yet deeply ironic effect that Merleau-Ponty exerted on the postwar generation of philosophy students. They learned their lesson too well: awakened to the new concepts and methods of structuralism, they deserted the field to become linguists, anthropologists, or psychoanalysts, at least in theory (*History of Structuralism I* 40).

Dosse also foregrounds the multiple and interesting ways in which the year 1966 marked the conceptual and cultural triumph of structuralism as a critical and intellectual force, and at one and the same time, the beginning of its decline. In their period of ascendance through the 1950s and into the 1960s, structural anthropology and linguistics drew from Formalism a strong undercurrent of positivism and a belief in the possibility of making the human sciences something close to science. The break with structuralism and the emergence of poststructuralism, then, pass through a historical and conceptual

critique of this epistemological confidence and methodological passion that occurs on multiple fronts in ways that were often not entirely clear at the time. Here, and in almost every case, a new conception of philosophy returns to challenge and displace structuralism's epistemological and cultural prestige. If 1966 is the banner year of ascendant structuralism, it is also the tipping point where devastating philosophical critiques of the concepts of sign, system, and speech were deployed in a number of fundamental works that, coincidently, seemed to arrive together like independent springs joining a mighty stream. The most important of these works included Lacan's *Écrits* and, a year later, Jacques Derrida's *Of Grammatology,* with its critical deconstructions of the foundational concepts of structuralism—the role of speech and sign in Saussure's *Cours* and the place of structure and system in Levi-Strauss's anthropology, as well as its interrogation of the Rousseauian subject's desire for complete transparency to itself. (Later, we will also have to examine the more complicated case of Althusser's *For Marx* and *Reading Capital,* both published in 1965.)

Undoubtedly, however, the most surprising and paradoxical event of the year was the wholly unexpected critical and popular success of Michel Foucault's *Les mots et les choses,* translated into English as *The Order of Things.* Foucault's pathbreaking book offered a philosophical and historical account of the human sciences which, while bringing a new and spectacular image of structuralism to popular attention (adding Foucault to the structuralist tribe of Levi-Strauss, Lacan, and Barthes), also demarcated the limits of structuralist thought. Originally subtitled an "archaeology of structuralism," the book was considered (somewhat mistakenly, and even by Foucault himself) as providing a philosophical synthesis of structuralist thought in the previous fifteen years. Retrospectively, the book was forcefully understood as one of the first fundamental works of poststructuralism, where in viewing the history of the human sciences as series of discontinuities, Foucault both excavated and drew in sharp outline the horizons or limits of structuralist thought.

One of the central ideas of *The Order of Things* was to map out how the creation and elevation of the human sciences—in general grammar, natural history, and political economy—could also result paradoxically in the "death of man" and a profound antihumanism. The multiple and powerful ironies of Foucault's perspective at the time are on full display in an interview broadcast in 1966 on the popular French television program *Lectures pour tous.*[101] Here

---

101. Later, Foucault defines more clearly the epistemological break or line of flight dividing French philosophy of the 1960s: "What separates a philosophy of experience, meaning, and the

Foucault presents himself as the enunciator of a new position of thought, taking sides with Levi-Strauss and Dumézil, Lacan, and Althusser against Sartre, whom he characterizes as "a man of the 19th century, for his entire enterprise aims at making man adequate to his own signification" (*History of Structuralism I* 330, *384*). In a similar way, Foucault strongly implies that in the current era, philosophy has lost its power and function, or perhaps has simply disappeared into other conceptual activities. "Philosophy" here means "Sartre," of course, as the sign of a superseded Marxist and phenomenological humanism. "We have arrived at an age," Foucault continues, "which is perhaps that of a pure thought, thought in action, and disciplines as abstract and general as linguistics, equally fundamental as logic, or even literature since Joyce, are activities of thought. They hold the place of philosophy: not that they take the place of philosophy, but that they are the very deployment of what was, in another time, philosophy" (*History of Structuralism I* 330–331, *384–385*).

There is a valuation of structuralism here for displacing "man" as the focus and object of the human sciences, while also producing a perspective that carves out a place and creates a distance dislodged within culture so that it may be grasped critically. In this lies Foucault's implicitly Kantian project of making his archaeology of knowledge not an account of the past so much as an interrogation of the present, where structural anthropology becomes less about the study of other or "primitive" cultures than the expression of a will to make our own culture appear as strange to us as Levi-Strauss's description of the Nambikwara. Foucault's archaeology was not about restoring to unity lines of thought progressing ineluctably to our present civilization, but rather locating the discontinuities that separate thought in present and past *epistemes,* or discursive regimes of knowledge, by demarcating their borders, horizons, and startling shifts in perspective. In bringing his particular historical perspective, fueled by Bachelard and Canguilhem, to bear on the foundations of the human sciences, Foucault achieves something like an ethnology of the past, where we take ourselves, the provenance of our selves, as alien others. Humanism (and positivism), as a thought becoming fully present and transparent to itself and evolving without interruption in a linear time, is here seriously undermined.

---

subject, from a philosophy of science [*savoir*] and of the rationality of the concept? On one side, filiation linked to Sartre and to Merleau-Ponty; and then another, which is that of Cavaillès, Bachelard, Koyré, and Canguilhem." "La vie: l'expérience et la science" [1977], *Revue de métaphysique et de morale 1* (January–March 1985): 4; my trans.

At the same time, Foucault's particular and deeply original Nietzschean view of history marked the beginnings of an erosion of confidence in structuralism's scientism and its positioning of something like a structuralist subject of knowledge, who in marking out the logic of systems somehow stood outside or to one side of them. At this particular moment, Foucault fully embraces structuralism's successive displacements of the subject in structural linguistics, structural anthropology, and Lacanian psychoanalysis, while adding to them his Nietzchean remapping of the history of knowledge. However, if structuralism is less a method than the "awakened and unquiet conscience of modern thought," in reviewing the discontinuities and tectonic shifts of past knowledge, archaeology also seeks out fractures and points of instability in the present that render not only the limits of our knowledge in its state of actuality but also the possibility for new thought to come.[102] In an era marked by the death of God, the death of the author, and the death of man, Foucault sought not to deepen and extend structuralism's antihumanism and cultural pessimism, but rather to ask us to understand the subject, not in its forms of identity, but rather in its differences, and so to take as our perspective in the present our discontinuities with the past as the acknowledgment of fractures of thought that still reside within us. No doubt such a perspective draws clearly the limits of thought and erodes claims to progress in thought, but it also aims to clear the grounds for new forms of thought or subjectivity. Structuralism might indeed be the realization of a particularly modern consciousness, but Foucault's archaeology also raises the critical question of how to go beyond this consciousness, since it is unquiet and discontent. In its historical conception of the human sciences that returned them to a context defined by the history of science and philosophy, The Order of Things in fact submitted structuralism to a profound epistemological critique, and this critique—both Kantian and Nietzchean, and in certain respects, Heideggerian—was imminently philosophical, though certainly in a way other to Sartre, but perhaps similar to Merleau-Ponty. In some respects analogous to Derrida's work of the period, there is a strong element of creative destruction here, which wants to take full account of the conceptual horizons of structuralism in order to make a new way of thinking possible, and in Foucault's case, perhaps a new politics, thus opening a path for philosophy after structuralism.

From a contemporary and North American viewpoint, we tend to map this path as the road to Theory as a discursive practice or genre in the humanities,

---

102. Foucault, *The Order of Things* (New York: Vintage Books, 1970), 208; trans. mod. from *Les mots et les choses* (Paris: Éditions Gallimard, 1996), 221.

whose founding moment might well have been the International Colloquium on Critical Languages and the Sciences of Man convened at Johns Hopkins University on 18–21 October 1966, organized in cooperation with the sixth section of the EPHE. This somewhat legendary colloquium included a great variety of participants representing, roughly speaking, both structuralist and phenomenological perspectives, including Jacques Lacan, Roland Barthes, and Tzvetan Todorov, as well as René Girard, Georges Poulet, Lucien Goldmann, Jean Hyppolite, and many others.[103]

In retrospect, the most explosive and influential text presented was Derrida's "Structure, Sign, and Play in the Human Sciences." Indeed, there is also something significant here in the gesture of importing French thought to North America that fuels our present conception of Theory. However, while the American organizers of the conference no doubt considered these papers as contributing to the project of a new literary theory, whose genealogical roots descended from Wellek and Warren through Formalism and structuralism, in the French context of 1966, theory was perhaps a less powerful concept than science or method. The Americans, in this respect, play an important role in the invention of the contemporary discursive genre of Theory. A second irony would be how the stage is set here for the creation of Theory through the return of philosophy to the study of literature—Derrida's work in particular would exert a steadily rising influence across the next two decades. Paradoxically, the emergence of a specific concept of theory, or the sense of Theory as a specific kind of practice, occurs through the return of philosophy within the fault lines that gradually separate poststructuralism from structuralism as represented conceptually in Derrida's important essay.

Yet Derrida's writing is philosophy and not "theory," poststructuralism and not structuralism, and from the other side, the path from Formalism to structuralism in linguistics, anthropology, and psychoanalysis is forged less under the emblem of theory than that of "science" or "method." The human sciences founded in France and exported to North America are not synonymous with what Dilthey would have called *Kulturwissenschaft,* though undoubtedly they fall close to the semantic domain defined in his concept of a general *Wissenschaft.* In the context of French structuralism, *science* may have followed this genealogy, but it also inserted itself into a whole new and specific constellation

---

103. For a fuller account of the conference and its aftermath, see the various prefatory remarks by Richard Macksey and Eugenio Donato in *The Structuralist Controversy: The Languages of Criticism and the Sciences of Man* [1970], ed. Richard Macksey and Eugenio Donato (Baltimore, Md.: Johns Hopkins University Press, 2007), ix–xxv.

of meanings. The commitment to sign, structure, and system was first seen as a path alternative to philosophy and displacing it, whether in the form of existentialism, phenomenology, or metaphysics. It was also a way to challenge academic institutions like the Sorbonne and attempt to create new ones. Finally, the discourse of structure or signification sought to establish a new epistemological and critical perspective, and to open a new territory for the human sciences between philosophy and literary history. Especially in the example of Levi-Strauss, structuralism claimed a social and critical genealogy descending from Marx, Saussure, and Freud, and asserted for itself an epistemological and critical power superior to its rivals in its scientificity. Here again, as in so many other historical contexts, theory hovers in an unstable space, as if held unsteadily between science and philosophy. Nevertheless, from within the EPHE, a new discursive path to theory was being forged in the effort to create an epistemological and ethical space that challenged structuralism while trying to find new concepts for situating image and aesthetics within the project of a general semiology, and all this within the domain of film.

## 16. After the Long Eclipse

> One sees reborn everywhere, after a long eclipse, the interest for
> theoretical discussion.
>
> —Christian Metz, "On Classical Theories of Cinema"

In his fascinating reassessment of filmology in France, "L'aventure filmologique," Martin Lefebvre unearths an intriguing document—a proposal for a *thèse d'État* submitted by a young researcher at the Centre Nationale de Recherches Scientifiques (CNRS) who proposes to extend the filmological project into a new domain more or less ignored by the movement itself, what he calls "filmolinguistics." Admitted to the French linguistics section of the CNRS in 1962, this young scholar was Christian Metz. This project, which would result in the publication in 1971 of one of Metz's most compelling and difficult works, *Language and Cinema*, demonstrates that while filmology had been forgotten by many others, Metz maintained a continuing interest in it throughout the 1960s. References to articles in the *Revue de filmologie* pepper the footnotes to his numerous essays in this decade; in addition, Metz repeatedly reaffirms the methodological centrality of Cohen-Séat's distinction between filmic and cinematic facts. Yet more important, Metz's frequent references to the movement,

which often reveal both admiration and an internal struggle with its scientific aspirations, project a certain shared vision with filmology—that the "filmolinguistic" or cine-semiological enterprise is in many respects indebted to both criticism and history yet remains epistemologically distinct from them. In this case, filmology and semiology intersect in another domain. Metz is searching for a new direction for the academic study of film, one that will bring it within the larger context of the human sciences as conceived by structuralism.

Metz is often considered to be the discursive founder of the structuralist enterprise in film. Revisiting Metz's earliest publications reveals a more complex and often surprising picture, however, and yet another kind of project. In a group of texts published between 1964 and 1972, Metz marks out a conflicted conceptual space within structuralism—between the aesthetic discourse and the emergent discourse of signification, between phenomenology and semiology, between semiology and film, and between sign and image— whose stakes are played out in the imagination and construction of theory. Indeed, the early Metz takes on two projects in the early 1960s whose scales are enormously ambitious. Having become associated with the École Pratique des Hautes Études (EPHE) from 1963 under Barthes's tutelage (and in 1966 elected a *directeur d'études*), Metz takes on one of the central obstacles to expanding linguistics into a general semiology of culture—that is, to show that the methods and concepts of structural linguistics and the study of speech or *langue* are applicable to nonspoken phenomena; in short, photography and film. As is clear even in Barthes's early essays on photography, the image is viewed here as both an object of fascination and an obstacle to a general science of signs, which can only demonstrate its universality if it can master the image in signification. The enunciative a priori or implied defining question of the aesthetic discourse was, "In what ways can film be considered an art?" And in repeatedly returning to this question, debating it, worrying it, probing it from different angles and from within a variety of conceptual frames, the discourse fractured and eroded the concept of the aesthetic itself in a way commensurate with the larger project of modernism in the arts. The enunciative a priori of the discourse of signification, raised by Barthes in "Rhetoric of the Image," is, "How does meaning get into the image?," as if the image itself, in its analogical plenitude, is opaque to meaning.[104] Semiology can lay claim to founding a general science of signs only if it can demonstrate that the image

104. "Rhetoric of the Image," in *Image / Music / Text* (Glasgow: Fontana Press, 1993), 32. Also see, in the same volume, "The Photographic Message" and "The Third Sense."

is surrounded by meaning, crossed with or shot through with signification, bathed in sense. However, and in a way analogous to the aesthetic discourse, semiology founders somewhat in its confrontations with the image; or, as Barthes's encounters with the image make clear from the beginning, from a semiological perspective there is something traumatic, anxious, or imponderable in the image that semiology felt compelled to master, and in many respects, fails to master. Barthes will finally embrace the idea of an unmasterable core of non-meaning in the image in his return to "phenomenology" in *Camera Lucida*.

Therefore, one central concern of Metz's earliest essays is to contribute to a general semiology of culture by working within the context of the EPHE in a specialized domain, that of cinema. Alternatively, out of this project unfolds another one, less remarked upon yet equally ambitious. More than Barthes, I think, Metz quickly became keenly aware of the difficulties not of the image, but of renovating the concepts of structural linguistics to extend them to nonlinguistic expressions. At the same time, if the semiological program was to include film, one also needed to take into account a historical discourse on cinema reaching as far back as the 1920s to show how these writings were already approaching, if often in conceptually imprecise and nonsystematic ways, the problem of film *as* discourse. After Guido Aristarco, Metz is one of the first important figures to place the aesthetic discourse in a historical frame, to consider it in all its syncretism and dispersion across continents, languages, and decades as a special genre of discourse, distinguishable from both history and criticism, and one that has a history seeking conceptual unity. Like Aristarco, Metz is constructing an archive (which will be recognized retrospectively as the first canon of classical film theory), but a directed one—selecting texts, identifying predecessors, locating where conceptual foundations have been laid.

This project is not without its ironies and paradoxes. On one hand, Metz is entirely a product of his discursive context. In excavating and refashioning the aesthetic discourse in the early 1960s, he is guided ineluctably by a retrojecting framework that revisits and unavoidably rediscovers in the first fifty years of writing on film a preoccupation with language and signification commensurate with, if only incompletely and in a fragmentary way, the larger discourse of structuralism. On the other hand, through his cinephilism, his commitment to phenomenology, and his attachment to postwar French film culture, Metz is at odds with structuralism. The twinned project of contributing to a new cine-semiology and to recovering and paying homage to a special literature on film does not necessarily lead to building a general science of culture

through linguistics. Metz desires to be rigorous, conceptually precise, and methodologically systematic, but he refrains from making this into a desire for science or for philosophy; it is, rather, a desire for *theory*.

Emerging out of a series of overlapping yet conflicting discursive formations—phenomenology, filmology, structuralism, classical film aesthetics, and cinephilism—in a series of important texts of the 1960s, Metz finds his way in theory, and in so doing, begins to construct an enunciative position or perspective that can finally be recognized as "theoretical." Metz builds a map and a picture of the history of film theory (here it can finally be called as such) through the discursive formations of structuralism and semiology, and in so doing brings into sharp outline a series of discursive shifts moving along multiple trajectories: of institutional contexts (from the Sorbonne/Institut de Filmologie to the EPHE and Centre d'études des communications de masse [CECMAS]); groups of objects (language, sign, system, text); the designation and deployment of concepts (*langue/parole*, signifier/signified, syntagm/paradigm, denotation/connotation), and positions of address, "structural man" or film "theorist." Contrary to the usual conception of the early Metz as the founder of a certain discourse and of a method—cine-semiology and the structural analysis of film—Metz here becomes a unique figure within the larger discourse of signification in its era of methodological passion. Metz's particular conception of theory is directed by a kind of ethical searching at odds with the discursive context that produced him, one that questions a whole mode of existence (in structuralism, in film study, in theory) through the conceptual will to forge a new form of life in thought around the cinema. A closer look into his essays of the 1960s gradually uncovers the will to locate a position or perspective expressed in the form of a certain moral reasoning. An inheritor of the institutional and academic discourse of filmology, as well as the phenomenology of Bazin, and inhabiting discourses that are simultaneously cinephilic, philosophical, and ethical, in these essays Metz positions himself as the conciliator between several postwar discourses traversing film and the human sciences, as if to find a new place for film in the human sciences through theory.

Metz's construction of a place for theory—its positions of address, its points of intersection and conflict with other forms of discourse, its epistemological extensions and limits—unfolds on a sinuous path that moves forward by looping back on itself at frequent intervals in a recurrent process of revision and refashioning, moving in uneven lines across several essays. Undoubtedly, the most fascinating and most complex account occurs in the first half of Metz's

first professional article, "Le cinéma: Langue ou langage?" published in 1964 in the issue of *Communications* devoted to "Semiological Research."[105] In short order, Metz takes up the problem of history and theory again in his review of the first volume of Jean Mitry's *Aesthetic and Psychology of Film*, "Une étape dans la réflexion sur le cinéma" ("A Stage in Reflection on the Cinema").[106] The line continues in a 1967 review of Mitry's second volume, "Problèmes actuels de théorie du cinéma" ("Current Problems in Cinema Theory") before another phase of methodological reflection and revision occurs in parallel: first in the opening chapter of *Language and Cinema*, and then in the republication of the two essays on Mitry in *Essais sur la signification au cinéma, II* (Paris: Éditions Klincksieck, 1972), which are grouped together with a new prologue in a section titled "On Classical Theories of Cinema." Besides making many other significant contributions, then, Metz was one of the first key figures to adopt a metatheoretical perspective in film study—a reflection on the components and conceptual standards of theory construction, as well as a historical view of the development of film theory. Metz is one of the first main figures after Aristarco to make present and perspicuous a new concept of theory by constructing theory as an object, examining its history, and testing its present and potential claims to generate knowledge.

That Metz moves, as if searching out stepping-stones to cross an unruly stream, from a stage in reflection to current problems of theory, and then to the assertion of an antecedent and historically locatable period of film theorizing is significant, as we shall soon see, and all the more so in that the canon of film theory so familiar to us today was still fragmentary, incomplete, imperfectly translated, and hardly known. Still, one finds throughout the 1960s the emergence of a certain historical consciousness in the form of a desire to revisit,

---

105. The article was reprinted in Metz's first collection of essays, *Essais sur la signification du cinéma* (Paris: Éditions Klincksieck, 1968), 39–93. It appeared in translation as "Cinema: Language or Language System," in *Film Language: A Semiotics of the Cinema* [*1974*], trans. Michael Taylor (Chicago: University of Chicago Press, 1991), 31–91. As I will discuss further on, the English title of the essay is misleading and the translation itself marred by many errors and infelicities. For this reason, I will refer to the essay with its French title. All citations from this essay are my own translations, with French page numbers from the *Essais* provided in italics. For a detailed overview of Metz's publications and curriculum vita, see *Christian Metz et la théorie du cinéma*, special issue of *iris* (Paris: Éditions Klincksieck, 1990), 299–318.

106. The first Mitry review essay was published in *Critique* 214 (March 1965), 227–245, and the second in *Revue d'esthétique* 20 (April–September 1967), 180–221. Dudley Andrew has recently stated that he has "always dated the advent of academic film studies at the moment when Metz leapfrogged over Mitry as he reviewed the latter's *Esthétique et psychologie du cinéma.*" See his "The Core and Flow of Film Studies," *Critical Inquiry* 35 (Summer 2009): 896.

recollect, reorganize, and systematize thought about the cinema, especially as represented in Kracauer and Mitry's great books, preceded by Jay Leyda's pioneering translations of Eisenstein's *Film Sense* (1942) and *Film Form* (1949).

Nonetheless, until the 1970s, a great number of key theoretical texts were unavailable in French, and indeed in many other languages: Eisenstein and Pudovkin's work appeared only in scattered fragments and excerpts, Vertov was hardly known, and key texts by Balázs were available only in German. The French genealogy scattered across the diverse texts of Canudo, Delluc, Dulac, Moussinac, Faure, Epstein, Gance, Clair, Cocteau, Feuillade, L'Herbier, or the surrealists was dispersed in often hard-to-find publications. The fiftieth anniversary of the invention of cinema inspired the publication of two important collections in 1946, Marcel Lapierre's *Anthologie du cinéma: Retrospective par les textes de l'art muet qui devint parlant* (Paris: La Nouvelle Édition) and Marcel L'Herbier's *Intelligence du Cinématographe* (Paris: Éditions Corrêa), but valuable as they were, these volumes were hardly more than a mélange of testimony by directors, actors, and inventors interspersed with selections from aesthetic writings, assembled under rubrics that revealed no special concept of "theory." Still, in France as in Italy, postwar film culture did have a sense of a canon for the aesthetic discourse, as represented by Henri Agel's little pedagogical volume for the Que sais-je? series, *Esthétique du cinéma* (Presses Universitaires de France, 1957), which refers to and closely follows Aristarco's canonization of Balázs, Pudovkin, Eisenstein, Arnheim, and Spottiswoode, though without reproducing any of their texts. The first collection of Eisenstein's texts in French, *Réflexions d'un cinéaste,* appeared only in 1958.

Throughout this period of recovery, collection, and anthologization, a historical perception emerges of there being a corpus of film theory that would be relatively delimited and self-contained if only one could assemble all the texts in an orderly way. This desire to discover or construct a canon is fueled both by the rarity of sustained studies of film aesthetics in the classical period and by the cultural and academic marginality of film and film studies. Even in Metz's case, this perception of rarity and marginality leads to a tendency to think of the history of film theory as a series of monuments: Balázs, Arnheim, Eisenstein, Kracauer, Bazin, Mitry—all major figures who could anchor a field or mark out its borders. (And one believed this territory could in principle be taken in from a single field of vision—even in the early 1970s, the devoted student of cinema could still dream of reading every published work in film theory, in English or in French, as the books would hardly fill one shelf.)

Metz's expert command of German and English, and his institutional placement as an academic researcher in a field that as such did not yet exist, no doubt abets and fuels a drive to assemble, organize, and arrange, methodically and systematically, the available "research" on cinema, as if to reassure himself of a certain place in the history of thought about cinema, or even to show that this thought exists and has a history. No doubt he is also inspired by Mitry's own drive to organize systematically a certain thought about cinema, to ratify it and to show that it has methodological unity and value. At the same time, it is not only the discourse of structure and signification that drives Metz's interest in resolving what might be viewed as the conceptual oxymoron of linking film and language, for "Le cinéma: Langue ou langage?" also appeared against the background of a wave of writing on the problem of "filmic grammar" and of a general interest in film as a rhetoric or a discourse. Metz's retrojection, which finds from Balázs to filmology the unifying thread of language or signification in discourse on film, is therefore not unreasonable. As Metz noted on several occasions, both Cohen-Séat and Souriau were important precursors to the semiological project. In fact, a number of authors working in the context of filmology sought to treat the question of discourse in film with greater precision and rigor, though without recourse to or even awareness of the conceptual frameworks of linguistics or formalism. Cohen-Séat himself published an important study on "filmic discourse" that was expanded and republished as a new chapter in the second edition of the *Essai* and whose conclusions anticipate Metz's in interesting ways.[107] With the ex-

---

107. "Le discours filmique," *Revue internationale de filmologie* 5 (1949): 37–48. Cohen-Séat recognized early on the difficulty of placing the problem of discourse in the established sections of the Institute for Filmology. Is it a purely formal problem to be examined under Group II, Technical Studies, he wonders, or a psychological problem for Group I, or a comparative problem for Group IV, wherein speech or verbal discourse would be compared and contrasted to filmic discourse? Almost as if he were anticipating Metz's early work fifteen years in advance, Cohen-Séat suggests that if such a comparative project were to take place, in order to avoid "a game of unconscious analogies," one would need to consider it "with all the due seriousness, in order to adapt to its method, the enormous labor, the prodigious richness of detail and subtlety accumulated by linguistics" (38; my trans.). Equally striking, Cohen-Séat complains of the imprecision with which such questions are usually addressed. Thus, Cohen-Séat's conclusions broadly anticipate Metz's initial work toward a semiology of film. Though film cannot be considered a language in the strict sense, he argues, this does not mean it cannot be treated as a discourse. Once this is understood, research can address seriously the problem of defining filmic signs, as well as questions of order and transition (syntagms and marks of punctuation). And finally, in a phrase that could have been lifted from Metz, Cohen-Séat concludes, "The cinema is an art precisely because it is not a language, and there even where it resists language. In

ception of Roland Barthes, whose studies of "Le problème de la signification au cinéma" and "Les unités traumatiques au cinéma" appeared in the *Revue internationale de filmologie* 32–33 and 34, respectively (1960), semiological concepts were notably absent in the journal. The pursuit of a strictly linguistic analysis appeared unsound to many of the principal voices of the filmology movement, and indeed the semiological discourse was still suspiciously foreign, in both the figurative and literal sense, to many French academics.

There was a definitive fracture between filmology and semiology, then, but this was a fault line shifting in the common soil of method. And in spite of filmology's privileging of the cinematic over the filmic fact, Christian Metz noted retrospectively that the distinction was instrumental for setting the conditions that made a semiology of film possible. Francesco Casetti has also explained in detail the breadth of interest in this period in questions of "film language" or "grammars of film" in a wide range of studies in English and Italian, as well as French.[108] Structuralism and semiology were not the only contexts for the discourse of signification, but belonged to or emerged in parallel with a broader enunciative modality that was prepared for by a more general, and often inexact, interest in film grammar or rhetoric. Here again, Russian Formalism was in the avant-garde of the discourse of signification. As Metz would correctly point out, both Eikhenbaum and Eisenstein offered imaginative and innovative accounts of the filmic sign. Indeed, in his 1964 essay, Metz is responding to this discourse, both exploring and defending semiology as a "scientific" framework for the study of filmic signification. But again, in the immediate postwar period, the idea that the image could function as a sign or symbol was discursively widespread.

---

effect, nothing prevents us from asserting that neither film nor art abide being treated to the blows of syntax or grammatical tools [*que ni le film, ni l'art, ne supportent d'être traités à coups de syntaxe et d'outils grammaticaux*]" (45). Edward Lowry also notes how a number of essays collected in Souriau's anthology, *L'Univers filmique*, anticipated a range of questions and concepts that would soon arise in film semiology. See his *The Filmology Movement and Film Study in France* (Ann Arbor, Mich.: UMI Research Press, 1985), 92–97.

108. See esp. chap. 4, "Cinema and Language," in Casetti's *Theories of Cinema, 1945–1995* (Austin: University of Texas Press, 1999), 54–73.

## 17. An Object, a Method, a Domain

> [The] cinema is not a unified object; it is also by this measure that the
> semiological enterprise today, somewhat outrageously, targets as its objective
> the global study of cinematographic facts.
>
> —Christian Metz, *Language and Cinema*

Discourse, then, is in the air at the same time as the first canons of aesthetic writing on film are being collected and organized. It is not clear that Metz viewed the initial phase of his work as contributing to a (semiological) theory of film so much as appealing to film as a problem in the transition from linguistics to a general science of signs. Metz will thus regroup and reconfigure the canon of film theory as constituted by Aristarco and others to include film semiology as a necessary stage toward developing a "scientific" problem and attendant vocabulary, in which film is only a part.

To better understand Metz's construction of theory, along with the epistemological stakes and perspectives invested in that term, it may be best to begin at the point where Metz concludes the first phase of his thinking: the introduction to his magisterial *Language and Cinema*. Nearly ten years after filing his proposal to study "filmolinguistics," the connection to filmology had not been forgotten. In hindsight it is clear that Metz conceived both "Le cinéma: Langue ou langage?" and *Language and Cinema* as functioning in ways analogous to Cohen-Séat's *Essai*—that is, as setting out a methodological foundation as a kind of conceptual grid: imposing conceptual order, reducing the problem to a manageable scale, defining and aiming at certain problems while excluding others. *Language and Cinema* is a sort of reconception and rewriting of the *Essai* but from the standpoint of the discourse of signification, which in 1971 has fully bloomed, meaning also that it has begun to fade. Four years later, with the publication of yet another deeply influential methodological statement in *Communications*, "The Imaginary Signifier," Metz would help found a new discourse, that of the subject and ideology.

In a strong sense, the central question of the introduction to *Language and Cinema* is how to bring theory to cinema, or in other words, and in a way very similar to Eikhenbaum's concern with method, how to filter, reduce, or circumscribe the object of investigation to make it the proper object of a theory. The cinema in its largest possible conception, Metz argues, is a total social fact in Marcel Mauss's sense. As a multidimensional whole, it does not lend itself to a unified and rigorous examination, but rather only to "a heteroclite mass

of remarks implicating multiple and various points of view."[109] As a possible object of theory, this is another way in which "cinema" is analogous to "language," for language in its largest sense also confronted Saussure as a global, variegate, and multidimensional social whole whose scale and complexity escaped any theoretical purchase. A theory, then, requires a principle of pertinence, a sort of filter or grid that sets the conceptual perimeters of a theoretical object and establishes the lines of latitude and longitude guiding its systematic study. The cinema as such, like language as such, is too vast to be a possible object of knowledge. Saussure laid the foundations for a theory of signs—semiology—in defining *langue* as a system of signification underlying language more generally, and therein lies a possible opening into film theory. In examining the system of signification, semiology refinds language in another sense, and finds other senses in language. A theory of film, rather than a theory of cinema, will have to perform a similar reduction, isolating only those components of the filmic fact that are discursive or textual.

Metz continues by observing that although narrative film began to emerge about the same time as Saussure was giving his course on general linguistics, theory was a long time coming to film, or at least the components of a theory wherein one could clearly establish criteria for defining filmic and cinematographic facts. (And these are social facts; just as filmology draws support from Durkheim, Metz leans on the terminology of Mauss.) That the history of film theory has unfolded, higgledy-piggledy, in the accumulation of heteroclite and syncretic observations and texts is a result of the relative youth of cinema as an art form and lack of institutional setting. The history of cinema has not wanted for "theorists," Metz observes, though it has, until recently, lacked the constituents of a theory. To make film a possible object of knowledge means reducing the scale of investigation, plotting out recognizable property lines, flattening and shaping the landscape, and giving it an architectural design. In an astonishing (if unconscious) paraphrasing of Souriau, Metz rewrites the profile of the (classical) "film theorist."[110] In the early decades of writing on the cinema, Metz observes, "What one most often called a 'cinema theorist' was a sort of one-man-band [*l'homme orchestre*] who ideally held an encyclopedic knowledge and

109. *Language and Cinema*, trans. Donna Jean Umiker-Sebeok (The Hague: Mouton, 1974), 9, 5; trans. mod.. Originally published as *Langage et cinéma* (Paris: Larousse, 1971). Page numbers in the French original will be given in italics wherever I have modified the translation.

110. See, for example, the opening paragraphs of Souriau's "Nature et limite des contributions positives de l'Esthétique à la Filmologie," *Revue internationale de filmologie* 1 (July–August 1947): 47.

a quasi-universal methodological formation" (*Language and Cinema* 10, 5). One needed to be a historian, Metz continues, with complete knowledge of world film production, as well as an economist who could understand the industrial circumstances of production. To define film as art, one also needed to be an aesthetician, and if one wished to comprehend film as a meaningful discourse, one was also a semiologist. Finally, to the extent that one wanted to excavate in the content of particular films' various psychological, psychoanalytic, social, political, or ideological facts, "nothing less than a total anthropological knowledge was virtually required" (10, 6).

In short, the classical era risked producing little more than "a heteroclite mass of remarks implicating multiple and various points of view." What is surprising, nonetheless, are the conceptual richness and precision of early contributions to understanding film (here Metz draws clearly his canon) in the texts of Balázs, Arnheim, or Laffay, in the writings of Eisenstein and the Russian Formalists or, later, Edgar Morin and Cohen-Séat where, as Metz notes, the choice of principles of pertinence is already more self-consciously made. For Metz, these names represent phases, stations, or stages on the way to theory, or a theory yet to come. The classical period is thus not a total but only a partial eclipse—light peers through, and it is waxing. If the space opened between Aristarco in 1951 to Metz in 1964 defines a period in which film theory will gradually achieve (historical) consciousness of itself, in the period between 1964 and 1971 film theory not only acquires a name, it also takes on a form and acquires a method and epistemology—it becomes a genre of discourse. (This is also true in the broader domain of the human sciences.)

The year 1964 is not only the date of publication of Metz's seminal and foundational essay, "Le cinéma: Langue ou langage?" It also falls between the years of publication of Jean Mitry's two volumes of *Aesthetic and Psychology of Cinema* (1963 and 1965). No doubt, a figure like Mitry embodies more than any other the image of an *homme orchestre* that Metz sketches on the first page of *Language and Cinema*. Metz's deep appreciation of Mitry's arguments and his accomplishments—fully set out in his two critical reviews on Mitry in 1965 and 1967, respectively, and his frequent citations of Mitry's magisterial if flawed work—are sincere and his praise fulsome. Nonetheless, this praise is attenuated by the curious place reserved for Mitry in Metz's genealogy of theory. Metz praises Mitry's books as the synthesis and the outcome of an entire era of "reflection on film"; reflection, however, and not theory. For as Metz will soon make clear, from the standpoint of a possible film semiology Mitry's work is the apogee, but also the denouement and conclusion, of a certain way

of thinking about film. The question before Metz here is "theory": what counts as a theory of film, what are its conceptual components and its characteristic activities, and who can lay claim to being a subject of theory, its author or enunciator? In posing these questions in a series of works between 1964 and 1971, and sketching out historical markers and directions, in fact, in raising theory's history as a theoretical question, Metz not only invents film theory but also becomes the first exponent of what I have called the metatheoretical attitude. In these seven short years, for film studies at least, Metz becomes "discursive" in Foucault's sense—not just the author of film theories, but the focal point of a new system of address, which emits from a new institutional context with its own rhetorical style and sense of place in history, setting out a new conceptual framework defined by precise principles of pertinence and implicit criteria of inclusion and exclusion for the practice of theory.

In looking back retrospectively at the first phase of general reflection on film, Metz observes that, in fact, there are two kinds of "theories" proposed. (The quotation marks are Metz's.) On one hand, in everyday language, the word "theoretician" still "frequently designates an author whose writings are above all normative, and whose principal aim is to exert influence on films to come, indeed, to prescribe a preferential choice of subject for these films" (*Language and Cinema* 11, 6). This idea of a normative or prescriptive perspective chimes well with Noël Carroll's argument that classical theories are often marked by an injunctive component.

But another path has been forged through the aesthetic discourse, above all by the authors who occupy Metz's preferred canon. These are writers who "have devoted all or an important part of their cinematographic efforts to analyzing films such as they exist, and who appear as so many precursors of a *description* of film, in the sense given this work in the human sciences and notably in linguistics" (*Language and Cinema* 11, 6). These authors are precursors, then, of a descriptive rather than prescriptive form of analysis that attends to films as they are rather than some possible future ideal film, yet to be created. There are two sides or dimensions of this pretheoretical reflection, then: "one on the side of the work to come, thought in terms of *influence,* which does not hesitate to advise or prescribe, which wants to respond directly to the working problems of an 'artist creator,' and which only has sense in this perspective, and one on the side of filmic discourses *already given,* and which seeks to analyze them as facts" (11, 7). An analogous situation exists in aesthetics, Metz suggests. But the significant point here is Metz's preference for a descriptive theory of cinema, whose main outlines are prefigured, though in a scattered

and disunified way, in the most important authors of the discourse of aesthetics. These writers, however, lacked principles of pertinence that could ground and unify their observations about the state of film language. As such, they could follow only furrows they had already plowed, circling endlessly back to the aesthetic a prioris guiding their thought.

The main outlines of Metz's approach should already be clear, for what he seeks in theory is something close to Eikhenbaum's "method." A film theory is descriptive, it functions through the immanent analysis of existing works, and it requires principles of pertinence (what Eikhenbaum called principles of specificity) to establish clearly the facts to be investigated and to include some types of observation while excluding others. What counts, then, as a principle of pertinence?

For Metz, the founding principle of a possible film theory was established by Cohen-Séat in his 1946 *Essai sur les principes d'une philosophie du cinéma*—that of the distinction of filmic from cinematographic facts—which conceptually characterizes "film," in Metz's terms, as a *"localizable signifying discourse,* in contrast to the cinema which, thus defined, constitutes a more vast 'complex' at the heart of which, nevertheless, three aspects predominate forcefully: the technological, the economic, and the sociological" (*Language and Cinema* 12, 7). To localize signifying discourses already places film theory on the side of the filmic fact, and a descriptive analysis of the filmic fact is best served by the concepts and methods of semiology. "It will suffice to acknowledge," Metz concludes, "that [what] we will call 'film,' apart from further specification, [is] the film as a signifying discourse (text), or further, as a *language-object:* Cohen-Séat's filmic fact" (13, 8). Semiology will have little to offer to technological or economic research on cinematographic facts, though accounts of film language are somewhat closer to sociology. And perhaps, as filmology wanted, the study of cinematographic facts will be unified on a larger scale by their own principles of methodological pertinence, and so produce their own theories. In any case, Metz is laying the groundwork here, after Cohen-Séat, for producing a theory of film in contrast to a theory of cinema, and this theory will be formal and semiological.

Metz clearly signals his debts to filmology in these passages. In particular, Étienne Souriau is singled out as a theoretical predecessor in laying the groundwork for another principle of pertinence for the discourse of signification: the designation and circumscription of "filmophanic" experience as the focus of analysis, or the film as perceived by its spectators in the time of actual

projection.[111] However, film in this sense is also a multidimensional phenom-
enon composed of a variety of social, psychological, psychoanalytic, and
aesthetic facts, including the physiology and psychology of motion percep-
tion, filmic memory and comprehension, the production of an impression of
reality, social analysis of content, or the study of iconography, the history of style,
and the morphology of filmic forms. To the extent that the object of semiol-
ogy is to study film considered as or in relation to language, one might think
that the study of the filmic fact should be further subdivided along the broad
lines of psychology, sociology, aesthetics, and linguistics. Semiology would
only need to concern itself, then, with a theory of filmic discourse.

However, Metz is careful to note that to understand film as a meaningful
discourse means considering the entire film, or the multidimensional aspects
of language in relation to film whether aesthetic, psychological, or sociologi-
cal. Just as linguistics maps only with some difficulty the interface between
phonology and phonetics—the sonic material of language and the organiza-
tion of acoustical sense—one cannot locate film as a discourse without taking
into account the complex organization of, in Louis Hjelmslev's terminology,
its matters of expression: not only moving photographic images, but also
sounds, music, speech, and graphic inscriptions. By the same token, psycho-
logical and cognitive mechanisms of perception and cognition cannot be
strictly separated from the study of discourse and signification. And finally,
again adapting Hjelmslev's concepts, Metz relates that structural analysis
cannot neglect the form of content of different films—their internal organiza-
tion of sense along semantic or even thematic lines. As an object of theory,
filmic discourse is not so clearly definable—the formal object stands out in a
design whose main lines are distinct yet also permeable and slightly unsta-
ble, and this is no less true in the context of linguistics. Here Metz summa-
rizes in one paragraph the main argument of the second half of "Le cinéma:
Langue ou langage?" While film is no doubt of a different order than speech
[langue], as an aesthetic means of expression, and a meaningful one, it has
"quasi-consubstantial relations" with the system of language (16, 11). "Cine-
matographic codes exist," Metz concludes, "but without the consistency and
stability of natural languages; the filmmaker and the speaker are confronted

111. See "La structure de l'univers filmique et le vocabulaire de la filmologie," *Revue interna-
tionale de filmologie* 2, no. 7/8 (1951): 236; revised and reprinted in *L'univers filmique*, ed.
Étienne Souriau (Paris: Flammarion, 1953), 8.

with already constituted forms, anterior to their proper activities, but not to the same degree or in the same way. Here, therefore, semiological analysis is tightly associated with the 'aesthetic' of film. . . . Because the film (contrary to the cinema) constitutes a delimitable space, an object devoted in its various scales to signification, a closed discourse can only be considered 'as a language' in its entirety, or not at all" (17, *11*).

The problem that repeatedly arises in the opening pages of *Language and Cinema* describes a particular kind of friction between object and method. The domain of filmic facts also describes a vast and multidimensional space that is not so easily contained or reduced, and if semiology is to stake an epistemological claim here, it must be through method, which can lay out what is specific to the practice of semiology and what it shares with other, related disciplines. "From object to method, the relation is always bilateral," writes Metz. "What one calls a *domain* of research is a zone whose principle of determination, in the last analysis, always appears as an indiscernible mixture of 'object' and 'method'" (*Language and Cinema* 17, *11*). Thus the problem of method must continually confront the fact "that the cinema is not a unified object; it is also by this measure that the semiological enterprise today, somewhat outrageously, targets as its objective the global study of cinematographic facts" *(ne saurait sans quelque démesure se fixer comme but l'étude totale du fait cinématographique)* (18, *12*).

At the same time, method must know how to build good fences to make good neighbors. Whether interested in the filmic fact or not, the various research domains of psychology, sociology, aesthetic, and even semiology are imperfectly distinct and perpetually embarrassed at their frontiers. Alternatively, the study of closed texts, such as a narrative film, "represents par excellence the place where the reciprocal implication of disciplines is maximally inextricable. A closed text—story, myth, play, novel, etc.—is always, and always at the same time, a total cultural object and a kind of restricted object with respect to the general production of a society. For one reason or another, it lays out a kind of space where, more than any other, the different 'human sciences' run alongside one another, and do so closely because on a restricted surface" (18, *12*). Within this space, film can become a variety of objects, depending upon the disciplinary perspective that predominates; it is according to method, then, that it possibly becomes one of a variety of objects, say, a discursive one.

On one hand, it is normal that semiology would draw support from the data (but not the methods) produced by neighboring disciplines in the human sciences; on the other, the structural analysis of film must stake a claim to its

proper domain—the film as a "total signifying-object" (*Language and Cinema* 19). Generally speaking, the domain of semiology is the critical study of the forms and logics of cultural signification, often by extending the concepts and methods of linguistics through the annexation of a variety of cultural objects, such as film. And within the domain of semiology, one then construes the filmic fact in terms of the discursive structure of film. Semiology then becomes the platform upon which the global study of filmic discourse can take place. However, along the way, it may be that a structural *linguistics* will be displaced by the structural analysis of *film,* even if this analysis is still inspired by linguistics. And so Metz concludes, "This book would never have been undertaken without the idea that only a so-called semiological inspiration is capable of eventually providing the framework for a coherent and unified knowledge of the filmic object. On the day when this goal is in view of being achieved, the semiology of film will only need to preserve its name: it will then really be (or more really be) what it is today programmatically: a theory of the filmic fact, and not a particularly linguistically-inspired approach, even if we must pass through one to attain the other" (19–20, *13*). A theory of the filmic fact—the whole first chapter has led to this point where a theory can follow from a method, and at the same time, "methods are things that cannot be interchanged (and which can not be 'blended' without great danger of giving birth to monsters), but facts and knowledges [*les données et les connaissances*], bits of acquired experience, can and must circulate freely. Those who do not know the cinema will never make from it a semiology" (20, *13*).

The first epoch of general reflection on film has now come to an end. One can no longer be satisfied with a variety of heteroclite observations, but must clearly choose a principle of pertinence; in other words, theory must rally around a method, which can unify synthetically from a singular perspective the data and knowledge gathered within its domain. What was previously called "film theory" included observations concerning filmic and cinematographic facts, but often without differentiating them. Though often illuminating, these approaches were eclectic and syncretic, drawing on a variety of methods without applying any one in a consistent or even self-conscious way. The discourse of aesthetics was not yet a theory of film. The discourse of structure and signification signals another mutation in this history, then, as the opening of a new phase, which Francesco Casetti has quite rightly characterized as "methodological." In this transitional moment, Metz argues that methodological pluralism is a necessary though nonetheless provisional exigency. One sees here both a defense of filmology, its persistence as a fellow traveler supporting the

discourse of signification in film, and the flowering of a "theory of the filmic fact," derived from the methods of a linguistically informed semiology. Most striking throughout this chapter is Metz's implication that semiology (linguistics?) is somehow provisional or less stable than sister disciplines in the human sciences, and that theory has not yet arrived here in the form of a singular and unifying method. A striking commonality, then, between the discourses of aesthetics and signification, despite all the characteristics and criteria that divide them, is the sense that theory is yet to come, always ahead of us as a third possibility, envisageable but so far unattained.

## 18. A Care for the Claims of Theory

> Those who know Metz from the three perspectives of writer, teacher, and friend are always struck by this paradox, which is only apparent: of a radical demand for precision and clarity, yet born from a free tone, like a dreamer, and I would almost say, as if intoxicated. (Didn't Baudelaire turn H. into the source of an unheard of precision?) There reigns a furious exactitude.
>
> —Roland Barthes, "To Learn and to Teach"

Metz's concern with method in the introduction to *Language and Cinema* is already on full display in "Le cinéma: Langue ou langage?" Throughout the 1960s, it is fascinating how Metz seems so concerned with mapping out and clarifying the variety of epistemological frameworks within which film study takes place, as if in his first published essay he needs to create a new mode of existence in film and in theory. The essay is both manifesto and methodological statement, dividing and ascribing tasks, probing and defining concepts, and laying out positions of address. More important, it wants to explore the conditions of possibility wherein a synthetic and unified theory of film might be constructed, and as such it is both a prelude and a pendant to the introduction to *Language and Cinema.* That such a global and unified approach to film might be possible is the lesson Metz learns from Mitry's *Aesthetic,* and that a global and unified approach to the problem of signification as such is possible is the very air Metz breathes throughout the 1960s. This idea directs, after all, the project for semiological research outlined in *Communications* 4 with all its methodological passion. What remains to be understood is the place of a possible *film* theory in this discursive universe—now already somewhat ahead of what Metz will characterize as Mitry's summing up and closing off of classical

film theory, but also somewhat behind in making its own positive contributions to a general semiology. Theory as such is yet to arrive in academic film study.

The title of the essay is significant: can the sense of film be studied from within the concepts and methods of linguistics, whose object is *langue*, or the virtual system of natural languages? Or if film is a language (how could it not be, since it conveys meaning?), what kind of language is it, or by what right do we refer to it as a language? The essay aims not only at rendering more precisely an object of study but also at creating and evaluating a perspective from which that object can be known, and in many respects, valued.

Already this is a somewhat strange position to occupy within the context of a "scientific" structuralism. Be that as it may, if theory is a problem searching for an explanation, Metz here redraws a fairly cloudy picture in sharp outline. In so doing, he shifts the discursive landscape and remaps the entire territory of the aesthetic discourse onto the discourse of signification. Where before the persistent problem was "Is film an art, or has it transformed the concept of art?," now the problem is "How do images convey meaning, or in what ways can images be considered as signs?" This question lies at the heart of the semiological enterprise and is the key to its aspirations to become a general science. If linguistics is only a subdomain of a more general semiology, then the conceptual domain of speech, and the scientific foundation of linguistics, must be extendable to images, especially to moving images. This turning of the question shifts all the centers of gravity of the earlier discourse; it displaces elements in their orbits and creates new sources of illumination, lighting up new features of the landscape and throwing shadows over previously prominent landmarks. With what would soon be recognized as Metz's characteristic precision and attention to detail, the very long prologue to the essay works back through the history of film theory as it was known at the time, but with a specific agenda in mind. The prologue focalizes a persistent question of earlier writings on film, but one running in the background, as it were, and brings it forward. Again, one outcome of this move is to recast retroactively this discourse as "film theory," indeed to see in a variety of otherwise eclectic accounts the problem of language and signification in film, and to see them as false starts or incomplete movements waiting for the proper general concepts and methods to place them in a framework where they can be articulated and resolved, moving forward in a genuinely dialectical fashion.

Here key differences become apparent. More often than not, the aesthetic discourse proceeds through an immanent analysis. It begins with the idea

that filmic expression has a specific identity anchored in materials, processes, or automatisms that belong only to film. Semiology extends these medium specificity arguments for a certain time, only finally to renounce them in the second semiology, whose turning point is Metz's *Language and Cinema*. However, Metz's earlier essay produces another, more violent mutation of perspective, and one that accounted for the resistance to semiology by more aesthetically inclined thinkers. In a very real sense, film as such was no longer the object of theory (and in *Language and Cinema* that object will entirely disappear into a conceptual, virtual space). Rather, the discourse of signification begins from a general yet precise methodological perspective—that of the "science of signs"—of which film or photography will be only a part of the universe of cultural signification. In the context of the École Pratique en Hautes Études (EPHE), this science was forged in the commitment to linguistics and marked by Saussure's unaccomplished dream of creating a general theory of signs. In this respect, (semiological) film theory was initially considered as only one component or subdomain of a general account of signs.

However, photography and film were of special interest to both Barthes and Metz in the early 1960s because they posed a special and in many respects intractable problem for a general and inclusive theory of signs, at least from a Saussurian perspective. As I have remarked in several contexts, the aesthetic discourse inherited from the philosophy of art a system of categories that divided and ranked art forms according to criteria of spatial or temporal expression. Among the many disorienting features of film was to present itself as an uncanny hybrid of space and time, thus producing the need for new concepts and categories, and in some cases, unsettling and remapping the idea of the aesthetic itself. Being forged in the history of linguistics (running parallel in a curious coincidence with the history of film), semiology confronted in film another intractable division, that of speech and image. Through its commutation tests and concepts of double articulation, syntagmatic and paradigmatic analysis, denotation and connotation, messages and codes, semiology was born in a scientific context confident that its analysis of speech or natural languages was extendible into anthropological and literary structures of expression. The open question in the heroic era of structuralism was whether these concepts and categories would prove pertinent or even applicable to more general forms of expression, especially analogical and pictorial images. Or even—and this is the question that Metz's essay both wants to answer and finds nearly impossible to answer—is the very notion of "film language," so prominent among the Soviet theorists and in the fad for gram-

mars of film in the 1950s, a legitimate formulation, or is it in fact an oxymoron? If the image cannot be considered a sign, and if narrative film cannot be analyzed as a language or aesthetic discourse, then the scientific project of a general semiology, a complete theoretical account of signifying phenomena, was an impossible fantasy. This project preoccupies Metz throughout the 1960s, bringing him into conflict and debate with Umberto Eco and Pier Paolo Pasolini. It also inaugurates the discursive genre of film theory within the context of the larger episteme laid in place by the more general history of structuralism.

Metz's essay is thus the launching pad for a new sense of theory, marked by the adoption of a vast new range of concepts, a shift in rhetoric and positions of address, and new institutional contexts. Film becomes an academic enterprise, subject to scholarly debate in university seminars and colloquia by trained researchers, in ways that presuppose a common methodological background or framework, even if that framework is open to revision. But here there is another important point to emphasize. Before the discourse of signification, there is no "film theory"; there are only aesthetic writings on film. Aristarco's rhetorical move is ratified thirteen years later by the discourse of signification; or rather, by the early 1960s, the invention of *theory* as a discourse in the context of structuralism has fully and invisibly accomplished a retrojection, both carving out and bridging over an epistemic breach, wherein theory enters the ordinary language of academic discourse as if it had been always there, as if, from the time of Canudo's earliest essays, we were and had always been "theorists."

We find ourselves again beginning with an ending. The conclusion to "Le cinéma: Langue ou langage?" comes round again to the opening to underscore the stakes of Metz's arguments. (It also anticipates in interesting ways the introduction to *Language and Cinema*.) It is certainly the case that the essay remains a foundational text, laying out the elements for a semiology of cinema, performing for film studies the work that Barthes's "Elements of Semiology" performed for the study of literature and of culture in general. Metz is concerned not only with working through and critiquing metaphorical uses of the concept of language in relation to film form and narration but also with making more conceptually precise how one may speak of filmic meaning within the conceptual vocabulary of linguistics and semiology, and finally, with how film both challenges and enlarges the prospects for achieving a general semiology of culture.

These accomplishments would have been enough to assure Metz a place in the history of modern film theory, and this with his first professional academic essay at the age of thirty-three. But fully half of the text is devoted to another question, and one not often discussed: the specificity of theory as a concept. Just as Metz is clearing the ground and making more precise how and under what conditions the concept of language can be applied to the study of meaning in film, he is also concerned with mapping precisely appropriate uses of the term "theory." Here Metz is equally convinced that there is a literature or language of theory, and that not all writings on film are theoretical; thus his implicit desire to establish the parameters of theory as a discursive genre. Recall that, with the exception of Aristarco, the term as such has until now, 1964, been deployed only infrequently, irregularly, and inconsistently; no one embraces it, or if they do, they equivocate even in the larger context of structuralism. Through the discourse of signification, Metz draws the contours of the concept, gives it form, shape, and appearance through a nominative process. Hereafter, vernacular uses of the term will become less habitual as theory comes to denominate a specific kind of practice and a more or less well-defined genre of academic discourse.

Metz concludes his essay in asserting that until 1964 there have been four ways to approach film study: film criticism, cinema history, filmology, and "theories of cinema." (The scare quotes are again Metz's.) While the history and criticism of film must certainly contribute to a complete understanding of the cinematographic institution, they are not the central focus of Metz's interest. Nevertheless, what Metz calls the "theory of cinema" is less a present discourse than a historical one (if one is past, another new one must be emerging), whose great exponents were Eisenstein, Balázs, and Bazin. Metz characterizes this approach as "a fundamental reflection (on the cinema or on film, depending on the case) whose originality, interest, significance and, in sum, whose very definition is tied to the fact that it was also made from within the world of cinema: 'theorists' were either cineasts, enthusiastic amateurs, or critics."[112]

In contrast, filmology approached the cinema from the outside, carrying out research on cinematographic facts through the domains of psychology, psychiatry, aesthetics, sociology, and biology, whose fundamental figures are Gilbert

---

112. "Le cinéma: Langue ou langage?" in *Essais sur la signification au cinéma* (Paris: Klincksieck, 1968), 90, *92*. Trans. Michael Taylor as *Film Language: A Semiotics of the Cinema* (Chicago: University of Chicago Press, 1991). I remind the reader that all English translations are my own, and that corresponding page numbers from the original French version are given in italics.

Cohen-Séat and Edgar Morin. No doubt, many of the concerns of film theory and filmology are complementary as represented by what Metz calls the border cases of Rudolf Arnheim, Jean Epstein, and Albert Laffay. Both approaches are indispensable to the territory of activities that Metz wishes to mark out, a synthesis no doubt possible since it is nearly accomplished in the first volume of Jean Mitry's *Aesthetic and Psychology of Cinema*.

But there is something missing in this story. Despite the variety and repetitiveness of the appeals to the idea of language in theoretical writing on film, and given the fact that no less a figure than Cohen-Séat underlined the importance of the study of the filmic fact as discourse, there have been few points of contact between linguistics or semiology and the study of film. That linguistics has ignored film is not unreasonable, but here Metz has a more daring move in mind. The time has come to bring together in a synthetic way the work of the principal theoreticians of film, filmological research, and the vocabulary and methods of linguistics as a way to finally realize "in the domain of cinema the great Saussurian project of a study of the mechanisms through which individuals transmit human significations in human societies. The master of Geneva did not live long enough to witness the importance that cinema would have for our world. No one contests this importance. We have to make a semiology of cinema" *(Il faut faire la sémiologie du cinéma)* ("Le cinéma: Langue ou langage?" 91, 93). Curiously, the specificity of the study of film would seem to disappear in the accomplishment of a general semiology; at the same time, the project of semiology cannot move forward without a passage through the problem of how meaning is transmitted through images.

This is a thorny problem that will require some tricky conceptual gymnastics in the essay. We will eventually find our way back to them. But for now let us return to the idea that Metz is trying to survey a vast landscape, in both film study and linguistics, to lay out the perimeters of a new and more contained conceptual space. For the moment, he is less certain of what it is than what it is not. It borders on history and criticism and draws support from them, but at the same time it is spatially distinct from them. It appears to be temporally distinct from "film theory" as a historical discourse; at the same time, coming from outside the cinematographic world, filmology is also not "film theory." What is, in fact, the discursive position that Metz is trying to construct for himself and for the academic study of film?

This question functions as a sort of enunciative a priori structuring the conceptual and rhetorical space that links "Le cinéma: Langue ou langage?," "On the Classical Theory of Cinema," and the introduction to *Language and Cinema*

into a common discursive network. In each iteration of the question, in pursuing a drive toward theory, Metz recurrently finds himself equally confronting the idea that film theory does not yet exist; rather, we find ourselves in a middle period where at best we are only on the way to theory, and that in most respects what will be finally accomplished is not a "film theory," but rather an incorporation or subsumption of the filmic fact into the general domain of a semiology of culture.

This untimeliness of theory as a conceptual and rhetorical position—always to come and always past, never fully present as an epistemological perspective—is on full display in Metz's writings on Mitry. The interest of these essays lies primarily neither in Metz's clear and useful account of Mitry's books nor in his criticisms of certain of Mitry's concepts, but rather in Metz's attentiveness, striking in its perspicuity, to a certain concept of theory. Through Metz, film *theory* achieves a certain presence, stature, or standing. There is confidence here that film theory has a structure and a history, that it develops and evolves according to a definable arc, and that it seeks a form, which it has not yet attained. For Metz, Mitry's books are thus a stage or stepping-stone in this progressive arc of film theory. They have an intermediate status—summing up and concluding one phase and opening out to another—and an uncertain temporality. They have deep roots in the past, and thus belong conceptually in most respects to classical film theory, yet in their drive toward building a global and synthetic account of meaning and the moving image, Mitry's work anticipates a theory yet to come. (It is significant that Mitry produces an "aesthetic"; Metz calls this work a "theory.") Thirteen years after Aristarco's pioneering book, film theory gels, thickens, and begins to appear in clear outline as the possibility of a systematic and unifying conceptual framework for the study of cinema.

In "On the Classical Theory of Cinema," Metz also outlines a historiography of theory: that theory is a way of thinking about film that has a history, that it has had a "classic" phase, which is coming to a close in Mitry's work, a future that can contribute to a global account of the social life of signs, and a present though intermediate phase, which is laying the conceptual foundation for a possible general semiology of the cinema, though in a fragmentary and piecemeal fashion. (Though Metz himself does not say so, this vision of theory does not arise actually from the history and discursive structure of aesthetic writing on film, but rather from a larger discursive territory—that of the history of structuralism, already anticipated in my account of Eikhenbaum and Russian Formalism.)

Metz's 1971 presentation of the two texts on Mitry, contemporaneous with the writing and publication of *Language and Cinema,* is striking in this respect. In a few short paragraphs, Metz takes pains to lay down definitive historical markers, so many stages in the theory of film marked by discursive fissures and breaks that overlap in uneven strata. The first section of Metz's 1972 collection—on the classical theory of cinema, and in particular, the works of Jean Mitry—is meant to give an account of how problems of theory were posed in the years of publication of Mitry's two volumes, 1963 and 1966. Metz wants to put into perspective the "classical" period of film theory (the scare quotes are his own, a doubt or hesitation concerning the temporality and conceptual cohesion of such a concept), of which Mitry's books are at once the apogee and closing gesture, and from which they draw their conceptual and historical significance. The books thus define a precise historical segment in the stations of theory: "It was before the theoretical renewal of 1968–69; just before and in another sense, well before. It was well after the great theoretical era of silent film. It was just after the Bazinian wave. As for filmology, one no longer spoke of it. A hollow period [*période creuse*] . . . : there was not enough interest in theory to know who was already part of it, and who was then passing into a vast forgetting."[113] The lack of interest in Mitry's important books, Metz argues, is caused by their uncertain historical position—they bear witness to the importance of a past tradition that had reached its point of culmination, and having thus exhausted itself had also outlived its audience.

Metz puts the "classical" period within quotation marks not only to signal its temporal uncertainty (How far into the present has it dilated? How deep into the past has it contracted?) but also to clear a space for a new discursive terrain. Through Mitry, the classical discourse has reached its point of culmination in the present, but it is not part of the present; it cannot find a resting place within the modern or actual discourse, the discourse of signification, but must remain disjunct from it on several levels. The deep irony of this disjunctiveness is Metz's recognition of the many points of contact between Mitry's work and the emerging discourse of signification.

This hole or hollow in the progress of film theory *("période creuse")* would not long remain empty. Metz quickly notes that his own first steps in conceiving the project of a film semiology, "Le cinéma: Langue ou langage?," was published

---

113. "Sur la théorie classique du cinéma: A propos des travaux de Jean Mitry," in *Essais sur la signification du cinéma, II* (Paris: Éditions Klincksieck, 1972), 11; my trans.

in 1964 in between Mitry's two volumes. ("Une étape" is contemporaneous with that essay, as I have already noted.) But despite the novelty of semiology, and the possibility it presents for real theoretical advancement, Metz reiterates his sentiment that it cannot be considered as an absolute beginning for film theory. In its inaugural moment, semiology must take into account, reconsider, and reevaluate what preceded it and made it possible. This task is neither an afterthought nor a supplement, Metz emphasizes, but rather engages directly the value of theory itself.

In a single page, then, and apart from a foreword the first page of Metz's book, one can already begin to see clearly his conception of the place of semiology in the broader historical perspective of film theory. What is not so clear is how the gesture of placement itself constructs a history of theory with divisions, continuities and discontinuities, way stations and mile markers, retrospective glances and retrojecting movements. Classical writers were on the way to theory, as it were, but could take it only so far. Writing in 1971, Metz believes he sees a future for theory, a renewal and setting of new directions. In between falls a period of transition, a time of taking stock, of clearing terrain, and of clearly establishing principles of pertinence that can make real theoretical work possible. Among the other hopes placed in it, film semiology was thus charged with the task of finally building the foundations of a film theory that would contribute to the larger project of constructing a general science of signs.

But what in fact are the criteria defining theory in this sense? How is it different from previous writing on film, and how does it anticipate its place in the general, critical semiology to come?

Mitry's conceptual concerns here overlap with those of the younger Metz and of semiology in other interesting ways, above all with respect to questions of analogy, representation, the "coefficient of reality" attributed to film, and film's phenomenological character. In fact, these are all qualities of photography and film that would rub up against and resist the incorporation of mechanically produced images within a linguistically inspired account of signs in both Barthes's and Metz's texts of the early 1960s. Metz remarks upon this as a problem for the "first semiology," which constructed an intractable opposition between the analogical and the coded.[114] As Metz relates, "The first

114. The question of whether the analogical image could be subdivided into smaller distinctive units and thus to what degree one could identify codes interior to the image is one of the key points of contention between Metz, Umberto Eco, and Pier Paolo Pasolini. Referring to this as a debate on the relative value of graded and coded signs, Peter Wollen provides an astute com-

semiology could not conceive that analogy itself might result from certain codes, whose proper action is to produce the impression of their absence. And further, today still, if one wishes to critique the illusion of reality, is it not necessary to take the fullest account of the reality of that illusion? Thus a gap still resides between arbitrary codes and analogical codes, even if the latter, precisely, are at present conceived of as codes" ("Sur la théorie classique" 12).

In retrospect, one of the most striking aspects of Metz's first text on Mitry, "Une étape dans la réflexion sur le cinéma," is not only his suggestion of a clear historical transition between two ways of thinking about the cinema but also his sense that this thought distributes itself historically in distinct if sometimes overlapping and interpenetrating genres. Metz writes of Mitry's book, "This work, taken on its own terms, represents the most serious effort of general synthesis to date of which cinema has been the object."[115] In its breadth, ambition, and logical structure, one imagines it suggests for the first time the real possibility of a general and synthetic theory of film.

If Mitry's book embodies both a point of culmination and a distinct division, how is it alike or different from other texts that historically considered themselves, or were considered, "theories of cinema"? Metz sets aside journalistic or anecdotal accounts as well as film history to describe as theory general accounts of film itself divided onto two lines: "The first emerges from what one calls the 'theory of cinema': written by cineasts or critics, or by enthusiastic amateurs, they place themselves in any case within the cinematographic institution and consider the cinema first as an *art*. The others, of more recent appearance, adopt the 'filmological' perspective: approached from the outside, the cinema is grasped as a *fact* with psychological, sociological, and physiological dimensions, and—more rarely—aesthetic dimensions" ("Une étape" 13). Whereas they might have complemented one another, theory and filmology have, more often than not, experienced tense relations. Perhaps they are two sides or dimensions of a single theoretical approach. They are alike in their generality, Metz offers, as well as in their distinctiveness from what Metz calls "differential studies" of individual filmmakers, genres, or national cinemas. "How can one understand the cinema without being a bit of a 'filmologist,'"

mentary in his *Signs and Meaning in the Cinema* [1969] (London: British Film Institute, 1998). See esp. the chapter on "The Semiology of the Cinema," 79–118.

115. "Une étape dans la réflexion sur le cinéma" in *Essais sur la signification du cinéma, II* (Paris: Éditions Klincksieck, 1972), 13; my trans. Metz also refers to the book as the "first general treatment of cinema available in the world" (13), strangely ignoring the 1960 publication of Kracauer's *Theory of Film*.

Metz asks, "since film puts to work phenomena that go well beyond it? And how to understand it without being a bit of a 'theoretician' because the cinema is nothing without the cineasts who make it?" (14). Among Mitry's great achievements is that he brings these two dimensions together in a single work, by a thinker who is also a maker. Moreover, in its great synthetic arc, Mitry's book establishes a line of thought and a network of filiation and common concerns that reasserts, once again, the emerging canon of classical film theory: Balázs, Arnheim, Jean Epstein, Eisenstein, Bazin, Albert Laffay, Gilbert Cohen-Séat, and Edgar Morin. One finds conjoined within Mitry, then, the aesthetic or "theoretical" line of classical film theory and the scientific or "filmological" line that is a sort of precursor to modern film theory.

Later in the review, Metz characterizes the classical period as a time of violent polemics and blind combat, of too-general analysis and contradictory claims for the metaphysical essence of cinema. Although Metz would later revise this opinion, Eisenstein and the Soviets come in for particular criticism for their lack of rigorous terminology, approximative and inexact analysis, and avant-garde enthusiasms rendered in an "artistic" style. In contrast, Metz offers that Mitry's book marks the passing of this era and the emergence of a new phase of reflection on film, opening "an epoch of precise research, which even if its objectives are general, will no longer be vague or uncertain in its methodological reasoning. . . . This book has brilliantly concluded an epoch that was sometimes brilliant but which risked aging badly if prolonged immoderately. *Aesthetics and Psychology of Cinema* opens a reflection on film to the perspectives of a new epoch, which will have the face of those who make it" ("Une étape" 34). This new era, of course, is the era of signs and meaning, and if Mitry marks the point of termination of one line of thought, moving toward theory, perhaps Metz marks the beginning of another.

We are finally approaching the beginning of "Le cinéma: Langue ou langage?" The essay is divided into two almost equal halves: the implicit concern of the first half is to review the history of film theory and to construct an idea of what it means to have a theory; the second half works through methodological problems of applying linguistic concepts to film. It is revealing that most glosses on this foundational essay ignore the first twenty-five pages, as if there were something there that was inassimilable or perturbing to the project of the second half, which lays down the groundwork for a semiology of film. There are perhaps two reasons why the first half of the essay seems so out of place, or

perhaps out of time, a long delay or digression before Metz moves on to the presumed semiological heart of his argument. To understand the first reason means comprehending that Metz himself does not know or has not yet found the place or position from which a theory can be articulated. It is as if one were trying to speak without yet knowing the grammatical rules of a language, or even its pronominal functions. Metz is searching, trying to find his place in theory without yet being certain of what defines the epistemological stakes and value of theory construction. The ground continually shifts beneath his feet as he seeks out a stable foundation on which to build a new epistemological perspective (the semiological) alongside an ethical analysis. In fact, it is this ethical dimension of Metz's questing for theory that seems indigestible, though in hindsight it may be the most original and fascinating line of thought in his argument. The reflexivity of these pages is dizzying as Metz tries to put in place a vision or concept of theory that does not yet exist as such, and at the same time reflects continually on the value of theory as an enterprise. Though Metz is no Nietzschean, one sees him here in almost a Zarathustrian mode, asking, "What does the 'theorist' want, and what does he will in wanting it?"

The second reason derives from the place the essay itself occupies in the history of film theory: not only does *theory* as such not yet exist as a concept (we almost literally see it here in a process of discursive emergence), one also cannot yet place it in a *history*. It is as if the concept cannot emerge without having a certain historical consciousness of itself, heretofore lacking. Theory's archive does not yet exist. It must be reassembled and evaluated from scattered texts in multiple languages; one must make of it a corpus, defining within it salient questions, problems, and debates with their own internal regularities and zones of classification.

This historical self-consciousness of theory, and the desire to assemble critically an archive from which the potential for theory construction can be adjudicated, is a fairly unique accomplishment for the period. By the same token, this sense of a history of (film) theory could occur only under two conditions. It requires, first, that there is a sense of a canon of aesthetic writing on film as a sort of prelude to theory. Filmology by no means provided this canon, nor is there yet textual evidence that Metz was aware of Aristarco's *Historia*. However, both polyglot and polymath, and an intensely curious and exacting researcher, Metz constructs his own canon as it were, from German and English as well as French sources. Metz's canon conforms in interesting though coincidental ways, with first canons of Daniel Talbot and Richard Dyer MacCann,

though with an exception: Metz is refining the definition of theory and who is capable of constructing theories; his principle of selection is guided by a concept of theory where earlier collections are not.[116] Second, this canon must define a certain kind of historical space, where there is not only "theory" but also competing theories and ideas, grouped together historically. Francesco Casetti has commented astutely that theories in the classical period were local formations contained in distinct social and national communities that were rarely in direct contact with one another. In the postwar period, a new discursive environment occurs, not only where a new idea of theory is coming into existence but also where there is the awareness of an *international* history of film theory composed from an archive whose fundamental texts are now copresent, spatially and historically, and in dialogue with one another. Moreover, here the syncretism and eclecticism of the classical era are defined retrospectively from the point of view of an epistemological space where structuralism follows on the heels of filmology, and where a unified and globally applicable theory in the human sciences seems possible. In constructing a space for theory, Metz is clearing the grounds, shifting back through the history of writing about film to sculpt a concept with precision, to review its possible senses, and to reorganize it in a unified field held together with well-formed and consensually accepted principles of pertinence.

We have finally arrived, through a series of loops and digressions, though important ones, at the first pages of "Le cinéma: Langue ou langage?" Most astonishing in retrospect is how Metz begins emphatically with an implied *ethical* question: from what place does theory speak? In an essay that wants to explore what a theory of language can offer film, the stakes first unfold in a critical evaluation of the language of theory and what theory values in taking film as an object of knowledge.

It is odd that so much of 1970s theory opposed Metz to André Bazin (an indicator of the retrospective and retrojecting force of political modernism and the discourse of ideology), for in the opening paragraph of the essay, the cards of the argument are fully stacked in Bazin's favor. Citing a 1959 interview with Roberto Rossellini in *Cahiers du cinéma*, Metz observes that at the very turning point of modern cinema in Europe, Rossellini speaks of the great silent age of Soviet montage and the idea of editing as an all-powerful manipulation

---

116. Compare, for example, Daniel Talbot, ed., *Film: An Anthology* (New York: Simon and Schuster, 1959; repr. Berkeley: University of California Press, 1966), and Richard Dyer Mac-Cann, ed., *Film: A Montage of Theories* (New York: E. P. Dutton, 1966).

of meaning as things of the past. The era of montage was an indispensable phase of cinematic creation, but now it is giving way to other strategies, and other aesthetic approaches to reality. Here, Rossellini (and Metz) might as well be quoting chapter and verse from Bazin's "Evolution of the Language of Cinema." Montage was also thought a theory, Metz suggests, not only because it was one of the first sustained concepts of cinema but also because of its scientific pretensions. Trained as an engineer, the young Eisenstein came to believe in the possibility of engineering reality and subjectivity through the reconstruction of film language. And in this respect, a certain concept of montage became coextensive with the cinema itself in a long line of influential writers: not only Eisenstein but also Pudovkin, Alexandrov, Dziga Vertov, Kuleshov, Balázs, Renato May, Rudolf Arnheim, Raymond J. Spottiswoode, André Levinson, Abel Gance, and Jean Epstein. Metz calls this a fanaticism for montage, whose adherents refuse doggedly and categorically any form of descriptive realism to the cinema. Two problems thus arise about the status and location of language in cinema, especially in relation to the shot and to the referential status of profilmic space. Eisenstein's process is one of fragmentation and reconstitution. That an uninterrupted segment would have its own sense and beauty is unthinkable. In the early Eisenstein, the profilmic space is a raw material to be dissected and reconfigured into a new series whose meaning is unambiguous. Thus for Metz, "Eisenstein does not miss any opportunity to devalue, to the profit of concern for sequential arrangement, any art that would invest itself in the modeling of the segments themselves" ("Le cinéma: Langue ou langage?" 33, 41).[117]

Metz thus characterizes the era of montage as being dominated by a spirit of manipulation and of engineering the spirit. The theme of the ethical dimension of theory starts to emerge along these lines, and very soon it will be clear that Metz is contrasting two forms of life or modes of existence characteristic of his modernity—the structural and the phenomenological—in order to explore how an *aesthetic* semiology comes to designate a third path inspired by the phenomenological aesthetics of Mikel Dufrenne, and to a certain extent, the early Barthes. In the opening pages of this essay, an unquestioned foundational text in the history of film theory, what we find is rather a strong ethical statement, which continues into the second section. The question of film language has hardly yet been asked. The central problem here seems to be the

---

117. In later essays and retrospective footnotes, Metz significantly softens and complicates his original assessment of Eisenstein. In this early work, Metz is offering a selective ethical reading of Eisenstein, incomplete though not unjust, to make him an exemplar of "structuralist man."

value of the shot of whatever duration in relation to the sequence, and then the question of where meaning is expressed in the composed film. And what is most striking in the second section is how the ethical question, rather than the theoretical one, advances; or yet more complexly, how the ethical and the theoretical advance in turns like two strands that weave one around the other. The engineering spirit of sovereign montage has not fallen into the past except in the cinema, Metz asserts; instead, it finds itself reborn in the new cultural attitudes of the human sciences. Where one would think that Metz's ambit is to present the value of structural linguistics for the study of film, one finds instead a heartfelt plea to soften the structuralist activity by bringing it into contact with modern film—that is, with art. What links the Soviet obsession with decoupage and montage to a certain modern attitude in the human sciences is a passion for manipulating elements through dismantling and reconstructing them—Metz calls this a *jeu de mecano,* playing with Erector sets, a childhood preoccupation that carries forward into the more adult activities of "engineers, cyberneticians, indeed ethnographers or linguists" ("Le cinéma: Langue ou langage?" 34, *42*).

So here, slowly and subtly, before it is even apparent that Metz is addressing the question of *langue* or *langage,* the problems of linguistics and of the multiple and confusing overlapping senses of "language" weave themselves into his text. Film should be confronted as a language, but what kind of language, with what sort of linguistics, and from what perspective? Indeed, what languages of theory must be spoken or rewritten to examine the possible senses of language in relation to cinematographic art? With undisguised irony, Metz associates information theory and distributional analysis with playing with model trains: disassembling, classifying, and reassembling always interchangeable parts—rails, straight, curving, and forked—into ever-renewable configurations. Though himself trained in structural linguistics, what Metz is straining toward slowly is a deep criticism of modern linguistics for denaturing and de-aestheticizing language. No doubt, like boxes of rails and connectors in a model train set, ordinary language may be characterized by fairly strict kinds of paradigmatic choices that yield richly varied syntagmatic chains, all of which are open to modelization. (This, in point of fact, is close to what Saussure referred to as *langue,* an implicit and restricted set of invariant operations underlying mechanisms of sense in ordinary speech.) But there is still something in language that resists modelization and the engineering of meaning, something that remains open and ambiguous, only ever partially and incompletely coded, and something also that sticks to the world of experience and is not so

easily reduced to a virtual system. Information theory wants to reduce the thickness of language to a message, because

> it pulls along too much "substance" within itself, it is not totally organiz-
> able. Its double substantiality, phonic and semantic (that is to say, two
> times human, by the body and the mind) resists complete pigeon-holing
> [*résiste à l'exhaustivité de la mise en grilles*]. Furthermore, has the lan-
> guage that we speak become—quite paradoxically when one thinks of
> it—what these American logicians call "natural" or "ordinary" language,
> whereas in their eyes no adjective is required when they speak of their
> machine languages, more perfectly binary than R. Jakobson's best analy-
> ses. The machine has stripped human language of its bones, sliced it up
> into neat sections where no flesh adheres. These "binary digits," perfect
> segments, now only need to be assembled [*montés*] (programmed) in the
> required order. The perfection of the code is triumphantly achieved in
> the transmission of the *message*. This is the great celebration of the syn-
> tagmatic mind. ("Le cinéma: Langue ou langage?" 35, 43)

In case one misses his meaning, Metz continues by focalizing in the "linguistic machine" a variety of modern preoccupations with automatization, commodi-fication, and the overprocessing of raw nature into denatured products where, finally, "the prosthesis is to the leg what the cybernetic message is to the human sentence" (35, 43).

In the opening sections of his essay, then, Metz is objecting to two kinds of theory, in film and linguistics, which are connected by a preoccupation with "engineering" and a way of construing language. What Metz is searching for now is a theoretical alternative both to montage "theory" and to hard structur-alist analysis. (Perhaps the former is too far to the left, a failed utopia leading to Stalinism; the other, too close to the right, and a mechanized and commodi-fied society.) In hard structuralism, language is treated as a product, Metz as-serts, or more clearly, a raw material that must be refined in a well-defined process: one analyzes by isolating constitutive elements of paradigms; then these elements are redistributed into isofunctional categories ("straight rails to one side, curved rails to the other"). However, the moment that one antici-pates in theory,

> the one thought of from the beginning, is the syntagmatic moment. One
> reconstitutes a double of the first object, a double totally thinkable since

it is a pure product of thought: the intelligibility of the object has become itself an object.

And one has not in the least considered that the natural object has served as *model*. Quite to the contrary, the constructed object is the object-model; the natural object has only to hold up to it. Thus the linguist tries to apply the givens of information theory to human language, and what the ethnographer will call "model" is not in the least the reality examined but rather the formalization established from it. ("Le cinéma: Langue ou langage?" 36, *44*)

Reality has disappeared into its simulacrum.

Published in 1964 in the rapidly ascendant arc of structuralism, and in the flagship journal of the semiological enterprise in France, this paragraph must have been stunning, even bewildering to some readers, for Metz continues by linking information theory to French structuralism itself. No less a figure than Levi-Strauss is chided for "pacifying the real as 'non-pertinent'" ("Le cinéma: Langue ou langage?" 36, *44*). This theory of abstracting and modeling the real is then linked to the structuralist activity as defined by Roland Barthes, Metz's mentor at the École Pratique, who is himself criticized because his aim is not to represent the real, but to simulate it. The structuralist activity "does not try to imitate the concrete face of the initial object, it is not 'poesis' or 'pseudo-physis'; it is a product of simulation, a product of 'techne.' In sum, the result of a manipulation. Structural skeleton of the object erected into a second object, always a sort of prosthesis."[118] Metz, soon to be considered the godfather of cine-structuralism, has here retreated from the core concepts of structuralism. Or perhaps he is trying to imagine another kind of structuralism, and another path to theory, one where the hard structuralism of Levi-Strauss can be softened in the passage through aesthetics in general and film in particular.

After Levi-Strauss and Barthes, the next link in Metz's chain of argumentation is Eisenstein, considered as a hard structuralist *avant la lettre*. And in a similar fashion, film *theory* must seek still another path, not in a return to the filmic past, to the engineering or manipulative attitude that now, ironically, replicates itself in hard structuralism, but rather one in relation to modern cinema, which presents an ethos alternative to the machinic mind. Rossellini

118. (36, *44*). The interior citations are from Barthes's essay "The Structuralist Activity," originally published in *Lettres nouvelles* (February 1963): 71–81, and reprinted in Barthes's *Essais Critiques* (Paris: Éditions du Seuil, 1964).

is again the avatar of a new way of thinking. "To Rossellini who exclaimed: 'Things are there. Why manipulate them?,'" Metz writes, "the Soviet might have responded, 'Things are there. They must be manipulated.' Eisenstein never shows the course of the world, but always, as he himself said, the course of the world refracted through an 'ideological point of view,' entirely thought and *signifying* in each of its parts. *Meaning* does not suffice; one had to add signification to it" (*Le* sens *ne suffit pas, il faut que s'y ajoute la signification*) ("Le cinéma: Langue ou langage?" 36–37, 44).

This is not a political contrast, as Metz makes very clear, but it is an ethical one, and one with theoretical consequences. If Eisenstein veers too far toward the materialist side of modernity, the scientific and engineering mentality, on the phenomenological side, Bazin's desire for a direct contact with things through film is too idealist. At stake in this contrast is how one approaches the concept of sense or meaning in relation to signification. At this very moment in the text, semiology makes a surprise appearance as an intermediary possibility, perhaps bridging the materialist and the phenomenological attitudes, or in fact, softening structuralism with phenomenology. Rather than a direct contact of consciousness with things, or a deconstruction and remaking of meaning in a simulacrum, semiology, Metz argues, is concerned with something else:

> What I call the "sense" of the event narrated by the cineast would be, in any case, a meaning *for someone* (no others exist). But from the point of view of expressive mechanisms, one can distinguish deliberate signification from the 'natural' meaning of things and beings (continuous, global, without a distinct signifier, thus the joy read on a child's face). The latter would be inconceivable if we did not already live in a world of meaning, but it is also only conceivable as a distinctive organizing act through which meaning is redistributed: signification loves to cut up precisely discontinuous signifieds that correspond to as many discrete signifiers. ("Le cinéma: Langue ou langage?" 37, 45)

In this Eisenstein goes too far, not aesthetically but theoretically. Referring to the magnificent segment of the stone lions rising up in protest in *Battleship Potemkin,* Metz argues, "It wasn't enough for Eisenstein to have composed a splendid sequence, he intended in addition that this be a fact of language [*langue*]" (37, 45). How far can the passion for construction go? Metz protests. One variation on the imagination of the sign would be a cybernetic art finally

reconciled with science, a vision of poetry programmable by machines. This is an extreme example of a certain orientation of modernity, one of its possible paths, where whether carried forward into aesthetic creation or into cybernetics or structural science, it leads to dubious results.

There is a genealogical line, then, that Metz draws from the modernity of sovereign montage to that of Barthes's vision of "structural man." Along this line, it must be said, there are many points of attraction for Metz. Both *cinéphile chevronné* and structural linguist, admirer of Eisenstein (in theory and practice) no less than Rossellini, adept at phenomenology no less than semiology, how to counterbalance all these opposing forces? And how to do so in theory and through language? Indeed, how to seek out in language—both a theoretical conception of language and in a certain conception of theoretical language—a place that reconciles these interests? How to find one's distinct place in theory? In implicitly asking these questions, Metz is forging for himself here a new form of life in theory.

But to return to my reading, here Metz notes two reservations with respect to his criticisms of structural man or the "syntagmatic mind." The historical existence of Constructivism in film and film theory waxes and declines well before the emergence of structural man, who appears after the Liberation in France. In fact, the historical situation is yet more complex, as I have already shown. The emergence of a Formalist or structuralist attitude is contemporaneous with the triumphant period of Soviet cinema and aesthetics. The two evolve in tandem and in close contact with one another, especially in the pages of *Lef* and through the work of Eikhenbaum, Brik, Shklovsky, and Jakobson in Moscow and Saint Petersburg. Moreover, even if the period of sovereign montage is thought to be concluded, structuralism in the 1930s was just entering a period of gestation before arriving with Levi-Strauss, Jakobson, and Martinet in France, all fresh from their encounters in New York. This does not detract from Metz's main point, however. In the historical moment when a certain mentality (call this from our perspective a certain form of life in language and in theory, but what Metz calls an "intellect-agent") becomes conscious of itself and gains confidence in itself, it deserts the cinema, where a new form of modernism is asserting itself in neorealism and the French New Wave. Moreover, the cinematic domain is too small; structuralism needed to deploy its forces on larger territories. It is thus understandable that at the beginning structuralism would have to feel its way slowly toward a field so rich and complex as film.

But here Metz's second reservation arises. Metz finds it paradoxical that the cinema would be considered such a rich domain for the early syntagmatic mind of the 1920s, for it seems to be in conflict with the analogical power of the film image as well as its phenomenological sensitivity to the real—what Metz calls a continuous and global image without a distinct signifier, which is resistant, in fact, to strict codification. Even from a semiological perspective, Metz's bets for a new film theory, indeed for modern theory as such, are placed on the real, or at least a certain image of the real:

> Is it not the peculiarity of the camera to restore to us the object in its perceptual quasi-literality, even if what one gives it to film is only a fragment pre-selected from a global situation? The close-up itself, the absolute weapon of the montage theorists in their struggle against visual naturalism, is it not at the smallest scale just as much respectful of the face of the object as a wide shot? Is not the cinema the triumph of this "pseudo-physis" that the manipulative mind precisely refuses? Is it not based completely on the famous 'impression of reality' that no one contests, which many have studied, and to which it owes simultaneously its "realist" tendencies and its aptitude for staging the fabulous? ("Le cinéma: Langue ou langage?" 38, 46)

And here is the dilemma in which Metz finds himself, the double bind that requires a solution in theory. What is most modern in theory, structuralism, finds itself in conflict with what is most modern in cinema, Rossellini or Bazin's phenomenology of the real. And indeed film (or more precisely, the analogical image)—which might be thought as marginal to the larger enterprise of structuralism whose concern is with all of culture and all of language—will soon become the focal point through which semiology must distinguish itself from linguistics. The image is in conflict with language, and what is most advanced in theory is at odds with the most powerful aesthetic concepts of modern cinema. In league in many respects with Barthes's writing on photography in the same period, Metz must now remodel a concept of language to find a new way to approach semiology—not a science (filmology), but something methodologically rigorous and conceptually precise; not a hard structuralism, but a soft one.

From a semiological perspective, film theory could only have a paradoxical status in its current state. Given Metz's view that the cinema does not lend itself

well to manipulation or to the engineering mind, why did it generate so much enthusiasm for certain "theorists of construction" (*"théoriciens de l'agencement"*) like Eisenstein and the Russian Formalists? In Metz's opinion, the great attraction of film for Constructivism was based on a fundamental conceptual error. Like a language, film seemed to have fundamental and distinct levels of articulation—from the photograms on the film strip to shots, to sequences, and to larger structural parts—that could be broken down, reconfigured, and rearticulated. Why should one not see a meaningful system of articulations there? Metz continues in observing that "the error was tempting: seen from a certain angle, the cinema has all the appearances of what it is not. It seems to be a kind of language; one saw there a *langue*. It authorized and even required decoupage and montage: one believed that its organization, so manifestly syntagmatic, could only proceed from a *prerequisite* code, even if presented as not yet fully conscious of itself. The film is too clearly a message for one to suppose it without code" ("Le cinéma: Langue ou langage?" 40, *47–48*).

This is perhaps the moment to follow Metz in a short digression. The problem of the essay—cinema, *langue ou langage?*—so limpidly posed in French has always presented obstacles to English readers, above all in translating the term *langue*. *Langue* is not exactly speech, nor is it language. In a footnote to these paragraphs, Metz explains the basic conceptual distinction where for Saussurianism *langue* is a highly organized code, while language covers a zone of interest more amorphous and more vast:

> Saussure said that language is the sum of *langue* and speech. Charles Bally or Émile Benveniste's notion of the "language fact" goes in the same direction. If one wants to define things and not words, one would say that language, in its most extensive reality, appears every time that something is said with the intention of saying. . . . No doubt, the distinction between verbal language (language properly speaking) and other "semes" (sometimes referred to as "language in the figurative sense") imposes itself on the mind and must not be mixed. But it is [also] normal that semiology would take an interest in all "languages" without prejudging from the beginning the extension and limits of the semic domain. Semiology can and must draw important support from linguistics, but the two cannot be confused. ("Le cinéma: Langue ou langage?" 40, *47–48, n5*)

Two problems arise from this terminological digression. First, on the side of code, *langue* is neither speech nor language, nor is anything gained from op-

posing natural and aesthetic languages. Metz needs something more here than Formalism's main principle of pertinence, the distinction between practical and poetic language. Second, semiology must deal with a vast range of meaningful phenomena (semes), many of which are not linguistic in nature. Yet as a science of meaning, linguistics has not been surpassed, and must still nourish the concepts and methods of semiology. The contrast between *langue* and *parole,* or code and message, is not only a key principle of pertinence for Saussure's linguistics but also essential to his imagination of a more general semiology. Message, speech, language, and seme are all *actualized* instances of meaning, but the *langue* underlying them is *virtual.* Where *langue* is so close in French to "tongue," or "national language," here it is more like a virtual force, nowhere present in any instance of signification, yet at the same time underlying all meaning as the structured system of differences from which an expression gains and transmits sense.

Herein lies a conceptual confusion where all the various "grammars" of film and treatises on "film language" have come to grief. Because films are understood, and are repeatedly understood, one searches in them for a conventional syntax. Yet at best one will find only fragile and partially coded elements torn from reality, like "a great river whose always moving branches deposit here and there its bed, in the form of an archipelago, shaped from the disjointed elements of at least a partial code. Perhaps these small islands, hardly distinct from the watery mass, are too fragile and scattered to resist the external forces of the currents that gave birth to them, and to which in return they remain always vulnerable" ("Le cinéma: Langue ou langage?" 40–41, *48*). Metz later continues this line of thought in a significant passage: "In the cinema, everything happens as if the signifying richness of the code and that of the message were connected together [*unies entre elles*]—or rather, disconnected—by the obscurely rigorous relation of a kind of inverse proportionality: the code, when it exists, is coarse. Those who believed in it, when they were great cineasts, did so in spite of themselves. When the message becomes more refined, it undermines the code—at any moment, the code can change or disappear; at any moment, the message can find a way to signify differently" (48–49, *56*). The impermanent, unstable, and even historical nature of code in aesthetic expressions already throws up a challenge to Saussure, who insisted that only a synchronic analysis could reconstruct the underlying system of a *langue.* All the phenomenological qualities of analogical artifacts, and indeed the historical variability and innovativeness of art, erect conceptual barriers to a theory of the code, at least in a strict sense.

The open question for theory, then, is how to remain sensitive to the open and complex processes through which films have, gain, or give the appearance of intelligibility. On one hand, Constructivist or Formalist writing on film goes too far in taking shots for words and sequences for phrases, thereby finding the structure of *langue,* speech, and other forms of "pseudo-syntax" within the filmic message. Sovereign montage dismantles the sense interior to the image to slice it up into simple signs exploitable at will. On the other hand, without montage, or rather the extreme forms of montage, modern cinema unveils another kind of expressivity, and therefore a kind of "language" immanent to the analogical image itself in its phenomenological density and richness. Metz calls this another or alternative kind of organization *(agencement),* where "the signifier is coextensive with the whole of the signified, a spectacle that signifies itself, short-circuiting the sign properly speaking" ("Le cinéma: Langue ou langage?" 43, *50*). Following Merleau-Ponty's lecture on "Cinema and the New Psychology," and indeed a whole line of postwar reflection on the phenomenology of the image, Metz finds film to be the phenomenological art *par excellence,* where the moving image, "like a spectacle of life, carries its meaning within itself, the signifier only uneasily distinct from the signified. 'It is the felicity of art to show how a thing begins to signify, not by reference to ideas that are already formed or acquired, but by the temporal and spatial arrangement of elements'" (43, *50*).[119] The film image short-circuits the linguistic sign, but at the same time it is not life itself, but rather a composed, complex, heteroclite image; not a *langue,* but nonetheless a language, and again following Rossellini, a "poetic language" (44, *51*).

Thus the title of the essay already gestures toward Metz's key dilemma in theory. The problem of meaning in film must navigate carefully between, on one hand, the domain of *langue* and the conceptual precisions of structural linguistics, and on the other, language, or the phenomenological richness of the analogical and aesthetic image. This dilemma organizes all the great rhetorical poles of the essay, including the recurrent contrast between Rossellini and Eisenstein in the realm of poetics, and the historical distinction between the "classical theorists" of film and the broader, more synthetic semiology to come.

---

119. The interior citation is from Merleau-Ponty's "The Film and the New Psychology," a lecture originally given at IDHEC in 1945 and reprinted in his *Sense and Non-sense,* trans. Hubert L. Dreyfus and Patricia Allen Dreyfus (Evanston, Ill.: Northwestern University Press, 1964), 57–58; trans. mod.

At the same time, these are also ethical choices, laying out approaches to life and to thought, as the odd introduction to the essay makes clear. As an alternative to structural linguistics, Metz searches out an aesthetic or poetic semiology to forge a compromise where the search for a place in theory might define a domain that is both conceptually precise and aesthetically rich. Even more striking is the way that for Metz the new, modern cinema already anticipates, reconciles, and transcends these oppositions in its very forms; it is ahead of or anticipates theory in this respect.[120] The modern cinema includes both montage and sequence-shot in its creative repertoire, and here Metz agrees completely with Mitry that there is no film without montage, or rather editing. The analogical power of the image, the near fusion of signifier and signified, cannot define the whole of the film image, but only one of its most important components—the photographic image. The image is not reducible to the photographic alone. The shot enters into many kinds of combinations and on various scales or degrees: "A film is made of many images, which take their sense, one in relation to the others, in a play of reciprocal implications" ("Le cinéma: Langue ou langage?" 43, *51*). The signifier and the signified are thus separated in a way that indeed makes "language" possible. Therefore, through their interest in aesthetic or poetic language, even the Bazinians and Left Bank filmmakers have the merit of having conceived a sort of spontaneous and intuitive semiology that refuses any consideration of cinema as a *langue*.

Finally, there is yet another polarity that must be reconciled in Metz's essay, and this polarity poses two obstacles to the kind of aesthetic semiology Metz is searching for. Within the historical space of "classical theories," which Metz no doubt considers the precursors to a more modern approach signaled by

---

120. This observation draws out an interesting contrast between the early work of Metz and Raymond Bellour, who otherwise were so closely allied. Bellour understood early on that the primary testing ground for the structural analysis of film should target a certain classicism; in short, Hollywood film, especially Hitchcock. In contrast, to put his "large syntagmatic categories" to the test, Metz turned to a minor though important New Wave film, *Adieu Philippine*, and investigates narration in *Fellini's 8½*, both of which have essays devoted to them in *Film Language*. His frequent references to Left Bank filmmakers are not simply a matter of taste, I think, but rather are more generally representative of a feeling for the conceptual power and inventiveness of the new cinemas, and one that would be echoed later in Gilles Deleuze's work on the time-image. The tight link between "modern theory" and "modern cinema" is also in full view in the panels on semiology and film incorporated into the Mostri del Nuovo Cinema in Pesaro in 1966 and 1967, which generated important critical discussions in which Barthes, Metz, Eco, and Pasolini all had roles to play. See, for example, Casetti's *Theories of Cinema*, 135.

semiology, there are two possibilities or pathways on the way to theory: one that veers too closely to language and another that strays too far from it. On one hand, there is formalism or constructivism, what Metz calls the adherents of "cine-*langue*"; on the other, there are the "aestheticians," such as Balázs and Arnheim.[121] In each instance, it seems always to be the case that theory has not yet arrived: one constructs the components of a theory, but then there occur the false starts, detours and digressions, culs-de-sac, where in the aesthetic discourse one veers either toward Constructivism and cine-*langue* or toward art and expression; theory must reconcile the two. The second obstacle is that the conceptual genealogy of cine-semiology descends directly from the Formalists (in the broadest sense), who, Metz implies, may have posed the problem for film in a limited or inadequate manner. And this observation turns round to complicate the first problem. In 1964, a linguistically inspired semiology passing through structural anthropology aims high, hoping to construct a general and critical account of culture as language. But if a general semiology is to transcend linguistics to become a comprehensive account of the life of signs in society, of signifying culture, it must widen conceptually the province of language to include nonlinguistic expressions. And here all the most intractable problems will pass through the analogical arts, primarily photography and cinema, "messages without codes," as Barthes put it at the time. The artistic domain, which at first glance seemed tangential, now becomes the central obstacle to constructing a general theory. Suddenly, the minor art of film is a major concern for semiology. Moreover, to construct a theory by bringing the two domains in contact with one another, to produce a defendable epistemological perspective on the filmic fact that is equally attentive to the phenomenological experience of film, Metz needs a new concept of language, one that, like filmology, comes from outside the cinematographic institution but that also remains attentive to the expressive power and complexity of the works themselves.

121. This contrast was implicitly understood in the classical period. In a 1931 review of Granowsky's *Lied vom Leben,* Arnheim complained about "the strange way in which Russian film artists ruin the chance of visualizing things through their penchant for theoretical constructions. The Russians are real fanatics of film theory. They have thought up almost cabbalistic systems; yet the application to the actual work of art is for the most part not very satisfactory." The implication is that there should be some conceptual alternative to the Russian approach, and perhaps one that is more aesthetic and less theoretical. See "Granowsky probiert," in *Rudolf Arnheim: Kritiken und Aufsätze zum Film,* ed. Helmut H. Diederichs (Frankfurt am Main: Fischer, 1979), 233. I was led to this fascinating quote by Sabine Hake's *The Cinema's Third Machine: Writing on Film in Germany, 1907–1933* (Lincoln: University of Nebraska Press, 1993), 278.

To be on the way to theory, then, means returning to but also remapping the problem of speech or cine-*langue* in prewar writing on film and, from the perspective of modern aesthetics and structural linguistics, to pass judgment on the first stage or phase of theory, which now implicitly, though in a scattered and disunified way, follows the Ariadne's thread of the concept of cine-*langue*, and this, paradoxically, in the era of silent film. Metz is well aware of the irony: "No era was more verbose than that of silent film. So many manifestos, vociferations, invectives, proclamations, prophetic statements, and all against the same fantasmatic adversary: speech" ("Le cinéma: Langue ou langage?" 49, 56). And all seeking purity of expression, as it were, in a moving visual image of universal power.

At the same time, the concept of cine-*langue* sought out something like a universal syntax in the silent image, something that made of images a "language," but a nonverbal one. In returning to and remapping the canon of aesthetic writing on film, Metz defines a twofold project. On one hand, he identifies and defines a certain genre of writing on film—film theory—and gives it a conceptual valence distinguishable from history and criticism. Historically, this is both a backward-looking and forward-projecting gesture, which in each case launches itself from a space located within the discourse of signification. On the other hand, the objective of constructing a new idea of film theory is to make it part of a larger project—the general semiology to come as the foundation for the human sciences. At the same time, this rewriting or remapping is a retrojection, reformatting the aesthetic discourse in the structure of the discourse of signification, making of it the first or preliminary archaeological phase to which film semiology will be a second and intermediary step contributing to a general science of signs.

After stating his criticisms and hesitations concerning the status of the concept of cine-*langue*, Metz returns to them to examine what elements or characteristics bring them close to theory or render them as stages or stepping-stones, partial and fragmentary attempts, to find a path toward theory. The seduction and the sin of early writings were to have been on the right road but going too fast in the wrong direction. Many found a path toward theory through the problems of meaning and language; nonetheless, they operated with an inexact, even mistaken, concept of signification and of language,

> for at the moment when they defined the cinema as a non-verbal language, they still imagined confusedly that a pseudo-verbal mechanism was at work in the film. . . . A thorough review of theoretical writings of

the period makes easily apparent a surprising convergence of concep-
tions: the image is like a word, the sequence is like a sentence, a sequence
is constructed from images like a sentence from words, etc. In placing
itself on this terrain, the cinema, proclaiming its superiority, condemned
itself to an eternal inferiority. In comparison to a *refined* language (ver-
bal language), it defined itself without knowing as a courser double. ("Le
cinéma: Langue ou langage?" 50–51, *57–58*)

This is what Metz calls the paradox of "talking cinema," in expression and in
theory. The key aestheticians of the silent period and the transition to sound
had an unclear and even somewhat perverse understanding of the complex
relationship of speech to image. They viewed this relationship as antagonism
and rivalry, which blinded them in theory to the wealth of possible combina-
tions and interactions between image and speech, each equally impure, each
equally enriched, by their mutual interaction. Looking back at this period his-
torically, like Bazin but for different reasons, Metz observes that for a certain
cinema, nothing changes in fact during the transition to sound. Declaring film
to be a "language," indeed a universal aesthetic language of images, the "theo-
rists of cinema" confused it with a *langue*—a relatively restricted system logi-
cally anterior to the message: an image opposed to speech in principle yet
speaking to all as clearly as words. At the same time, actual speech seemed to
bring to film only "an unhappy surplus and an ill-timed rivalry" (55, *61*).

In fact, not until a new modern cinema was born, perhaps with *Citizen
Kane* in the early 1940s, did the image transform itself to welcome a new rela-
tionship with speech, and not any kind of speech, but rather a modern aes-
thetic discourse. The modern cinema appears again in Metz as a sort of herald
for theory—the protoconceptual *theoros* who announces a new relationship of
image to language that can be finally understood only in a new construction
of theory, where Metz's aesthetic version of structuralism hopes to make a
contribution. Here the modern cinema finally becomes a "talking" cinema
that conceives itself as a supple aesthetic language, never fixed in advance, al-
ways open to transformation. Referring explicitly to Étienne Souriau (and
implicitly to André Bazin), Metz writes that the long take has done more for
talking cinema than the advent of sound, and that a technological innovation
can never resolve an aesthetic problem—it can only present the problem be-
fore a second and properly artistic creation comes to suggest possible solu-
tions, which can consequently be expressed in theory. In this manner, the
modern cinema of Alain Resnais, Chris Marker, and Agnès Varda constructs a

new conceptual relation of language to image, a complex yet "authentically 'filmic'" discourse ("Le cinéma: Langue ou langage?" 56, 62). In many respects, they present to semiology what is at stake in a film discourse.

We are now close to the end of the first half of the essay. After all of his criticisms of Constructivism, of cine-*langue* and Erector-set cinema, Metz then concludes the first half of "Le cinéma: Langue ou langage?" with an appreciation of cine-*langue* as theory, or perhaps pointing the way toward theory. Metz offers that these writings formed a whole body of theory, which must be evaluated as such. The open question here is, what are the components and conceptual stakes of theory that appear in outline or in their initial steps in the 1920s and 1930s and that are more or less clearly distinguishable from criticism on one hand and history on the other?

And there is another term in this equation—art. Metz observes that there may have been an Erector-set cinema but not Erector-set films. "Cinema" here means an idea or a concept imagining, desiring, or proselytizing for a certain kind of film. But, *pace* Arnheim, the great films of Eisenstein or Pudovkin transcended their theories: "The common tendency of many films of this period were only hypostasized in the writings and manifestos. The tendency never realized itself completely in any particular film" ("Le cinéma: Langue ou langage?" 56, 62). Aesthetic thinking through a filmic discourse, in this respect, always remained ahead of theoretical expression itself. This observation is related to Metz's subsequent comment that from a historical perspective, the cinema could become conscious of itself, as film and as art, only through excess or exaggeration; hence, the ecstatic tone of the period's manifestos and various *cris de coeurs*. The period of cine-*langue* is thus important for two reasons. First, after 1920 or thereabouts, it coincides with the birth of an idea of cinema as art, and thus represents the emergence of a kind of historical consciousness as well as an anticipation of theory through aesthetic practice. Second, Metz notes that his central question—cinema *langue* or language— could begin to be presented only at the moment when the first film theories were being conceived. The whole conception of cine-*langue*—though preliminary, incomplete, and excessive—nonetheless raises questions of both art and language. Though Metz does not say so directly (he says it everywhere indirectly), the path to theory is signposted here as passing through, and perhaps beyond, the domains of the aesthetic and the linguistic. The possibility of theory, however, had to wait for more modern approaches to both art and linguistics, and in this respect, film, like every art, exhibited its protoconceptual and anticipatory force. At the apogee of sovereign montage, Metz concludes,

and without attendant theories or manifestos, directors like Stroheim and Murnau prefigured the modern cinema. This idea of cinematic modernity is, of course, Bazin's, and at the same time, *il faut faire la sémiologie du cinéma.*

The theory to come—film theory as a stage or step toward a global and uni-fied semiology—must pass through the linguistic and the concept of *langue,* and at the same time it must become "translinguistic" by addressing the prob-lems posed by nonverbal languages. Here the question of cinema has pride of place. And at this point, interestingly enough, Rossellini is evoked once again to establish that film is an art rather than a specific sign-vehicle, and must be treated as such semiologically. The simple conclusion and the profound irony for the discourse of signification are that while films are powerfully meaning-ful and expressive, nothing can be gained for semiology by considering them as analogous to a *langue.* But just as a general semiology will come into being only by transcending and subsuming the domain of linguistics, film theory will become a subdomain of semiology in recognizing concretely the ways in which cinema is a language without a *langue.*

Testing the conceptual limits of *langue* in order to map out the possible and legitimate ways of treating filmic expression as language is the great technical task of the second half of Metz's essay. That useful pedagogical task must be left aside here.[122] The important point to conclude with is to account fully for the role played by the aesthetic, or a transformed idea of the aesthetic, in forg-ing the discourse of signification.

In one of the most remarkable sentences of the essay, Metz writes, "The 'specificity' of cinema is the presence of a language that wants to be made art, in the heart of an art that wants to become language" *(La 'spécificité' du cinéma, c'est la présence d'un langage qui veut se faire art au cœur d'un art qui veut se faire langage)* ("Le cinéma: Langue ou langage?" 59, 65). There are two direc-tions of "language," then, neither of which is predisposed to being understood as a *langue.* On the one hand, there is what Metz calls an *"imaged discourse"*

---

122. Briefly, Metz's main objective is to trace out all the ways signification in film is unlike a *langue* but like a language according to the following criteria: within the image discourse there is no double articulation; filmic syntax is forged at the level of sequence composition, making film more like "speech" than *langue;* narrative film is characterized by strong syntagmatic orga-nization with weak paradigms, or rather, commutations are possible only at the level of large units of organization; and film, like other art forms, is less communication than an open system of expression. Linguistics, in other words, points the way to showing what film is not *(langue)* and what it is, a language or discourse of art.

*(discours imagé),* that is, the moving photographic image as "an open system, difficultly codifiable, with its non-discrete fundamental unities (= images), its too natural intelligibility, and its lack of distance between the signifier and signified" (59, 65). But on the other hand there is a *"filmic discourse"* that draws upon a variety of other elements to compose a film expressively, not only with moving images and montage but also with dialogue, music, sound effects, written elements, structures of narration, and patterns of spatial and temporal articulation both invented and borrowed from the other arts, which are only partially codifiable. "Art or language," concludes Metz, "the composed film is a yet more open system. . . . The cinema that we know . . . (there will perhaps be others . . . ) is a 'menu' with many pleasures: it enduringly weds consenting arts and languages in a union where the powers of each tend to become interchangeable. It is a community of wealth, and in addition, love" (59, 65).

To construct a film theory while maintaining a love of cinema, to make this theory conceptually possible and terminologically current, will now mean knowing to what extent the vocabulary of linguistics advances or blocks the passage through film to a general semiology. For the possibility of semiology here is also the path to having or possessing a theory, or to know that one thinks theoretically. To become or be on the way to theory, the discourse of signification has to find itself prefigured in the aesthetic discourse. This was equally the case for Cohen-Séat's vision of filmology and Souriau's concept of aesthetics. Or to put it in a different way, theory is only the partial and intermediate phase of transition toward a more general science. If filmology as a general science exists, there is no need for film theory, which could also only be a subdomain of a general science of aesthetics.

For all the pages so far written in this essay, and for all the twists and turns taken in Metz's brilliant argument, the question still before him, then, is that if the cinema can in no way be considered a *langue,* then how to defend his conviction that a "filmolinguistics" is both possible and desirable, and that it must be solidly grounded in the vocabulary and method of linguistics?

For Metz, one of the founders of the discourse of signification, the path to a global semiology and a science of signs must pass through a linguistically inspired *film* theory. This conviction produced two consequences for his writings of the period. First, his retroactive historical reconstruction of a certain history of writing on film from the 1920s produces a canon where in fact to claim their status as theory means to have considered the problem of language in whatever form. A process of retrojection is at work here, where the highly variegate and

contradictory aesthetic discourse is being (has been) transformed by the discourse of signification. The past canon of film theory is thus selectively formed to contribute to a debate in which filmolinguistics or cine-structuralism will be both the culmination and the passage to new, broader, and more synthetic forms of knowledge. Theory here becomes a theory of language and structure, inspired by Saussure, a process begun already by the Formalists in the 1920s and 1930s. Tracking back for the moment from our restricted view on Metz's first essays to include the prolific work of other writers of the period, including Umberto Eco, Pier Paolo Pasolini, Raymond Bellour, Noël Burch, Emilo Garroni, Yuri Lotman, Peter Wollen, Sol Worth, and many others, even including Jean Mitry, we can see that despite the will to forge a common method and conceptual vocabulary for (cine-)semiology, the discourse of signification was itself a highly variegate and in some senses syncretic discourse. Nonetheless—and here filmology indicated a real and fundamental change—there was a sense common to almost everyone of a shared, international dialogue or debate within a more or less common set of problems and concepts, of moving forward through conceptual conflict to a more precise and unified approach defined by the problem of signs and meaning in images.

Marc Vernet has observed that Metz's writings can be organized into three distinct phases, each with its particular style of writing, each of which defines its own particular conceptual and epistemological space distinct from the others: the collected essays of the 1960s, *Language and Cinema,* and finally, "The Imaginary Signifier."[123] These phases are all points of passage or transition in theory, moving from the problem of signification to that of the text, and finally, to psychoanalytic accounts of the signifier. In taking account of the variety of Metz's contributions, and his extraordinary drive and commitment continually to revisit critically and to remap the stakes of theory, both epistemologically and evaluatively, we can better understand his unique contributions, not only to building film studies as a modern university discipline but also to forging a discourse now often taken for granted: the theory of film. What drives Metz's epistemological and ethical searching from the very beginning is his dual sense of both the fundamental necessity of theory as conceptual critique and innovation, and an idea that theory is always open and incomplete, not yet arrived and always to come. In the decades of semiology's

---

123. See Michel Marie and Marc Vernet, "Entretien avec Christian Metz," *iris* 10 (April 1990): 276.

methodological passion, Metz was one of structuralism's most powerful critics, and one of its true believers, but by the early 1970s, the dream of a global and unified science of signs was rapidly fading—the discourse of signification was fraying and splitting into new formations; structuralism was turning into poststructuralism, and theory was becoming Theory.

In this respect, it is interesting to return to the introduction to *Language and Cinema* and its retroactive account of what Metz calls the three phases of "film theory." In the first phase, what was referred to as the theory of film was eclectic and syncretic, and "called upon several methods without applying any of them in a consistent manner, and sometimes without being aware of doing so" (*Language and Cinema* 20, 13). The semiology of the cinema, which preoccupied Metz throughout the 1960s, and whose crowning achievement was *Language and Cinema,* is obviously here only an intermediate stepping-stone—not yet a theory but building the foundations of a methodology on the shoulders of filmology through a process of conceptual clarification and reorganization in the context of a general science of signs. Metz continues by anticipating a third phase to come,

> where various methods would be reconciled in depth (which could imply the common disappearance of their present forms), and film theory would then be a real synthesis, non-syncretic, capable of precisely determining the field of validity of different approaches, the articulation of various levels. Today, it may be that we have reached the beginning of the second phase, where one may define a provisional but necessary methodological pluralism, an indispensable course of treatment through division [*une cure de morcellement*]. The psychology of film, the semiology of film, etc., did not exist yesterday and may no longer exist tomorrow, but must be allowed to live today, true unifications never being brought about by dictate but only at the end of numerous studies. (21, *14*)

It is a tribute to Metz's influence on the field, and his own capacity for self-criticism and innovation, that Noël Carroll will echo this sentiment twenty-four years later in his own introduction to a collection coedited with David Bordwell, *Post-Theory.* Moreover, Metz's major turn to psychoanalysis only four years after *Language and Cinema* would force a wild shift in the discourse of signification and, at the same time, set in place a new discursive situation of

increasing conceptual pluralism, opening the era of contemporary theory in film, media, and art. There is a certain irony here in noting Metz's close agreement with Bordwell and Carroll about the prospects for theory and its incompleteness, that we have not yet entered a conceptual space where a theory of film is possible.

At the same time, in what may have been his last interview, Metz characterizes this openness or incompleteness as a kind of ethics or modesty in theory. The interview with Marie and Vernet ends with Metz offering a tribute to Roland Barthes as his only real master. Metz describes this debt to Barthes as a care for the claims of theory, of thinking theoretically, while maintaining a certain flexibility or openness: to not be attached to a theory, but rather to change positions according to need. In this, one better understands Metz's rejection of the idea that the study of film could be the object of a science or *Wissenschaft*, and that in fact the serious or theoretical study of film would always take place through a methodological pluralism that was open-ended and irresolvable. But there is something else. "This practical philosophy, which [Barthes] transmitted to me rather than taught me," Metz offers, "is a sort of ethic—the will to furnish, in the very movement of research, an amiable and open space [*un espace amical et respirable*]" ("Entretien avec Christian Metz" 296). Call this theory as generosity.

## 19. The Sense of an Ending

> Even if passed and mourned, wouldn't theory return like a ghost in
> unexpected forms?
>
> —Vincent B. Leitch, "Theory Ends"

In *The Archaeology of Knowledge,* Michel Foucault wisely notes that the closer in time one stands to a discursive formation, the more difficult it is to evaluate it conceptually. The threshold of existence of a new discourse, he writes, "is established by the discontinuity that separates us from what we can no longer say, and from that which falls outside our discursive practice; it begins with the outside of our own language; its locus is the gap between our own discursive practices."[124] Perhaps the contours, scale, dimension, and volume of a discourse become

---

124. Trans. A. M. Sheridan Smith (New York: Harper and Row, 1972), 130.

apparent only once one no longer occupies it. One must live an external discontinuity before past internal continuities become visible, and this is no easy task. The possibility of tracing out the architecture of a thought occurs only by standing on the far side of a fracture or division in which we believe, rightly or wrongly, that our own thought has become different. But if you stand close to the frontier, how can you know if you are approaching the border, standing at its limits, or perhaps have never even left the territory you thought you were mapping from a distance?

Here we have reached our most difficult point of passage, and not because our maps are too vague, but rather because they are too precise, are crowded with detail, and correspond too closely to our places of intimate habitation. Moving now to the final sections of this book, I realize ever more strongly how my attempts to understand the conceptual vicissitudes of theory have veered wildly in perspective, sometimes plunging into one or two texts in florid detail, making them carry the weight of an entire discursive formation on the space of a few pages, then retreating to the horizon to frame the most panoramic view possible. I have noted already that the discontinuities between the aesthetic discourse and the discourse of signification are more violent than the ones dividing the discourse of signification from that of ideology or culture, which are more subtle and joined by intertwining common roots. Another difficulty in accounting for this point of passage is not only its proximity to us, so close that we still live on the breath it exhales, but also the curious conceptual frame in which Theory is now pictured as something singular and precise, a veritable genre of discourse, but also as varied and complex, continually overflowing its perimeters and throwing shoots in all directions. No single text or restricted corpus can represent the highly elaborated cross-disciplinary space that defines Theory in the humanities today—a larger and less detailed view is required. Yet, as we shall soon see, there may be one exemplary yet now ghostly figure who can still bring the epistemological and ethical stakes of Theory into sharp focus.

Odd, then, that Theory should be treated as a singular genre of discourse in the humanities, for as Vincent B. Leitch has noted, since the end of World War II, it has unceasingly branched into a succession of schools, movements, and trends: formalism, myth criticism, Marxist criticism, psychoanalysis, hermeneutics, structuralism and semiotics, reader-response criticism, post-structuralism, postmodernism, feminism, queer theory, critical race theory, postcolonial theory, new historicism, cultural studies, media studies, and so

on.[125] In the period from 1968 to about 1980, especially in the newly emerging field of academic film studies, one still believed in the possibility of Theory as a more or less coherent discursive field that drew on disparate conceptual elements and discourses but was nonetheless unifiable across the broad problematic of ideology and the subject. Any number of books like Rosalind Coward and John Ellis's *Language and Materialism: Developments in Semiology and the Theory of the Subject* (Routledge and Kegan Paul, 1977) or Kaja Silverman's *The Subject of Semiotics* (Oxford University Press, 1983) argued for the possibility of constructing a unified account of the subject in relation to ideology and culture from the building blocks of textual semiology, psychoanalysis, and Althusserian Marxism, whose foundational model was, implicitly or explicitly, Julia Kristeva's formidable and fascinating book *La révolution du langage poétique: L'avant-garde à la fin du XIXe siècle, Lautréamont et Mallarmé* (Éditions du Seuil, 1974). All of these works, and many others, formed the conceptual background of what I have called the discourse of political modernism, whose discursive and conceptual template was forged in *Tel Quel*'s *"théorie d'ensemble"*—a loose amalgam of semiology, psychoanalysis, and Marxism as represented in the work of the very different thinkers united in the pages of the journal such as Kristeva, Philippe Sollers, Roland Barthes, Jacques Derrida, Marcelin Pleynet, Jean-Louis Baudry, and others. By the early 1970s, *Tel Quel*'s *"théorie d'ensemble,"* as filtered through the pages of French film journals such as *Cahiers du cinéma* and *Cinéthique,* and then transplanted across the English Channel to the newly reorganized journal *Screen,* was becoming what was simply referred to as *film theory.* This was the dynamic era of the materialist theory of the subject and its relations to ideology as forged in language or signification.[126]

From the mid-1980s until the present time, however, Theory is better characterized as a disaggregated and rhizomatic proliferation of fields and problems. In the first part of my genealogy of theory, discursive transformations and displacements occurred across centuries and decades; since the 1980s, it is as if discourse-time has accelerated and space splintered. Conceptual move-

125. Vincent B. Leitch, "Theory Ends," *Profession* (2005): 122–128. Recall that Galin Tihanov remarks on a similar multiplicity in "Why Did Modern Literary Theory Originate in Central and Eastern Europe? (And Why Is It Now Dead?)."

126. For a deeper and more complex account, see my *The Crisis of Political Modernism: Criticism and Ideology in Contemporary Film Theory* (Urbana: University of Illinois Press, 1988); 2nd ed. (Berkeley: University of California Press, 1994). I will give a fuller account of the discourse of political modernism further on.

ments coalesce, crest, and spread out in the space of a single decade, or in even more compressed time frames. But within these waves, larger patterns still form. For example, Leitch notes how the poststructuralism of the 1980s gives way in the 1990s and after to a new wave of cultural studies, which in turn multiplies into a variety of disaggregated yet conceptually individuated subfields: body studies, disability studies, whiteness studies, media studies, indigenous studies, narrative studies, porn studies, performance studies, working-class studies, popular culture studies, trauma studies, science studies, and so forth.

In a sense, the variability and discontinuity of theory here, as well as the unceasing internal movements of its disjunctive archaeological layers shifting at uneven rates of change, are little different from the late eighteenth and nineteenth centuries, except perhaps that rates of change are now exponentially accelerated, and forking paths more numerous. Theory, such a small and simple word, continues to unravel then into a variety of semantic domains and frames of reference that rapidly branch and multiply, though not without a certain logic. In addition, each new ramification of theory seems to inspire renewed criticisms and proclamations of its exhaustion, ending, or passage into history.

In "Theory Ends," Leitch provides a succinct and perspicuous summary of not only the semantic range of theory in its current uses but also how it is framed by its detractors. In a first sense, theory refers loosely to a range of contemporary schools or movements such as structuralism, semiology, psychoanalysis, and their branching out into the varieties of cultural studies. Here theory is largely synonymous with social criticism, broadly conceived. In its perceived domination of the humanities, it is targeted for critique by conservative scholars devoted to mid-twentieth-century models of formal and moral criticism and to preserving a traditional canon of works. In this context, theory is synonymous with "a historically new, postmodern mode of discourse that broaches long-standing borders, fusing literary criticism, philosophy, history, sociology, psychoanalysis, and politics" ("Theory Ends" 123).

Other versions coalesce around more grounded methodological perspectives that conceive the work of theory as examining the conceptual foundations or contexts of criticism. Here, according to Leitch, "theory designates general principles and procedures—methods—as well as the self-reflection employed in all areas of literary and cultural studies. A small but vigorous skirmish against such theory has been enjoined by neopragmatists who oppose foundational principles, with the result that few nowadays defend theory in its most ambitious methodological or scientific pretensions" ("Theory Ends" 123). In this context, ambitious metatheoretical work has now yielded to more pragmatic

and small-scale accounts of theory as a toolbox of ready-to-hand conceptual devices that are deployed contingently, and whose usefulness is judged according to their potential for producing new and innovative critical perspectives. This approach is in turn targeted for criticism by defenders of objective interpretation in the context of New Criticism and hermeneutics. And then there is even a looser conception where "theory denotes professional common sense— what goes without saying and what every specialist knows—so that everyone in the field has a theory, although some people do not realize it. In this view, theory is a sociohistorical construction complete with contradictions and blind spots yet shored up by the current status quo. But the equating of theory with professionally configured common sense paradoxically ends up diluting its specificity, its conflicts, and its counterhegemonic agendas" (123). In contrast to a more rigorous methodological account, this conception of theory as a sort of professional *sensus communis* is unmarked by the need for epistemological critique or ethical clarification.

The so-called postmodern varieties of theory have a distinctly foreign and specifically French cast. Often referred to as high or grand Theory, this sense still reaches high philosophically and moves along the lines of structuralism and poststructuralism as laid out in the works of Levi-Strauss, Lacan, Althusser, Foucault, Deleuze, Derrida, Kristeva, Lyotard, and others. Here opposition has arisen not only from conservative scholars but also from liberal and left theorists who indict Theory for a range of sins: "philosophical idealism, obscurantism, nominalism, and quietism, charges early made famous by certain Marxists, feminists, critical race theorists, and cultural studies scholars" ("Theory Ends" 123). Leitch further explains, "Insofar as contemporary theory and postmodernism are often linked with social constructivism, standpoint epistemology, cultural relativism, and popular culture (versus the literary canon), they constitute threats and often targets for conservative thinkers, left- and right-wing" (127n2). In *Philosophy's Artful Conversation,* we will find similar criticisms arising in the post-Theory debates in contemporary film studies of the 1990s, but from the more targeted perspective of promoting a version of theory construction influenced by postpositivist philosophies of science. In every case, however, criticism is generated around similar concerns of epistemology and axiology. The turning point here, as Leitch points out, was the revelation in 1987 of Paul de Man's early anti-Semitic writings, a moment of great symbolic import that marked both the waning of the dominance of a certain poststructuralism and the increasing influence of new historicism and cultural studies, as well as renewed calls for an end to theory.

In an analogous way, Martin Jay has argued that theory seems always to be situated in a semantic network of meanings and values that oppose and deride it, or find it to be irrelevant. In their resistance to theory, these values appeal to a variety of alternative experiences or practices. There is first what Jay beautifully calls "the pathos of ineffability," which asserts that theoretical concepts are a fortiori violations of the objects they undertake to comprehend.[127] In turn, these objects are valued for their resistance to conceptualization as a power of the real that offers categories of experience that are implicitly inconceivable or untheorizable. Here the subsumptive force of theory is viewed as undermining or being inadequate to the expression of difference, or the particularity of experience as lived. Then there are prereflexive practices that value a deep hermeneutics of reading, looking, or listening as phenomenological attentiveness to objects in their singularity and concreteness in contrast to the abstractions and generalities of theory. Closely related to this idea is belief in the natural intelligibility of narrative as particularized stories through which meaning and value can be recovered by attentive and sympathetic reading. Jay observes, "The project of recovering the 'voices,' of those silenced by dominant accounts of the past derives in large measure from a belief in the irreducibility of unique stories to larger patterns, such as those imposed by theoretical generalization" ("For Theory" 25–26). Finally, there is the position of institutional critique, closely associated with the work of Stanley Fish or Pierre Bourdieu, which focuses on institutions and communities of theory from a sociological perspective in order to debunk them as "little more than a tool in the struggle for distinction in cultural fields or power in interpretive communities" (26).

In Jay's view, examining theory in relation to its critics demonstrates both its responsiveness and its deep connection to the problems, questions, or experiences that invoke and challenge it: the intractability of objects, the indecisiveness or ambiguity of practical criticism, prereflexive experiences that falter before understanding, the singularity of modes or practices of criticism or interpretation that may be directionless without concepts, and the institutional frameworks that enable acts of theorizing themselves. "What makes theory necessary, if by itself insufficient," Jay offers,

> is precisely the no less blatant incompleteness of its others. That is, in the imperfect world we inhabit, indeed in virtually any world constructed by

127. "For Theory," in *Cultural Semantics* (Amherst: University of Massachusetts Press, 1998), 22.

fallible humans, no possibility of self-sufficient immanence exists on the level of practice, experience, hermeneutic interpretation, narrative intelligibility, or empirical facticity. Nor, to look in the other direction, can we reduce theoretical communities to mere stratagems of power, functional only in the acquisition of cultural capital, social distinction, or institutional control. For in so doing, we ignore precisely the reflexivity, the capacity to reflect on their own institutional embeddedness, that necessarily sets such communities apart from others in the world. ("For Theory" 27)

At a fundamental level, theory in its many variants refers to moments of self-reflexive understanding responsive to the lack of self-sufficient immanence or openness that characterizes both theory and its others, with the proviso that the conceptual powers of theory thus derive from acknowledgment of its epistemological incompleteness.

When concepts of theory are correlated to schools and movements, when it is conceived as the subject of intellectual history, or when we target it as an object of thought or critique, no doubt we feel that all things, good or bad, both flower and decline; or depending on our concept of history, occur in waves, cycles, or time-delimited trends. Leitch notes that there have been many ends to theory, which are in fact so many displacements and remapping of concepts of theory: formalism and New Criticism being displaced by structuralism and poststructuralism, then poststructuralism succeeded by British cultural studies, which in turn spreads out in a disaggregated North American version into the varieties of field studies. Yet across these changes there seem to be certain persistent commitments, arising generally out of the projects of poststructuralism: the deconstruction of binary concepts and the leveling of hierarchies, a commitment to interdisciplinarity, and the desire to preserve theory as a form of social criticism and as a way to identify sites of cultural resistance, especially through the analysis and redress of discriminatory attitudes and practices.

Soon we will also see that the persistence of theory is tied ineluctably to the concept of ideology and its critique, or that the continual analysis and evasion of the snares of power require a specific relation to theory, with its promise of possibilities for the liberation of thought and the projection of other modes of existence. Theory passes and returns; is challenged, debated, and critiqued; yet endures with a kind of utopian promise. The still-unexamined question, however, is why theory should persevere as a site of persistent anxiety and aggression, as well as other complex emotions. What Paul de Man famously

characterized as "resistance to theory" has now been replaced by a more general malaise or uneasiness, whose ironies and paradoxes are expressed by the fact that theory's endings are recurrent, multiple, and interminable, and that each proclamation of its passing, every mournful eulogy or triumphant gravedance, yields renewed and often powerful examinations of its powers, goals, histories, meanings, and values. To feel one's self at the end of something inspires reflection on its ends, which may imply a defensiveness toward past incarnations, nostalgia, and longing for better days, or anxiety before an uncertain future. However, times of uncertain ends and historical self-examination suggest another possible direction. "The past of theory demonstrates that theory has a future," Leitch concludes. "Neither the inheritance of theoretical concepts, problems, and debates nor the search for effective methods and pragmatic protocols nor the influence of perennial theory texts nor the borrowing from neighboring fields nor the critique of the status quo seems likely to disappear. Like a riverbed, theory changes yet abides. . . . Even if passed and mourned, wouldn't theory return like a ghost in unexpected forms?" (124–125).

## 20. "Suddenly, an Age of Theory"[128]

I have strayed somewhat from the task of accounting for the continuities and discontinuities of the passage from the discourse of signification to that of ideology and culturalism. And other puzzlements await, such as how to imagine what comes after "contemporary" film theory and how to evaluate a post-Theoretical moment in film and media studies, or the arts and humanities. I have no intention here of writing even a short history of contemporary film theory. (How can one define the "contemporary," such a paradoxical concept? Is it not the present we eternally occupy and the near future that hovers just in front of it? How far into the past does it extend?) Instead, these contextual comments are meant to give purchase on the curious logic and temporality of the meanings of theory after 1970, and to show the possibilities for both theory's persistence and its potential transformation into something else, what we may want to call philosophy.

Not a history of contemporary theory, then, but something like the elements of a historiography of concepts, enunciative modalities, and discursive

128. From Elizabeth Bruss's *Beautiful Theories: The Spectacle of Discourse in Contemporary Criticism* (Baltimore, Md.: Johns Hopkins University Press, 1982).

formations in which developments in the academic study of film might stand, *pars pro toto,* for the vicissitudes of theory in the humanities more generally. That Theory should come to describe or identify a genre of discourse or a practice of thought and writing is, I believe, a product of the 1970s. Before 1950, for example, one hardly thought about the notion that there might be a canon of aesthetic writing about film; before 1960, it was uncommon to refer to this canon as "film theory." (In a similar vein, the annual bibliography of the Modern Language Association established a rubric for "Literary Criticism and Literary Theory" only in 1967; before, the rubrics were "Aesthetics" and "Literary Criticism.") My principal argument in the preceding sections was that in many respects Christian Metz invented and imagined the place from which film theory could be enunciated. More accurately, his early writings were the focal point of a number of intersecting discourses wherein the practice of theory takes shape conceptually and discursively, not only within the framework of filmology and postwar film criticism but also with respect to the larger movements of semiology and structuralism. At the same time, like filmology, semiology had no need of a special concept of theory. With its proximity to anthropology and to linguistics, it basked in the reflected light of the natural sciences and of imagined progress toward a unified conception of the human sciences. Justifiably or not, it could take for granted the presence of a common vocabulary and research program framed by a method, and the potential for refining and enlarging its domain through internal critical debate. Before the mid-1960s, as a word and a concept, theory had no special value except in local instances. And when it was invoked, it was usually a gesture of pointing toward the "science" in the human sciences.

From the late 1960s and throughout the 1970s, however, the institutionalization of cinema studies in universities in North America and the United Kingdom became identified with a certain idea of theory that indicated the eruption of a new discontinuity. This was less a theory in the vernacular, abstract, or natural scientific senses than an interdisciplinary commitment to concepts and methods derived from literary semiology, Lacanian psychoanalysis, and Althusserian Marxism, echoed in the broader influence of structuralism and poststructuralism on the humanities.[129] In the newly emerging

129. It is interesting to note the place theory served in the battles to create new disciplines in the 1970s such as women's studies, film studies, or postcolonial studies. In each of these cases, theory appeared as something central to the formation of new areas of study, yet often sitting uneasily within them. The place of the new French feminisms within the history of women's studies in the 1970s and 1980s would itself make for an interesting history. One attempt to ex-

discipline of film studies, this presumed synthesis coalesced around what I have called the discourse of political modernism. According to what logic, and within which presumed genealogy, did this discourse lay claim to being called "theory"? From the perspective of the creation of academic film studies, especially in North America and the United Kingdom, the contemporary concept of film theory is woven from two intersecting genetic ribbons, one internal to the formation of the discipline and one external to it, though both profoundly marked by the histories of French structuralism and poststructuralism. The internal line winds through the interlocking trajectories of Aristarco, Mitry, and Metz, and leads toward the pioneering work of Dudley Andrew. Call this the archaeological line where in very different ways these authors contribute to the academic study of film by constructing a canon of *film* theory and framing its history—laying out monuments and main authors, identifying major concepts, and drawing forth continuities and points of possible synthesis. The first collections of the 1960s such as Daniel Talbot's *Film: An Anthology* (Simon and Schuster, 1959) and Richard Dyer MacCann's *Film: A Montage of Theories* (E. P. Dutton and Co., 1966) were early attempts at historical recovery, though without any special concept of the function and status of theory as a discourse. Following Peter Wollen's seminal *Signs and Meaning in the Cinema* (British Film Institute, 1969), in the 1970s, the idea of film theory achieves a new presence and stature in the first edition of Gerald Mast and Marshall Cohen's *Film Theory and Criticism: Introductory Readings* (Oxford University Press, 1974), in the publication of the first volume of Bill Nichols's *Movies and Methods* (University of California Press, 1976), and above all in Dudley Andrew's deeply influential critical assessment *The Major Film Theories* (Oxford University Press, 1976). In the French context, one might also add Dominique Noguez's collection *Cinéma: Théorie, lectures* (Klincksieck, 1973) and then Jacques Aumont et al., *Esthétique du film* (Nathan, 1983).

Although each of these books has distinct and often contesting perspectives and critical commitments, the anthologies in particular are marked not only by a desire for historical preservation and presentation but also by the idea that there are conceptual interests and continuities that thread through and unify film theory as a kind or genre of discourse where Münsterberg,

---

plore this problem (and all the more interesting since it comes from the other side of the Atlantic) is François Cusset's *French Theory: How Foucault, Derrida, Deleuze, & Co. Transformed the Intellectual Life of the United States,* trans. Jeff Fort with Josephine Berganza and Marlon Jones (Minneapolis: University of Minnesota Press, 2008).

Arnheim, Kracauer, and Balázs dialogue with Pudovkin and Eisenstein or Bazin, who then discourse with Metz, Eco, or Wollen. What is most fascinating and original in Andrew's 1976 book in particular is not only the idea that film theory has a history but also that there is something like an independent structural core to the concept of theory itself that gives it identity and consistency and serves as a basis for contrasting, comparing, and evaluating approaches in their similarities and differences. Thus film theories—despite their debates, conflicts, and differences of approach and method—are conceived as belonging to an identifiable set, perhaps describable as Theory as such. In addition, both *Signs and Meaning* and *The Major Film Theories* make present and perspicuous a line of thought that remains mostly implicit in the other works. Like the early essays of Metz before them, these books evince a certain historical self-consciousness where theory comes more and more to identify and differentiate itself, to stake its claim as a particular way of discoursing about film or art, with its own special conceptual concerns, rhetorical strategies, and enunciative positions; in other words, these works exhibit a metatheoretical perspective as a critical reflection on the logical status of theory as a practice distinct from criticism or history. Andrew sees this most clearly when he writes in the introductory pages of *Concepts in Film Theory* that Christian Metz's landmark review of Jean Mitry in 1964 "is not so much a break as a turning of theory around upon itself," of theory inventing itself, as it were, by taking itself as an object of critical reflection.[130] In a strong sense, this critical reflection became possible only when film study had become an institutional and academic discourse, a process coalescing in the seven-year period separating Wollen's and Andrew's books.

The reflexivity of the metatheoretical attitude is as much historical as conceptual. The process of inventing or remapping a certain concept of theory as a genre of discourse, and as a special kind of critical or epistemological perspective, occurs through a backward glance that seeks out ancestors and traces continuities, retrospectively and retroactively, in precedent discourses. This genealogical research produced valuable historical documentation, analysis, and context. But also, like an orphaned child searching for lost relatives, it was often guided by the need to find its proper family name, to construct and reaffirm an imaginary identity of which it felt bereft—hence the often retrojecting character of early periods of theory formation, which reclaim "traditions"

---

130. Dudley Andrew, *Concepts in Film Theory* (New York: Oxford University Press, 1984), 17.

while thoroughly transforming them in their own image, or rather the image to which they aspired.

The emergence of contemporary film theory was no different in this respect. This effect is particularly striking in the editorial transformation of *Cahiers du cinéma* in the years immediately following the student and worker uprisings in France in May and June of 1968. Well into the 1960s, the editorial policy of *Cahiers* was marked by a continued commitment to *auteur* criticism and to the promotion of a serious cinephilic culture. Despite having been founded by André Bazin (would Bazin have considered himself a "film theorist"?), one would hardly call the magazine a journal of film theory, even though it published several important early texts by Christian Metz, as well as occasional works of historiographical interest such as George and Ruth Sadoul's filmographic and bibliographic accounts of Pudovkin and Vertov. However, through the spring and summer of 1968, the magazine underwent an editorial shift in response to the political and social crisis in France, first by turning away from Hollywood to historical and contemporary cinema understood as challenging mainstream filmmaking, both formally and politically, and then in January 1969 by taking an explicitly "theoretical" as well as a distinctly political turn that would, by the end of 1969, result in a crisis of ownership at the magazine.

The transformation of *Cahiers du cinéma* by theory was all the more striking considering its independence, that is, the absence of an institutional context, whether academic or party political. (The same might be said for the British journal *Screen* after its break with the British Film Institute in 1971.) Or perhaps it would be more accurate to say that the institutional context briefly shifted from an academic framework to one defined by the flourishing of independent reviews and little magazines. This theoretical turn took place on two interrelated fronts. First, beginning with issue 209 in February 1969, *Cahiers* began a major project of translating the principal published works of Sergei Eisenstein, which continued month by month throughout the early 1970s. Many of these texts were hardly known outside the Soviet Union. At the same time, this work of resurrection and review was guided by the desire to recover a history of international Marxist thought in both filmmaking and theory, and to situate the magazine in relation to that history. As the editors wrote in concluding their famous editorial "Cinema / Ideology / Criticism" in the fall of 1969, "In our view, the only possible direction for criticism is to build on the theoretical research of Russian filmmakers of the 1920s (above all, Eisenstein), in the attempt to elaborate and apply a critical theory of cinema, a specific

mode of apprehending rigorously determined objects, with direct reference to the method of dialectical materialism."[131] *Cahiers* was not alone in this respect. A newer journal, *Cinéthique,* was engaged in similar work, and in London, *Screen* produced important translations and contextual work on Vertov, Eisenstein, Kuleshov, Russian Formalism, Bertolt Brecht, and Walter Benjamin, as well as on Soviet Constructivism and production art in *Lef* and *Novy Lef.*[132] It might also be said that like *Tel Quel, Change, Cahiers pour l'analyse,* and many other journals of the time, the commitment to left politics through theory was made possible because of the independent standing of these reviews with respect to the university or other mainstream institutional settings.

In the May–June 1970, *Cahiers* also produced a special double issue devoted to "Russia in the 1920s" that included an interview with Lev Kuleshov and translations of texts by Vertov, Eisenstein, Tynyanov, Eikhenbaum, and Kozintsev, as well as Lenin, Khlebnikov, and Meyerhold. Also published were important contextual and historical essays, including an extensive introduction by Jean Narboni to two texts by Eikhenbaum and Tynyanov from the *Poetika Kino.* It would appear that Eikhenbaum's 1946 call to theory in film was finally being answered, and in fact, with the exception of the now all-but-forgotten filmology, virtually all of the errant discursive streams I have described in the

131. Jean Narboni and Jean-Louis Comolli, "Cinéma / Idéologie / Critique," *Cahiers du cinéma* 216 (October–November 1969): 15; my trans. The most well-known English translation, by Susan Bennett, appeared in *Screen* 12, no. 1 (Spring 1971): 27–36. In retrospect, this translation seems tendentious in a way that smooths out the style of the text to make it seem more formal and "scientific," indeed structuralist. In my translation, I have tried to preserve the more writerly style of the text, so influenced by writing in *Tel Quel,* and have retained the implied references to deconstruction and other aspects of poststructuralism. French readers of the time also would not have missed that the way "dialectical materialism" is referred to here references the attempts of Althusser and his followers to build a Marxist philosophy out of a critique of "empiricist" epistemologies. The language of the *Cahiers'* editorial clearly implies a desire to develop a Marxist and scientific film criticism in the context of Althusser's epistemological writings.

132. For a deeper review of the theoretical commitments and historical context of this period in both France and the United Kingdom, see my *Crisis of Political Modernism,* esp. chaps. 1 and 3. Another still essential point of reference is Sylvia Harvey's *May '68 and Film Culture* (London: British Film Institute, 1978). For a brief history of *Screen,* see Philip Rosen's "*Screen* and 1970s Film Theory," in *Inventing Film Studies,* ed. Lee Grieveson and Haidee Wasson (Durham, N.C.: Duke University Press, 2008), 264–297. Rosen situates the project of *Screen* and contemporary film study with respect to the history of Western Marxist critical theory in his invaluable doctoral thesis, *The Concept of Ideology and Contemporary Film Criticism: A Study of the Position of the Journal Screen in the Context of the Marxist Theoretical Tradition,* dissertation, University of Iowa, 1978.

preceding pages flow here toward a single watershed. First, there is the historical or archaeological perspective opened up by Aristarco and Metz that situates classical theory in relation to contemporary developments, though now seen from a committed Marxist perspective. (Indeed, as we shall see momentarily, the peculiar contemporaneity of 1970 is to situate both Theory and Marxism in a new and precisely defined framework; this will be the external genetic line.) In fact, Narboni credits the Soviet montage school with being the first movement "to think of the cinema in theory," or indeed to create a "school" of theory guided by an ideology, that of the Bolshevik revolution.[133] Only by creating itself through theory or by inventing a concept of theory, Narboni argues, could the Soviet cinema break with an earlier ideology of realism and an idea of film as serving only to reproduce literary or theatrical works, and thus to think of itself as a specific artistic practice. No doubt, Narboni understands this theoretical rupture as being fueled by its revolutionary context, just as *Cahiers*'s own "epistemological break" was inspired by May 1968 and its aftermath.

If there is a special concept of theory at work in postrevolutionary Russia, it is no doubt influenced by the Marxist and Leninist characterization of the relation of theory to practice. But more specifically, as *theory* Narboni insists on the special contexts of OPOYAZ and the Moscow Linguistic Circle, as well as the general interest of Russian Formalism in the cinema. Here the archaeological trend meets contemporary theory in a specific conjuncture. Noting that the work of the Formalists was hardly known in France before 1958, the date of the French translation of Propp's *Morphology of the Folktale,* and is only really rediscovered as read through the history of structuralism in Todorov's 1965 collection, *Théorie de la littérature,* Narboni reasserts here the central interest of Eikhenbaum's "Theory of the 'Formal Method,'" not only for the historical texts he is placing in context but also to the more general projects of structuralism and semiology, which must now guide critical work in and on film. Indeed, Narboni places Eikhenbaum and Tynyanov's early treatments of language and film explicitly in relation to the work of Christian Metz.

In all of this, however, there is also a disruption with respect to the discourse of signification, still so present and close both geographically and temporally. In his general introduction to the issue and in his text on the *Poetika Kino,* Narboni orients the history of Russian Formalism and film theory not only in

133. "Introduction à 'Poetika Kino,'" *Cahiers du cinéma* 220–221 (May–June 1970): 57n3; my trans.

relation to the critical project of structuralism but also with respect to a break or mutation in the development of a critical semiology: "It is not our place to account for the considerable significance of these works for the fields of literature and linguistics, of structural research and to the 'human sciences,' nor to explain the movement through which a modern semiotic, which incorporates their theoretical accomplishments, also tends to overtake them and to deconstruct their philosophical presuppositions through the elaboration of a *theory of textual production as signifying practice.* We will make do here as well with referring only to the work in progress around Jacques Derrida and Julia Kristeva" ("Introduction à 'Poetica Kino'" 52; my emphasis). Here Narboni's text opens out centrifugally to the external genetic ribbon where contemporary film theory rapidly takes shape in the context of a more general discursive transformation, where the poststructuralism of Derrida and Kristeva, both authors closely associated with *Tel Quel,* displaces and refashions structuralism. Contemporary film theory thus unfolds out of a larger conjuncture where a certain idea of Theory is taking shape, not only under the influence of Derrida and Kristeva's texts of the late 1960s and early 1970s but also, and especially, under the influence of Louis Althusser.

## 21. The Fifth Element

> The semiology of signifying practices . . . is ready to give a hearing to any or all of those efforts which, ever since the elaboration of a new position for the speaking subject, have been renewing and reshaping the status of meaning within social exchanges to a point where the very order of language is being renewed: Joyce, Burroughs, Sollers. This is a moral gesture, inspired by a concern to make intelligible, and therefore socializable, what rocks the foundations of sociality.
>
> —Julia Kristeva, "The System and the Speaking Subject"

In *The Crisis of Political Modernism,* I suggest that the contemporary moment of film theory coincides with the emergence of a set of questions and problems that at the time were felt to be both urgent and new. In turning to the concept of ideology, and the possibility of opposing ideology with a scientific or "theoretical practice," film studies began to discover itself in theory, and to reorient and define itself in relation to a left tradition of art and cultural criticism.

The emergence of semiology as the study of the social life of signs was linked early on to "deconstruction"—in the sense of uncovering and displaying

analytically the unconscious structures underlying all symbolic expressions—as well as a desire to promote social change through a transformation of language. This critical tendency is also evident in Formalism's interest in avant-garde poetry, such as Russian Futurism, and its implicit if uncomfortable relation to the Soviet Revolution, and to the interest of many of the discursive founders of structuralism in Marx and Freud. However, before 1968 the connection between semiological analysis and ideological criticism is not conspicuous. The most significant exception is Roland Barthes's 1956 essay "Myth Today," where a critique of ideology is repetitively linked to the demystificatory potential of semiology as an analytical science. The renewed assertion of this linkage in the turn to the 1970s will signal a new mutation of theory where the discourse of signification becomes one of ideology.

Like theory, ideology is largely absent as a special concept in structuralism. Though retroactively reinvoked in film studies and cultural studies of the 1970s and 1980s, Barthes's political gestures in 1956 are rather the exception that proves the rule. The concept is almost completely absent in the work of Christian Metz until his pathbreaking turn to a Marxist-inflected psychoanalysis in 1975 with the publication of "The Imaginary Signifier" in *Communications* 23. One might say, then, that contemporary film theory emerges with *Cahiers du cinéma*'s "theoretical break," which was first affirmed as such in Jean Narboni and Jean-Louis Comolli's editorial of October–November 1969, "Cinema / Ideology / Criticism." In this deeply influential text, Comolli and Narboni proposed to reorient the magazine toward a scientific critical approach, a "theoretical practice" of criticism, where Althusser's critique of idealist or empiricist ideologies would be welded to formal and semiotic analysis as a way to understand cinema's potential for either perpetuating or disrupting its relationship to the dominant ideology of capitalism.

In "Cinema / Ideology / Criticism," the problem of signification is decisively reoriented around that of ideology, which now becomes a kind of tutor-concept. For example, when Comolli and Narboni assert in an oft-quoted statement that every film is a political film, they suggest at the same time (and not without some consequent friction with the writings of Althusser and his followers) that film is an ideological practice, and moreover, that a scientific film criticism can identify a scale of varying relations between ideology and form. This idea is aptly represented in *Cahiers*'s well-known typology of seven categories ranging from films "which are bathed in ideology in every part, expressing and transmitting it without discrepancy or perversion; they are blindly loyal, and above all, are blind to this loyalty itself" (13) to films

that perform a double action on their ideological assimilation. First, by direct political action: at the level of "signifieds," through the explicit treatment of various political subjects (treatment—not in the sense of discussing, repeating, or paraphrasing, but rather in the transitive sense: action on—of an explicitly political subject that initiates a turn of criticism on ideology, which supposes a theoretical work absolutely contrary to the ideological); a political act tied necessarily . . . to a critical de-construction of the system of representation. At the level of their process of formal invention [*au niveau du processus de constitution des formes*], films like *Not Reconciled, The Edge,* or *Terra em Transe* carry out an interrogation of cinematographic representation (and mark a break with the constitutive tradition of this representation).

We repeat that only this double action (at the level of "signifiers" as well as "signifieds") has a chance of being effective *against* (in) the dominant ideology: double action, indissoluble, economical-political / formal. (13)

In between these two poles there is another, more ambiguous category, wherein a symptomatic reading can locate in an otherwise apparently nonprogressive film the possibility of an internal critique, and a variable or discrepant relation to ideology:

Here the ideology has not been transposed as such by the [conservative or reactionary] intentions of the author of the film . . . but rather it encounters obstacles before which it deviates or swerves, and sees itself exhibited, shown, denounced by the filmic framework in which it is held, and which *plays against it,* its limits are seen and at the same time transgressed, forced by the critical work, a work which can be detected by an oblique or symptomatic reading, which beyond the apparent formal coherence of the film grasps its discrepancies, its fault-lines, cracks which an ordinary film is incapable of provoking. The ideology becomes a textual *effect,* which does not persist as such—only the work of the film allows its *presentation,* its exposition. (14)

Several features are worth noting in this linking of signifying practice to ideological practice. First, a semiological vocabulary ("signifier / signified") persists in a context where the fundamental concepts of structuralism are being displaced and reworked in other domains. This retention of a certain struc-

turalism within an otherwise poststructuralist context will be a persistent feature of contemporary film theory within the larger domain of Theory in general.

Second, as I have discussed at length in *The Crisis of Political Modernism*, the evaluative dimension of this scale, and others like it produced at the time, is based on the assumption that signifying practices produce "knowledge effects," and may do so to varying degrees. Theory frames, reveals, makes visible, or gives access to the possibility of an otherwise occluded epistemological value or relation, in the text or in relation to the text. Tutored overall by a broad binary system that opposes realism to modernism, or the classical text to modernist *écriture*, mainstream filmmaking is considered as producing an illusory "reality-effect" that transparently communicates the dominant ideology in contradistinction to an avant-garde practice, which working at the level of form or of the "signifier" will reflexively interrupt this transmission. For Comolli and Narboni, "the cinema's most important task, therefore, when cognizant of the nature of the system that makes it an ideological instrument, is to problematize [*mettre en question*] the system of representation itself: to put it into question as cinema and to provoke a slippage or a rupture with its ideological function" ("Cinema / Ideology / Criticism" 13).

Third, the possibility of this disruption in the field of representation, of recognizing the potential breaks with or within a signifying practice, turns on criteria of representation and visibility. The criterion of visibility is ineluctably linked to the preceding notions of epistemological value and formal innovation, such that formal work on the signifier is thought to produce knowledge—or the possibility of a knowledge to be completed by criticism—of how film functions as an ideological practice. Political modernism is thus a kind of epistemological modernism where the presumed knowledge effect is a making visible of the ideology-effect.

Fourth, the rhetoric of the break or rupture, within or from ideology, persists across a range of critical writing, which produces knowledge as an interval— the opening of a reflexive space within the text, or again, in relation to the text. In this manner, theory is linked to epistemology as, paradoxically, the axiological dimension of the discourse; it functions as a sort of value produced, reflexively and parthenogenetically, in practices where the break with realism is made apparent. It is not just the concept of ideology that forms the core of contemporary film theory, the axis on which all other questions turn, but more importantly, the possibility that a *theoretical practice* will emerge in

a break from ideological practices, and one with real cognitive and demystifi-catory effects. Throughout the discourse of political modernism, whether in the film journals or in the larger context of French poststructuralism, this transformation of cognitive value is presented as a turn from idealism to ma-terialism, which is in turned mapped as a passage from illusion to knowledge. What is unclear, however, though fiercely debated within the pages of *Cahiers du cinéma, Cinéthique,* and then *Screen,* is the location of this materialist, theo-retical practice, which seems to float uncertainly in the overlapping spaces of aesthetic practice on the one hand and critical method on the other. The unan-swered and in fact undecidable question of the discourse of political modern-ism is, where is this knowledge effect produced? In the film through formal work on representation, or in a specific kind of critical or even philosophical work? And in either case, what is the mechanism for producing these knowl-edge effects? Eventually, we will have to turn to a deeper examination of Al-thusser's critique of idealist or empiricist epistemologies to unpack these questions, and to know better what the value of theory is in this context.

However, there is a fifth element missing from these characterizations of theoretical practice, though nonetheless implied everywhere in them. The pos-sibility of producing knowledge effects or not requires the presence of a subject or spectator as the target for these effects of recognition and misrecognition. If semiology appears to one side of dialectical materialism, psychoanalysis must now appear on the other. Structuralism's discourse without a subject, which preserves its scientificity in theory through the relation of sign and system to meaning, is now transformed as what Julia Kristeva calls alternately semiotic, *signifiance,* or the subject in process. Indeed, the questions of how to charac-terize this subject—What is its place within or with respect to the signifying processes of cinema or other aesthetic practices? How and where is it produced? What are its activities or not, and how is it differentiated?—will all be guiding questions for contemporary theory, and the principal compass points on its map. The problem of the subject will also supply criteria for understanding, first, the synthetic moment of Theory across semiology, Marxism, and psy-choanalysis, and then its disaggregation into accounts of the feminine, queer, black, postcolonial, or subaltern subject.

For the moment, however, it is interesting to note the relative absence of the subject as such in French film theory between 1968 and 1975, despite the fact that it is the fundamental question implied everywhere in writings of the pe-riod. To achieve real force and presence within Theory and the discourse of political modernism, the concept must wait first, externally, for Julia Kristeva

to integrate fully the work of Jacques Lacan into her accounts of *signifiance* and signifying practice, and then, internally, for psychoanalysis to erupt fully in film theory through the work of Jean-Pierre Oudart, Jean-Louis Baudry, and finally Christian Metz. The launching of contemporary film theory's psychoanalytic moment happens dramatically with the publication in 1975 of a special issue of *Communications* on psychoanalysis and cinema, edited by Metz, Thierry Kuntzel, and Raymond Bellour, and continues in earnest in *Screen* in essays by Stephen Heath, Laura Mulvey, Jacqueline Rose, Colin MacCabe, and others. (Metz's long and erudite methodological account of the transformation of the study of signification by psychoanalysis, "The Imaginary Signifier," which opens *Communications* 23, was translated almost immediately in *Screen*.) In all of this work, ideology is conceptualized not just as a discourse, but as a specular relation produced both within film as a discourse through point of view and deictic relations and in the situation of recording and projection as a series of mutually supportive dialectical relations. Ideology is considered as a special kind of practice here, one that produces, through film form and projection, an almost inescapable regime of sight and power. In Jean-Louis Baudry's influential essay "Cinema: Ideological Effects Produced by the Basic Apparatus," cinema becomes a kind of philosophy machine for producing and perpetuating an idealist perception and conception of the world.

*Cahiers du cinéma*'s version of political modernism, and its commitment to a critical practice conceived in the context of a dialectical materialism, orients itself explicitly and directly within a discursive framework constructed and refined in *Tel Quel* in a ten-year period running from the mid-1960s to the mid-1970s. The history of *Tel Quel* as an independent review of literature, criticism, and philosophy runs parallel to all the major conceptual developments of structuralism and poststructuralism in France. In *The Future of Theory*, Jean-Michel Rabaté also notes how *Tel Quel*, published between 1960 and 1982, takes up a line of thought forming as early as 1953 in Barthes's *Writing Degree Zero*, where the political responsibility and possibility of literature are addressed in terms of a "morality of form."[134] Though *Tel Quel* would suffer a variety of editorial and political upheavals and transformations, its unifying aim throughout the 1960s was to link a cultural politics of the avant-garde to contemporary experimental literature while promoting a new "science" of writing and textuality. Key components of *Tel Quel*'s program from the beginning were to

134. (Oxford: Blackwell, 2002). See esp. 71–76.

publish together formal experiments in literature (for example, Ponge, Mich-aux, Bataille, Artaud, Pound, and many writers of the *nouveau roman*) with critical accounts of problems of language and literature, all within the common framework of a transformative cultural politics that imagined radical literary experimentation as a site for cultural resistance and a renewal of language. Under the dynamic but often contentious leadership of Philippe Sollers, the nature of the journal's politics would change—from a disquieting silence on the conflict in Algeria to a rapprochement and then break with the French Com-munist Party leading to a phase of militant Maoism, and finally ending in a reactionary flirtation with the *nouveaux philosophes*—but the linking of mod-ernism, writing, and politics remained constant. The force of this constancy came from the commitment to place poetic practice in a dialogue or dialectic with a theory of literature, a force given impetus not only by structuralism and the presence of structuralist writers like Barthes, Gennette, Eco, and others in the pages of the journal but also by the "rediscovery" of Russian Formalism through the work of Todorov and then Kristeva. Indeed, the sense of theory as a specific alignment between literary experimentation, critical self-reflection on the immanence of poetic language, and the promise of cultural change is no doubt inspired by the insertion of the Formalist conception of theory into this network of conceptual commitments.

Nevertheless, the shift from theory to Theory is leveraged by another con-ceptual turn in which the transition from structuralism to poststructuralism was marked by a rapid transformation of the conceptual field that took place largely within the pages of *Tel Quel*. This shift begins with the first contributions of Derrida and Kristeva.[135] While Derrida deconstructed an entire structuralist architecture that associated speech with the site of truth and the presence of thought to itself and that tried to master difference through systems of binary terms, Kristeva was busy remapping the foundational structuralist concepts of sign and system while extending them in new directions. Kristeva arrived in Paris from Bulgaria on Christmas Eve, 1965. Her presence at the École Pra-tique des Hautes Études (EPHE) was quickly and strongly felt through Barthes's mentorship and her participation in his seminar; her association with *Tel Quel* was sealed through marriage to Philippe Sollers in 1967. In particular, Kriste-

135. Derrida's first publication in the review, an essay on Artaud titled "La parole soufflée," appeared in 1965; Kristeva's first contribution, "Towards a Semiology of Paragrams," was pub-lished in 1967. Both writers would continue to publish important essays in the journal, as well as books in the series "Collection Tel Quel" at La Seuil, at least until Derrida was publicly criticized as an idealist philosopher in 1974.

va's work of the late 1960s was deeply influential in transforming the discursive terrain of semiology, helping to reorient it in a synthetic way toward psychoanalysis and dialectical materialism while introducing a new series of influential concepts—for example, intertexuality, genotext and phenotext, signifying practice, *signifiance,* the subject in process, and a new concept of Text as an infinite productivity of meaning. In Rabaté's account, *Tel Quel* thus drafted the project for a poststructuralist Theory where a "combination of Saussure, read by Derrida, of Marx, read by Althusser, and of Freud, read by Lacan, provided a fundamental trilogy mapping a new scientific and critical knowledge" (*Future of Theory* 87).

In brief, these are the elements of the "theory of textual production as signifying practice" referenced by Jean Narboni. And if a contemporary film theory is emerging in the pages of magazines like *Cahiers du cinéma* and *Screen* in the early 1970s, not to mention a new notion of Theory as such across the arts and human sciences, it owes much to a network of concepts presented and refined in the pages of *Tel Quel.* At the same time, this special concept of Theory, or the acknowledgment and promotion of Theory as a practice, came only gradually into focus even within the pages of *Tel Quel.* Nonetheless, the standard was clearly raised with the publication of a collection in 1968 titled *Théorie d'ensemble* (Éditions La Seuil). It is interesting to note the invocation of "theory" here, and the suggestion of the existence of a general Theory in a little magazine that intermittently, then permanently after 1967, appended "Science / Literature" to its title. (After 1970, it would also add "Philosophy / Politics.") For the most part, *Tel Quel* had no special concept of theory before this point in time. Or perhaps it is better to say that the appearance of the collection in 1968 marked an evolution in the concept, now come to the fore, resulting from twinned influences dating from 1965: first, a new appreciation of the Russian Formalist idea of a theory of literature, and then a particularly French Marxist concept of theory associated with the sudden prominence of Althusser after the publication of *For Marx* and *Reading Capital.* As will be seen in a moment, the idea of theory, of there being a *practice* of theory, is explicitly Althusserian and is not so distant from the meaning of "science" as evoked by *Tel Quel.* In the same year, a Group for Theoretical Studies was created with contributions from Sollers, Kristeva, Derrida, Jean-Joseph Goux, and others, and a conference organized with *La Nouvelle critique* linked the review's theory and practice of the text to Marx's critique of political economy and the concept of ideology, with explicit reference to the work of Althusser.

Without making any judgments of value (and I will still defend any number of Althusser's concepts, psychoanalysis, and certain approaches from semiology), what is most striking in the effort to project a unified picture of theory in the late 1960s and early 1970s was the confidence that a common framework could be drawn from such conceptually and historically diverse sources. To make this claim is not to delegitimate individual works or conceptual innovations in Althusser, Lacan, Barthes, Derrida, or Kristeva. Rather, what interests me is the desire or drive in this moment for, as the writers of *Tel Quel* expressed it, *"une théorie d'ensemble"*: the idea that an otherwise diverse group of writers, perhaps joined by certain conceptual family resemblances but otherwise very diverse and even contestatory in their different approaches to problems of philosophy, history, meaning, and politics, would project themselves as contributing to a collective theory.

What does it mean, then, for *Tel Quel* to evoke a *"théorie d'ensemble"*? *"Ensemble"* is conjoined significantly to *théorie* here as a way to invoke a whole constellation of references: a collection of texts, a theoretical corpus, a collective or group theory, and indeed a theory, like structuralism, tending toward a formalizing science. The reference to the mathematical set theory of the Bourbaki Group *("théorie des ensembles")* would not have been missed by cultured French readers. Nonetheless, if science referred first to linguistics and structuralism in the journal, it was now more clearly allied to Althusser's epistemological defense of dialectical materialism.

Citing the important work of Patrick Ffrench on the history of *Tel Quel,* Rabaté also notes how the introduction to the collection pushes the sense of a corpus in another direction where "Theory hesitates between a radical philosophical questioning of literary concepts and the more etymological sense of a 'list' of authorities, or the ritual 'procession' of tutelary figures invoked and yoked together" (*Future of Theory* 85).[136] The brief introduction to the volume, "Division de l'ensemble"—which begins significantly with citations from Mallarmé and Marx ("Ideas do not exist separately from language")—sets out in an admirably concise way both the historical precursors and the new directions of *Tel Quel*'s theoretical practice. The very first paragraph signals the importance of a " 'formalism,' linked to the birth of 'structuralism' " that retroactively made apparent a critical rupture in ways of approaching the "so-

136. See Ffrench's *The Time of Theory: A History of Tel Quel (1950–1983)* (Oxford: Clarendon Press, 1995), as well as "Introduction" and "Chronology" in *The Tel Quel Reader,* ed. Patrick Ffrench and Roland-François Lack (London: Routledge, 1998), 1–18.

called literary" text.[137] The scare quotes are significant in that the introduction marks a series of historical displacements that will finally yield in *Tel Quel*'s version of poststructuralism the conceptual framework wherein the senses of contemporary theory are honed in their break with an "ideology of linguistics" ("Division" 22). The editorial notes a specific kind of historical process, "also verifiable in the history of science," where "a reworking of foundations always occurs, not in the move that immediately precedes the revision, but rather in the movement that precedes this move" *(un remaniement de base se fait toujours, non sur le coup qui précède immédiatement celui de la refonte, mais sur le coup qui précède ce coup)* (21, 8). The references to Althusserian epistemology, where sciences are formed in a process of rupture with their ideological precursors, would also not have passed unnoticed. But the immediate sense of this passage is to mark out a new space for Theory not only in a displacement that links structuralism to surrealism, formalism, and the birth of structural linguistics in the 1920s but also in a precedent genealogy that threads through Lautréamont and Mallarmé, Marx and Freud—Marxism and psychoanalysis yoked to avant-garde French poetry. Here are two epistemological breaks, as it were, combined with a retrojection that is meant to validate *Tel Quel*'s own vision of a literary political modernism linked to psychoanalysis and Marxism.

Although the volume includes a great number of writers associated with the journal, the introduction foregrounds, as discursive founders of contemporary theory, Barthes, Foucault, and Derrida in whose work is manifested a series of transformative concepts: writing, text, unconscious, history, work, trace, production, scene. The introduction also stresses the importance of Lacan and Althusser as theoretical "levers" throughout the volume. These three discursive authors are then attributed with laying out the three main axes of an open space where theory and writing interact on multiple planes. For example, Foucault's essay on Alain Robbe-Grillet, "Distance, aspect, origine," is credited with identifying a specific milieu where "signifying practice" is exercised, not as poetry or fiction, but rather in an *écriture* that produces an open, productive, and nonrepresentational space. Barthes's essay on Sollers, "Drame, poème, roman," sets out the potential for a new analysis of Text as a practice founded

137. "Division de l'ensemble" in *Théorie d'ensemble* (Paris: La Seuil, 1968), 7–10; trans. Patrick Ffrench as "Division of the Assembly" in *The Tel Quel Reader*, 21. Original page numbers are given in italics wherever the translation has been modified. In *Tel Quel* 31 (Fall 1967), Sollers published a short essay titled "Programme" that anticipated "Division de l'ensemble" in interesting ways. It represents, perhaps, the first eruption of a special concept of Theory in the journal.

necessarily in theory, where new forms of writing decenter both the subject and history. What is at stake here, the anonymous editor (probably Sollers) writes, "is to enlarge the tear in the symbolic system in which Western modernity was born and continues to live . . . in order to decenter it, to withdraw its thousand-year-old privileges, such that a new writing (and not a new style) can appear" ("Division" 22–23, 9). In turn, Derrida's text is assayed as inscribing a theoretical leap where the concept of *différance* dislodges writing as the sign of truth, and opens a space critical of "all the metaphysical sediments deposited in the 'human sciences'" (23, 9). These three dimensions of writing, finally, suggest a fourfold project, which would be the collective project of Theory as such: *to unleash a movement* capable of mapping out a discontinuous history of text in their points of difference and conjuncture; *to elaborate concepts* adequate to rethinking this history of texts and of *signifiance; to unfold a plural history* or histories as a way of "communicating theory and practice through a series of radical breaks precisely identifiable in their time" (23); and finally, "*to articulate a politics* logically linked to a non-representational dynamic of writing" (23; emphases in the original text).

The editorial introduction to *Théorie d'ensemble* can thus be read as a road map to political modernism, especially in the desire to connect "a politics logically linked to a non-representational dynamic of writing" to "the construction of the relations of this writing to historical materialism and to dialectical materialism" ("Division" 23). In this respect, the emergence of Theory is best understood as a series of overlapping influences, weaving and turning around one another in a complex series of folds and intercalations. (Significantly, however, the tides of influence flow in only one direction—while "French Theory" is reread, translated, filtered, and transformed in a variety of international Anglophone contexts, with a few significant exceptions, the Parisian intellectual village remained opaque to any reciprocal influence.) Contemporary film theory, inaugurated in the pages of *Cahiers du cinéma* in the period between 1969 and 1975, largely incorporated the discourse and rhetoric of *Tel Quel,* though no doubt transforming it in interesting and original ways. In relay, from 1971 *Screen* is largely following the lines set out by *Cahiers du cinéma,* though often amplifying and refocusing them in a rather provocative manner; the same may be said for the influence, direct and indirect, of *Tel Quel.* On one hand, before 1975 *Screen* evidences the desire for a kind of formalizing scientificity, linking questions of method in textual semiotics to appropriations of Althusser that, through Ben Brewster's influential translations, magnified the

claims for theory as a secure cognitive context for critically examining and breaking with ideology. It is significant that Derrida does not pass through this filter, such that throughout the 1970s the most influential work in *Screen* reads as a peculiar and highly selective mix of structuralism and poststructuralism. Even psychoanalysis is not strongly present before 1975, and then again, only intermittently until Stephen Heath's dossier on suture and his important work on sexual difference is published from 1977.

On the other hand, from about 1975 the work of Julia Kristeva comes to be keenly felt by a variety of writers, including Peter Wollen, Laura Mulvey, and Stephen Heath. Indeed, it is less *Cahiers* that is responsible for the fifth element than *Screen* itself, which places Kristeva's emphasis on the "subject in process" at the forefront of contemporary theoretical discourse. Where deconstructive philosophy tended to destabilize the conceptual foundations of structuralism and semiology (as well as, implicitly, the claims to scientificity for dialectical materialism), Kristeva's semiotic or semanalysis was read as extending and renovating the project of a science of the text. Kristeva's work builds an important conceptual bridge linking Greimas's laboratory at the EPHE to Lacan and Derrida's seminars at the École Normale Supérieure and finally to the critical enterprise of *Tel Quel*. As importantly, Kristeva was instrumental in the formation of a feminist theory allied to materialism and Lacanian psychoanalysis that reverberated especially in the British context of the 1970s, entering into a dialogue with the pioneering work of Juliet Mitchell, Jacqueline Rose, and Toril Moi as well as writers associated with the important review *m/f*.[138]

Kristeva's contributions to poststructuralist theory are multiple and complex. In a variety of influential texts published in the late 1960s and early 1970s, leading from her first important collection of essays, *Sēmeiōtikē: Recherches pour une sémanalyse* (1969), toward her magisterial *La Révolution du langage poétique* (1974), Kristeva displaced and rewrote structuralism's foundational concepts into a complex and ramified account of discourse as a heterogeneous space marked by process or production. Kristeva forcefully criticized semiology on two accounts. First, through its foundational concepts of sign and system, semiology conceives language as a homogenous and atemporal

---

138. For a more replete account of this connection, see again my *Crisis of Political Modernism,* esp. chap. 8 on "Sexual Difference." Kristeva's influence on concepts of identification, the subject, and ideology, particularly in *Screen,* are also discussed critically in chaps. 6 and 7, esp. pp. 186–192.

space, unaffected by change, history, or a differentiated subject. This leads to the second dimension of her critique, which views structuralism as either absenting the subject, as it were, or producing it through "the rehabilitation of the Cartesian conception of language as an *act* carried out by a *subject*. On close inspection, as certain linguists (from Jakobson to Kuroda) have shown in recent years, this 'speaking subject' turns out in fact to be the *transcendental ego* which, in Husserl's view, underlies any and every predicative synthesis, if we 'put in brackets' logical or linguistic externality."[139]

A critique of a semiology of systems and of its phenomenological foundations must start, then, from a "theory of the speaking subject" where language is conceived as a heterogeneous space of enunciation—a site where the subject is located, produced, and reproduced in discourse—and as a process driven by the relation of unconscious to conscious thought, as well as the body's relation to language, desire, and the drives. If signifying practices produce or sustain a subject in relation to signification, that subject must also be divided within itself. The linguistic system, which Kristeva associates with the Lacanian concept of the symbolic, is thus only one dimension of a dialectic motored by the force of negativity, a concept Kristeva adopts from Hegel's logic. Kristeva characterizes negativity in relation to desire and to the Lacanian Imaginary as the disarticulatory force of the drives in relation to language, which she calls the "semiotic disposition." Fueled by desire, fantasy, and the primary processes, in poetic practice the semiotic disposition is defined by grammatical deviation, intense phonemic materiality, the overdetermination of sense, discursive lapsus and ellipses, and various syntactical and modal irregularities; in short, the eruption of drive-governed and unconscious processes into the materiality of language itself. Negativity is in fact the foundation of her "revolution" in poetic language. It defines the specificity of signifying practices not as the transmission or communication of meaning, but rather in the formal transgression of meaning, and the subject not as the master or origin of sense, but rather as riven by the libidinal and somatic forces within it as well as by its external relation to history and social institutions. In her own account, Kristeva writes,

> The moment of transgression is the key moment in practice: we can
> speak of practice wherever there is a transgression of systematicity, i.e.,

139. "The System and the Speaking Subject," in *The Kristeva Reader*, ed. Toril Moi (1986), 27. Originally published in the *Times Literary Supplement* (12 October 1973): 1249–1252.

a transgression of the unity proper to the *transcendental ego*. The subject of the practice cannot be the transcendental subject, who lacks the shift, the split in logical unity brought about by language which separates out, within the signifying body, the symbolic order from the workings of the libido (this last revealing itself by the *semiotic disposition*). Identifying the semiotic disposition means in fact identifying the shift in the speaking subject, his capacity for renewing the order in which he is inescapably caught up; and that capacity is, for the subject, the capacity for enjoyment. ("The System and the Speaking Subject" 29)

Transgression marked by negativity is thus a key concept both for Kristeva's *semanalysis* and for her version of political modernism. It marks, in fact, the work of a Hegelian dialectic across two dimensions whose point of intersection is her concept of the speaking subject. The first—call it the external or historical dimension—retains the structuralist thesis that "what semiotics has discovered in studying 'ideologies' (myths, rituals, moral codes, arts, etc.) as sign-systems is that the law governing, or, if one prefers, the *major constraint* affecting any social practice lies in the fact that it signifies; i.e., that it is articulated like a language. . . . One may say, then, that what semiotics had discovered is the fact that there is a general social law, that this law is the symbolic dimension which is given in language and that every social practice offers a specific expression of that law" (25). The symbolic dimension of language wants to conserve the system, instrumentalize signification, and preserve and stabilize the subject with respect to its structural place with respect to the Family and the State. But this desire for system and stabilization is repeatedly undermined by an internal relation—Lacan's equally Hegelian dialectic of identification where the imaginary turns on the symbolic, and the semiotic disposition disrupts the subject's relation to language and social order. The speaking subject is a "subject in process" because it is ineluctably caught up in a dialectic that can never be finished, stabilized, or trapped by meaning—the system is always doomed to fail.

Kristeva's semanalysis thus sets the fundamental framework for the discourse of political modernism and for the idea of Theory that would accompany it. In an admirably rigorous way, it sought not to overturn structuralism and semiology, but rather to expand and ramify them in a conceptually unified space where linguistics was remodeled in relation to psychoanalysis and Marxism. Likewise, it turned semiology from its concern with ordinary language and communication to the study of poetics and aesthetics, forging a sustained commitment where Theory was built out critically from the analysis

of art and literature. In writing of signifying practice and of a subject in process, Kristeva located the subject as the site of both production and reproduction in which a dramatic conflict was played out—between the symbolic and the imaginary, the system and desire, the conscious and the unconscious subject—whose stakes were either the preservation or destabilization of social order. And by treating discourse as the site of transgression and the capacity for enjoyment, semanalysis foregrounded an account of the subject as an unstable, processual space, divided within itself by desire, the unconscious, and the force of the drives but also open to change and transformation. Through concepts like negativity, the semiotic disposition, and the subject in process, literature and art were made the central and dynamic sites of a revolutionary politics and a critique of ideology.

In transposing many of these themes to contemporary film theory, most of the key figures writing in *Screen* were deeply committed to the centrality of the subject in process for both a critical account of ideology and for posing modernist alternatives to what was called the "classical realist text" of Hollywood cinema. Whether she was referenced directly or not—and Kristeva was both translated in *Screen* and cited frequently—her concepts of negativity and the subject were key components of the work of Peter Wollen, Colin Mac-Cabe, Stephen Heath, and Laura Mulvey. Mulvey, of course, but also Stephen Heath and others would bring out in film theory another important aspect of Kristeva's work—that is, her attentiveness to feminism and to psychoanalytic accounts of sexual difference and identification, where poetics became identified with the possibility of an *écriture féminine*.

However, before pursuing this line of thought further, one last aspect of semanalysis as the framework for Theory or theoretical practice must be addressed. In stressing the concept of negativity and the disarticulatory force of the semiotic disposition within language, what is missing is an account of the epistemological frameworks and stakes of Kristeva's sense of theory. Very clearly, as a theoretical practice, semanalysis considered itself a scientific practice in ways similar to structuralism. But here the stakes of "science" have changed considerably. They were no longer defined necessarily by Levi-Strauss's dream that structuralism would find itself awakening next to the natural sciences on judgment day, but rather within the framework of historical and dialectical materialism. This commitment was shared with contemporary film theory, though as I have already pointed out, on either side of the Channel the stakes of theoretical practice turned less on discourse or poetics than on criteria of visibility wherein the critical response to ideology and Kristeva's con-

cept of negativity were mapped onto a dialectics of miscognition and recognition as a passage from the imaginary to the symbolic or from illusion to knowledge. Kristeva, however, offered no such confidence or security. If the great innovation of Kristeva's semiotic was to reconsider discourse as both system *and* transgression, how could Theory preserve or conserve its own epistemological coherence and desire for systematic exposition and critique? This question is most striking for Kristeva, whose commitments to lucidity in logical exposition and coherence in argumentation are extraordinary, whose discourse is marked everywhere as "scientific," and whose work from the late 1960s progressed steadily toward the grand synthesis represented by the *Revolution in Poetic Language*. Kristeva thus stands admirably for the great unifying tendency of theory, or the desire to weave a general Theory of the subject in discourse from the strands of semiotics, psychoanalysis, and Marxism.

Alternatively, as Toril Moi points out in her vivid and concise introduction to "The System and the Speaking Subject" in *The Kristeva Reader*, the practice of theory in semanalysis also had to confront an internal contradiction. "Insisting as it does on the heterogeneity of language," Moi comments, "semiotics is caught in a paradox: being itself a metalanguage (language which speaks about language) it cannot but homogenize its object in its own discourse. In this sense, then, semiotics is structurally unable to practise what it preaches" (24). However, rather than undermining the possibility of scientific or theoretical knowledge, Kristeva mobilizes the concept of negativity to preserve the openness of theory. The ineluctable dialectic of system and negation or transgression means that the semiotician, in Moi's words, "is forced always to analyse her own discursive position, and thus to renew her connection with the heterogeneous forces of language which, according to Kristeva, is what makes language a productive structure in the first place" (24).

Theory itself, then, is marked by the open circularity of semiosis and *signifiance*. For Kristeva semiology is somewhat paradoxically an exemplary theory as the site not only where ideology may be examined as produced through signifying processes but also where knowledge is produced of and in language. In her own contribution to *Théorie d'ensemble*, "La Sémiologie: Science critique et/ou critique de la science," Kristeva notes that as theory, semiology itself is characterized by a division or heterogeneity characteristic of all language, and thus becomes a special kind of critical signifying practice. As a critical science, semiology formalizes language using methods borrowed from mathematics and other formal sciences in order to comprehend its functioning in terms of

"the axiomatization . . . of signifying systems" (*77, 82*).[140] At the same time, the critical analysis of language is possible only through the medium of language, and in this respect semiology is distinguished from its sister sciences through its powers of taking itself as its own object. In Kristeva's conception, it is the site of a special reflexivity that in taking language as its object in a system of formal modeling is also capable at the same time of modeling the model, and thus takes its own underlying theory as an object of analysis and critique. "Semiotics," Kristeva writes,

> is thus a type of thought where science sees (is conscious of) the fact that it is a theory. In every instant of its production, semiotics thinks of its object, its instruments and the relation between them, and therefore *thinks itself,* and in thus turning on itself becomes *the theory of the science it constitutes.* This means that semiotics is always both a reevaluation of its object and / or its models, a *critique* of these models (and therefore of the sciences from which they were borrowed), and of itself (as a system of stable truths). As the meeting point of the *sciences* and an endless *theoretical process,* semiotics cannot be constituted as *a* science let alone *the* science: semiotics is an open form of research, a constant critique that turns back on itself, offering its own auto-critique. As it is its own theory, semiotics is the kind of thought which, without raising itself to the level of a system, is still capable of modeling (thinking) itself. (*77, 82–83*)

In that a critical semiology is always refinding its theory within itself, it is always beginning again but in a noncircular way: "Semiotic research remains a form of inquiry that ultimately uncovers its own ideological gesture, only in order to record and deny it before starting all over again. 'No key to no mystery,' as Levi-Strauss said. It begins with a certain knowledge as its goal, and ends up discovering a *theory* which, since it is itself a signifying system, returns semiotic research to its point of departure, to the model of semiotics itself, which it criticizes or overthrows" (*77–78*).

Thus a critical semiology is at the same time a critique *of* semiology that opens onto something else, ideology, in the sense of continually reliving or

---

140. "Semiotics: A Critical Science and / or Critique of Science," trans. Seán Hand, in *The Kristeva Reader,* ed. Toril Moi (New York: Columbia University Press, 1986), 74–88. Originally published in *Théorie d'ensemble* (Paris: Seuil, 1968), 80–93. Page numbers from the French edition are given in italics when the translation is modified.

reinvoking the process through which in Althusser's epistemology, scientific knowledge is produced. Like Althusser, Kristeva credits Marx with being the founder of a scientific practice that in challenging Hegel's logic and the idea of teleological and absolute reason nonetheless preserves an idea of scientific practice where the process of formulating models is "doubled by the theory underlying the very same models. Created as it is by the constant movement between model and theory while at the same time being situated at a distance from them (thus taking up a position in relation to current social practice), this form of thought demonstrates the 'epistemological break' introduced by Marx" (79).

Semiology unveils how science is born within ideology and at the same time extends a theoretical gesture where it reflexively separates itself from ideology; in producing knowledge about language, it simultaneously examines the process of knowledge as production in language. The construction of a systematic metalanguage requires a reflexive attentiveness to contradiction, which means that the desire to build Theory and to acquire theoretical knowledge is not teleological, but *productive*. Kristeva's semanalysis, like Theory itself, is motored no doubt by a Hegelian rationality, indeed perhaps a Hegelian conception of science. As theory, it resembles nothing so much as the self-actualizing and self-revealing subject of Hegel's *Phenomenology of Spirit*. However, Kristeva takes pains (though I think with uneven success) to project an image of theory where the dialectic, both unending and aspiring to ever-greater levels of subsumption and unity, can never achieve universality.

Semanalysis is without question a "theory," but to my knowledge, apart from this essay, Kristeva never produced a methodological account in which the epistemological stakes of theoretical practice could be examined, interrogated, and defended and in which philosophy might adjudicate the possible relationship between science and ideology. To better understand these problems, we must turn finally and directly to the key figure for the emergence of Theory: Louis Althusser.

## 22. "A Struggle without End, Exterior and *Interior*"

> In order to know itself in its theory, philosophy has to recognize that it is no more than a certain investment of politics, a certain continuation of politics, a certain rumination of politics.
>
> —Louis Althusser, "Lenin and Philosophy"

Kristeva's concept of negativity and her implied concept of theory are not only key components of contemporary film theory; in many respects, the dialectic of negativity and the reflexive critical force of theory can be understood as fueling the historical structure of Theory itself in its movements from unification to disaggregation. One of the great paradoxes of Theory—the source of both its powers and its miseries—is that it is driven from within by internal contradiction. As in the Hegelian dialectic, negativity drives the discourse forward, causing it to ramify and expand by producing new concepts and seeking out new powers of criticism. The specific site of contradiction, however, is how the concept of the subject is deployed in relation to this dialectic, first as a space of epistemological contest and then in relation to concepts of difference and identity.

The key question of contemporary theory—especially to the extent that psychoanalysis persists within it—is, how can the subject secure an epistemological standpoint separate from ideology, and with respect to which ideology can be criticized? From what subjective space is critique possible, and what founds or secures the subject's potential to recognize, comprehend, and contest the snares of power? These two questions are profoundly interrelated, and yet are in many ways irreconcilable. From his 1964 essay "Freud and Lacan" to his later influential study "Ideology and Ideological State Apparatuses" (1970), Althusser argued that psychoanalysis contributes conceptually to an account of theory and ideology in two ways. First, it aids in understanding the psychological processes through which subjectivity is produced in representation, and in turn helps to explain the functioning of irrational belief and contradictory behavior—for example, why subjects act repeatedly against their own economic or political interests. Second, like Marxism, psychoanalysis becomes a privileged terrain for Althusser's larger epistemological project, which wants to know how knowledge is produced and by what means, both conceptually and historically, and how a science can separate itself from ideology. Here the problem of theory is a site both for defending the scientific standing of psychoanalysis and for presenting the possibility of a scientific disengagement

from ideology, or at least the possibility of a materialist and scientific understanding of the functioning of ideology. Kristeva's turn to psychoanalysis, however, frames the idea of the production of the subject in language in another way. As the site of transgression, Kristeva's subject in process projects a space and a situation where the force of ideology is continually eroded and the potential for new sites and possibilities of subjectivity is created. Left unclear in either case is the question of how this subject could be found in possession of—or to discover or rediscover, either internally or externally—the critical and epistemological potential for standing outside the institutions or apparatuses of power to which it is subjected. In other words, how is the subject produced (or renewed) in theory?

I have already remarked how in the late 1960s *Tel Quel*'s *"théorie d'ensemble"* achieves a new discursive presence and force where the more positivistic or scientific senses of theory in filmology or structuralism are displaced and reorganized semantically around or within dialectical materialism. In this context, the institutional context of theory gravitates from the École Pratique des Hautes Études to the École Normale Supérieure (ENS), where from 1948 Althusser served as "caïman," or director of studies for students preparing their *agrégation* to teach philosophy at the secondary level; in 1954 he was promoted to the post of *secrétaire de l'école littéraire.* At the beginning of the 1960s, despite his modest institutional position and cyclical struggle with clinical depression, Althusser exerted an enormous influence through his seminars, his publications, and his sponsorship of the relocation of Lacan's seminar to the ENS in 1964, thus making of it another powerful epicenter of structuralist activity. I have also already remarked on the somewhat ironic role philosophy plays in this context. A perhaps unintended effect of the era of high structuralism was the departure of many students from philosophy into other areas such as psychoanalysis, anthropology, and linguistics.

At the same time, Althusser insisted that philosophy must not renounce its traditional place as a sovereign discipline, especially in the domain of epistemology. Indeed, while Althusser is often recognized today for his contributions to the study of ideology, his work is better understood in the frameworks of epistemology and the philosophy of science. Althusser's major project was twofold. First, he defends the idea that Marx founded a science, historical materialism, and a specific philosophy, dialectical materialism. Second, through his "structural" Marxism, and in some ways analogous to Merleau-Ponty, Althusser sought to preserve for philosophy a key role within the epistemology of the human sciences. Althusser devoted his seminar of 1962–1963 to the

conceptual origins of the human sciences, and sought to locate Marxism within the other dominant strains of structuralism in linguistics, anthropology, and psychoanalysis. (The following year would produce his famous seminar on "reading *Capital*.") Here philosophy has a special though somewhat ambivalent function with respect to the other domains of structuralism. In his "Remarks on the Terminology Adopted," added to his essay "On the Materialist Dialectic" as published in *For Marx*, Althusser locates the Marxist concept of theory in a remark by Engels in the *Anti-Düring:* "'If theoreticians are semi-initiates in the sphere of natural science, then natural scientists today are actually just as much so *in the sphere of theory, in the sphere of what hitherto was called philosophy.'*"[141] Although Althusser would soon finesse the distinction, here philosophy is strongly associated with ideology, and Althusser argues that Engels invokes *theory* as a way to demonstrate Marxism's capacity to critique and supersede its philosophical predecessors. In turn, Althusser forges a special concept of *Theory* to distinguish dialectical materialism as a practice distinct from philosophy and in fact displacing it. In a manuscript from 1965, Althusser puts the matter directly, asserting that dialectical materialism holds a privileged place in the history of philosophy because it

> transformed philosophy from the condition of an *ideology* into a *scientific discipline.* In fact, Marx was in some sense *compelled,* by an implacable logic, to found a radically new philosophy, because he was the first to have thought scientifically the *reality of history,* which all other philosophies were incapable of doing. Thinking the reality of history scientifically, Marx was obliged, and able, to situate and treat philosophies—for the first time—as realities which, while aiming for "truth," while speaking of the conditions of knowledge, belong none the less to history, not only because they are conditioned by it but also because they play a social role in it.[142]

141. Trans. Ben Brewster (New York: Pantheon 1969), 162. Originally published in *La Pensée* 110 (August 1963) and reprinted in *Pour Marx* (Paris: Maspero, 1965), 5–46. Original page numbers are given in italics when the translation has been modified. Althusser's most synthetic and compelling account of these problems appears in his preface to *Reading Capital,* "From *Capital* to Marx's Philosophy," trans. Ben Brewster (London: New Left Books, 1970), 13–69.

142. "Theory, Theoretical Practice and Theoretical Formation: Ideology and Ideological Struggle," trans. James H. Kavanagh in *Philosophy and the Spontaneous Philosophy of the Scientists & Other Essays* (London: Verso, 1990), 10.

For Althusser, the function of philosophy with respect to the human sciences was to produce a general Theory of theoretical practices capable of weighing and testing the value of their scientific claims, and distinguishing to what degree they had separated themselves from ideological forms of knowing. Within this framework, a new concept of theory was taking shape and achieving new standing and prestige—explicitly or implicitly, Althusser's senses of theory, largely transmitted through *Tel Quel* and joining film studies through *Cahiers du cinéma* and *Screen,* came to define the project of theory for the contemporary discourse. One of Althusser's key texts on theory is "On the Materialist Dialectic (On the Unevenness of Origins)." Here Althusser argues not only for the importance of theory to Marxism but also that theory has specificity as a *practice* commensurate with other types of practice—for example, ideological, economic, or political. Althusser calls practice "any process of *transformation* of a determinate given raw material into a determinate *product,* a transformation effected by a determinate human labour, using determinate means (of 'production'). In any practice thus conceived, the *determinant* moment (or element) is neither the raw material nor the product, but the practice in the narrow sense: the moment of the *labour of transformation* itself, which sets to work, in a specific structure, men, means and a technical method of utilizing the means" ("On the Materialist Dialectic" 166–167). This definition sets up Althusser's key concept of knowledge-as-production, or as a specific form of intermediate conceptual labor.

Among Althusser's other contributions is to redistribute or redefine the conventional Marxist distinction between theory and practice. The distinctiveness of theory as a practice is in no way to be considered in its more ancient philosophical senses as disengaged speculation or meditation. Rather, it is fully considered by Althusser to be part of the structured whole of society and in continual interaction with other forms of practice. Moreover, theory has a special relationship with politics. On one hand, as in a Leninist conception, as theory, dialectical materialism orients and guides political activity by giving it a scientific foundation. But on the other, in a theme to which Althusser will continually return, theory is considered something like an implicit knowledge that is never absent from Marxist politics, which is always active within it historically though often in an inchoate or nonphilosophical form.[143] This is an important idea to which we will return.

143. A key text examining this issue is Althusser's essay "Sur le travail théorique: Difficultés et ressources," *La Pensée* 132 (April 1967): 3–22.

What defines the practice of theory, then? On what material does it work, how does it produce, and what product does it produce? The raw material of theory is given in representation, concepts, or facts provided to it historically by other practices whether empirical, technical, or ideological. In this way, theoretical practice works on or transforms ideological practice in a specific sense. No science is founded all at once, but rather undergoes a more or less long prescientific or ideological phase of historical formation. The concept of ideology is not treated here as either illusion or a necessarily false knowledge. Rather, it is both a stage in the history of sciences and a characteristic of certain idealist forms or structures of knowledge, which Althusser characterizes as "empiricist." In contrast to Althusser's concept of knowledge-as-production, the explicit danger of an empiricist conception of science is that its conceptual work becomes displaced or invisible—that is, it ceases to acknowledge that it has a theory or is indebted to a theoretical practice. As a form of idealism, empiricism denies or ignores the historical structure of knowledge and suppresses the active and historical role of theoretical practice in producing knowledge. This is why Althusser maintains a sense of theory as a historically founded form of epistemological critique, which as such is also the dialectical motor for further refinement, clarification, and progress in philosophy. The danger of empiricism is to believe that direct knowledge of the real is accessible without the mediation of concepts or theoretical practice, or that knowledge resides in objects and needs only to be extracted by direct and unmediated observation.[144] In other words, empiricism refuses to recognize that knowledge is conditioned historically in a material practice of ongoing conceptual production and transformation sensitive to external social conditions.

A key component of Althusser's epistemology is to contrast scientific and empiricist forms of knowing as competing modes for the mental appropriation of reality. From the standpoint of the history of science, Althusser adopts

144. On the question of empiricism as a form or structure or knowledge, see the extraordinary section 10 of Althusser's preface to *Reading Capital*, 34–40. In Ben Brewster's account, "Althusser uses the concept of empiricism in a very wide sense to include all 'epistemologies' that oppose a given subject to a given object and call knowledge the abstraction by the subject of the essence of the object. Hence the knowledge of the object is part of the object itself. This remains true whatever the nature of the subject (psychological, historical, etc.) or of the object (continuous, discontinuous, mobile, immobile, etc.) in question. So as well as covering those epistemologies traditionally called 'empiricist,' this definition includes classical idealism, and the epistemology of Feuerbach and the Young Marx" (*Reading Capital* 313).

from Bachelard the idea that the production of knowledge also appears out of a qualitative discontinuity, both theoretical and historical, in the form of an "epistemological break." This discontinuity involves a specific form of dialectical labor and conceptual transformation "which establishes a science by *detaching it from the ideology of its past* and by *revealing this past as ideological*" ("On the Materialist Dialectic" 168; my emphases). The process of Theory or the production of knowledge involves two conjoined operations: the critique of an older, ideological form of knowledge and, in a dialectically critical or self-critical gesture, the production of a new scientific one. Perhaps an essential component of theoretical reflection is to be in contradiction, or rather to be able to reflect in and on contradiction, in which case the contradiction is in Althusser's terms "overdetermined."

A detachment and a revealing: when contradiction is overdetermined, there is both a discontinuity and a turning. Theory turns back on itself to reflect, from within and without, on the conditions of existence of the contradiction itself within the complex structure of a greater whole as it unfolds in time, producing a situation where from within a given theoretical practice a distance or perspective is produced from which one can discern a new epistemological quality. There is not one form of theory, in this respect, but several, which must be qualitatively distinguished: *theory,* "theory," and Theory. Althusser calls *theory* any theoretical practice of a more or less scientific character; perhaps this is something close to what I have called the vernacular sense of theory. In contrast, "theory" is reserved to describe "the determined *theoretical system* of an actual science (its fundamental concepts in the more or less contradictory unity given at a moment in time). . . . In its 'theory,' any determined science reflects on its results, which become the conditions and means of its own theoretical practice, within the complex unity of its concepts (a unity, by the way, which is always more or less problematic)" ("On the Materialist Dialectic" 168, 9). But in this context, there is another qualitative transformation that yields Theory in the form of a materialist *dialectic* at the heart of dialectical materialism. This is the general Theory of theoretical practice whose epistemological standards are adjudicated by a process "which transforms into 'knowledges' [*connaissances*] (scientific truths) the ideological product of existing 'empirical' practices (the concrete activity of men)" (168).

Althusser's account of the production of knowledge as organized by conceptual practices that are both transformative and self-transformative, and that secure new epistemological standpoints through discontinuities or an internal distancing that enables both critique and separation from ideologically

conditioned knowledge, is historical in multiple senses. Theories and the process of theory are formed within determinate social conditions. They are conditioned by the structured social whole in which they occur and by situations of social conflict to which they are aligned, but they are also historical in that there is no end to the process, not even in a teleology that would lead to a classless society. Althusser stresses that there is no pure theory or scientific state that can finally be achieved in a materialism that would be finally free of idealism or the taints and threats of ideology: "We know that a 'pure' science only exists on condition that it continually purifies itself, of a science free from the necessity of its history, on the condition that it frees itself unceasingly from the ideology which occupies it, haunts it, or lies in wait for it. The inevitable price of this purification and liberation is a continuous struggle against ideology itself—that is, against idealism, a struggle whose reasons and aims can be clarified by Theory (dialectical materialism) and guided by it as by no other method in the world" ("On the Materialist Dialectic" 170–171, *10*).

The historical structure of theory as the critique and production of knowledge has other consequences. A science may happily function for a long time without any further reflection on its "theory"—its method and corpus of concepts. Indeed, one can say the same about political practice, which often functions effectively without recourse to any explicit theorization or theoretical knowledge. The will to construct a Theory would then seem to be fairly rare and always difficult, and this is so for two reasons. First, the need to produce a Theory of theoretical practice, to turn back on the epistemological framework of the science itself to critique or modify it and to test its limits, always happens after the fact in moments of blockage or crisis. And second, philosophy always seems to follow behind science in this respect. The process of Theory can never appear ex nihilo, but only after a long period of conceptual invention and methodological exploration. Philosophy must always return to science, to systematically work in or through its concepts, evaluating, refining them, testing their weaknesses and blind spots—in short, producing the Theory of a theoretical practice through critique and symptomatic reading. In contrast to historical materialism, whose object is the historical constitution and transformation of modes of production, according to Althusser,

> the object of dialectical materialism is constituted by what Engels calls *"the history of thought,"* or what Lenin calls the history of the *"passage from ignorance to knowledge,"* or what we can call the history of the pro-

duction of knowledges—or yet again, the historical difference between ideology and science, or the specific difference of scientificity—all problems that broadly cover the domain called by classical philosophy the *"theory of knowledge."* Of course, this theory can no longer be, as it was in classical philosophy, a theory of the formal, atemporal conditions of knowledge, a theory of the *cogito* (Descartes, Husserl), a theory of the a priori forms of the human mind (Kant), or a theory of absolute knowledge (Hegel). From the perspective of Marxist theory, it can only be a *theory of the history of knowledge*—that is, of the real conditions (material and social on the one hand, internal to scientific practice on the other) of the *process of production of knowledge*. ("Theory, Theoretical Practice and Theoretical Formation" 8)

Theory is thus always a materialism in a strict sense—it works on the concepts and methods of an already established discourse, and never stands completely outside of them abstractly or ideally.

The idea that history, and the history of theory, is a process without a subject, that there is potentially no end in which theory or science is finally and completely triumphant over ideology, and that the struggle to attain Theoretical knowledge is constant, led Althusser to several phases of self-criticism and revision, and produced tensions in his relations with the French Communist Party. For the moment, though, it is important to hold onto the idea that a key capacity of theoretical practice is the potential to achieve a state of transformation where through epistemological critique a discourse separates itself from a prescientific or ideologically conditioned thought by grasping the historical conditioning of that thought in class conflict. At its heart, for Althusser philosophy is the site of an epistemological struggle between idealism and materialism as forms of thought allied to the larger conflicts between capital and labor.

In its capitalized form, then, Theory defines a process where the philosophy of dialectical materialism, a philosophy unwritten by Marx himself but whose unfinished concepts are strewn more or less systematically through his later works of political economy, is gradually forged by excavating and refining logically those concepts through the systematic study and reevaluation of Marx's texts. One of Althusser's most controversial and influential arguments at the time was that there is no single underlying system to Marx's thought, but rather that the process of discovering or founding dialectical materialism is marked internally by a fundamental discontinuity where the mature Marx

separates himself from his earlier attachments to Hegel, Feuerbach, and other strains of humanism. The historical evolution of Marx's thought internalizes and exhibits the structure of the theoretical process itself, and this process is later carried through in certain works of Engels and Lenin; it is also, of course, the method and project of Althusser's seminars on reading *Capital*. The process of theory is one of continuous dialectical critique, autocritique, and transformation through a series of conflicts and discontinuities, and the function of Theory is to adjudicate the degree of scientificity of a science in terms of its commitments to a dialectical and materialist epistemology. This is the key to understanding Althusser's recurring argument that while Marx completely founded a new science—historical materialism—the philosophy of that science, dialectical materialism, as the complete and interrelated system of concepts that underlay its practice remains incompletely worked out.

Here there is a fundamental tension between philosophy and Theory, one that occurs not only at the level of names or concepts but also in terms of critique and epistemological value. On one hand, by 1965 Theory had become synonymous with or a substitute for philosophy itself in a certain French context. Indeed, when Althusser inaugurated his edited collection at Éditions François Maspero, it was called simply "Theory," and very often in Althusser's own texts Theory was shorthand for the philosophy of dialectical materialism. When Althusser's students at the ENS founded their journal, the *Cahiers marxistes-leninistes,* it was emblazoned with the exergue "Marx's theory is all-powerful, because it is true"—that is, Theory was the site of scientific truth, one that perhaps transcended and replaced philosophy. On the other hand, if one followed Althusser's writings closely, theory should be considered as a process of constant critique and struggle in which the path to philosophy was only gradually disengaged through the process of turning Theory on theory in an ever-vigilant critique of concepts and methods. Thus in *Cahiers pour l'analyse,* another important journal linked to the ENS and deeply influenced by both Althusser and Lacan, theory was envisioned as a kind of an epistemological research whose role was to interrogate critically the scientificity of psychoanalysis, linguistics, and logic with a view toward constructing a unified science, conceived as a psychoanalytic and materialist theory of discourse. Theory here becomes the site of a kind of scientific Leninism in the avant-garde of critical thought, which returns us to the perspective of *Tel Quel.* The concept of Theory in the two journals is the same, giving testimony to a common discourse network and set of institutional affiliations.

Althusser soon revisited and criticized this concept of Theory as a unilateral, abstract, and therefore misdirected characterization of dialectical materialism. This self-criticism amounted to a revision of the relation of theory to practice in a way that sought a concept of theory that was more tightly integrated with political practice. In so doing, the senses of Theory were transformed in ways that would resonate powerfully, though often in subterranean and unacknowledged ways, across the contemporary discourse. Althusser's revision of the relation between theory and philosophy was presented publicly in a lecture given on "Lenin and Philosophy" at the Société Française de Philosophie in February 1968, and published in 1969 in the book of the same name. However, the broad outlines of his new position were still more clearly stated in a 1968 interview published in Italy in *l'Unità* and then reproduced in *La Pensée* as "La Philosophie comme arme de la révolution (Réponse à huit questions)."[145] This turn in theory follows Marx, Lenin, and Gramsci in asserting that philosophy is fundamentally political, that it is a direct intervention in the political, especially in the domains of epistemology and the relation of theory to practice. The role of philosophy, according to Althusser, is to represent the class struggle in the domain of theory, and in this respect philosophy is neither science nor pure theory, but rather a practical political intervention in the domain of theory. However, philosophy is not a politics, but rather serves political practice through theoretical interventions, assuring that strategies are informed and directed scientifically through historical and materialist analysis. As Theory, then, dialectical materialism does not stand above or outside other instances like the political. Rather, it preserves a place and function for philosophy as something like a point of intersection or interface between the political and the theoretical: it refines and critiques the place of materialism in theory; inspired by practice, it also returns (scientific) theory to practice as a guide for politics.

However, there is another kind of internal relation where theory bridges or links philosophy and politics, one with further consequences for understanding not only the place of the Subject but also classes or categories of subjects in contemporary theory. To engage in theory is to embark on a process of self-transformation. For Althusser, an intellectual is by definition allied to the class

---

145. *La Pensée* 138 (1968): 26–34. Trans. Ben Brewster in *Lenin and Philosophy, and Other Essays* as "Philosophy as a Revolutionary Weapon" (London: New Left Books, 1971), 11–22. Original page numbers appear in italics when I have modified the translation.

perspective of the petit bourgeoisie, and to engage with theory is to embark on a long and arduous process of reeducation: "A struggle without end, exterior and *interior*" ("Philosophy as a Revolutionary Weapon" 12, *27*). The careful study of Marxist-Leninist theory can help certain intellectuals pass into the perspective of the working class. In this respect, the process of theory—of the acquisition of theory and its points of passage or transformation—is nourished by two streams: the *science* of historical materialism and the *philosophy* of dialectical materialism. Althusser relates that philosophy is one of the two theoretical "weapons" of class struggle. But Althusser's main point is, again, that while Marx fully constituted a historical science with the publication of *Capital,* the presence of an independent Marxist philosophy is underdeveloped and inchoate. The great project that results in the essays collected in *For Marx* and in the collaborations resulting in *Reading Capital,* both published in 1965, is to show that there is a philosophy of Marx that does not unfold in continuity through Marx's life, but rather appears in an intellectual crisis or break wherein Marx turns from the Hegelian and humanist writings of his youth to create a genuinely original perspective that is at once philosophical and political. And since Marx himself never wrote a method, or argued himself for the philosophical consistency of his work, this philosophy must be rendered perspicuous in a transversal reading of later works beginning with the *Theses on Feuerbach* and *The German Ideology,* and continuing through the *Communist Manifesto, The Poverty of Philosophy, A Contribution to the Critique of Political Economy, Wages, Price and Profits,* and the volumes of *Capital,* both published and unpublished.

The process of critique, self-critique, and symptomatic reading must be carried out in other areas as well. Often in science or philosophy, materialism is blocked or one is blinded to it by bourgeois ideology. (Only proletarian militants, Althusser believes, are capable of spontaneously recognizing the value of materialism in theory or in practice.) Thus one of the primary tasks of theory, whether in scientific or political practice, is to recognize and understand the significance of a Marxist-Leninist science and philosophy, and to struggle against bourgeois ideology on both the political and scientific fronts, internally and externally, including critiquing the primary forms of bourgeois philosophy—neopositivism, phenomenological or existential subjectivism (humanism), and structuralist ideology, and therefore to make of dialectical materialism the scientific foundation of the human sciences.

Now, Althusser suggests that everyone has a spontaneous conception of the world directed in fact by ideological practices, whether religious, moral, juridi-

cal, political, and/or aesthetic. These world-conceptions are represented in theory by philosophy, which becomes the site of struggle between antagonistic frameworks, idealist or materialist, for understanding society. The problem is how to define and sustain the epistemological position of a materialist philosophy for politics and against ideology, and here Althusser's historical philosophy of science, and his concept of theoretical practice, returns as a kind of philosophical politics. As soon as a theoretical domain is established by a science, philosophy comes into existence. It makes possible conceptual understanding, without which there are only ideological world-conceptions. The constant struggle in philosophy, then, is to distinguish between forms of ideological and scientific knowing; in short, idealism and materialism. A detachment and a revealing: theory means making present and perspicuous the underlying concepts of a practice, whether scientific, political, or ideological, and thus opening them up to a process of materialist and dialectical refinement and critique that leads to an epistemological break where those concepts are framed at a distance and from a new perspective. To engage in this process is to become a philosopher. And while no man is spontaneously a philosopher, says Althusser, he is capable of becoming one *("Tout homme n'est pas spontanément philosophe: il peut le devenir")* ("Philosophy as a Weapon" 18, *31*). To become a philosopher is to become subject to theory, or to be capable of producing theory or engaging in theoretical practice.

Three observations might clarify some of the more obscure or difficult ramifications of Althusser's arguments. First, for Althusser theory is a site of transition or transformation. A science can come into being and establish itself as a practice without having fully developed itself conceptually—its concepts can be thinly drawn or inchoate, and yet it can still function productively. When a science turns to theory or seeks out its theory, it is usually blocked, at an impasse, or in a state of epistemological uncertainly. This is why philosophy follows science in Althusser's conception. A science extends, renews, or even discovers itself by passing through philosophy. It becomes a real science through Theory in a process of self-reflection and self-criticism wherein its conceptual architecture and epistemological framework are finally made fully perspicuous and thus available for evaluation.

Second, theory is not only the site for constructing and refining concepts; it is also the site of revolution, or less dramatically, a point of rupture and transformation in knowledge—the point of passage where ideology is overcome by scientific thought.

In one of Althusser's more famous assertions, history is a process without a subject, such that materialism is considered an antihumanist philosophy.

Analogously, the passage toward scientific knowing is also a process without a subject in the sense that science is not subjective—it does not derive its value from a spontaneous and free or self-identical consciousness. In both cases, the process is transsubjective and collective. But there is a deep paradox in this argument. Idealism and ideology serve to perpetuate the class dominance of the bourgeoisie. But Althusser equally asserts that through its experience of militancy and class exploitation, the proletariat has a conception of the world that is spontaneously materialist, if not exactly philosophical. In virtue of its exploitation as a class of subjects—historically and epistemologically—the proletariat exists as a historically formed epistemological stance, inchoate perhaps, but "scientifically" in advance of the petit bourgeoisie. *"It is because the working-class movement knew itself in Marxist theory that it recognized itself in it,"* Althusser wrote earlier ("Theory, Theoretical Practice and Theoretical Formation" 33).

Here already, Althusser presents the idea of the necessary and spontaneous capacity of the exploited to understand the nature of their exploitation and their capacity for resistance, an idea that will later be central to identity politics. At the same time, materialist intellectuals serve as a sort of Leninist conceptual avant-garde. Through their expertise in theoretical practice, intellectuals draw out, support, and refine theory's concepts. In so doing, philosophical work is meant to effect a dual transformation—theory clarifies and brings into focus what the exploited class already spontaneously knows in virtue of its exploitation; it also transforms conceptually the petit bourgeois intellectual, bringing him into congruence with the epistemological perspective of the proletariat. The proletarian is spontaneously materialistic and scientific; the petit bourgeois intellectual is spontaneously idealist. Through theory, both must become philosophers from their two starting points, though in fact, the intellectual must lead the workers, while taking inspiration from their exploitation.

Therefore, understanding Althusser's concept of theory means understanding fully how it inhabits the intersection of two points of reference. "In order really to understand what one 'reads' and studies in these theoretical, political and historical works," Althusser asserts, "one must directly experience oneself the two *realities* which determine them through and through: the reality of theoretical practice (science, philosophy) in its concrete life; the reality of the *practice of revolutionary class struggle* in its concrete life, in close contact with the masses. For if theory enables us to understand the laws of his-

tory, it is not intellectuals, nor even theoreticians, it is the *masses* who make history. It is essential to learn with theory—but at the same time and crucially, it is essential to learn alongside the masses" ("Philosophy as a Revolutionary Weapon" 20, *32*).

Again, we find here a spontaneous and unreflected relation to materialist theory in militant proletarian struggle. Intellectuals have access to the tools and practice of theory, but may not be guided by the right theory, and in fact, both the proletariat and intellectuals are continually subject to the lures of ideology and idealism. Philosophy, or rather dialectical materialist Theory, must thus become the compass or navigational tool in political struggle. Citing Lenin, and this is one of the key arguments of "Lenin and Philosophy," Althusser claims that the master function of philosophical practice is *"to draw a dividing line between true ideas and false ideas"* (21, *33*), which is at the same time to make a line of demarcation between class friends and class enemies. Therefore, "Philosophy represents the people's class struggle in theory. In return it helps the people to distinguish in *theory* and in all *ideas* (political, ethical, aesthetic, etc.) between true ideas and false ideas. In principle, true ideas always serve the people; false ideas always serve the enemies of the people" (21, *33*). Theory is a political compass, then, whose points of navigation are both epistemological and ethical, leading to a life guided by materialism, and only difficultly achieved.

And here is my third and final point. There is a vacillation or even an undecidability within Althusserian epistemology—between truth and falsity, ideology and science, theory and philosophy—that renders it paradoxical. Whether ostensibly Marxist or not, this paradox inhabits all the contradictory sites and stages of Theory within the discourse of ideology, whether from a psychoanalytic or cultural studies perspective. The class of subject might be defined by gender, sexual orientation, ethnicity, a history of colonial exploitation, or any other identity defined in an asymmetrical relationship to power, but identity politics is always anchored in what one might call an identitarian epistemology: a class of subject is defined collectively and homogeneously through the (visible) signs of its discrimination or exploitation, and in virtue of its otherness spontaneously achieves a (nonrecognized) knowledge or capacity for criticism. In turn, theory serves to recognize and value that (self-)knowledge, to make it present and active.

There is a tension here, however, with later versions of identity politics in the 1980s and 1990s. Every politics of identity relies on defining a class of

discrimination and / or exploitation. However, in contrast to Althusser's emphasis on the collective nature of knowledge or self-knowledge within a class of subject, later theory will become the expression of a monistically defined individual oppressed consciousness, living its oppression as an individual member of the class. Nonetheless, Althusser's concept of Theory remains strongly present, if often unrecognized as such, in almost every instance of contemporary theory.

## 23. Becoming a Subject in Theory

> One knows very well that the accusation of being in ideology only applies to others, never to oneself.
>
> —Louis Althusser, "Ideology and Ideological State Apparatuses"

Understanding fully Althusser's influence on contemporary theory and the discourse of ideology requires a shift in historical perspective with respect to standard accounts. Contemporary film theory turned to Althusser primarily for a theory of ideology and its critique. But in a way not dissimilar from my discussion of the introduction to Hegel's *Aesthetic,* Althusser's broader project throughout the 1960s was to reassert the importance of philosophy for Marxism, and to separate and clarify conceptually the relationship between theory, philosophy, and science. This is the reason why I have stressed Althusser's place in the field of epistemology.

One way to look at contemporary theory is less as a discourse of ideology than as a series of ramified and conflicting projections of an epistemological space that stands to one side or outside of ideology, or is resistant to ideology, and thus preserves a perspective or a framework with respect to which ideology is spontaneously counteracted with "knowledge." This critical space is more often than not anchored monistically. From the standpoint of Kristeva's semiotic psychoanalysis, this monistic space is the Subject whose body is organized expressively by the drives in their relation to sexual difference; for cultural studies, it is located in a category or class of subjects. In either case, these two presumptions often intersect in a similar characterization: the subject recognizes or identifies itself; it is self-identifying and self-knowing, able to recognize others and to recognize itself in others through its self-sameness, which is also a difference marked by a negative and asymmetrical relation to power. Moreover, there is epistemological value in this relation, not only in its

powers of recognition (of its self and its like community) but also in its difference and its subjugation to hierarchies of power. While power pressures this subject from all sides and continually exerts its forces upon it, achieving few or no benefits from power, the subject preserves an ideological and ethical distance from it—its mode of existence is to be other to power, and to be in a position to know this critically.

There is no discourse of ideology, then, without a corresponding appeal to an epistemological space free from or resistant to ideology. In the period ranging from 1969 to 1975, figures like Comolli and Narboni, on one hand, and Metz, on the other, maintained a clear commitment to the idea that only a continuously elaborated and self-critical theoretical practice was capable of producing a perspective or framework in which the ideological effects of the film text and the cinematic apparatus of recording and projection could be parried, analyzed, and critiqued. Theory, then, becomes the site of a continuous and perhaps interminable struggle to locate a space wherein the subject (or the text) could elude epistemologically the snares of ideology.

Along these lines, the discourse of ideology in contemporary film theory can be laid out as branching series—sometimes overlapping, sometimes running parallel to or interfering with one another—in terms of their different characterizations of the subject in relation to ideology, and in how different concepts of theory were deployed to understand the nature of this subjectivity in relation to problems of culture and power. Thus, the period from 1969 to 1975 might be characterized as the phase of the "apparatus" and the "transcendental subject." The concept of apparatus should be understood here in multiple interwoven senses. First is the sense of a conceptual apparatus adopted from *Tel Quel,* but yet more deeply influenced by Louis Althusser's efforts throughout the 1960s to construct a materialist epistemology and philosophy of science. The editors of *Cahiers du cinéma* were relatively clear in this respect that their theoretical practice sustained a *critical* apparatus—that is, a theory of reading—that took both the aesthetic and economic practice, of film or cinema, as an object of criticism. In this sense, no additional theory of the subject was necessary since, as Althusser frequently asserted, the condition of science was to be process without a subject. To *be* a subject was to be subject *to* or a subject *of* ideology.

What did it mean, then, to consider aesthetic and economic practices as "apparatuses," or an interlocking set of apparatuses? This was the main question of Jean-Louis Baudry's influential essay "Cinéma: Effets idéologiques produit par l'appareil de base," published in *Cinéthique* 7/8 in 1970. Baudry was among

the first writers to apply Lacan's essay on the mirror-stage to questions of iden-tification and cinematic spectatorship. But as I discuss more fully in *The Crisis of Political Modernism,* Baudry is better understood as applying Althusser's account of knowledge-as-production to cinematographic technologies of re-cording and projection, and following *Tel Quel's "théorie d'ensemble,"* to place this technology on the terrain of the battle of materialism against idealism. Baudry's essay exemplifies how Althusser's epistemology was translated into the discourse of political modernism, and how a version of Althusser per-sisted, sometimes covertly or even inadvertently, and with all its attendant contradictions, as a set of underlying assumptions for the discourse of ideol-ogy in general.

Baudry adopts an Althusserian vocabulary (with a smattering of decon-struction) to argue that below or beyond the effects of any given film, the sys-tem of cinematographic recording and projection functions like a conceptual machine. It is a productive apparatus, and what it produces is an omniscient and idealist vision of the world. Baudry's argument tries to accomplish two principal tasks in this respect. The first is to compare the camera's mental ap-propriation of reality with Althusser's account of the empiricist structure of knowledge. Here Baudry plays on the dual sense of "apparatus" *(appareil)* as both technological machine and conceptual structure. If both empiricist episte-mologies and cinematographic recording present themselves optically—the construction, attenuation, and management of a gaze—then Baudry asks, "Does the technical nature of optical instruments, directly attached to scientific prac-tice, serve to conceal not only their use in ideological products but also the ideological effects which they may themselves provoke?"[146] This leads to the second task, where Baudry tries to find within this apparatus the possibility of a reversal, where an idealist and ideological structure of vision can turn on itself reflexively, revealing itself and making itself present to another kind of sight, a materialist and "theoretical" one.

To respond to his question, Baudry describes the specificity of cinematic recording as the "specularization" of the subject in three stages: the delimitation of the frame, the production of the illusion of continuous movement through the suppression of difference of the series of frames in projection, and in a

---

146. Trans. Alan Williams as "Ideological Effects of the Basic Cinematographic Apparatus," in *Narrative, Apparatus, Ideology,* ed. Philip Rosen (New York: Columbia University Press, 1986), 286–287.

process of double identification, both with the characters in the film and with the camera's staging of a vision of the world. Following the arguments of another *Tel Quel* writer, Marcelin Pleynet, on the ideological effect of *perspectiva artificialis* in Quattrocento painting, Baudry argues that the construction of space in the cinema similarly "elaborates a total vision which corresponds to the idealist conception of the fullness and homogeneity of 'being,' and is, so to speak, representative of this conception. In this sense it contributes in a singularly emphatic way to the ideological function of art, which is to provide the tangible representation of metaphysics" (Baudry 289).

In its standard uses, the cinema is a mechanism for producing ideology, whose effects reside in the form of a substitution that mimics the psychical constitution of the subject while remodeling it more perfectly. Moreover, the essay follows closely the main lines of Althusser's account of ideology as laid out in his article "Ideology and Ideological State Apparatuses" published in the same year: that ideology functions in the form of a "representation" (the scare quotes are Althusser's) of the imaginary relation of individuals to the real conditions of their existence; that as representation ideology has a material existence embodied in a practice or apparatus; and that the function of ideology is to interpellate or produce individuals as subjects. The function of ideological apparatuses is therefore to produce a structure of recognition in which one is attracted to a vision of one's self as a particular kind of subject, and at the same time, one is also subjected to a particular kind of vision. "[This] is the transcendental subject whose place is taken by the camera," writes Baudry,

> which constitutes and rules the objects in this "world." Thus the spectator identifies less with what is represented, the spectacle itself, than with what stages the spectacle. . . . It constitutes the "subject" by the illusory delimitation of a central location—whether this be that of a god or of any other substitute. It is an apparatus destined to obtain a precise ideological effect, necessary to the dominant ideology: creating a phantasmatization of the subject, it collaborates with marked efficacy in the maintenance of idealism. . . . Everything happens as if, the subject himself being unable—and for a reason—to account for his own situation, it was necessary to substitute secondary organs, grafted on to replace his own defective ones, instruments or ideological formations capable of filling his function as subject. In fact, this substitution is only possible on the condition that the instrumentation itself be hidden or repressed. (Baudry 295)

This idea of ideology as productive of a transcendental subject closely follows Kristeva's account. Moreover, Baudry's argument echoes Althusser's own example at the end of his essay on ideological state apparatuses of how religious ideology projects a structure where an Absolute Subject functions as a specular center of attraction that interpellates individuals into subjects, which subjects them to the Subject as it were, in a process of recognition and misrecognition that operates through a play of mirrors and misleading identifications. More precisely, Baudry implicitly characterizes cinematic representation as producing or reproducing the three constitutive errors of empiricist thought as outlined by Althusser in his preface to *Reading Capital*. The cinematographic apparatus is a site of knowledge, but its uses produce an idealist or even falsifying knowledge where cognition is reduced to the form of an optics. Since all knowledge resides in the domain of the visible world, conceptual knowledge about the world is confused with the world itself, which in turn means that the theoretical or conceptual instrumentality formulating and conditioning this knowledge is suppressed. As a structure of vision and misrecognition, the transcendental subject is produced through the suppression of any recognition or comprehension of a given labor, or process of transformation, where the cinematographic apparatus intervenes between a determinate raw material in the form of "objective reality" and a determinate product in the form of ideological interpellation.

Where Baudry differs from Althusser (and Kristeva), reading him selectively along lines laid out generally in *Cinéthique* in the early 1970s, is in the suggestion of the possibility of reversing this situation from within the apparatus itself, and thus to transform ideological aesthetic practices into theoretical practices, thus aligning them with the materialist production of knowledge. According to Baudry, in order to accomplish a deconstruction of the ideology produced by the camera, the question then becomes, "Is the work made evident [*Il s'agira de savoir si le travail est montré*], does consumption of the product bring about a 'knowledge effect' [Althusser], or is the work concealed?" (Baudry 287). Unambiguously, Baudry asserts that cinema's potential for achieving a break with its ideological function corresponds to the degree in which the work of its instrumental base—photographic registration, serial regulation of movement, the process of identification in projection—can be made legible *(lisible)* within the text: "concealment of the technical base will . . . bring about an inevitable specific ideological effect. Its inscription, its manifestation as such, on the other hand, would produce a knowledge effect, as actualization of the

work process, as denunciation of ideology, and as critique of idealism" (288). In chapter 3 of *The Crisis of Political Modernism,* I provide a fuller critique of this rather extraordinary assertion of cinema's possibilities for becoming a deconstructive theoretical practice. The main point, however, is that Baudry's argument, which is entirely characteristic of the discourse of political modernism, is ordered by a dialectic of visibility and suppression aligned with the opposition of illusion to knowledge, idealism to materialism, and ideological to theoretical practice, in which one criterion of visibility is substituted for another in a logic of binary reversibility. Extraordinarily, to know means only to *see*—that is, the process of production within the text—and seeing correctly gives access to knowledge. In this manner, the idea of an aesthetic "theoretical practice" offered within the discourse of political modernism produces as if in mirror construction the very structure of the empiricist epistemology it is supposed to counteract.

In the early to mid-1970s, *Screen* largely adopts and seeks to expand a version of film theory that incorporates and refines Althusser's critique of empiricist epistemologies, while also making of it a theory of representation and antirepresentation where the problem of knowledge also turns on the question of visibility. To the extent that there is a concept of the subject here, it is the subject of ideology, held in a relation of misrecognition. But similar to Baudry and other writers in *Cinéthique,* this position is thought to be formally reversible, and reversible within the text. This leads to the curious position, noted in the conclusion to *The Crisis of Political Modernism,* that there is no text in theory, or rather that the conceptual and epistemological powers of theory are given over to or disappear into the modernist text, which seems, in its presumed disruption and critique of realism and transparency, to be autoproductive of a certain knowledge. The task of criticism is only to complete that process.

This discourse begins to shift in 1975, opening a new phase that extends until around 1990. On one hand, this year marks the apogee of the dream of producing a unified theory and method in which the concept of film theory matures. But on the other, no sooner is a certain idea of theory fully formed than it begins to splinter along two lines, one defined by the influence of feminist theory and debates on sexual identification and spectatorship, the other by the steadily rising influence of cultural studies. Along these same lines, the discourse of political modernism reaches its point of maximum influence through the concepts of suture and subject positioning. At the same time, it begins to unravel rapidly in the new framework of postmodernism, which puts pressure

on all of the grand binaries that sustained political modernism—realism/modernism, ideology/theory, transparency/deconstruction, idealism/materialism—no less than undermining the coherence of binary logic itself.

The first landmark event here is the publication in *Screen* of Ben Brewster's translation of "The Imaginary Signifier" in summer 1975, just a few months after its publication in France. The impact of Metz's essay in English (no doubt far greater than its effect in France) occurred on multiple levels. Where before *Screen* was concerned with promoting rigorous work in textual analysis and problems of method in film semiology, linking them both to historical predecessors in left criticism, suddenly psychoanalysis comes to the foreground and with it the centrality of the cinematographic apparatus. Or, as Metz might have preferred, theory turned from problems of *filmic* signification to an idea of *cinema* as a complex institution, which preserves and reproduces itself by producing forms of desire in relation to vision: scopophilia, fetishism, and voyeurism. In other words, implicitly following Althusser's critique of empiricism and his preliminary work on ideological state apparatuses, Metz characterizes the cinematic institution as geared toward the production and reproduction of subjectivity. (As we shall see, Metz's curious silence with respect to Althusser and Kristeva indicates a certain respectful skepticism toward the political possibilities of theory, either as a scientific theoretical practice or as transgression.)

At the same time, Metz's essay is also a methodological statement, which not only broadly maps out the principal questions, concepts, problems, necessity, and stakes of transforming semiology by psychoanalysis (here entering into an implicit dialogue with Kristeva) but also insists throughout on the necessity of theoretical self-reflection. Indeed, theory achieves a new stature here in relation to the subject. To the extent that Metz presents the cinematic institution as an almost perfectly functioning machine, there would seem to be little hope of avoiding the attraction and lure of its socially sanctioned forms of scopophilia. But here Metz differs significantly from Baudry. Where Baudry pins vague hopes on a deconstructive power that lies within the apparatus itself, which can dialectically turn on itself and make visible otherwise suppressed mechanisms of signification, thereby undermining the transcendental subject and encouraging a new knowledge and perception, Metz holds no such hope. Instead he makes the case for the critical powers of theory itself in a necessarily external relation that requires not only a multidisciplinary work of conceptual invention and innovation but also an unceasing internal process of critical self-reflection or self-analysis. If one's (ideological) relation to the apparatus is

passive, then theory itself requires a counteracting activity where another subject must produce itself in theory by introducing a fold or internal distancing within itself that disrupts its relation to desire and the imaginary, exercises a strategic sadism both on itself and on its object of desire (the cinema), and thus replaces scopophilia with epistemophilia transforming one's relation to the image through concepts. This is not so much a denigration of vision as Martin Jay proposes, but rather a suspicion of desire where an ever-vigilant theory is the conceptual counterweight to desire.[147]

In 1975 the concept of the apparatus reaches it apogee of influence but also encounters its point of most profound crisis. Closer to *Cinéthique* than *Cahiers,* until this point *Screen* considered the apparatus and the classic realist text as efficient dialectical machines for producing an idealist and transcendental subject. (Is there no escape from the apparatus?) These arguments echoed *Tel Quel* in proposing a certain kind of modernist aesthetic practice in the form of a theoretical countercinema whose primary models were Bertolt Brecht, Straub and Huillet, and Jean-Luc Godard and Jean-Pierre Gorin's Dziga Vertov Group. It is also significant that the issue of *Screen* devoted to "The Imaginary Signifier" included a Marxist-feminist critique of psychoanalysis by the American critic Julia Lesage, "The Human Subject—You, He, or Me? (Or, the Case of the Missing Penis)." References to feminist theory and to the women's movement were almost completely absent from *Screen* before this point, even as they were becoming increasingly important and influential in both British and North American political and film culture. This state of affairs shifts dramatically when *Screen* published in its next issue what is perhaps the most influential and intensely debated essay in contemporary film theory—Laura Mulvey's "Visual Pleasure and Narrative Cinema."

Mulvey's essay on visual pleasure—the product of several years' work in both theory and filmmaking, as well as collective work in the British women's movement—opens a new and important direction in contemporary Anglophone theory; or better, presents a fork in the road with express routes to Freudian and Lacanian psychoanalysis on the one hand and questions of sexual difference on the other. The impact of Mulvey's essay should be understood in the context of the pioneering work of many other writers, including Pam Cook and Claire Johnston, as well as widespread interest in recovering and promoting

---

147. See Jay's compelling and original account in *Downcast Eyes: The Denigration of Vision in Twentieth Century French Thought* (Berkeley: University of California Press, 1993), in particular, chap. 8.

the contribution of women filmmakers to the history of cinema. Mulvey's essay, however, was the ignition point for what would become among the primary interests of film theory deep into the 1980s: feminism, feminism and political modernism, and debates on the specificity of the female spectator. But before Mulvey's contribution can be assayed, another fork on the highway to theory must be briefly sketched out, indeed, a parallel route under construction that was bound to overtake and transform the psychoanalytic one—cultural studies.

The Centre for Contemporary Cultural Studies was founded in 1964 by Richard Hoggart at the University of Birmingham. Influenced by the native British Marxism of Hoggart and Raymond Williams, in 1970 the Centre began producing a journal, *Working Papers in Cultural Studies (WPCS)*, which was an exact contemporary to *Screen* and in many respects a rival to it, at least with respect to developing a Marxist politics and a theory of ideology in relation to representation. Similar to *Screen*, the Centre and *WPCS* were sites for lively debates on cultural politics and criticism with similar commitments to the work of Althusser and Barthes for developing a contestatory cultural criticism, but outside the framework of *Tel Quel* and without a deep commitment to psychoanalysis. Among the most influential works for what would become a discourse of culture were Stuart Hall's essay "Encoding/Decoding," first circulated as a stenciled paper in 1973 and continually reprinted in the next two decades, the special issue of *WPCS* 7/8 "Resistance through Rituals" (Summer 1975), Dick Hebdige's *Subculture: The Meaning of Style* (Methuen, 1979), and David Morley's, *The 'Nationwide' Audience: Structure and Decoding* (British Film Institute, 1980). Significantly, none of these works centered on film, but all would have a significant impact in pushing the emerging field of film studies in the directions of media studies and cultural studies.

From 1975 until the early 1990s, then, Theory branched into two streams—one defined by psychoanalysis and feminism, the other by cultural studies of media. The two streams continually interacted at their edges, of course, and feminist film theory itself would undergo an internal debate on female subjects or spectators where tension accrued between psychoanalytic and culturalist accounts. Both streams were in turn complicated by another external genetic line. As the influence of *Tel Quel* faded, the 1980s were strongly marked by another conceptual framework that rapidly unfolded across discourses in and of arts, though largely exhausting itself in the 1990s—that of postmodernism. In all of these respects, the discourse of ideology began to turn on that of culturalism in ever-more-complicated combinations.

Throughout the 1980s, the terms of Theory are shifting, though around or in relation to a common center of gravity—the question of the subject and ideology—which remains the background of every cultural debate and conceptual importation. However, on this ground, there is already tension between the concept of signifying practice, especially as defended in *Screen,* and the commitment in cultural studies to think of cultural consumers not as "spectators," but rather as active and differentiated readers or producers of meaning. This tension was in turn complicated by the increasing tendency to treat the problem of meaning not in relation to the Subject of psychoanalysis, but rather as classes or categories of social subjects. This shift was not necessarily a rejection of "French theory" as much as a remapping and rebalancing of concepts drawn from Althusser, Barthes, Lacan, Foucault, and later Michel de Certeau and Pierre Bourdieu. In contrast to film theory, even Derrida would have a role to play through his influence on Gayatri Spivak and Homi Bhabha's contributions to subaltern and postcolonial theory.

The steadily rising influence of cultural studies contributed in other significant ways to the vicissitudes of theory in the 1980s. Like film theory per se, cultural studies had an abiding interest in questions of Marxism, poststructuralism, feminism, postmodernism, media studies, postcoloniality, and critical race theory, all of which would provide points of commonality and collaboration with the expanding field of film studies. However, organized around the concept of culture, film was only one of a constellation of elements under examination, which also included television, music and fashion subcultures, and indeed broadly, all forms of popular culture and mass media.

Here the concept of culture rivals film as an object of theory and contributes to one of the major trends of the 1980s: the disappearance of film into the general study of culture, or the incorporation of film into the broader matrix of media studies. I have already commented on the irony of this historical situation in *The Virtual Life of Film.* Just as the study of film starts to achieve real presence in university curriculums, and begins to contribute in significant ways to critical and historical studies in the arts and humanities, the moving image, so long associated with theatrical cinema, begins to unravel into a variety of electronic and digital media, appearing on new kinds of screens through a variety of platforms and distribution channels. At the same time, the explosive influence of postmodernism in the arts and critical theory—despite the internal conceptual dissensions arising between its various conceptions in architecture, philosophy, social theory, and critical theory—quickly undermined and overturned the discourse of political modernism. In philosophy and critical theory,

there was a new skepticism toward the possibility of conceiving theory as a generalizable or unifiable doctrine with secure epistemological standpoints and claims to universality. Jean-François Lyotard's *The Postmodern Condition: A Report on Knowledge* (1979), published in translation by the University of Minnesota Press in 1984, set the framework for this new epistemological perspective of reduced expectations. If modernism's critical potential was founded by the clash of great regimes of representation and knowledge, postmodernism emerged from an increasing incredulity toward master narratives and the grand dialectical movements of philosophy or history—the dialectic of Spirit, the emancipation of the oppressed, the accumulation of wealth, or the founding of a classless society. The postmodern condition emerges, then, in an environment of increased skepticism marked by the proliferation of micronarratives and "phrase regimes" alert to difference, diversity, and the incompossibility of cultural contexts and situations, where the great hierarchies of knowledge and value are fragmented and leveled out.

In the domain of art and art theory, beginning with Hal Foster's influential 1983 collection *The Anti-Aesthetic,* and Fredric Jameson's work leading up to the publication of *Postmodernism, or the Cultural Logic of Late Capitalism* in 1991, the discursive framework of postmodernism largely displaced political modernism, and in turn, both the object and subject of Theory were transformed. With respect to the influence of *Tel Quel,* the combination of cultural studies and postmodernism led to a rapid dissolution of the fundamental binary of modernism and realism, a declining commitment to the transgressive claims of modernism, and a steadily rising interest in the popular, thus blurring the axiological line between high art and the popular arts or mass media. The discourse of political modernism eventually disappeared as the stakes and framework of experimentation in the arts underwent profound shifts, substituting transgression, negativity, and critique for strategies of appropriation, recontextualization, parody, and irony, as exemplified in the work of Sherry Levine, Cindy Sherman, Barbara Kruger, Dara Birnbaum, and Martha Rosler, among many others. In a process happening across all media—architecture, photography, film, video, painting, sculpture, and performance art—modernist commitments to formal abstraction and medium specificity were in rapid decline. Indeed, the late 1970s and early 1980s witness the emergence of conceptualist and "postmedium" strategies leading to a destabilization of the concept of medium as such. Film theory and film studies responded to this period of transition in a complex and contradictory way, first because the main unifying framework of theory was in a state of tension with cultural

studies but also because cultural studies was more conceptually prepared to deal with the unraveling of film into television, video, and eventually interactive media across the 1980s and 1990s. Indeed, by 1991 what might be called postmodern cultural studies, whose turning point in the United States is the conference in Champagne-Urbana that produced the massive and influential collection *Cultural Studies* (Routledge, 1992) edited by Lawrence Grossberg, had completely displaced the influence of *Tel Quel,* and by the same token had undermined the synthetic gesture of Theory, thus promoting its disaggregation and multiplication into ever-increasing streams of fields.

Throughout the 1980s and into the 1990s, the rise of media studies and new critical interest in popular television, video art, and electronic media produced a situation where as the object of theory film gave way to a new concern with visual studies and the multiplication of screen cultures driven by the demands of multinational capitalism and proliferating simultaneously on global and capillary scales. At the same time, cultural studies had created a new conception of a class or collective subject of mass culture, attentive to the differential contexts of reading and readership, that overturned or reversed the logics of apparatus theory and the subject in process. The apparatus was no longer all-powerful, and the subject in process was no longer specifically aligned to a negativity associated with the avant-garde. Cultural studies produced readers rather than spectators, placing new emphases on an active consumption of culture where, depending on context, meaning could be pulled in a variety of directions. The Leninist notion of intellectuals as the avant-garde of theory was thus undermined by the spontaneous agency of resistant readers. Psychoanalysis would not completely disappear. The concept of negativity and the drive-governed bases of signification were now marshaled, rather, to explain the subject's always open, incomplete, and contradictory relation to meaning. To the extent that transgression was diminished as a concept, perhaps the death-drive was overtaken by the pleasure principle? In any case, just when psychoanalysis seemed to be conceptually exhausted, Slavoj Žižek appeared on the scene to encourage us to enjoy our symptoms.

Taking a satellite view, perhaps it is now possible to picture the topography of contemporary film theory as it stretches from the politically charged date of 1968 toward the mid-1990s and turns from a discourse of ideology to one of culturalism. In contrast to either the aesthetic discourse or the discourse of signification, contemporary theory fully embraces its name, and accepts the concept of Theory as such as a practice or even a discipline within the arts and humanities. An idea of Theory is deployed widely, not only in academic and

critical discourses but also within the arts themselves—this is truly an "age of Theory." However, this great umbrella term, so easily evoked or gestured to, also obscures or camouflages a number of distinct divisions, conflicts, and debates. Our satellite map must be complemented with another kind of topography, which can account for major and minor geological shifts, fractures and fault lines, and complex patterns of parallel and intersecting lines.

Out of *Tel Quel*'s *"théorie d'ensemble"* and Kristeva's concept of signifying practice stretches the discourse of political modernism, which reaches its point of maximum influence in the late 1970s with *Screen*'s interest in psychoanalytic concepts of suture and subject positioning. As theories of discourse, these lines can be understood as extensions and modifications of the precedent discourse of signification. Parallel to so-called *Screen* theory is the discourse of identity and culture, which not only overtakes political modernism but also largely remains dominant today to the extent that "theory" still exists. Both are variants on the discourse of ideology, of course, but the steadily rising arc of cultural studies in film and media studies could also be mapped against a decline or displacement of psychoanalysis.

This fault line is especially apparent in the history of feminist film theory. The concept of the transcendental subject produced a significant impasse or blockage in theory in the form of an identity without difference. To the extent that the apparatus was considered an efficient dialectical machine, both psychological and ideological, for reproducing the transcendental subject of idealism, all paths toward a materialist epistemology appeared to have been barred. In "Visual Pleasure and Narrative Cinema," Laura Mulvey turned negativity and the reflexive force of theory back on apparatus theory itself, and thus introduces the idea that the transcendental subject of cinema is in fact gendered, that it produces and universalizes forms of perception and desire that sustain not only idealism but also patriarchy. The line of questioning that Mulvey's essay inaugurates is, how does the apparatus sustain sexual difference while privileging only one of its terms, and where can other potentialities of difference be located within it? Her argument is fully framed within the discourse of political modernism, however, and her proposed solution is to produce another kind of cinema, both avant-garde and materialist, in order "to free the look of the camera into its materiality in time and space and the look of the audience into dialectics, passionate detachment."[148] Stephen Heath's essay on "Narrative Space," published in *Screen* in autumn 1976, introduces another

148. "Visual Pleasure and Narrative Cinema," *Screen* 16, no. 3 (Autumn 1975): 18.

turn, incorporating Kristevan concepts of negativity and the subject in process to a theory of the spectator. The process of reproduction of the subject is always at risk, Heath argues, and inclined to fail, and thus must be continually sustained in a spatial and temporal dynamic that bolsters the idealist system of representation. But the potential is always there to release another kind of cinema (materialist) and another kind of subject (open to ideological transformation).

Here the problem of difference is still organized around the concept of signifying practice, whose ideas of *signifiance* and suture sustain an immanent relation of the subject to discourse. The subject is produced through discourse, as it were, and if the text and apparatus are productive of a certain form of subjectivity, then the response is to produce another kind of text. While Mulvey's essay aspired to locate the possibility of a new form of materialist text and spectatorship, one could not necessarily say that the text would be feminist or forms of identification "feminine." Indeed, while Mulvey and others brought the critical concepts of a psychoanalytic feminism to bear powerfully on the patriarchal logic of classical film form, many unanswered questions remained. Was there no place for the female spectator in the classical Hollywood cinema? And what were the possibilities for locating and defining the possibilities of female authorship and the poetics of a feminine style or *écriture?*

At this point the reflexive critical force of theory begins to open new fault lines within feminist theory itself. Throughout the late 1970s, essays in *Screen* were increasingly concerned with questions of subjectivity and subject positioning, leading up to Stephen Heath's exhaustive overview of psychoanalytic theories of sexual difference and identification, "Difference," in the autumn 1978 issue. As importantly, in 1981 Mulvey published her "Afterthoughts on 'Visual Pleasure,'" which attempted to account for the activity and pleasure of the female spectator with respect to classical Hollywood films. From 1978, then, through the early 1980s and up to *Camera Obscura*'s special issue on the topic in 1990, defining the psychological specificity of the female spectator and the potential for a feminist avant-garde practice together defines a dominant series within contemporary film theory as articulated in important essays and books by Linda Williams, Mary Ann Doane, Kaja Silverman, Teresa de Lauretis, and many others.[149]

149. For a fuller account, see chap. 8 of *The Crisis of Political Modernism*, as well as my subsequent book *The Difficulty of Difference: Psychoanalysis, Sexual Difference and Film Theory* (New York: Routledge, 1991).

From the late 1970s through the 1980s, theory is not only turning to new problems—such as feminine identification, the female spectator, and feminine *écriture*—but also turning on itself in the form of negation and critique. Psychoanalysis is the framework not only for posing and exploring these questions but also for testing and interrogating patriarchal biases within film theory and psychoanalytic theory themselves. Moreover, both within and outside of feminism, psychoanalysis itself was being challenged from within by feminist theory and from without by cultural studies, which by the early 1980s were producing important accounts of female readership in the context of ethnographic and reception studies. The important idea here, however, is to emphasize that theory itself is being transformed in a relatively new way, where one might say that one of the primary activities of theory is to be engaged in theoretical critique, to be continually turning back onto itself, probing itself for limits, biases, ideological flaws, ellipses, and blind spots. This critical dimension of theory is not new, of course. But what is novel in contemporary theory is how this reflexivity continually turns around and transforms dialectically the problem of the subject—its forms of identity or difference, and the limits and possibilities of knowledge of itself and in its relation to power.

In a conceptual framework so committed to psychoanalysis, the unconscious, subjective difference, and the transgressive force of desire and the drives, in retrospect one of the most curious features of contemporary theory is how the concept of negation or critique returns continually to the problem of identity. Where earlier psychoanalytic accounts focused on the drive-governed processes of transgression as an erosion of identity that had to be shored up in ideological representations, beginning with the question of the specificity of the female spectator, theory as theoretical critique turned increasingly to a politics of identity that amplified rather than eroded the assurance of self-knowledge. This odd tension was already present in Althusserian epistemology, as I have shown. Here the crisis of representation in political modernism and the idea of a subject positioned in or by discourse is turned inside out, and through theory the site of the political turns from the text to the subject and the subject's capacity to produce both texts and readings. Moreover, in a context so committed to antifoundationalism and antiessentialism, this capacity returned continually to the criteria of bodies marked by their external and asymmetrical relation to power through differences of gender, ethnicity, race, class, sexual preference, and all actual and historical forms of exploitation.

One of the very great achievements of this age of theory was its deep ethical commitments to political activism and the desire to critique and seek redress

for inequality, discrimination, oppression, and injustice. No apologies are necessary for these very real achievements. Among the absolutely key and resolutely unexamined structural components of the logic of contemporary theory, however, and this despite its intense and recurring patterns of reflexivity and critique, was the tendency to construct a concept of identity as the site of a special epistemological space in relation to ideology or power. In virtue of its asymmetrical relationship to power, what we might call the excluded or differential subject was granted special powers of agency, (self-)knowledge, and critique that freed it to interrogate all strategies of domination as well as the imbrication of others in the snares of power. The power of negation here produced another kind of continuing crisis of representation, but this time not relating to the immanent structure of signifying practice, but rather to external relations of exclusion that returned in the capacity of identity to critique how the other, or I as other, is represented by others. Asymmetry in the experience of power was thus assumed to produce a special kind of epistemological privilege in the double form of a critique of representation and its biases, and the possibility of knowing bias and eluding it through self-representation as other. Disenfranchisement in relation to power was thought to produce a countervailing power in the form of the possibility of critique.

Though strange to think of it now, the structure of this form of knowledge is oddly Hegelian in its logic. Negativity drives a form of critique whose product is a new form of self-consciousness, and through the negation of the negation a new identity is synthetically achieved that not only overturns the asymmetry of master and servant but also produces new and higher possibilities of freedom and knowledge. (That Alexandre Kojève's original if eccentric reading of Hegel was deeply influential for Lacan, not to mention Kristeva, and that Hegel's *Phenomenology* played analogously important roles in Simone de Beauvoir's *The Second Sex* and in Frantz Fanon's *Black Skin, White Masks,* give additional credence to the idea that Hegel's dialectic of self-consciousness lurks in the deep structure of theory.) In any case, the ramifying drive of contemporary film theory is marked first by critique—that is, the stepping outside a current theoretical position in order to expose its limits and contradictions. Here theory takes itself as its own object on a new metatheoretical level, not to create a new concept of theory, but rather to expand its range of subjects in a dual sense, producing not only new themes, concepts, and arguments but also new sites of epistemological interrogation and evaluation. And then appears the second dimension of theory, which seeks beyond or to one side of ideology to project a space of the other who claims to speak from a horizon beyond ideology.

From about 1985, the disaggregation but also expansion of Theory through-out the humanities is fueled by reflexivity and critique. Questions of differ-ence and spectatorship were complicated by the increasing importance of critical race theory and postcolonial theory, a renewed interest in Third Cin-ema, and in the wake of increasing gay activism, especially in response to the AIDS pandemic, the emergence of queer theory. Each of these internal move-ments within theory is marked by conferences or publications that serve as *"in-staurateurs du discours"* in Foucault's sense, both instituting and institutional-izing new series within the discourse. At the same time, new series are also generated by a critical folding or turning of the discourse upon itself to probe its ethical limits or horizons and to project new epistemological spaces marked by difference. Thus buoyed by the context of Juliet Mitchell's feminist psychoanalysis and the new French feminisms of Kristeva, Irigaray, and Mon-trelay, in 1975 Laura Mulvey's "Visual Pleasure and Narrative Cinema" opens contemporary film theory and the discourse of the transcendental subject to a critique of its androcentric and patriarchal biases, and generates new questions around the possibility of female spectatorship and women's aesthetic practice. Important debates on black aesthetics and racial difference in authorship and spectatorship were opened by James Snead's pioneering program "Recoding Blackness: The Visual Rhetoric of Black Independent Film" (Whitney Mu-seum of American Art New American Filmmakers Series, 18 June–3 July 1985), and in 1988 with the publication of *Blackframes: Critical Perspectives on Black Independent Cinema,* edited by Mbye B. Cham and Claire Andrade-Watkins (MIT Press, 1988) and *Screen's* "Last Special Issue on 'Race,'" edited by Isaac Julien and Kobena Mercer. With the publication of Judith Butler's deeply influential *Gender Trouble* (Routledge, 1990) and the important anthol-ogy *How Do I Look?* (Bay Press, 1991), the emergence of queer theory intro-duces a highly productive new series of concepts and questions, where from both within and without, feminist theory and theory as such are criticized for reducing the problem of gender to the binary frame of the heterosexual matrix. Nonnormative sexual practices thus become sites marking the instability of gender identities, and in turn new strategies of agency and resistance are pro-posed as "a set of parodic practices based in a performative theory of gender acts that disrupt the categories of the body, sex, gender, and sexuality and occasion their subversive resignification and proliferation beyond the binary frame."[150]

---

150. Judith Butler, "Preface (1990)," in *Gender Trouble: Feminism and the Subversion of Iden-tity* (New York: Routledge, 1999), xxxi.

From 1990, then, contemporary theory finds itself fully enmeshed in the decade of identity politics. Where the period from 1968 to 1975 is marked by the desire to forge a more or less unified theory of ideology and the subject out of the context of French structuralism and poststructuralism, the period from 1975 to 1990 produces separate yet interacting series of critiques where the transcendental subject of apparatus theory is criticized as supporting a masculine visual privilege, patriarchal ideology is challenged by posing the specificity of feminine identification and practice, queer theory interrogates the heterosexual presumption, and finally critical race theory promotes interest not only in the specificity of the African-American spectatorship but also in all the possible subjective categories marked differentially by ethnicity, hybridity, and diasporic cultures. Under the influence of cultural studies, each of these series generates new approaches to questions of agency and resistance wherein psychoanalysis and cultural studies enter into an uneasy alliance, and where Laura Mulvey's essay, "Visual Pleasure and Narrative Cinema," serves not only as a target of respectful critique but also as a continuing point of anchor for the discourse in general. If Althusserian epistemology and *Tel Quel*'s *"théorie d'ensemble"* forged discursively the conceptual framework in which we think Theory, we have now reached a point where cultural studies has fully come into its own, psychoanalysis is on the wane, and *Tel Quel* is all but forgotten. And this is also where one might mark the end of contemporary film theory around 1995.

We would seem to be at a historical juncture where Theory is triumphantly dominant in film studies as well as the arts and humanities. But such a picture leaves aside the fundamental importance of the "new historicism" in the 1980s in both film studies and the study of literature, as well as the more sociological orientation of most of cultural studies. Also in film studies, from the late 1980s there is a new interest in narratology, historical poetics, and cognitivism, as well as a desire to critique and temper poststructuralism through an appeal to postpositivist philosophies of science. There are multiple ironies in the historical turn. Retrospectively, Steven Knapp and Walter Benn Michaels's provocative and influential argument against Theory in 1982 can be understood as inaugurating what would be one of the most influential frameworks for both literary and moving image study in the 1980s and 1990s—the historically grounded cultural studies of texts.[151] By 1995, the irony is redoubled in that the pragmatic and historical approaches they promoted, which were received with antagonism

---

151. See "Against Theory," *Critical Inquiry* 8, no. 4 (Summer 1982): 723–742. This issue of *Critical Inquiry* was devoted to discussion and debate of Knapp and Benn Michael's then-controversial positions.

by the deconstructive and psychonanalytic lines, would eventually be folded into the larger contexts of cultural studies, new historicism, and historical poetics. As importantly, perhaps we have too quickly forgotten the discovery of Paul de Man's wartime writings in 1987, the "culture wars," and the conservative critique of leftist domination of the humanities that erupted at about the same time, and which dominated public debate deep into the 1990s, all of which is to say that the two decades stretching from 1975 to 1995, which define the era of contemporary theory, are also full of tension, conflict, and debate where Theory, or various approaches to theory, are challenged at every turn from both within and without. We have returned again to Vincent Leitch's characterization of the paradox of theory, where each disruption, each new moment of negation and critique interrogates the ends of theory and projects the end of Theory.

The problem of endings returns us to the question of the contemporaneity of Theory. Here is a deeper problem, for the contemporary is also what is actual or what is present to us as a lived situation. A contemporary sense of the state and history of a discourse or a discipline is always bound to a certain present interest that frames the ever-shifting ways in which we search out conceptual ancestors, ignoring some and elevating others, forging commonalities and establishing differences, setting out boundaries, and thus seek to define our present position on a timeline where progress may be asserted and defended. Contemporaneity is also often assessed contingently by grand historical disruptions. Thus the end of World War II became the common frontier of our postmodernity with any number of other intermediary eruptions punctuating it—the war in Vietnam and other postcolonial movements of the 1960s; the civil rights movement in the United States followed by the international student rebellions of 1968 as well as the feminist movement; the conservative backlash of the Reagan years; and then the first and second Gulf Wars. These historical and social eruptions all inspired new centers of interest around questions of spectatorship and subjectivity—from the perspectives of feminism, race and ethnicity, the postcolonial and subaltern. In writing "The Imaginary Signifier," did Christian Metz realize he was ceasing to be modern and clearing the terrain for contemporary film study, by challenging his earlier work on signification and laying out the methodological grid for investigating psychoanalytic accounts of spectatorship and identification? And if, from the perspective of the contemporary, film theory is closing off and opening on to something new, what comes after the contemporary?

We are close, then, to having to examine the paradox of a new disruption where a postcontemporary moment is projected into the conceptual space

defined by post-Theory. And if we are now in the position of asking what comes after the "contemporary," we must also ask, what comes after Theory? (I will take up this question again in a companion volume, *Philosophy's Artful Conversation.*) What Lukács suggests, and what we saw in the first aesthetic accounts of cinema, is that the call for theory is the appeal to the new, the actual, or the contemporary—what breaks from the past to anticipate the future. At the same time, embedded within the concept of theory is a discontinuous history of conceptual usage whose genealogy is as long as it is incomplete. Each time we evoke or invoke theory in the humanities, we lift the weight of this history on our backs, or more likely, we tread lightly upon it, as if to leave undisturbed the bones of our ancestors, unaware of how many geological layers lie beneath our feet.

No doubt, when we search for a theory or theories, we seek to comprehend, understand, or explain objects, ideas, or states of affairs that attract our thoughts as well as block them. But the problem with theory is that it is torn from within by two diverging genealogical roots—one sunk very deeply in the ancient ground of philosophy, the other recently matured and flourishing out of the history of positivism and the empirical sciences—that have been unequally nourished in the twentieth century. Or to compound the metaphor, one could think of these as two different dimensions of our conceptual life, each involving different conceptions of time and history. The time of science, or rather the image of truth that drives the scientific attitude (though not the history of science itself), is linear, defining a sense of progress through the accumulation of new data and the refinement of hypotheses through falsification. The more recent associations of theory with scientific method produce a tendency to view our conceptual life, sometimes even in the humanities, in terms of a rationality that is linear and conflictual, dominated by a teleological search of truth, if not as a progressively refinable image then as a repressed or hidden being, value, or identity to be uncovered or revealed. At the same time, in the humanities, the scientific image of theory is too close to us, and the philosophical conception too distant. And ironically, in the twentieth century, philosophy itself was responsible for producing this distance within its own history, conforming its image of thought to that of science.

No doubt we reflexively link our image of theory to science, and modern philosophy, more than any other domain, has encouraged us to do so. But while a genealogy of theory seeks conceptual clarity, it cannot confuse this desideratum historically with the search for origins in either science or philosophy. Not one identity, many lines of descent.

# ACKNOWLEDGMENTS

The gift of friendship is everywhere present in this book. I am above all grateful for the colleagues and companions who endured with patience and good cheer my obsessive probing of the vicissitudes of theory, and who shared their time, thoughts, knowledge, and skills of critical reading to help me bring into focus my sometimes meandering arguments.

Lindsay Waters, Executive Editor for the Humanities at Harvard University Press, was unwavering in his support for this project, which grew in scale and ambition beyond either of our expectations. I am very grateful for his encouragement, advice, and above all, patience. A few courageous friends undertook the task of reading large sections of the manuscript, providing invaluable advice. Foremost among these are my most loyal and penetrating critic, Michael Westlake, and my equally critical and supportive partner, Dominique Bluher. John Hamilton also carefully reviewed the first part of the book, making many helpful suggestions and saving me from embarrassing infelicities of German, Latin, and Greek. James Chandler provided many helpful suggestions for structuring the project as a whole. I am equally grateful for the detailed and constructive reading given this project by anonymous readers for Harvard University Press. Among the other dear friends and colleagues who shared their work, ideas, and criticisms were Richard Abel, Dudley Andrew, Homi Bhabha, Karl-Alfred and Eliane Bluher, Sarah Childress, Alex Galloway, Stephen Greenblatt, Michael Holquist, Martin Jay, András Bálint Kovács, Martin Levebvre, John MacKay, Geoffrey Nowell-Smith, Brian Price, Robert Ray, Eric Rentschler, Judith Ryan, Masha Salazkina, Steven Shaviro, Diana Sorensen, Megan Sutherland, Charlotte Szilagyi, Galin Tihanov, Maureen Turim, and Justin Weir. The ever-extraordinary Renée Pastel provided invaluable editorial help, verifying citations, reviewing translations, and copy editing with her usual precision

and thoughtfulness. I am also grateful to Mark Tansey for kindly permitting the reproduction of his painting *West Face* and to James McKee at Gagosian Gallery, New York, for her help in obtaining permissions and images.

The genesis of many of the ideas and arguments for this book occurred at one of the most exciting and challenging events of my academic career: the Radcliffe Institute Exploratory Seminar on "Contesting Theory," co-organized by Stanley Cavell, Tom Conley, and myself, which took place in May 2007. An early version of my essay "An Elegy for Theory" was circulated as a discussion paper at this workshop, whose participants included Richard Allen, Sally Banes, Edward Branigan, Noël Carroll, Francesco Casetti, Joan Copjec, Philip Rosen, Vivian Sobchack, Malcolm Turvey, and Thomas Wartenberg, as well as Allyson Field, Dominique Bluher, and Meraj Dhir. After this workshop, I needed no further convincing of the power of conversation to generate new thought and critical commentary, and I thank all who participated for the lasting influence of their ideas and criticisms.

Many of my arguments were also honed by responding to challenging audiences at invited lectures and conferences at a variety of institutions: Oklahoma State University; the Humanities Center at Johns Hopkins University; Concordia University; the Columbia University Seminar on Cinema and Interdisciplinary Interpretation; the Laboratory for Advanced Research on Film and Philosophy at the Instituto de Filosofia da Linguagem, New University of Lisbon; the Udine International Conference on the History of Film Theory/ Permanent Seminar on the Histories of Film Theories; the Institute for Advanced Study, University of Minnesota; Leopold-Franzens-Universität at Innsbruck, Austria; Wayne State University; the University of Florida, Gainesville; and the Society for Cinema and Media Studies. I am especially beholden to the staff, colleagues, and fellows who shared with me one of the most extraordinary and fertile semesters of my career at the Internationales Kolleg für Kulturtechnikforschung und Medienphilosophie in Weimar, including the generous and brilliant co-directors of the institute, Lorenz Engell and Bernhard Siegert.

Portions of the manuscript have appeared as articles including "An Elegy for Theory," *October* 121 (Summer 2007); "Ricciotto Canudo and the Birth of Film Aesthetics," *Cinematic* 8 (Spring 2008); "The Aesthetic Discourse in Classical Film Theory," Dossier on Classical Film Theory, *Screen;* and "A Compass in a Moving World" in *Thinking Media Aesthetics,* edited by Liv Hausken et al. (Peter Lang). I wish to thank the editors of these publications for their attentive comments and suggestions and for their kind permission to reprint this material here.

A final thank you, and perhaps the most important one, goes out to my undergraduate and graduate students at Harvard University. My *Elegy for Theory* was shaped in deeply influential ways by students in several iterations of my seminar on Philosophy and Film.

# INDEX